The Aesthete in the City

Also by David Carrier

Artwriting
Principles of Art History Writing
Poussin's Paintings: A Study in Art-Historical Methodology

David Carrier

The Aesthete in the City

The Philosophy and Practice of American Abstract Painting in the 1980s

The Pennsylvania State University Press
University Park, Pennsylvania

Library of Congress Cataloging-in-Publication Data

Carrier, David, 1944–
 The aesthete in the city : The philosophy and practice of American
abstract painting in the 1980s / David Carrier.
 p. cm.
 Includes bibliographical references and index.
 ISBN 0-271-00943-8
 1. Art criticism—History—20th century. 2. Art criticism—
Philosophy. I. Title.
N7476.C36 1994
701′.18′097309048—dc20 93-8852
 CIP

Published by The Pennsylvania State University Press,
Barbara Building, Suite C, University Park, PA 16802-1003

It is the policy of The Pennsylvania State University Press to use acid-free paper for the
first printing of all clothbound books. Publications on uncoated stock satisfy the mini-
mum requirements of American National Standard for Information Sciences—Perma-
nence of Paper for Printed Library Materials, ANSI Z39.48–1984.

In memory of Adrian Stokes
and for Joseph Masheck and Leo Steinberg

Nihilism is needed to clear the way for creativity, to make it plain that the world is without significance or form. And Will-to-Power imposes upon that unshaped substance the form and meaning which we cannot live without.

—Arthur C. Danto

For Nietzsche there is no single best narrative. . . . The will to power . . . insists that many views of the world are viable.

—Alexander Nehamas

Contents

List of Illustrations

Acknowledgments

Earlier versions of these texts, or related materials, were given in dialogues presented with Mark Roskill at the Fashion Institute of Technology, New York, and with David Reed at the Whitney Museum; at the Studio Art Department, Princeton University; Art Center, College of Design, Pasadena, California; the Department of Studio Art, Columbia University; Emma Lake Artists' Workshops, Mendel Art Gallery, Saskatoon, Saskatchewan, Canada; for the Departments of Philosophy, Central Michigan University and University of Houston; the Department of Art, University of Texas at Austin; the Department of Art History, Brown University; Blossom-Kent Art Program, Kent State University, Kent, Ohio; and the San Francisco Art Institute. I thank my colleagues at these institutions for inviting me and these audiences for their comments.

Anita Silvers and Michael Ann Holly provided challenging commentaries on a paper that Jerrold Levinson invited for a meeting of the American Society for Aesthetics in 1990; their good criticism, which persuaded me not to publish it, influenced the presentation in this book. Alan Tormey and Gary Schapiro were commentators on my *Artwriting* at the American Phil-

osophical Association in 1989; my response is republished here. This book would not exist without the generous help of many people at Penn State Press; special thanks to Lisa Bayer, Kate Capps, Cherene Holland, Susan Lewis, Sanford G. Thatcher, and Philip Winsor.

I thank the many artists—not only those written about here or in my other published criticism—who discussed their work and art criticism with me. I am grateful to the art dealers who supported my work: Pamela Auchincloss, John Good and Carol Greene, David and Renee McKee, Max Protetch, and Victor Ruggerio, who let me curate a show. At *Arts,* Richard Martin, and, more recently, Barry Schwabsky—who has supported my work, and introduced me to artists and galleries—were generous editors. I also thank Thomas West, Jill Lloyd, and Michael Peppiatt of *ArtInternational;* Donald Crawford of the *Journal of Aesthetics and Art Criticism;* and Roger Malina and Pamela Grant-Ryan at *Leonardo.*

The essay on Manet benefited from editorial suggestions by Richard T. Vann of *History and Theory;* my article on Benjamin was written because Aldo Rostango asked me. One essay on David Reed was written at the invitation of Stephen Bann, and originally published by Reaktion Books. My early essay on Scully was commissioned by the late John Caldwell; my essay about Scully and Mondrian, invited by a journal editor who then had to cut it, was generously rescued by Garner Tullis, who published it in his monograph *Sean Scully: Prints, 1987–1991* (New York, 1991). I learned a lot going with David Reed to galleries and museums. I thank the various artists, John Post Lee, the Mary Boone gallery, and Morgan Spangle, formerly of RubinSpangle Gallery, for plates; Per Jensen has been especially helpful. This is the second of my books edited sensitively by Frank Austin, whose patience remains admirable.

A draft of this book was constructively criticized by Richard Kuhns and Kermit S. Champa. On separate occasions, I have had the opportunity to spend some few hours with the two most important American art critics; I thank Clement Greenberg and Leo Steinberg for answering my questions and challenging my beliefs. I have discussed art on many occasions with my kind friends Paul Barolsky, Frances Lansing, Mark Roskill, and Richard Shiff. My writing (and life) has been made happier by Arthur Danto. I owe a great debt to my wife, Marianne Novy, who has taken the time to give me both support and critical perspective. And Teddy Seidenfeld deserves acknowledgment for trying to run the department in which I teach in an ethical way.

My greatest debt is to the three artwriters I think of as my teachers—

writers (I never formally studied with any of them) whose help was crucial. When I was young, it was my good fortune that Adrian Stokes was the first artwriter I seriously read. He encouraged me—I greatly regret that I never met him—and later Ann Stokes Angus, Philip Stokes, and Ian Angus gave a very vivid sense of his world. In the 1970s I spent a lot of time in Stokes's London house talking about art with them and looking at Adrian's paintings. A few years later, Joseph Masheck, a very generous person, also encouraged me. As long as I have been writing about art, I have been rereading Leo Steinberg's beautiful texts, marvelous and challenging models. In response to my essay on his work in this book, he asked who were his followers, implying that I was mistaken to think him influential in that way. I do think of myself as his follower, though it is true, as also with Adrian and Joe, that part of what I have learned is how to write criticism which is very different from his.

Introduction

In the late 1970s, after for some years teaching the philosophy of art, I wrote to Joseph Masheck, then editor of *Artforum*. I wanted to argue with his "Iconicity" essays in an academic way, but he suggested that I would learn more by writing criticism. He introduced me to Sharon Gold, the first of many good painters I met and wrote about during the 1980s. Seeing how painfully naïve I was, she was patient. Many other New York artists who allowed me into their studios also were my teachers. When later I read Marjorie Welish's essays about the studio visit, I found she had truthfully described this part of my life.

Thanks in part to President Reagan's economic policies, it was possible for a lot of art to be made, displayed, and written about in New York during the 1980s. It was hard not to see this as a tragicomedy. Tragic because, even in this prosperous era, it was hard to become an artist. Comic because, although the most fashionable neo-Marxist theorizing stressed the critical political power of art, such theorizing lacked what that leftist empiricist Bertrand Russell called a robust sense of reality. Perhaps leftist artwriting would have been more plausible if it had involved some plan for political

action. Insofar as it was merely an academic position, it was easy to criticize. But I grant that when people do act, judging their actions can be hard. Félix Fénéon, Seurat's great supporter, started out as an anarchist and ended up working for an art dealer. His revolutionary art criticism has stood the test of time; his politics remains harder to evaluate. Should we ever take the politics of artwriters seriously? I do not believe that looking at, and writing about, art prepared me to be a social critic. But that I am a skeptic about the claims of the influential writers in *October* does not mean that I am a formalist, though I do admire the great formalist writers.

Although I had in graduate school read (in English) Hegel, Merleau-Ponty, and Sartre, my training was in the Anglo-American analytic tradition. In 1968 the most important living aestheticians were Nelson Goodman and my teacher, Richard Wollheim. In the 1970s I was fascinated by Adrian Stokes's visionary writing about the Quattro Cento. And E. H. Gombrich's *Art and Illusion* got me interested in art history. But Stokes and Gombrich, whose work I learned about from Wollheim, were little concerned with modernism and did not say much that seemed relevant to the art of the 1980s.[1] Arthur Danto, who had supervised my doctoral thesis (and who became a critic a little after I did), published *The Transfiguration of the Commonplace* in 1981, but only later dealt with its implications for art criticism.

Much of the most prestigious criticism of the 1980s, heavily concerned with theory, employed Continental philosophy. For someone trained in the analytic tradition, art criticism was intoxicating—as intoxicating (and hard to understand) as the political events of 1968 at Columbia University. Philosophy as I had studied it was a relatively disciplined activity; we philosophers had to give arguments and offer counterexamples. In the 1980s, theoreticians displayed a verbal virtuosity foreign to American analytic philosophy. Were philosophers to read criticism, I am sure they would find most of it intellectually frivolous, if not downright irresponsible.[2] Art critics, in turn, are unlikely to find much stimulus in academic aesthetics, which remains mostly unconcerned with contemporary visual art.

When critics cite Jacques Derrida, Michel Foucault, or Jürgen Habermas, as if the mere fact that they have made an assertion is reason to think it true, critics are likely to drive philosophers crazy. In the *Journal of Philosophy*, one cannot simply write, "as Russell said . . . as Danto demonstrated

1. One of my early publications was a Goodman primer for art critics, "Recent Esthetics and the Criticism of Art," *Artforum* 18, no. 2 (1979): 41–47. He was not the sort of writer the artworld was ready to take seriously.

2. See Noël Carroll, "Illusions of Postmodernism," *Raritan* 7, no. 2 (1987): 143–55.

. . . as Donald Davidson thought"; the editors want an argument.[3] Critics who cite authorities as if they were scripture produce eclectic texts. Since theorists differ in radical ways about crucial issues, using theory selectively—applying Derrida to Matisse, say, and some other theorist to Mondrian—is an obviously unsatisfactory procedure.[4] Art criticism ought to reveal more than the writer's reading. Perhaps art critics seem bolder than aestheticians because they are less given to doubt, or self-criticism. At any rate, I learned a lot by imitating the fasionable art critics and by arguing with them. Academic philosophy, like art history, has well-entrenched research techniques. Becoming a professor of philosophy or of art history requires that even mavericks start by appearing to conform. By contrast, in art criticism there is no licensing system. What still seems to me liberating is working essentially uninhibited by precedents. Matching pictures with words is challenging, especially when there are no conventions to fall back on.

I never tried to meet the famous senior artists whose work I most admire. Once an artist is well established, she or he can proceed in a relatively self-sufficient way. I most enjoyed writing about artists whose work had not yet been much discussed. I thought that what I said might make a difference to them, as it sometimes did. The styles of such artwriting have changed rapidly, which encourages experimentation and makes it easy to expect continued change. Since tradition has little power in art criticism, I wanted to find novel ways to describe artworks I enjoyed viewing. Writing criticism decisively influenced my work with art history. No one can write about Manet or Poussin without employing the well-entrenched ways of describing these painters' subjects. Even the most original commentary on much-discussed artists like these must, even if it ignores everything that has been written earlier, implicitly take issue with that tradition.

Reviewers regularly criticize (or praise) my writing on art history for being subjective. Perhaps this reflects my experience as critic. Unlike some writers linked with the new art history, I am obsessed with the traditions of art history; but it is true that sometimes my goal is to use the traditions against themselves. My *Poussin's Paintings* (1993) was very much influenced by discussions with David Reed and by the paintings of Sean Scully, a very different artist. When I came to think of Poussin as another artist I might

3. An instructive case study is provided by Paul Bové, "The Foucault Phenomenon: The Problematics of Style," foreword to Gilles Deleuze, *Foucault*, trans. S. Hand (Minneapolis, 1988).

4. See Richard Shiff, "Break Dancing," *Arts* (April 1991): 25–35.

have known, I was ready to respond to his art in a personal way. Academic art history seeks to be objective. "Historians coolly analyze; critics are passionately engaged."[5] Because history deals with historically distant figures, objectivity seems desirable and possible. Art criticism is a partisan enterprise. My judgment that Reed and Scully are important painters implies that some of their much-praised near contemporaries are overrated. Most other critics reject this view. Poussin scholars also argue ferociously, but mostly they agree about the value of his art.

This book has three parts. The first discusses the connections between art history and art criticism. Part Two offers a critical evaluation of some of the most influential theorizing from the 1980s. Jean Baudrillard, Walter Benjamin, Tim Clark, and Jacques Derrida were much discussed by artwriters, who often also used the ideas of Leo Steinberg. My essays in this section are polemical and partisan; my conclusions, often tentative. Admiring these writers, I thought that their philosophical arguments deserved to be critically evaluated. The third part reprints some of my criticism, which certainly refers to a lot of theory. Theory promised to elevate criticism out of journalism into the academic world. Who could not be tempted by that promise? Certainly I was. Writing about contemporary art, it seemed, might acquire some of the intellectual substance of the texts of Erwin Panofsky, Aby Warburg, and Heinrich Wölfflin, who made art history into a university subject. My sense, looking back, is that this promise was not fulfilled. The theorizing of the 1980s, wildly imaginative and extremely inventive—a grandly bold intellectual adventure—was too abstract. But I think these essays deserve republication, for they contain lots of ideas worthy of further discussion. My own best moments as a critic came when artists told me that I made visual sense of their work. It was great when Catherine Lee said that I was understanding her artistic development, and when Gary Stephan found that I had identified his images—the best moments in my writing involved such dialogue.

I feel that art criticism in the 1990s has much to gain by becoming more concrete. But this is only a generalization from my experience. Some 1980s' critics are opposed to theory on principle, judging it politically unacceptable or calling it unvisual. That is not my view. If the "leftist" theorizing turned out to depend upon utopian fantasies, at least American Marxists sometimes seemed open to new art in a way that conservatives often were not. An immensely stimulating leftist tradition, from which I have learned much,

5. Michael Ann Holly, "Past Looking," *Critical Inquiry* 16 (1990): 373.

dismisses the aesthetic as merely a creation of bourgeois society. I do think that a great deal could be learned from a genealogy of the museum, and of the art gallery. Conservative appeals to tradition can never be ultimately plausible, not when traditions have changed radically so very quickly. But what consistency then demands, in my opinion, is a critical look at the present. Richard Serra, whose most distinguished champions are leftists, is as much a product of what Marxists call late capitalism as Constable is of early capitalist England. Could artists so well supported by their societies really be radical social critics?

None of these theorists adequately discussed what most interested me, the sheer excitement of looking at paintings. Although one great, and greatly influential, theorist identified the pleasure in the text, visual pleasure was, for reasons Laura Mulvey explained, politically suspect. My sense is that texts stand to pictures somewhat as, in Cartesian philosophy, the mind stands to the body; and that the true task of artwriting is to solve what by analogy may be called the "text-picture problem," explaining discursively our sensual pleasure in the visual. Nor did the theorists talk enough about how very hard it was to be an artist. Becoming a painter required a crazy self-confidence, crazy because only in retrospect, when later someone has made serious art, could this belief be rationally justified. Part of the problem is that it was expensive and difficult to live in New York. In Manet's Paris, that city was the subject of art. When I was visiting critic for the Maryland Art Plan, I was amazed at the variety of art being made by the artists I was taken to visit. That artmaking impulse, which I always respect, is good. But today serious art could only be made in a city like New York, where there is a critical mass of people who care passionately, where everyone is watching everyone else. The odd mixture of cooperation and competitiveness required to produce unacademic art is only possible in such an urban environment. What always excited me about being in New York was being with so many people who cared passionately about art. Their artworld became, for those moments, my world.

If it was difficult to become an artist, it was even harder to have a career. As Mel Bochner said to me, contrasting the situation in Italy, Americans do not take much concern with long-term development. The artists I met early in the 1980s were getting shown and written about in serious journals. Today few of them still have real careers. Such is the rule, not the exception. It is hard to know how to realistically advise art students. I admire the few painters who have the talent and personalities necessary to survive, while I remain very aware of the human costs of this system, which can be ruthless.

Critics, too, need encouragement if they are to develop. When I had not yet achieved anything, a painter responded to my admiration of his work by offering me, in return, a grand gift, his unshakable confidence in my ultimate success as a writer. I owe a lot to Sean Scully.

No one, I think, has yet fully worked out the implications of what in the artworld is called pluralism and, in philosophy, following Nietzsche, can be called perspectivism. Does Peter Schjeldahl live in the same artworld as Hilton Kramer and Rosalind Krauss? Do they see the artworks as do Lynne Cooke, Lucy Lippard, and John Ashbery? My epigraphs from two Nietzsche scholars call attention to the philosophical implications of this problem. Studying perspectivism might help critics understand contemporary art. The argumentation about this issue that follows is closely linked with that of my previous books, which provide other, not incompatible perspectives on the relation between visual art, texts, and artworld institutions. In the 1940s, there was very little demand for contemporary American art; by 1980, that marketplace had become very well established. Major works by the artists of Pollock's generation became as much desired by museums as old-master works; and already their successors were well established. Since it was reasonable to expect that important younger artists would continue to appear in the American artmarket, a central concern of critics was to identify the new artists who developed this tradition. A number of other commentators have told the stories of the development of painting from Pollock's time to the present. My novel approach in *Artwriting* (1987) consisted in focusing on the history of art criticism. Just as there are histories of painting, stories with beginning, logical development, and conclusion, so too, I argued, the texts of artwriters can also be presented in this way. The philosophy of art criticism is a legitimate branch of philosophy.

In most such historical narratives, working out the conclusion is difficult. The Second Empire has disappeared, and so a historian can describe the end of that historical era. But since this American artistic tradition seems to be ongoing, I found a certain artificiality in establishing narrative closure by concluding the story at a seemingly arbitrary point in the present. Other artwriters do not have this problem. Arthur Danto, to whom *Artwriting* is dedicated, has argued that we are now at the end of the history of art.[6] That this may be the case does not necessarily show that the history of artwriting has also ended. One consequence of his view is that the end of the story of art is the end, the real end, of that tradition.

6. Arthur C. Danto, *The Philosophical Disenfranchisement of Art* (New York, 1986), chap. 5.

A philosopher could learn a lot from the history of art criticism in this period. A proper analysis of Danto's argument would require scrutiny of his philosophical system, in relation to the philosophers he has written about: Sartre, Nietzsche, and the Hegel commentator from whom he borrows, Alexandre Kojève. Such a study could be very rich, for it would require analysis of the poststructuralist dialogues of Derrida and Foucault with Nietzsche; and since Danto has also published a classic study of historiography, *Analytical Philosophy of History* (1968), an adequate commentary would need also to discuss his view of historical explanation. What would be required is both a study in intellectual history and a philosophical analysis.[7] I hope that someone will write that book. I believe that various true historical narratives may focus on different artists, starting and ending at different historical moments. To say that the history of art has ended is only to indicate that one narrative had ended. In another historical story, the same events may be differently described. Mine is a limited kind of relativism. Danto is not a relativist, and so for him explaining how it is possible for us to have such differences ought to be a real problem.

My *Principles of Art History Writing* (1991) is concerned with relativism as a historical question. It indicates how styles of art-historical explanation have changed; it does not explain how to understand contemporary artwriting, although some of its claims are relevant here. *Artwriting* defended a form of relativism, but when I came to the practice of art criticism I rejected relativism. Just as philosophers who were skeptics about the external world or the self nevertheless must presuppose the existence of what they call fictions when they act; so, although I defended a version of relativism, as a working artwriter I am not a relativist. What I can do, I would argue, is recognize that every narrative, my own included, has a certain fictionality. To say that all such histories are in part fictions is not, of course, to suggest that all are equally good. Just as some fictional stories are more plausible or otherwise better than others, so the same is true of artwriters' narratives.

Recently Danto has made some suggestions about critical differences that are relevant: "There are certain works, as certain persons, ones likes or dislikes for reasons having nothing much to do with their excellences or failure. . . . There are painters I know are good and even great whom I cannot like. . . . When someone actually likes or loves these artists, he or she must be a very different person from me."[8] This cannot be the whole

7. One starting point might be my "Danto as Systematic Philosopher; or, *Comme on lit Danto en français*" and the other essays in the volume edited by Marc Rollins, *Arthur Danto and His Critics* (Basil Blackwell, 1993).

8. Arthur C. Danto, *Encounters and Reflections* (New York, 1990), 9.

story. Danto implies that what is personal is only the critic's response to the artwork, not her or his judgment of its excellence. But often when critics disagree about contemporary art they disagree about whether it is good work.

I admire Danto's acknowledgment of the critic's necessary subjectivity. How hard it is to accept such genuine differences of opinion! Nowadays every famous younger artist is greatly admired by some critics and ignored or hated by others. That there are such disagreements is one source, I believe, of the much-discussed notion of postmodernism. Danto's earlier philosophical work on Nietzsche and on historiography gave him an original viewpoint, distinct from that of most theorists, on these issues.[9] And yet, even the reader who has closely studied Danto's earlier books would be hard-pressed to predict his art criticism. As Danto has observed, his conception of art history presents a view that his book on historiography "had pretty much taken a stand against . . . in principle."[10]

Danto and I share enough assumptions to make our disagreements of real interest. In a certain mood, such disagreements seem very frustrating. If I cannot see something that a good critic observes, he may think me blind. (Sometimes I feel blind when reading Michael Fried's art criticism.) If a friend and I differ about an ethical issue, that disagreement may be explained by some difference in beliefs. What is more frustrating is to understand how two people who may share many beliefs can *see* the same artwork, the same physical object, so differently. It is natural to complain that the other person is blind, as if she or he were unable to see what is right before both of us. And yet, since we do both see the same thing, that cannot explain our disagreement.

When two critics agree, there is nothing more to say; when almost everyone agrees, then there is no point in writing any more. Almost everyone today agrees that Caravaggio and Rembrandt are great masters, and so historians turn to other problems. (There is much productive argument about how to interpret their art.) What gives vitality to discourse about contemporary art is that there are radical disagreements, not only about how to interpret it but also about what works are important. Were there agreement

9. See his *Nietzsche as Philosopher* (New York, 1965) and his *Narration and Knowledge* (New York, 1985), whose core argument was originally published as *Analytical Philosophy of History* (Cambridge, 1968).

10. Danto, *The Philosophical Disenfranchisement of Art*, xiv. The argument of his *Mysticism and Morality: Oriental Thought and Moral Philosophy*, 2d ed. (New York, 1988), about the relation between morality and beliefs about matters of fact is relevant.

about what constitutes the canon, then there would be nothing more to say. Disagreements are necessary if discussion is to proceed. That description of the situation may seem to reverse the natural order of the analysis. The function of argumentation, we might think, is to identify the excellent art. But this assumes that excellence is a property of some artworks, which we must only see properly. Is this really correct? Reversing the order of the analysis may provide a better way of understanding why such disputes are difficult to resolve.

How dull the artworld would be were there general agreement. When Sir Joshua Reynolds in his *Discourses* asks whether Michelangelo or Raphael be the greatest artist, allows that Rubens, Poussin, and Titian are not unimportant, and offers a condescending judgment of his friend Gainsborough, how smug and boring he seems. He says nothing about Chardin or David, and he is unwilling to imagine that Gainsborough's work will be the origin of the great English tradition of landscape painting. Reynolds looks backward, entirely unaware that the canon he admires is about to be radically revised. A similar observation can now be made about Greenberg's canon, which has little place for Johns. One reason I find writing art criticism challenging is that at every point I am forced to rethink fundamental questions. Today, no one can yet really be sure how to understand the art of the 1980s.

My approach to these problems was anticipated by the conclusion of *Artwriting*. (Here I have learned from my critics.) "Though he is a practicing critic himself," a reviewer in an art journal observed, "Carrier is not embarrassed to proclaim 'the present-day function of artwriting is to advertise art.' "[11] But why should I have been embarrassed, since artwriting *does* sell art? That is not to say that this is the only function of such texts. Nor, so far as I can see, does criticism such as mine have much short-range influence on the artmarket. But unless someone believes that selling art is wrong, why should it be embarrassing to acknowledge that art criticism influences sales of art? I admire Fry because he persuaded his countrymen to acquire Cézannes and de-access their Sargents. If my writing also promotes good art I will be pleased, and vindicated.

Perhaps "in New York critics are . . . compromised by commercial forces," a more sympathetic reviewer allowed; but this may not show "the nature of art criticism . . . because of the uneasy balance in *Artwriting* between socio-historical analysis and philosophy."[12] But the claim that art crit-

11. Review, *Print Collector's Newsletter* 19, no. 1 (March–April, 1988): 30.
12. Antonia Phillips, "Generating a Consensus," *Times Literary Supplement* (27 May–2 June 1988), 587.

icism has a nature that can be compromised by commercial forces suggests that somewhere, sometime there was "purer" criticism. Yet often earlier, too, criticism played a real, practical role in establishing and maintaining artists' reputations.[13] A cover story in *Art in America* produces sales; when Ruskin wrote on Turner, or Diderot on Chardin, criticism also was linked with commerce. A critic is involved in making distinctions, and if she or he is taken seriously in the artmarket those judgments will have an effect.

In this way, art criticism differs from philosophy. Any analysis of a philosophical system that reduces it to a reflection of sociohistorical forces is bound to seem reductive. Descartes, Schopenhauer, and Wittgenstein gave arguments, and so to treat them as merely expressing the worldview of their time, or society, or sex fails to do justice to their positions. This kind of reductive analysis itself must make substantive philosophical claims about such argumentation. But since European and American art criticism has always existed within a marketplace, an analysis of criticism must, if at all plausible, employ some mixture of sociohistorical analysis and philosophy. Unlike philosophers, art critics influence sales of commodities.

A reviewer who became an art-journal editor, having allowed that "it is difficult to dispute Carrier's assertions regarding the market functions of criticism," nevertheless went on to say that "Carrier's conclusion does seem surprisingly facile in view of the subtlety of some of his analyses."[14] "One can admire Carrier's writing," another friendly commentator wrote, "and still long to rescue him from his own relativism."[15] But as is nearly always the case in life, only when the writer himself sees these problems is it possible to come up with a better analysis. No critic could be a relativist, for criticism requires offering judgments, and so making choices. And while there is a certain sociological interest in seeing what is in fashion, no working critic could think that art criticism was merely a branch of sociology. Perhaps a sociologist could see it that way, but only if he or she remained outside the artworld.[16] Maybe my uncertainties were best summed up by the reviewer who said, "It is hard to tell just what Carrier himself thinks about this purported situation, except that his attitude is complex and ironical."[17] Philosophers tend to be involved in potentially endless argument,

13. See Patricia Mainardi, *Art and Politics of the Second Empire* (New Haven, 1987), and Thomas E. Crow, *Painters and Public Life in Eighteenth-Century Paris* (New Haven, 1985).

14. Barry Schwabsky, Review, *Flash Art* (May–June 1988), 99.

15. Hearne Pardee, Review, *Art Journal* 48, no. 2 (Summer 1989): 196.

16. Such an argument is developed in Pierre Bourdieu, *Distinction: A Social Critique of the Judgement of Taste,* trans. R. Nice (Cambridge, Mass., 1984).

17. Michael Parsons, Review, *Arts Education Review of Books* (Winter 1990): 23.

but in practice people must act. In *Artwriting* it was all good and well for me to defend relativism. But as acting critic, I cannot but assert my values.

This book consists of a selection of my longer articles on the practice and theory of criticism written during the 1980s. I do not include many of my short reviews, nor essay reviews covering a variety of artists. My chosen essay format, and the one most accessible to me within the commercial art journals, focuses on individual artists and issues of theory. I have devoted my attention almost exclusively to a small group of abstract painters. My view, still highly unfashionable, is that what Greenberg called " 'American-Type' Painting" provides the natural starting point for an ongoing artistic tradition. As critic, I have remained loyal to my first love, painterly painting. I had the good fortune to meet some of the artists I admire early on. Together with a few others I have met more recently, they are the artists I have wanted to write about. Although a couple of them have become well known, work such as theirs remains relatively marginal in the commercial artworld; the most influential contemporary theorizing is hostile. When I consider the history of American art, this seems strange. Almost everyone admits that the most important American artistic movement was abstract expressionism, and that its best-known champion, Greenberg, is the finest American art-writer. But whether because in the 1960s Greenberg turned his attention to other abstract painters whose work has not stood the test of time, or because America has never become a visually sophisticated culture, despite the importance of its market in contemporary art—in any event, recent abstract painting has not found the theorists it deserves.

I admire the boldness of activist artists, and I share their sense of the political problems of New York and this country, as does every artist I know. I would enjoy being an aesthete, but nowadays an aesthete can not, and should not, escape acknowledging contemporary problems. It is easy to feel that any attempt to make art without explicit political content, especially abstract art, is merely escapist. The abstractions of Kandinsky and Mondrian were linked by them with ways of thinking that today are unacceptable; the ways Greenberg, Harold Rosenberg, and Meyer Schapiro talk about the politics of abstract expressionism are hard to take literally. And yet, the political art I have seen, which is in principle as collectible as the most elegant abstract painting, cannot, I think, change the world as some of its admirers would desire. Because I doubt that the world can be changed from within the artworld, I tend to be suspicious of such work.

One obvious omission in what follows is the issues raised by feminism. I wrote about many women in the 1980s, and after this book was completed

I had the good fortune to write a catalogue for one abstract artist I think obviously and absolutely magnificent, Catherine Lee.[18] For me personally, Agnes Martin, Elizabeth Murray, and Joan Mitchell were three of the strongest senior painters of this period. But I was not able to write about them. And although I read a great deal of feminist literature, I did not see how to relate it to my experience of painting. I now do; my next book discusses feminism in relation to the origin of modernism. A less obvious bias, as Lillian Ball has repeatedly reminded me, is my focus on painting rather than sculpture. But although I published essays on Richard Deacon and David Rabinowitch, and shorter accounts of Ball, Maureen Connor, and Joyce Robins (three sculptors I admire greatly), the essays I reprint record my sustained engagement with painters.[19]

For all of my skepticism about the viability of the analytical tradition in which I was trained, it has continued to influence my criticism. Clarity and straightforwardness are essential virtues, to my way of thinking, for all art-writing. In the end, I remain a philosopher. I assembled this book in 1991, unaware that it would constitute a kind of memorial to a period style. Soon afterward *Arts Magazine*, which had lived through the Great Depression, did not survive an economic downturn that changed the entire artworld system in ways no one had foreseen. The problems of the 1980s' art market, one that always seemed overextended, were obvious. But how art and its support system will develop in the 1990s it is impossible as yet to even guess. I hope that I will continue to be able to publish criticism, for I continue to meet challenging younger artists. In my second decade as critic, I am still learning. My work in the early 1990s owes great debts to Demetrio Paparoni, editor of *Tema Celeste*, and, most especially, to Garner Tullis, who has been an extraordinarily generous, extremely patient friend and teacher.

In this age of pluralism, in which all forms of art supposedly are equal, few people see unfairness in the failure of the artworld to take seriously artists like Barbara Westman. Every artist must envy her when her *New Yorker* cover art is seen everywhere, even in provincial cities like mine. And yet she, as much as any painter of modern life, changes the very way we see

18. See my "Catherine Lee," *Arts* 58, no. 10 (1984): 5; "Extending the Language of Abstraction," *ArtInternational* 12 (Autumn 1990): 60–62; and "Catherine Lee's Art," in *Outcasts: Catherine Lee,* a catalogue published by Lenbachhaus (Munich, 1992), 4–27.

19. See my "Richard Deacon at the Carnegie Museum," *Arts* (October 1988): 36–40; "William Tucker at Storm King Art Center," *Arts* (December 1988): 88; "New York, Whitney Museum of American Art: The New Sculpture, 1965–75," *Burlington Magazine* (May 1990): 377–78; "Joyce Robins at 55 Mercer," *Art in America* (March 1987): 140–41; "Maureen Connor," *Tema Celesta* 36 (Summer 1991): 83–84; and "Lillian Ball," *Tema Celesta* 37–38 (Autumn 1992): 94.

the city in which art is displayed. Her images have changed how I think about art, and I was thrilled that she could do the jacket of this book. She did the preliminary sketches in 1991 while I was giving a lecture to a demanding audience—aestheticians attending an NEH summer seminar—at the San Francisco Museum of Modern Art. A wonderfully busy scene, this was a moment I am happy to have memorialized in her caricature of *Un Bar aux Folies-Bergère,* depicting me on the left and Arthur Danto on the right. Whenever I look at her drawings I think of her great high spirits. My own favorite essay here, the title essay, is dedicated to her.

Part I

Aesthetics, Art Criticism, Art History

1

Artwriting Revisited

Looking back, it is easy for me to understand how I, trained as a philosopher, went astray and wrote *Artwriting*.[1] The crucial wrong turn came late in the 1970s, when I spent more time reading *Artforum* than the *Journal of Philosophy*. Art critics are fascinated by philosophy, but they think of it very differently than do most members of the American Philosophical Association. One difference is that critics write better than they think, while philosophers think better than they write. Style is important to artwriters, whose undisciplined use of philosophy and refusal to offer sustained arguments could infuriate philosophers. These problems are reinforced by the tendency of critics to refer to Derrida or Adorno, not Danto and Goodman. It is easy for a philosopher to make fun of philosophical art criticism, which often resembles what Baudelaire identifies as philosophical art: "everything is allegory, allusion, hieroglyph, rebus."[2] And yet, art critics in the late

1. Amherst, Mass., 1987.
2. Charles Baudelaire, "Philosophical Art," in *The Painter of Modern Life and Other Essays*, trans. J. Mayne (London, 1964), 206.

1970s were wrestling with some very real problems that have barely been touched upon by aestheticians.

The best way to identify these problems is to explain why the word "art-writing" is important to me. That art has a history is an important discovery. It was made by Vasari when he told the story of art from Cimabue to his own time, by Hegel in his lectures on aesthetics, and again by Wölfflin in his *Principles of Art History*. By a history I mean what Danto describes in his *Analytical Philosophy of History:* a sequence of events with one leading to the next, a narrative with some natural beginning point, a middle, and a plausible conclusion.[3] By contrast, fashion has development—skirts are short, then long; ties wide, then narrow—but no history. Change in fashion occurs because of boredom or commercial need. There is no internal necessity to that change, though it may interest a historian if it reflects the larger culture.

Pollock comes after analytic cubism, which comes after Cézanne. The history emerges when they are thus connected, as is suggested by mentioning them together in one sentence. Imagine a nonstandard history of modernism in which Salvador Dali comes after Wilhelm Leibl, who comes after Goya. It is hard to generate a history from that sentence. There is no obvious connection between Dali's imagery and Goya's; and their relation to the realism of Leibl is obscure. By contrast, the historical link Cézanne-cubism-Pollock is important, a cliché now hard to recognize because it has become a cliché.

We have a succession of things—artworks or texts—and the aim is to write a history of them. Just as art has its history, so also does the writing about that art. I thought that artwriting is a literary genre whose origin and development deserved discussion. Just as a literary historian tells the story of the French novel from Balzac to Proust, so I wanted to write the history of artwriting. Wölfflin and the other philosophical art historians narrate histories of art. To the best of my knowledge, no earlier writer had identified this problem. A philosophical historian of artwriting narrates a history of it, treating artwriting in the way that art historians treat art. Its history has a beginning, a middle, and an end. Of course, artwriting is about art, and as such it is of interest to the art historian. But that art has a history does not tell us that artwriting also does. That art has a history is a discovery. Only writing a history of artwriting will show if that can be done. Some philosophers think that such histories merely make explicit the implicit reasoning principles of artists themselves. Some art historians believe that their inter-

3. Reprinted as Arthur C. Danto, *Narration and Knowledge* (New York, 1985).

pretations only put into words the intended meaning of a visual artwork. Both these ways of thinking fail to do justice to the creative role of artwriters.

Once a convincing narrative has been written it is easy to see an artwork's place in history. When a good interpretation has been presented, then we know how to see that artwork. Because a convincing pattern has been created, it is not hard to believe that the order it presents is the order of history or that of the artwork itself. But the construction of an alternative history, another interpretation, reminds us that this order is our creation. The best way to understand this situation is to focus on the rhetoric of the artwriter, upon the ways in which her narrative is put together. Just as it is hard to concentrate on a painting's pigment when we see what it represents, so it can be difficult to focus on an artwriter's rhetoric when we want to attend to her argument. The crucial move in my work, always, is to ask how the text is put together. Only an analysis of artwriting's plot structure permits us to identify what will interest the philosopher, its argument.

My initial question was whether American art criticism of the period that interested me, from Greenberg to the present, has a history. After a history becomes well known, it creates a structure so seemingly natural that it is hard to envisage how different art appeared before it was written. Roger Fry reviewed Wölfflin's book on the baroque, and he wrote a great monograph on Cézanne. And yet, he failed entirely to see what today is obvious, that Cézanne's late work leads right to cubism. The distance between what Cézanne was doing at the time of his death in 1906 and what Picasso and Braque did in 1907 is, to our eye, so small that we cannot but be astonished at Fry's condescending, utterly uncomprehending commentary, in which he says that Picasso's "interpretation of vision is rarely profound. Sometimes he will seize the pretext of insignificant details . . . to serve a decorative end, sometimes he will find therein the excuse, and little more than the excuse, for a nearly abstract and *a priori* plastic construction."[4] Similarly, the early commentators on Jackson Pollock saw him as an aberration, a bizarre figure who had no place in art's history. It took Greenberg to write an account in which Pollock was seen as developing and extending the achievement of early modernism, advancing the achievement of cubism as, for Wölfflin, the baroque builds upon the classical.[5]

4. Roger Fry, *Transformations: Critical and Speculative Essays on Art* (Garden City, N.Y., 1956), 274–75.
 5. See Heinrich Wölfflin, *Principles of Art History*, trans. M. D. Hottinger (New York, n.d.).

What I first needed was a beginning, a conclusion, and a link between them. The starting point of my account was seemingly as inevitable as Vasari's choice of Cimabue and Giotto for the origin of his history. The most influential recent critic is Clement Greenberg. Of course, there is much American artwriting from before Greenberg. But insofar as American art only became something more than a derivative of European tradition in the 1940s, when Greenberg was writing criticism, his work provided a natural place to begin. My own history of American artwriting thus commences at the same point as the history of the great tradition of American painting begins. From the start, this painting was accompanied by philosophical artwriting. This is not true of art of other times. Giotto has no major contemporary artwriters, and Alberti's important quattrocento book gives no real historical perspective; only Vasari offers a history in which Giotto and the artists Alberti knew are figures.

That nowadays Greenberg continues to be denounced by critics shows his importance. I might have begun by discussing Greenberg's announced influences, 1930s' Marxism and T. S. Eliot, an obviously paradoxical combination that he synthesized by providing a sympathetic Marxist reading of Eliot. (Such an account could be the basis for an interesting social history; this, mysteriously, remains to be properly done.) My choice, rather, to contrast Greenberg and Sir Ernst Gombrich signaled the intention to place Greenberg in an art-historical context. Obviously this juxtaposition of a leading champion of American Marxism with an art historian whose great mid-twentieth-century artist is Oskar Kokoschka is provocative.[6] But my aim in thus defamiliarizing Greenberg's work was to point to some important affinities between him and Gombrich, affinities that for the narratologist are more important than their obvious differences in taste. What Gombrich does for art history, redoing Vasari in a history of painting from Cimabue to Impressionism, Greenberg does for modernist painting.

The concluding point of my account was equally obvious. Just as I began by describing the rise of Greenberg, so my story would end by explaining his fall. Such a story about a great man must be a tragedy, a revelation of his tragic flaw, the narrative an organic whole because it tells of one figure. Greenberg inaugurated a tradition that now has ended. But the "Greenberg" who figures in it is the artwriter, not the man, whose life continues, and that tragic flaw was an inevitable flaw in the theorizing of Greenberg.

6. See E. H. Gombrich, "Introduction," *Homage to Kokoschka* (London, 1976).

Since I was interested in criticism now, my history would show how the revelation of this tragic flaw necessarily led to the present critical situation.

After discussing Greenberg, it was natural to turn to Michael Fried. Even now his "Art and Objecthood," published in *Artforum* in 1967, still is regularly attacked, again a sure sign that he is an important figure.[7] Since he is a great admirer of Greenberg, it was necessary to explain how exactly he differs. And yet for all their felt affinities, it was difficult to narrate this transition. One possible approach would be to take up Fried's intellectual differences with Greenberg, which Fried himself describes briefly. Or the narrator might ask why Fried admires some painters Greenberg thinks unimportant. But to treat critics as if they were philosophers whose arguments conflict fails to do justice to their role within the artworld system. Refuting Fried's arguments, as has often been done, is almost as absurd as explaining the problems of the Russian economy by critically discussing Marx's texts. Nor does focusing on disputes about taste really explain much, for the relation of tastes to theorizing is complex.

The aim of a philosophical history of artwriting is to show that as the artworld system changes successive critics necessarily play different roles. I cover only a portion of the arguments of each writer. Just as Greenberg has but a limited interest in the intentions of artists, so I am more concerned with my reading of these texts than with their author's announced goals. Since Fried began writing criticism in the 1960s, inevitably his role differed from Greenberg's. He built upon the older critic's achievement while criticizing his claims. So, whereas Fried is usually linked with his senior fellow formalist, in my book his analysis is opposed to Greenberg's. Fried has often inadequately been criticized within a narrowly intellectual framework. I, instead, compare his view of 1960s' modernism and Stokes's account of Quattro Cento carving. Many commentators have been puzzled by Fried's highly personal characterization of what he calls theatrical art. He uses that phrase to identify the work he dislikes, opposing it to the modernist art he admires. Oddly, although his articles and this art are both well known, it has been very hard to understand how his vocabulary describes that art. Since Stokes, too, employs a binary opposition, a contrast between what he calls carving and modeling, I read Fried by comparing his rhetoric to Stokes's. If we can understand how to apply his binary opposition to categorize artworks, then Fried's concept of theatrical art becomes clearer.

7. Michael Fried, "Art and Objecthood," reprinted in *Minimal Art: A Critical Anthology*, ed. G. Battcock (New York, 1968), 116–47.

In his own later writing Stokes discovered that the best way to explain his employment of this vocabulary in his early books was in an autobiography. What is problematic about Fried's discussion of theatrical art is that, lacking some equivalent explication, it is hard to understand how he contrasts it to modernist artworks. Since Stokes is more self-conscious about the problems of style in artwriting, my juxtaposition provides a good way of explicating Fried's claims. To thus link Fried with Stokes (as earlier I related Greenberg to Gombrich) points to similar conceptual problems. Greenberg needs to justify the genealogies; Fried must explicate his binary oppositions. And these problems, revealed in the practice of artwriters who followed them, can now be made explicit in my analysis. The real difficulty arose in working out a plan of what happened after Fried.

What gave me the most trouble was this part of my narrative. Any history must be selective, but what principle of selection is here to be employed? In many histories, selection is determined by the genre of the narrative. A traditional history of Louis XIV focuses on his everyday life, his closest advisers, and his court. Roland Mousnier's studies of urban unrest and Emmanuel Le Roy Ladurie's studies of those outside the elite involve concentrating on different actors.[8] And in Fernand Braudel's account of economic and social history all the politicians are marginal.[9] Of what genre was my book? One genre of artwriting discusses all the published criticism. In his studies of nineteenth-century French art, Tim Clark shows how the misunderstandings of even unoriginal or uninteresting writers reveal something.[10] There would be a considerable sociological interest in such a study of American criticism. I could imagine an analogous history of American art criticism of my period describing all the well-known writers, not only Greenberg and Fried but also Harold Rosenberg, Hilton Kramer, and many minor critics.

But I wanted to write a philosophical history, and that demands a narrative in which there is a continuous argument. In his day, Rosenberg had some influence. But he was a feeble thinker, and his argument with Greenberg was of significance only in providing Greenberg the opportunity to develop his views. Similarly, Kramer has played little role in the argumen-

8. Roland E. Mousnier, *The Institutions of France under the Absolute Monarchy, 1598–1789,* trans. A. Goldhammer (Chicago, 1984); Emmanuel Le Roy Ladurie, *Carnival in Romans: A People's Uprising at Romans,* trans. M. Feeney (Harmondsworth, 1979).

9. Fernand Braudel, *Capitalism and Material Life, 1400–1800,* trans. M. Kochan (New York, 1973).

10. See his *Absolute Bourgeois* (London, 1973) and *Image of the People* (London, 1973).

tation that formed recent criticism. These are dogmatic judgments, as judgments of taste always are. But such judgments must be made in a philosophical history. To give attention to all artwriters may imply that they are of equal importance. The philosophical historian of criticism who gives equal space to Greenberg, Rosenberg, and Kramer is as inept as an art critic who treats Barnett Newman, Philip Pearlstein, and LeRoy Neiman as artists of equal importance.

Labels for artistic movements are sometimes revealing. Greenberg wanted to call abstract expressionism "American-Type Painting." Yet this colorless label was replaced by one that, for him, could not be more inaccurate—the movement is not expressionism. On the cover of his *Postminimalism* Robert Pincus-Witten is described as "the first critic to challenge the formalist hegemony of the Sixties."[11] But although he was very influential in identifying artists who became famous in the late 1970s and early 1980s, it was Rosalind Krauss's rival phrase, postmodernism, which caught on.[12] Understanding why this happened explains why she has a place in my book and he does not. Postminimalism is a period style, identifying what comes after minimalism in the way that post-Impressionism tells what came after Impressionism. Postmodernism is a label presented in an account making a stronger claim; it offers an explanation of why modernism ends. Although Pincus-Witten, a gracious, highly original writer, has a real eye, he offers no worked-out explanation for the historical change he so elegantly describes. Krauss does, and while this does not show that she is the more important writer, it explains why her work is a contribution to a philosophical history of artwriting.

Reconstructing Krauss's argument is not easy. The evolution of her views is bound up in various political struggles within the artworld. As philosopher, she is perplexing; a reader of her recent reviews of Danto's and Wollheim's books might dismiss her entirely.[13] How dismaying is her inability to argue or even to recognize an argument. How tiresome is her authoritarian substitution of names for argumentation. When she urges Danto to read Benjamin, and Wollheim to brush up on his Gombrich and Wittgenstein, she is unintentionally funny. That she believes in the poststructuralist cri-

11. Robert Pincus-Witten, *Postminimalism* (New York, 1977).

12. Rosalind E. Krauss, *The Originality of the Avant-Garde and Other Modernist Myths* (Cambridge, Mass., 1985).

13. Rosalind E. Krauss, "Only Project," *New Republic,* 12–19 September 1988, 33–38, and "Post-History on Parade," *New Republic,* 25 March 1987, 27–30.

tiques of the author's role as the source of unity of his work is apt, for her work lacks unity. And yet, she has something so say about important issues.

I link her semiotic theory to one developed more recently, and in an altogether different context of revisionist art history, by Norman Bryson. This permits me to present Krauss's insights, and point to problems in this account, without getting involved in a nonphilosophical history of criticism of her time. Here I discuss only one of Krauss's claims: to identify the postmodernist era is to indicate that the tradition of modernism has ended and that nothing is taking its place. Postmodernism is not another period of the history of art. Her rhetoric is akin to Gombrich's, since he claims that the history of representational art ended with Impressionism, and to Greenberg's, who says that a stretched rectangular canvas can be a painting. These affinities of Krauss and Greenberg cannot be adequately explained by observing that they share an interest in Marxism. Gombrich too has a similarly structured narrative, but he dislikes Marx. They all share this sense of an ending because they all present developmental histories of art, which have problems with endings.

What makes Krauss a moralizing critic is her implied claim that since the end of art has come it is objectively irrational that paintings continue to be made, as if that activity did have a future. Like an old-fashioned Marxist who argues that since the objective conditions for revolution exist it ought to occur, she seems to think that recent fashionable art only prolongs this waiting game. Douglas Crimp's highly influential article, "On the Museum's Ruins"—published in Krauss's journal, *October*—arguing that the museum is undermined by photography, must deal with two awkward facts. First, photography has been around for a century. So why only now should the museum be in ruins? It was not necessary to read Benjamin to learn the cliché, one of Flaubert's received ideas: "Photography, will make painting obsolete."[14] Second, since Robert Rauschenberg, whose collages are crucial in Crimp's argument, does not agree with this view of art's history, how can his work support this thesis? There is something absurd about arguing that the museum, which right now enjoys an unprecedented expansion, is actually in ruins. Of course its end may come, but not for the reasons Crimp claims.

Since I do not think the end of the history of art or of artwriting has come, I go on to discuss an entirely different figure, Joseph Masheck, whose

14. Gustave Flaubert, *Bouvard and Pecuchet*, with *The Dictionary of Received Ideas*, trans. A. J. Krailsheimer (Harmondsworth, 1976), 321.

late 1970s work preserves what is most valuable in Krauss, not by arguing with her positions but by offering an alternative practice of artwriting.[15] Masheck's practice avoids the problems shared by the narratives of Greenberg, Fried, and Krauss. What for me was, and remains, liberating about Masheck's work was his creation of a narrative form describing the ongoing development of art without making the presuppositions necessary for a history like that of Greenberg or Krauss. Eccentrically, Masheck did this because he, as a Catholic, rejected the view of images that Gombrich, Greenberg, and Krauss share. It is always revelatory to find that seemingly radically opposed thinkers share some deep common assumption. But since Masheck was writing criticism, not doing historiography, it is no surprise that his achievement was not recognized.

In some optimistic moods we like to believe that important work will be recognized as such. Today, when the baroque is back in fashion, there are no major undervalued seicento artists. And while there are relatively undervalued intellectuals, it would be surprising if any major figure is as neglected as were Frege or Simmel. So, personal factors apart, it was important for me to understand why Masheck's work has remained of marginal importance. That Stokes is a marginal figure is understandable — the professional art historian finds his beautiful writings a literary form that could not be more alien. Sir John Pope-Hennessy, one such historian, was, when young, a reader of Stokes. But that reading could not be reflected in his publications. A reader who knows how much my art criticism owes to Masheck's might ask whether there is not something perverse in this ultimate dismissal of his importance. In truth, it might better be said that there is something perverse in history itself. But the first task of a historian is to explain what happens, revealing after the fact that things necessarily had to happen thus, and not to moralize. And if my book was to end not with him but with a discussion of the situation of artwriting in the 1980s, then I needed to explain the changing role of art criticism. My move here is as unexpected and perhaps as ironical as Masheck's account of abstraction in relation to sacred images. Since art criticism has lost that autonomy which

15. His linking of abstraction with Byzantine art was anticipated by Greenberg's 1958 essay, "Byzantine Parallels"; yet here is one case where the differences between writers who seem to offer parallel arguments are genuinely revelatory: "The Byzantines excluded appeals to literal experience against the transcendent, whereas we seem to exclude appeals to anything but the literal; but in both cases the distinction between the firsthand and the secondhand tends to get blurred" (Greenberg, *Art and Culture* [Boston, 1961], 169). This contrast between literal experience and the transcendental is precisely what Masheck denies.

it once seemed to have, I turn to study the relation of artwriting to the artmarket.

Studying that marketplace raises a basic question about the viability of my project. Is artwriting a genre of writing constituted by a self-sufficient body of texts that can have a history? Since artwriting has a promotional function, its history is hard to describe apart from that role in the sale of art. Here a historical perspective on this commercial system is essential. When Greenberg published criticism in the *Nation,* as Danto does today, their activity has relatively little influence on the artmarket. It is the commercial art journals that have an immediate effect.

Compare the magazines in which Greenberg published his original essays with *Artforum,* where the articles and reviews come after a hefty section of advertising, and it is clear that the institutional role of art criticism has changed. In the 1940s, de Kooning—a well-known figure in the artworld— had his first one-man show in his forties. Nowadays many collectors, curators, and art dealers are in search of the young de Koonings. Artwriting's institutional role seemingly differs from philosophy's. Perhaps the recent history of American philosophy ultimately is better understood in a story about the rise and fall of the American empire. That we will know only when William James, Dewey, Quine, and Kripke are presented in a narrative revealing the real political concerns of their argumentation. Such an analysis, I imagine, will draw little support from consideration of the institutional role of philosophy. It seems fantastical that Philosophy Hall at Columbia or Emerson Hall at Harvard, the homes of two great philosophy departments, play the role of such public institutions as museums; or that the *Journal of Philosophy,* with its few pages of publishers' advertisements, has the kind of link with commerce that *Artforum* necessarily does.

The problem for a historian of artwriting is to show that today it has an identity apart from its commercial function. Art history and philosophy are supported within the university. Art criticism usually is not, and this lack of an institutional role implies some skepticism about its pretensions. That criticism is a commercial activity is not, as some naïve commentators think, itself the problem. If anything, the problem is that critics are so poorly paid. Once art journals acquire color plates, and pay their editors and contributors, they need advertising from galleries displaying work reviewed by their critics. Whatever her intentions, the art critic who discusses younger artists is promoting their careers. But moralizing is out of place, for everyone is working within a system that no one individual created and that is unlikely to be changed by any mere artwork.

Artists who have political views are likely to be leftists, and yet how little effect these views have. A recent cover article in *Art in America* complained that Hans Haacke's work, which interests me, was not in all of the best collections.[16] Haacke is at odds with the system in which this critic wishes him to have a more prominent role. I suspect that this system supports such opponents because they are judged unlikely to change it. Is Haacke's work really so surprising? An enterprising journalist might produce evidence to put corrupt businessmen in jail. But when Haacke shows that rich men manipulate the Manhattan real-estate market and that speculators make money from selling Seurats, is he giving us news?

My focus on artwriting thus does not imply a lack of interest in the larger artworld system in which artwriters, galleries, collectors, and museums play roles. To properly understand how artwriting functions, we need to understand this system. Some Marxists promote art involving image appropriation, visual allegory, and social criticism—neo-Duchampian work without much visual interest that depends upon this theorizing. Leftist critics have some power within the system that they, with some justification, loathe, but little capacity to change the system itself. Usually they promote art that, because it is of such little visual interest, must appeal only to collectors who are somewhat self-denying. What is fashionable is to deny the appearance of luxury in favor of sober, expensive plainness. Just as Alberti would have the quattrocento painter eschew the use of gold in favor of the perspectival calculations of Uccello or Piero, so Craig Owens prefers the image appropriations of Sherrie Levine and Cindy Sherman. Like those quattrocento Italians who, Baxandall reports, preferred the sober luxury of the most expensive plain black cloth to obviously ostentatious garments, Owens admires artworks lacking aesthetic interest.[17] Neo-Marxists thus tend to avoid giving what they could most usefully provide, a description of that system in which artworks are produced, promoted, and distributed.

My interest in this commercial system helps explain how a funny thing happened near the conclusion of my book. I started out with a clear agenda: write a narrative history of artwriting from Greenberg to the present in which each critic's work leads, inexorably, to that of the next. But I became increasingly suspicious about such narratives, increasingly aware of their quasi-fictional status. The claim that any such history presents logically

16. Benjamin H. D. Buchloh, "Hans Haacke: Memory and Instrumental Reason," *Art in America* (February 1988): 98.

17. See Michael Baxandall, *Painting and Experience in Fifteenth-Century Italy* (Oxford, 1972), 14–15.

necessary connections, rather than a rhetorically convincing reconstruction of that history, is implausible. This discovery, made also by the marvelous critic Carter Ratcliff, was of more than personal interest. The history of artwriting, as I conceive of it, was the gradual realization of the implications of this discovery. My book makes explicit what many artworld people implicitly recognized. Once artwriting was identified as rhetoric, then what status could art criticism have? Its claim to give us knowledge of art seemed to be undermined.

One cause of this change was imitation of Greenberg's histories. It was daring to suggest that Pollock picked up the concerns of cubism, the creation of a shallow illusionistic space. Greenberg provided a genealogy for Pollock's work, indicating how he continued the great tradition of early modernism. Monet and Cézanne were obviously important; so too, the genealogy implies, is Pollock, for he further develops their tradition. To maintain the tradition is to make works of quality equal to earlier acknowledged masterpieces. Greenberg holds a quasi-Kantian theory of taste. That theory and his genealogies point to the same conclusion: he sees that Pollock's work is great; he provides a genealogy for that work. Since I find Greenberg's theory of taste implausible, I can but point to the way in which his genealogies enforce quality judgments. To say that Pollock continues the tradition of Monet and Cézanne is to say that his art is as great as theirs; since their works are valuable, this implies that his should be also.

Greenberg must have been as surprised as anyone to see that his argumentation had this effect. But once its success was apparent, then other artwriters imitated him. Both his claims about taste and his genealogies were imitated, but the latter had the greater effect. I explain this difference by comparing his judgments of taste with connoisseurs' claims. When Ann Sutherland Harris rejects my Poussin attributions, then I can but look again, knowing that she has seen more of his work than have I.[18] But when we get to contemporary art, it is unclear whether anyone has this sort of special authority. When a critic dogmatically asserts that some younger painter is a great master, knowing the immediate practical consequences of such claims, I am skeptical.

His genealogies were the most imitable part of Greenberg's account. But once we recognize that such multiple narratives are possible, then how are we to pick between them? Robert Rosenblum's *Modern Painting and the*

18. On connoisseurship, see my "Early Poussin in Rome: The Origins of French Classicism," *Arts* (March 1989): 63–67.

Northern Romantic Tradition begins by juxtaposing an 1809 Caspar David Friedrich with a 1956 Rothko.[19] In his account, Rothko, Clyfford Still, Barnett Newman, and some of Greenberg's other abstract expressionists are seen as working, not out of Greenberg's French modernist tradition, but in an entirely different genealogy. Many genealogies are possible because the genealogy postulates a weak connection between the works presented in its narrative. We are not dealing here with opposed interpretations of the same historical events, as with a conflict between Marxists and their opponents about how to explain the French Revolution. Nor are we considering alternative interpretations of the same images, as when art historians argue about the meaning of old-master artworks. Rather, we are concerned with alternative ways of linking artworks in a narrative making little reference to the artist's intentions. Of course, if I think Friedrich's work banal, then I may find genealogies including it uninteresting. But that is a controversial judgment of taste. Once I give up the belief that the tastes of all qualified critics agree, then what can I, as critic, say to convince others? For a Hegelian who thinks that her narrative tells the story of Spirit, or a Marxist who believes that there is some particular story of what Fredric Jameson calls the human adventure, these cannot be problems.[20] But for the rest of us, the recognition of the ultimate arbitrariness of any particular genealogy opens very real problems. This was the situation for art criticism after Greenberg. I turn to describe the system in which artworks are exchanged, finding them interesting insofar as they tell us about that system.

To call this a sociological analysis is to take too narrow and traditional a view of aesthetics. Now the concern of philosophical analysis is that system of texts. What are the necessary preconditions that such a body of texts exists? To merely look at an artwriter's arguments is to treat her as a philosopher, someone making claims that are rationally debatable. A better model is provided by the anthropologist. Without sharing the beliefs of a tribe, she assumes that those beliefs have some function. Analogously, whenever I find a fashionable artist's work bad or an art critic's claims implausible, I make sense of their role by asking what function they serve in the present-day artwork.

Take the highly fashionable paintings of David Salle, works that raise an interesting question: Why does such painting attract so much interest?[21]

19. Robert Rosenblum, *Modern Painting and the Northern Romantic Tradition: Friedrich to Rothko* (London, 1975).
20. See his *Political Unconscious* (Ithaca, N.Y., 1981).
21. See my *Artwriting*, 115–18.

One plausible answer is that Salle's image appropriations give commentators so much to talk about. Feminists denounce him; deconstructionist critics explain that his pornographic images are just images, not real pictures of real women; and social commentators are fascinated by the popularity of neo-pornography.

Take the critic Donald Kuspit.[22] This enormously productive philosopher manqué loves to cite Frankfurt School philosophers and psychoanalysts. His almost impenetrable texts give the illusion of depth. I can understand the popularity of journalistic criticism, which gives useful information; I can admire Krauss. But why is Kuspit thought important? His obscure writings fill a role in an artworld fascinated with philosophical criticism. What Danto says can be evaluated. By contrast, Kuspit's texts seem "real philosophy" as nonphilosophers imagine it to be, deep and almost impossible to understand.

Like Salle's paintings, Kuspit's prose becomes interesting when we ask what function it serves in our artworld. That art and artwriting can be interpreted thus is less a discovery than a necessary working assumption of a philosophical study. Just as the art historian believes, and always finds, that she can construct a narrative history of art, so the student of artwriting believes, and always finds, that she can write a plausible history in which those texts, properly interpreted, are meaningful. The aim is to avoid adopting any particular partisan viewpoint. My evaluations of Salle and Kuspit are partisan. But even their admirers could understand my approach, which can be applied also to artists and critics I admire, since they too have a role in the artworld system.

Greenberg, Fried, Krauss, and Masheck all have expressed their dismay at the condition of the present artworld, and as a critic I agree. But what a philosopher here must seek is some way of transcending these partisan viewpoints, some Archimedean standpoint from which every particular position is, when properly interpreted, a part of the whole. This, the key Hegelian theme in my book, can be defended without any high-powered metaphysical assumptions. I do not believe that my history is the only possible account, that one whose narrative order mirrors the logical structure of the world. I do not believe there is any such structure, though I think that there are always means of making sense of the world. The development of a plausible rival account, another narrative covering the same period and employ-

22. See my "Art Criticism and Its Beguiling Fictions," *ArtInternational* 9 (Winter 1989): 36–41.

ing strategies I cannot presently envisage, would, I think, support these presuppositions of my philosophical history.

For anyone who looks at it rationally, the artworld must make sense. This claim is both humble and arrogant. It is humble because in principle it makes no claims about the merits of particular artwriters. It is arrogant because the aim is to find some neutral standpoint from which all the particular accounts can be evaluated. The claim that philosophy can locate such a standpoint may seem to attribute great power to it, but the claim is qualified when we recognize how little follows from the mere identification of such a position. The philosophically important claim of *Artwriting* is that such a position is available.

In that book the Overture focuses on Danto's aesthetic. Yet his criticism and recent theorizing are ultimately less significant than the work of Hayden White, which I mention only in passing. Studying artwriting of the 1960s, I arrived at a view of narratives similar to that which White's *Metahistory* attributes to nineteenth-century historians.[23] Inexplicably, his work has been neglected by artwriters. This is unfortunate, since his concern with the rhetorical strategies of their literature could not be more in tune with their interests. White presents a crucial epistemic problem that any analysis of rhetoric must address. Once we begin identifying the structures of a narrative, we face a problem of self-reflexivity: How are we to understand our own rhetoric? For example, when White says that words always distort, projecting some structure onto the world, how can he himself say that without distorting? I solve this problem by arguing that my account of artwriting's rhetoric is consistent with the claims of my own analysis. This part of my discussion has been misunderstood by some otherwise sympathetic readers. And yet it is essential to a philosophical analysis of artwriting. Philosophers will recognize the familiar difficulties of any epistemology that proposes a test for knowledge which, consistently applied, rules out that theory's claim to be knowledge. I subject my history itself to the same tests that it employs to judge other histories. Danto's aesthetic was my stalking-horse, but in some ways our positions could not be more different. Unlike him, I am a relativist about interpretation. Where he speaks of the end of the history of art, I think of the end of a narrative, which means that what for him are structures of history are for me but structures of texts. Unlike him, I take seriously the claim that artwriting is but a representation. Since I never

23. Hayden White, *Metahistory: The Historical Imagination in Nineteenth-Century Europe* (Baltimore, 1973).

would have conceived of this way of thinking about such matters apart from knowing his work, perhaps this disagreement demonstrates the fertility of a position that could inspire such a diverse interpretation.

What is conceptually interesting about this recognition of the importance of rhetoric in artwriting are the obvious deep parallels between illusionism in art and the equivalent in texts of artwriters. Just as illusionistic images trade on our ability to pretend that they present what they depict, so texts demand that we treat their narrative connections as convincing, though on reflection we are aware of their arbitrariness. There is not a difference in kind between responding to the plight of a character in a Jane Austen or a Muriel Spark novel and to an artwriter's rhetoric. Of course, there are matters of fact about artworks, as there cannot be about fictional characters. But since no mere listing of facts will show what the artwriter wants to claim (that an artwork is significant, interesting, or original), history and art history differ in this essential way from fiction.

The working critic aims to be suasive, but the philosopher seeks a way to understand this situation. Suppose that no philosophical argument can support judgments of taste. What follows is that the consensus is our collective creation. How contemporary art is understood depends upon our suasive skills. If we think that matters of fact are at stake, then it will seem preposterous to believe that artwriters can influence our collective beliefs. But although matters of fact do enter into artwriting, they do not, so far as I can see, determine how the artwriter evaluates contemporary work. The difference in style of the artwriting of Greenberg, Fried, Krauss, and their successors is as startling as the diversity in style of the artworks they most admired. And yet, just as it is the aim of an art historian to explain why Pollock and Morris Louis were replaced as major artists by Salle and his successors, so it is the task of the historian of artwriting to explain why these artwriters are the successive figures in our tradition.

Some distinguished historians of art history treat theirs as a purely historical investigation. What they say about Panofsky or Riegl does not seem likely to change the practice of art historians. According to one related philosophical tradition, aesthetics is not about art itself but is an analysis of the language people use to talk about art. Were this correct, my project would be absurd. I aim not to produce a metahistory, a history of artwriting isolating it from the practice of artwriting. Rather, I hope that a proper analysis would change the style of such writing, and even influence artists, by engendering a self-consciousness about the role of rhetoric in artwriting.

Artwriting marked the Proustian recognition that the two paths of my

life—my training as an analytic philosopher and my work as an art critic—ultimately are no further apart than Marcel discovers *le côté de chez Swann* and the Guermantes' way to be. And yet, that did not lead me to expect any working relationship between art critics and aestheticians. The distance between aesthetics and art criticism is such that, with one exception, nobody now writing criticism is taken seriously (or even known, to judge by the journals) by my fellow philosophers. My goal was to write a philosophically serious history of art criticism that would have some effect on actual critical practice. What makes recent American art criticism philosophically exciting is its rapid stylistic innovations, as rapid as those of the painting it describes. Now and then an interesting style of painting or writing is discovered. To then elaborate it endlessly is but an academic task. The worry that such change cannot continue is perhaps behind the chiliastic fears, or hopes, of those who think that these traditions are coming to an end.

Is this a real worry? History is an uncertain guide. Who would guess that when the Roman artworld seemed unexciting, after Michelangelo's death, that the Carracci and Caravaggio would appear; or that when Greenberg and Fried had formulated their theory of modernism, their successors would so quickly develop entirely different positions. Artists with formed styles may continue to do interesting work; artwriters cannot. De Kooning's ongoing development, and Motherwell's also, are hard to understand, and soon revisionist art historians will study them. But Greenberg and Fried stopped publishing art criticism in the 1960s, wise enough to quit while they were ahead. The reputations of some other artwriters have suffered because they do repeat themselves. As a relativist I hold that the end of a narrative is relative to the narrative purposes at hand and that the subject of a narrative is a fiction. You can tell a story ending wherever you choose about whatever you wish; it should be true to the facts, convincing, original, and plausible. There are endings in texts, but not in history as such; and so whether we see the history of art as continuing or ending depends upon our goals.

This argument rests on some controversial assumptions about historiography. Of course, it may be a matter of fact that a tradition of art has ended. Traditions have ended before. Ultimately, I do easily dismiss the end-of-art thesis, and my reason for doing so is simple. My philosophical stance is that no *a priori* argument can show that our tradition ended. Only experience can tell that, and my experience as critic tells me that it is too soon to say. The personal computer has replaced the typewriter; the CD, the LP; but apart from such cases of technological advancement, I do not think that any

philosophical argument that the end of art has come, neither Hegel's nor Edgar Wind's nor Danto's, can be persuasive. What their accounts do describe are real feelings that, because they are widely shared, are important. What can happen is that after the end has come, a good philosophical art historian will show why it did come. That there are so many artists, galleries, collectors, and museums means that there is a considerable vested interest in believing that something new will happen. But it may be that they will come up with nothing new.

I learned from *Artwriting* that a focus on the nature of writing about art as a literary genre could be extended to art history. Unlike philosophy, art history has only recently begun to examine its own methodology. There is much promising territory to explore. To explain how the writing of art history is a form of writing is to raise issues that have not been much discussed. Most of my recent publications, art criticism apart, are studies of the history of art history. I have gone wrong again. I spend more time reading the *Art Bulletin* than the *Journal of Philosophy*.

2

Abstract Painting and Its Discontents

*"I wouldn't push your line downtown, though. They're all into
Schapiro and Greenberg." She added, not unkindly, "You might
try reading them."*

—*Harry Matthews*[1]

Does abstract painting have a history?[2] A mere listing of a succession of
events, one after another, yields only an annal. What is demanded of a his-
tory is more; there must be some narrative connection between those suc-
cessive events, an explanation of how one connects with the next. A history
is a story, which means that it has a beginning and an end, and that there is
some reason for the inclusion of each episode in it. A story thus makes the
sequence of events that it converts into a history meaningful.

 Consider a history by Meyer Schapiro. In the 1931 Matisse retrospective
at the Museum of Modern Art, he identifies two radical changes in that
artist's style, "the sudden turn from an impressionistic style to an abstract,
decorative manner" and, "towards 1917, . . . the return to naturalism."
Rejecting the claim that these changes are "merely the vicissitudes of a

1. Harry Matthews, *Cigarettes: A Novel* (New York, 1987), 208. Thanks to Suzanne Joelson for
this reference.
2. See my *Artwriting* (Amherst, Mass., 1987), which draws on Arthur C. Danto's *Analytical
Philosophy of History* (Cambridge, 1968), now republished, with three new essays, as *Narration and
Knowledge* (New York, 1985).

restless, unstable sensibility," Schapiro speaks rather of "a broad determination and a purposeful end." Properly understood, this change reveals continuity. A history can contain complex changes, such as occur in Matisse's art from this period; what is excluded are arbitrary changes like those of fashion. At one revealing point Schapiro cannot explain this development. That Matisse's art circa 1913 "should constitute the transition from his abstract, decorative style to a more recent naturalism is indeed astonishing." Still this change depends upon a hidden order, one which is there even if we cannot find it. "We can only imagine, not discuss the causes."

Better hidden causes than the vagaries of fashion, which happen without apparent cause. There are painters whose work changes like fashion; because it lacks that deeper order which Schapiro finds in Matisse's development, their art is superficial. Such arbitrary change may be change in an artist's personal style. As study of Matisse's work from before 1906, or a visit to any art school, demonstrates, until an artist finds a personal style, she borrows from many sources. Once an artist has achieved a style, then certainly she may be influenced by other art, but now those influences themselves are part of the history of her development. When Matisse rejected Impressionism, that was not just because he sought fashionable novelty, but because he was working out the ultimate implications of that technique. Matisse "desired a structure and expressive movement which he could not find in Impressionism." The personal elements in his art—his rejection of Neo-Impressionism, which Schapiro attributes to the fact that its "method was not entirely congenial to his temper"[3]—influence an evolution that is impersonal or objective.

As Vasari borrowed his model for the history of Renaissance art from the ancients, so today a historian looking for a model for a history of abstraction might consider older art histories. Consider three well-known models. First, the history of the progressive improvement in techniques of representation—the older version of such a history is Vasari's *Lives*, the recent one is Gombrich's *Art and Illusion*. Second, the formal history of the development of more difficult methods of presenting forms in space, from the classical to the baroque—Wölfflin's *Principles of Art History*. Third, the social history of art, the account of landscape painting—Ruskin's *Modern Painters*. These narratives are histories; they explain why a particular starting point and conclusion are chosen, and they demonstrate how within that historical period one thing leads to another. For Vasari, Michelangelo is later than

3. Meyer Schapiro, "Matisse and Impressionism," *Androcles* 1 (1932): 21, 31, 33.

Masaccio because his images are more lifelike; for Wölfflin, baroque painterly works employ techniques unknown to classical linear artists; for Ruskin, Giotto's culture had a different view of nature, and so painted landscapes differently, than did Turner's.

Do these accounts offer a model for a history of abstract art? A Ruskinian social history of abstract art seems impossible. Such a social history links the content of the artwork with the larger society, and by definition abstract art lacks this kind of content. But this observation is less conclusive than it may seem, for some well-known accounts of abstract art assert that it has such content. To determine whether there can be a history of abstract art we must first consider another question: What is abstract art? The interesting problems arise because many artwriters deny that there is abstract art. That ought to seem strange. What could be more obvious than the distinction between a work that depicts something and one that does not?[4] But on some influential theories of abstraction, abstractions are really special kinds of representations. Gombrich, for example, claims that an abstract image is really a failed representation, one that we cannot read as a depiction.[5] Perhaps an abstraction is the result of emptying the content out of a representation.

This theory links the definition of abstraction to its history: abstraction is what must come after representation. But two dramatically different readings of the word "after" are possible. Abstraction is an end point in the history of representational art, what is created at that moment when there no longer is any content in a picture; so, then, no further development is possible. Or, abstraction is a novel genre, which develops like such earlier genres as still life and landscape, created relatively late in the history of European art.

Leaving aside the sociological theory, the two other models of histories both appeal to notions of progress. Later representational images are better, for Vasari and Gombrich, because they are more accurate representations. The baroque comes after the classical, according to Wölfflin, because the baroque artist creates spaces the classical artist does not know. These seem objective comparisons. Raphael's figures are more naturalistic than Giotto's, although that does not necessarily make them better. Rembrandt composes differently than Raphael, although again we may hesitate to speak of

4. See Richard Wollheim's account of de Kooning's metaphorical use of representational content in *Painting as an Art* (Princeton, 1967), 348–52.

5. This may be a very old-fashioned theory, but a variation on it has been adopted by the ultra-fashionable followers of Jean Baudrillard; see Chapter 5, below.

progress. But it is very hard to imagine an equally straightforward way of measuring the development of abstraction. One abstract work cannot be more accurate than another, for by definition an abstract painting lacks that kind of reference. And the belief that later abstractions are more complex, in the way that for Wölfflin the baroque is more complex than the classical, is not convincing.

The view of such otherwise diverse artwriters as Vasari, Gombrich, and Danto is that representation necessarily has a history. A first representation is made, then a better one; and once this process of making ever more accurate representations is systematically pursued, we have a history of representation. Of course, some semiotic theories of representation deny this, but they must either explain or undermine the intuition that Michelangelo knew things that Giotto did not. I say explain or undermine because there are two ways to think of the goal of the semiotic theory.[6] If they replace the traditional theories of progress in naturalism, then we have progress, but we understand it differently. But the aim may be to undermine our intuition that there is progress.

Is it possible to weaken that belief in progress? Someone might think that her native language is the natural language, like the Frenchman who proclaimed that French is *the* language of thought itself. Perhaps someday the theory that there is progress within European painting will seem as absurd as that Frenchman's claim. But if history is any guide this is unlikely. In a great many ways, our view of the art he knew is unimaginably different from Vasari's. We know that the landscape backgrounds of Titian will be developed into a novel genre, landscape painting; that Piero is far greater than Perugino; that Giotto learned from the medieval art Vasari despised. But possessing this knowledge is consistent, still, with accepting Vasari's basic evolutionary model. "Although Giotto was admirable in his own day, I do not know what we would say of him if [he] had lived in the time of Michelangelo . . . the men of this age would have not attained to the present pitch of perfection had it not been for their precursors."[7]

Consider Danto's thought experiment: "Imagine the history of art reversed, so that it begins with Picasso and Matisse, passes through Impressionism and the Baroque, suffers a decline with Giotto."[8] Instead of ad-

6. The best-known recent account is by Norman Bryson; see the essay that I coauthored with him, "An Introduction to the Semantic Theory of Art," *Leonardo* 17, no. 4 (1984): 288–94.

7. Giorgio Vasari, *The Lives of the Painters, Sculptors, and Architects*, trans. A. B. Hinds (London, 1963), 4:290.

8. *The Philosophical Disenfranchisement of Art* (New York, 1986), 105.

vance, we might see a decline, as in old-fashioned histories Roman art becomes decadent as Christianity causes a drop in artistic standards. The more radical antihistorical account asks us to envisage giving up the idea that there is any direction, whether progress or decline. That is much harder. A more parochial historical example may give a sense of the problems here. Whether single-vanishing-point perspective be only a convention or a discovery of how the world really appears has been debated since the publication of Panofsky's "Perspective as Symbolic Form."[9] Art historians like Gombrich who take the latter view have argued, repeatedly, that perspective is like a scientific discovery, a genuine advance in our knowledge of how the world is.[10] A strong version of the convention theory asserts that a Chinese scroll showing a landscape, the mountains in icons from before the time of Giotto, and Constable's *Wivenhoe Park* all are equally accurate representations of landscapes. That is hard today to imagine.

If an abstract work is one that contains no recognizable content, then maybe the very concept of abstraction is parasitic, historically and logically, upon some notion of representation. Historically, because an abstract image is all that remains after artists emptied out the content from their pictures. Logically, because an abstract work is one that is not representational. So while some cultures produce only representational works, there could not be a culture that created only abstract art. Of course, coming from a civilization that has known abstraction, we can anachronistically describe such works as abstract. But then we encounter the problem of what used to be called primitive art, but maybe is neither primitive nor, until it is set in our museums, art.

To claim that abstract art must come after representational art does not distinguish it from Michelangelo's painting, which, according to Vasari, *must* come after Giotto's; nor from Wölfflin's baroque art, which he asserts *must* come after what is classical. The more interesting question is whether the creation of abstract art simply marks the end point of a historical tradition or rather is the starting point of a new one. For Vasari, Michelangelo marks the culmination of his history. It is hard to see what could come next, and indeed, in his cyclical model, the natural, pessimistic conclusion is that the

9. G. Ballangé's French translation, *La perspective comme forme symbolique, et autres essays* (Paris, 1975), has an introduction with a summary of the literature, "La question de la perspective," by Marisa D. Emiliani.

10. See my "Perspective as a Convention," *Leonardo* 13 (1980): 283–87. Maybe technology offers a better model: Who would deny that the Wright brothers build a better airplane than Leonardo could have?

cycle will repeat. After another Gothic period of decadence, art's history might start all over again, inspired by Renaissance work as Giotto was inspired by what he knew of the ancients. In the eighteenth century Winckelmann claimed just that; for him, the Goths were the baroque artists. For Wölfflin, baroque is not the end of his history. He observes that the cycle of classical to baroque later repeats, in reverse order, in eighteenth-century French art, and he hints that the true heirs of baroque painterliness are the Impressionists.[11]

On a Vasarian model, abstraction cannot have a history; in a Wölfflinian history, it can. The theory commonly attributed to Greenberg, according to which modernism involves both a self-conscious use of the medium of painting and a concern with flatness, is not a Vasarian history.[12] Flatness in itself does not yield abstraction: Dubuffet's figurative works of the late 1940s are flat, while any number of abstract paintings use deep space. If this account is a theory of abstraction, that is, as Greenberg explains, because one effect of flattening the space is to squeeze out the place in which content exists. The rejection of formalism in the 1960s meant that the notion that there could be a history of abstraction no longer seemed plausible. Since then four other approaches, none showing it to have a history in my sense of that word, have been important.

First, there is autobiographical criticism. Artworks are understood in relation to the artist's life. She is happily married, then divorced; she goes to Italy and is reconciled with her eldest daughter; and all this is reflected in her art's development. This ahistorical approach is doubly disastrous: it makes it impossible to talk about abstraction as a movement, and it inescapably falls back on a naïve reading of content, treating images as signs of the artist's personal life. Autobiographical criticism yields a history of a personality like that found in a biography, but not an art-historical history. There is no link here between the development of a personality and the development of art. Unlike the other three theories, this one does not deny that

11. Although Wölfflin himself seems to have had relatively little interest in contemporary art, his account of the baroque is inconceivable apart from a general awareness of Impressionism. His one discussion dealing with contemporary art is "Boecklin 'classique' (Ulysse et Calypso)," reprinted in his *Reflexions sur l'histoire de l'art*, trans. R. Rochlitz (Paris, 1982), 91–97; see also Michael Podro, *The Critical Historians of Art* (New Haven and London, 1982), chap. 7.

12. Greenberg was acutely aware of this problem already in 1939 when he recognized that avant-garde "imitation of imitating" is akin to Alexandrianism, but with "one most important difference; the avant-garde moves, while Alexandrianism stands still" (*Art and Culture* [Boston, 1961], 8). This claim was made earlier by Arnold Hauser; Michael Ann Holly, in *Panofsky and the Foundations of Art History* (Ithaca, N.Y., 1984), 26, mentions Hauser's claim.

there can be a history of abstraction; it merely refuses to provide such an account.

Autobiographical criticism is a natural product of a culture in which famous artists, like poets or physicists, have their activities popularized in the Sunday *Times*. When Jasper Johns commands the prices, and consequent public attention, that make him a subject for the Sunday *Times*, what is more natural than that he is described thus? Artwriting has often linked the artist's life with his work. In describing the personalities of Pontormo, Raphael, and Michelangelo, Vasari explains something of why they were different artists. But this is not the historical part of his account. The unhappy effect of exclusively biographical criticism is to imply that art is just self-expression. Films or rock-and-roll music are accessible to everyone, and so stars' biographies are interesting; painting is a different sort of activity.

Second, there are theories that abstraction is the result of eliminating or abstracting away literal content, which perhaps can be recovered by understanding that process. According to Robert Rosenblum, Rothko's abstract paintings evolve "from a landscape imagery. . . . There are metaphorical suggestions of elemental nature; horizontal divisions evoking the primordial separation of earth or sea from cloud and sky."[13] We have a history, but only at a high price. Either we abandon the notion that Rothko really makes abstract art, on the ground that all images actually are representational, or we treat abstract images as a kind of end point of this process, the residue that remains when as much content as possible has been emptied out of the picture.

Often it is convenient to identify what we see in an abstract work by reference to representational associations. The problem lies in the methodological implications of this procedure. Very different things can look similar. On one reading of Rosenblum's account, he merely says that Rothko's abstractions look like such sublime depicted scenes. My position is that the presentation of a sequence of such parallels gives a reductive view of abstraction. This is why an artist is likely to seek to eliminate such content. While he may want to suggest represented forms, any too-literal content is distracting. Abstract art aspires to transcend reductive references to its content.

Third, there are theories that would collapse the very distinction between

13. Robert Rosenblum, *Modern Painting and the Northern Romantic Tradition: Friedrich to Rothko* (London, 1975), 213–14, 10–11. He seems ambivalent about such parallels, for he begins by asking whether a comparison of Friedrich's *Monk by the Sea* with an abstract Rothko is a pseudo-parallel.

representational and abstract art. I earlier treat this as a problem, but according to some theorists it is a desired goal. Their strategy differs from Rosenblum's approach, for they seek to undermine the contrast between representations and abstractions, not by arguing that all abstractions are representational, but by denying that there are any purely representational images. Here the revival of interest in allegory is influential. As an allegory both literally depicts something and has further symbolic meaning, so an image both shows what it depicts and really refers to another artwork. Today, read allegorically, all images, whether they resemble the landscapes of Constable or the abstractions of Newman, are images of images. Since abstract painting no longer exists, there cannot be any ongoing history of abstraction.

Fourth, and finally, there are the theories which admit that there can be abstract art, while treating it as an end point of art's history. Once abstractions have been created, no further evolution is possible, and so the only possible result is for the history of art to be over. Artists abandon first content, then expressive brushwork; and when only the blank, stretched canvas remains, it is not possible to go further. Once all the possibilities of abstraction have been put forward, as they were rather quickly in the second decade of this century, then any further abstractions will simply be recombinations of what already has been discovered. It is possible to create a novel image by combining Malevich's shapes with Kandinsky's color in a space borrowed from surrealism; but that sort of novelty is uninteresting. If new work is such an obvious combination of what has come earlier, then the history of art really has ended.

These four theories all deny that abstraction has a history. How are they to be argued with? For an abstract painter, it must seem painfully obvious that her work develops within the history of art. But just as Nietzsche's claim that God is dead is not refuted by observing that some people still attend church, so the work of these artists cannot itself be enough evidence to show that abstraction has ended. Critics of abstraction can correctly observe that much abstract art is undistinguished and unoriginal; but so too, as provincial museums reveal, was the bulk of the art produced at most times. Nor would the claim that there is no truly great art now being made be sufficient to show that the history of art is ended.

Here we are dealing with elusive feelings. Consider the responses to Danto's "End of Art." A person's life ends when he is dead, but to say that art's history has ended means, Danto explains, not that there is no more art being made, but that art no longer has a history. Perhaps Danto's rhetoric

reveals his own ambivalence. A former artist turned philosopher who, after writing on topics very distant from aesthetics, published first a philosophy of art and then art criticism cannot but have a complex relation to art.[14] When he argues that the history of art has ended, while allowing that this means that artists can then do whatever they like, he offers a variation on a Hegelian claim famously elaborated by Marx. For them, since the end of history is the beginning of freedom, it would be an unqualified good were that history to come to an end. Why then should not artists also celebrate the fact that their activity may have come to an end? When Danto allows that he was influenced by the "immense and bombastic, puerile and portentous, shallow and brash" work at an early 1980s' Whitney Biennial, then he makes a very different claim.[15] Art's history has ended because contemporary art is not very good. And when he argues that today's art and philosophy are no longer distinguishable he makes yet another claim. This can be read as an allegory about his life. Now Danto's life of the 1950s as artist and his recent work as philosopher has an unexpected unity. To the extent that his argument is confusing because it links these three very different claims, it is natural for a sympathetic reader to interpret it by thus allegorizing it.

Such an allegorical reading does not preclude a literal one. Since today artists' activity often depends upon theorizing which argues that their work has a place in a history that has an internal structure, to claim that art's history has come to an end is to assert that such artmaking can no longer be a serious activity. Within the history of European art there are periods in which theorizing played a very minor role. The golden age of Dutch painting was not accompanied by interesting theorizing about Rembrandt, Vermeer, and Saenredam. But much contemporary art is of interest, and perhaps even *is* art, only if we accept the theorizing that goes along with it. Work by a follower of Rembrandt is interesting, but once Duchamp produced readymades nobody could interestingly imitate him, which (*hélas!*) does not prevent most of the contemporary art shown at the Whitney from being more like the readymades than like Rembrandt's images. Sometimes an adequate theory is only developed much later than the work it describes. But today the absence of a historical theory of contemporary art *is* felt to be a significant lack. Whether because we have a more sophisticated (or differ-

14. See his "Munakata in New York: A Memory of the '50s," reprinted in *New Observations* 47 (April 1987): 3–10.
15. *The Philosophical Disenfranchisement of Art,* xiv.

ent) view of history, or because we are just better at constructing histories: in any case, we expect a history of abstraction to be possible. The lack of such a theory gives support to the belief that there can be no history of abstraction. It is easy to criticize the arguments given by those who hold that the history of art has ended.[16] The true power of such theories lies in their reflection of a widespread climate of opinion.

One reason the claims that the history of art has ended seem powerful is that no one has produced a convincing history of abstraction. Perhaps that will only be done by some future artwriter; meanwhile, maybe the very lack of such a theory will influence the development of that art. Abstract painters who continued to create when the consensus of critical opinion was hostile to their work had difficulty proceeding. The problem was not merely that they were producing unsellable objects. Only exceptionally self-sufficient individuals can believe in what they are doing when there is little support for their activity. Greenberg says that the critic who doubts "whether abstract art can ever transcend decoration is on ground as unsure as Sir Joshua Reynolds was when he rejected the likelihood of the pure landscape's ever occasioning works as noble as those of Raphael."[17] Indeed, what reader of Vasari's history could imagine Wölfflin's approach, which, while it discusses some of the same artworks, certainly gives a radically different view of them?

One characteristic of a genuinely original standpoint is that it will reject the shared assumptions of earlier commentators. The belief shared by Vasari, Wölfflin, Schapiro, Gombrich, Danto, and Krauss is that the alternative to a history (as I have identified that narrative form, with one event leading to the next) is conceptual chaos. Danto identifies the structures that he describes in his philosophy of history with "certain categories of thought that might be said to compose the metaphysics of everyday life—a spontaneous and perhaps unrevisable philosophy." A history is a way of "structuring our present in terms of our future and . . . past," and so while it is possible to imagine someone lacking such a consciousness, he would not be a very sophisticated person. Danto draws an analogy between historical consciousness and knowledge of other minds; "historical consciousness too sees events as having an inside and an outside, and marks a difference between the consciousness of living through events, and a consciousness of those events as seen from the outside."[18] A similar view appears in Jame-

16. Why, for example, should de Kooning be allowed to paint in his styles if in the early 1960s Stella showed that painterly brushwork was no longer possible?

17. Greenberg, *Art and Culture*, 134.

18. Danto, *Narration and Knowledge*, xiv, 342, 343.

son's influential claim that postmodernism is defined precisely by a schizo-phrenic inability to distinguish past, present, and future.[19] For him, as for Danto, the schizophrenic loses one capacity essential to self-definition.

But does this view of the self necessarily imply that a person will have a concept of history in the sense in which I have used that word? Jameson admits that schizophrenic postmodernist art is not necessarily the creation of schizophrenics, and indeed creating a highly complex artwork is not likely to be done by someone with the impoverished self-awareness of a schizo-phrenic. All of the attempts to promote the art of the insane, or of such figures as the abstract painter Forest Bess, only underline the differences between them and artists who go about their business in the New York artworld.[20] Gilles Deleuze and Felix Guattari, our famous defenders of schizophrenia, certainly have eccentric ideas about how to organize books. Sometimes they are brilliantly original, on other occasions merely verbose; but their purposeful activity has little in common with genuinely crazy writ-ing. But why then should we accept either Jameson's thesis or what is in effect a variation on it, Danto's claim that there is a link between thinking of one's personal history and a broader historical awareness?

For Jameson, there is something pathological about the culture of post-modernism; he calls it schizophrenic. But those who share neither his poli-tics nor his view of postmodernism will not have that reason, nor any reason, to apply that word both to individuals who lack a normal sense of time and to our culture, in which the larger sense of historical awareness is being attacked. And the same argument can be employed against Danto's view. Why may I not possess an everyday awareness of past, present, and future while denying that history has such a meaningful structure? That there is an *analogy* between these two views of history in itself gives no reason to think that they must be logically connected.

Biographical artwriting traces the development of a work in relation to the past, present, and future of one person without providing a history. If art is self-expression, there need be no link between the development of one artist and any others. That an artist's work exhibits such a personal history is entirely consistent with the belief that the history of art has ended. For Schapiro, Matisse's personality is of significance insofar as it fits him to contribute to a broader historical development. Danto's "End of Art" uses

19. Fredric Jameson, "Postmodernism; or, The Cultural Logic of Late Capitalism," *New Left Review*, no. 146 (1984): 59–92.

20. See *"I Knew It to Be So!" Forest Bess, Alfred Jensen, Myron Stout,* the catalogue of an exhibition curated by L. Luhring and D. Reed (New York, 1984).

a work from the period Schapiro discusses, Matisse's *Green Stripe* (1906), but to very different effect. According to Danto's expression theory of art, "The object is shown the way it is because the artist feels about the object the way he does." Danto's presentation of this theory both gives it a historical place in theorizing about art, as the natural successor to the position that painting is mimetic, and treats it as an ahistorical theory. Any artist whose work reveals feelings about her subjects expresses herself; since emotions themselves have not changed, "this is not a developmental history." Here a real tension between the historical place of that theory as the successor to theories of art as imitation and its ahistorical role is too quickly resolved when Danto says that "there simply is not the possibility of a developmental sequence with the concept of expression as there is with the concept of mimetic representation." For Schapiro, Matisse's act of expression is subsumed in a larger history; for Danto, the theory of expression means that "we must understand each work . . . in terms that define that particular artist we are studying, and what is true of De Kooning need have nothing to do with what is true of anyone else."[21]

Danto's view here is remarkably close to Gombrich's, which is ironical since the older man's ultimate limitation, Danto has written, is that he had too little contact with modernism.[22] Could Danto's view of art history be limited because his account of history is too traditional? Recent work in historiography offers an alternative view. All histories have quasi-fictional aspects. The starting and ending points may be changed; in different narratives, different events may be described; and there are various ways of describing the same events. Alternative histories, all true to the facts, are possible.

Schapiro's account of Matisse uses a narrative technique that is described laconically by Greenberg. "The nonrepresentational or 'abstract,' if it is to have aesthetic validity, cannot be arbitrary and accidental, but must stem from obedience to some worthy constraint or original."[23] Representational art is constrained by its need to be true to what it depicts; it is succeeded by painting that imitates the processes of its own creation. Just as, for Schapiro, there is a necessity in Matisse's seemingly capricious evolution, so, for Greenberg, this seeming break with the past marked by the rise of abstraction is, rather, a logical working out of this development. For them, art's

21. Reprinted in his *Philosophical Disenfranchisement of Art*, 100–104.
22. See his "E. H. Gombrich," *Grand Street* 2, no. 2 (1983): 120–32.
23. Greenberg, *Art and Culture*, 6.

history has an order that can be described. This is a Marxist idea, and when Greenberg wrote these lines he was still a Marxist; but this view of history survived his abandonment of that doctrine.

How can we determine whether there is continuity in the historical record? Committed abstract painters will feel certain that art still has a history, while those critics committed to denying that belief will be equally certain that abstraction cannot develop further. If abstract artists today draw on a rich slide library of images, their images do not look like those in older art; the critic who sees nothing new in 1980s' abstraction may be like the historian who finds Impressionist landscapes in Guardi's painterly Venetian scenes or finds still lifes in the tables of Renaissance Last Suppers. When we look hard enough, there nearly always is a precedent for any novel development. But Guardi was not Monet; nor was Leonardo Chardin. Precedents do not preclude real originality. It has been argued that only the relative unavailability in the West of art of the Russian revolutionary avant-garde has led to an overestimation of the achievement of some recent artists. But there is a difference in kind between those prescient quasi-minimalist Russian works and the intensive development of such concerns in the 1960s.

The availability of art from all cultures and periods of the past is a genuinely new development. Manet's trip to Spain was one decisive influence on his art. But he knew Italian frescoes and most Dutch art only in engravings; he knew nothing of Romanesque or Third World art. A New York artist need but go uptown to the Metropolitan to see a far greater variety of artifacts, and she need but stop at the bookstore to obtain good color reproductions of artworks from every culture. But here again, we may see not a break with the past but continuity. Because Manet was influenced by a lavishly illustrated catalogue of engraved reproductions of old-master art, tracing his pictorial sources is different than in the case of Caravaggio, where the art historian must determine what works he might have seen around Milan and in Venice. Picasso was influenced by African artifacts, Matisse by Islamic art in the Munich exhibition of 1910. Both painters knew more of historically and culturally distant art than did Manet; even within the history of modernism, there is not a radical break with the past, but continuity. The young artist in the Met who looks at the Manets, Matisses, and Picassos, as well as at the African and Islamic art, is not totally unlike those early modernists.

To ask whether there is continuity here or a break with the past seems inappropriate. There is both continuity and a break, and only a historian's interests, not the facts about the world, will determine how that history is

written. What most radically separates me, and some other artwriters of my generation, from Schapiro and Greenberg is less the obvious differences in taste than an inability to accept their view of history. They believe what Danto asserts: "Art history must have an internal structure and even a kind of necessity."[24] The only internal structure I can see in a history is that provided by a convincing narrative; the only necessity, that of a convincing story. And for me, the chiliastic claims of some Marxists that art's history is at an end confuse the structure of history itself with a human fabrication, those sentences which describe that history.

Abstract painters might find little comfort in this account, for it is also opposed to any claim that abstract art is the art of the future. Many of them argue that this is the century of abstract art. My experience tells me that they are correct. All of this argumentation will not reveal the future of abstract painting, but it does tell us something about our culture. How pictures or texts are read, or misread, is always interesting. Tim Clark's account of the confused responses by contemporary artwriters to Courbet and Manet reveals why their messages about class and sexuality were found threatening. Analogously, the confused arguments of our opponents of abstraction suggest that in our culture there is something threatening about that very conception of art. This seems strange. Why all these many attempts to insist that a tradition which maybe is only just beginning is already ended? What could be threatening about art without content cannot be what in Courbet and Manet disturbed the Parisian bourgeoisie.

The older accounts of abstraction speak of a certain freedom present in the art, though absent in the larger society. "The object of art is . . . more passionately than ever before, the occasion of spontaneity or intense feeling."[25] Nowadays, when the abstract-expressionist masterpieces attain old-master prices, and when the artworld has changed so radically, Schapiro's ideal cannot but seem utopian. In truth, however, it is abstract art itself that still poses this demand. Although Schapiro's view of history is dated, this claim is still valid. What a nonreductive approach to abstract work demands is a certain freedom on the viewer's part to look for art-historical connections, suggestions of represented or abstract forms that, whether or not consciously intended by the artist, are *in* the work.

24. Danto, *The Philosophical Disenfranchisement of Art*, xiv. I believe this in part because I find the argument of his *Analytical Philosophy of History* convincing. As he has noted, there is some problem in understanding how these two texts are consistent.

25. Meyer Schapiro, "Recent Abstract Painting" (1957), reprinted in his *Modern Art, Nineteenth and Twentieth Centuries: Selected Papers* (New York, 1978), 218.

Oddly enough, while critics have not generally been willing to grant such freedom to abstract artists, they have been happy to read the quoted images of artists like Salle in related ways. For all of the appearance of chaos in his work, it tells a story—as his commentators read it—which is just the sort of narrative that our audiences seem to want to hear, a story about the unreality of images and our inability to make sense of our world. The freedom of abstract painting consists precisely in its refusal to narrow down the story in such a way. In this sense, although abstract art has no political content, in virtue of these demands it makes on the viewer its very existence—as Schapiro correctly understood—is of political significance. In saying this, I am not advocating a neo-romantic return to the past. This is the only way to properly understand present-day abstraction. What I believe has been repressed by its critics is this role of what, paraphrasing Jameson, I call "The Political Unconscious: Abstraction as a Socially Symbolic Act." In another context, he writes: "The political, no longer visible . . . in the everyday world of appearance of bourgeois life . . . has at last become a genuine Unconscious."[26] Hence the reference in my title to psychoanalysis. Not the least of the ironies of the history of what they call postmodernism is that this act of repression has been undertaken in large part by critics who think of themselves as Marxists.[27]

26. Fredric Jameson, *The Political Unconscious: Narrative as a Socially Symbolic Act* (Ithaca, N.Y., 1981), 280.

27. The starting point for this chapter was a good question that the art historian David Summers asked me about *Artwriting:* Could art ever be in advance of its artwriters?

3

Erwin Panofsky, Leo Steinberg, David Carrier: The Problem of Objectivity in Art-Historical Interpretation

My cheeky title was inspired by an anonymous reader's complaint in a rejection letter, "and what's worse, at one point Carrier even compares himself to Panofsky." But why indeed should I not compare myself to him, since doing that is not, absurdly, to imply that my work is equally important, but to indicate how the methodological problems posed by his writing are also raised by mine? I have described the literary structures of art historians' writing, structures that the historiographer Hayden White calls the tropics of discourse.[1] Just as successful painters have a style, an identifiably personal way of representing what they depict; so the same is true, I argue, of art historians. But how then is objectivity of interpretation in art history possible? An answer to this question must be consistent with two facts: styles of artwriting change over time; every important interpreter has her or his own style. The aim of art history is to interpret a work objectively, to understand it, that is, as it really was intended to be seen. But if disagreements among art historians are sufficiently serious, it may be impossible to achieve

1. See my *Principles of Art History Writing* (University Park, Pa., 1991).

that goal. That art historians disagree says nothing about the possibility of achieving objectivity in interpretation. The real questions are: How serious are such disagreements? Are they serious enough to show that objectivity is impossible? I answer them by taking the parallel between artists and art historians as far as it will go—or even, for this too is useful, too far.

Like an artist, an art historian has a style. At the start of the second chapter of *Art and Illusion*, Gombrich retells a story that reveals something important about artists' styles.[2] A group of German artists seeks to transcribe the same motif "as objectively as possible," and yet "when they . . . compared . . . their efforts . . . their transcripts differed to a surprising extent." Understanding "these limits to objectivity" may, Gombrich suggests, help us understand naturalistic images. Consider the parallel question about the limits of objectivity of interpretation in art history. A group of art historians seeks to interpret the same artwork as objectively as possible, and yet when we compare their texts their interpretations differ to a surprising extent. Just as those German artists could compare their representations because they all sought to depict the landscape before which they stood, so we can compare the interpretations of these art historians because they are readings of the same artwork.

Each artist representing that landscape depicted it in his or her own style. Analogously, I speak of the style of an art historian. (This parallel appears occasionally in the earlier literature, but its implications have not been spelled out.[3]) Like a painter, an art historian comes—perhaps after some struggle—to acquire a style, which then can influence others, or be imitated. What makes Poussin's evolution so interesting is that when he arrived in Rome at the crossroads of 1630 many stylistic possibilities were available.[4] The dating of his early work is complex in part because he was subject to many influences—he had not yet found his own style. After a certain date, however, his evolution proceeded in a relatively self-sufficient fashion. Compare him to Gombrich, who, when he was young, also was subject to

2. E. H. Gombrich, *Art and Illusion: A Study in the Psychology of Pictorial Representation* (Princeton, 1961), 63–65. The story comes from Wölfflin.

3. See Meyer Schapiro's subtle characterization of Eugène Fromentin's *Old Masters of Belgium and Holland:* "Just as an Impressionist picture . . . has a composition within its seeming randomness, so in this apparently unplanned, unsystematic work . . . there is a structure, a large antithesis that underlies even the evaluations, shaping the latter into a drama of judgment" ("Fromentin as a Critic," *Partisan Review* 19 [1949]: 36). What no doubt makes this a natural parallel is Schapiro's comparison of Fromentin as painter and artwriter.

4. See my "Poussin, the Early Years in Rome: The Kimbell Art Museum, Fort Worth," *Arts Magazine* (March 1989): 63–67.

many influences. He has explained how his rejection of both formalism and Marxism, his critical response to Riegl, and his interest in psychoanalysis led him to form his style.[5] Like Poussin, he found his style, and then his evolution also proceeded in a relatively self-sufficient fashion.

Just as only a few artists develop such a personal style, so also in art history. Most art historians write in the style of their master. There are two different ways to understand this situation. However interesting their individual pieces, no artist or art historian whose works are not in an individual style can be judged a master. Perhaps it is better to have a bad style than none at all, for that at least shows that one's work is identifiably individual.[6] To say an artist or an art historian has an individual style indicates, then, that he or she is an important figure. Minor artists and art historians work in the style of others; great ones are influenced by earlier figures in the creation of styles of their own. Alternatively, to speak of styles may be less to use an honorific term than to employ a convenient way of classifying texts and artworks. The art critic often uses this technique, identifying younger artists by comparing and contrasting them to well-known figures. To say that their work is akin to Mondrian's or Matisse's is not necessarily to imply that they are as good, but it gives some sense of how to place their work. Talk about style provides a useful sense of expectation.[7] Style is a pigeon-hole, a way of identifying the novel by reference to what is well known.[8]

How is this personal element in artwriting consistent with the announced goal of art history, objectivity in interpretation? I first pose this question by

5. See my "Gombrich on Art Historical Explanations," *Leonardo* 16 (1983): 91–96.

6. See Alexander Nehamas, *Nietzsche: Life as Literature* (Cambridge, Mass., 1985).

7. For example, identifying the art historian Lawrence D. Steefel as a student of Meyer Schapiro whose thesis was on Duchamp permits us to anticipate what he will say about old-master art. (Steefel's essay on Duchamp is reprinted in *Marcel Duchamp in Perspective*, ed. J. Masheck [Englewood Cliffs, N.J., 1975], 90–106.) Since a painted shadow plays a major role in Duchamp's last painting, it is not surprising that Steefel's contribution to Poussin studies is "A Neglected Shadow in Poussin's *Et in Arcadia Ego*" (*Art Bulletin* 57 [1975]: 99–101). "Insofar as the patterning of the upper half of the painting suggests a more abstract mode of relationships and the lower half a natural human event, the relation between above and below suggests a transformation of schematic, didactic relationships above into an embodied, 'incarnated' reality below" (Lawrence D. Steefel, "An Unnoticed Detail in Petrus Christus' *Nativity* in the National Gallery, Washington," *Art Bulletin* 44 [1967]: 237). This account could apply word for word to Duchamp's *Large Glass*.

8. Sebastien Bourdon "was capable of imitating almost any style . . . but he never evolved one of his own" (Anthony Blunt, *Art and Architecture in France, 1500–1700* [Harmondsworth, 1973], 312). This judgment, a cliché, has perhaps hindered art historians from really looking at Bourdon's work; see Pierre Rosenberg, *France in the Golden Age: Seventeenth-Century French Paintings in American Collectons* (New York, 1981), 226–31, and my *Poussin's Paintings* (University Park, Pa., 1992), chap. 2.

using well-known examples I have discussed in detail in my published papers.

Pre-Panofsky, *Arnolfini Marriage* seemed a marvelous naturalistic image. If the meaning of the very small inscription was not altogether clear, that did not seem especially disturbing. Post-Panofsky, the work is an allegory whose every element is related to that inscription. Far from being a merely naturalistic image, it is a highly complex play of symbols. Pre-Panofsky, *The Arcadian Shepherds* is an Arcadian scene; the two versions contain the same words and express the same sense of nostalgia. Post-Panofsky, the two versions mark a dramatic change in the meaning of the depicted scene. The same words are very differently interpreted by the artist, a revision that reveals a major change in the conception of an Arcadia.

Pre-Steinberg: The two Caravaggios in the Cerasi Chapel, Rome, are puzzling, seemingly inept, compositions. Before this century, Caravaggio's reputation was low; although the revival of interest in his art led to a more positive evaluation of these works, even some of his admirers found them not altogether satisfactory. Post-Steinberg: These compositions stem from very intricate calculations about the site in which they are set.

Pre-Steinberg: Michelangelo's *Last Judgment* is a very famous, often-quoted work whose composition is not especially interesting. The theme is familiar. Post-Steinberg: Michelangelo's *Last Judgment* is a composition that links distant figures in a remarkably original fashion; and it is *not* a last judgment, but a work whose theology is original and that came to be seen in the Counter-Reformation, which occurred soon after it was painted, as heretical.

Panofsky's interpretations, published in the 1930s, provided a framework that was soon adapted by other art historians. Steinberg's essay on Caravaggio was published in 1959, and his work on Michelangelo appeared more recently. Since a consensus about the value of his work has not yet been achieved, it would be premature to radically divide the history of interpretation into phases occurring before and after Steinberg.[9] But what justifies applying these terms to his interpretations is that *if* they are accepted, we come to see that well-known pictures have been misunderstood entirely by earlier commentators. Since these four paintings are familiar works, it ought

9. Many traditional art historians are dismissive, as those who came before Panofsky were unwilling to accept his approach; other, younger writers borrow from his general approach, while questioning details. See, for example, the recent sympathetic commentary on another of his interpretations of a site-specific work: Craig Harbison, "Pontormo, Baldung, and the Early Reformation," *Art Bulletin* 66 (1984): 324–27.

to seem surprising that only now are they interpreted in highly original ways.[10] If Panofsky and Steinberg are correct, no earlier writer understood the intended meaning of these works. Just as it is surprising to find that a familiar person or place has qualities we knew nothing about, so it is disconcerting to learn that the established view of these artworks is entirely mistaken.

Compare two other less dramatic types of revisionist interpretation. I repeatedly saw Piero's *Nativity* without noticing what Paul Barolsky has observed—that if there are three angelic instrumentalists and two singers, that is because the ass in the background completes the trio of singers.[11] Since this is the sort of humor we may expect from Piero, this detail does not change our sense of an entire work in the way that Panofsky's and Steinberg's accounts aspire to do. Neither are we dealing here with cases in which a Marxist, a Freudian, or a feminist applies recently developed theories to reinterpret a familiar work. On some (perhaps overoptimistic) views of interpretation, such frameworks provide novel ways of describing paintings.[12] What Panofsky and Steinberg are saying, rather, is that earlier accounts fail to understand these works.

Once we see that the ass is one singer in *Nativity*, that *Arnolfini Marriage* is a symbolic image, and, if Steinberg is correct, that the Caravaggios in the Cerasi Chapel are site specific, then we are naturally inclined to say that we have discovered facts about the works themselves. The limitation of earlier interpreters, we then think, is that they did not see these features of the paintings. This is a natural conclusion[13]—it underlines the importance of making discoveries that change the way we see these pictures. But it is also potentially misleading. Art historians do discover facts, as when the documented date of Caravaggio's birth was found. But to treat interpretations as discoveries of facts makes it difficult to understand how original interpretations are debated. If Panofsky uncovered the facts, then how could any

10. When Steinberg writes about Picasso's *Les Demoiselles d'Avignon* ("The Philosophical Brothel," reprinted with additions in *October* 44 [1988]: 17–74), the situation may be different; a novel interpretation need not deal at as much length with earlier commentaries.

11. Paul Barolsky, "Piero's Native Wit," *Source* 2 (1982): 21–22.

12. See Richard Wollheim, *Art and Is Objects* (Cambridge, 1980), sec. 39 and Supplementary Essay 4. Marianne Novy uses a modern framework to better understand how Shakespeare's audience resonded to his plays, in ways she can now articulate better than they could (*Love's Argument: Gender Relations in Shakespeare* [Chapel Hill, 1984]).

13. This argument I owe to Alexander Nehamas's critical response to my *"Pale Fire* Solved," in *Acting and Reflecting*, ed. Wilfrid Sieg (Dordrecht, 1990), 75–87.

reasonable person disagree with him? That his interpretations were debated indicates that something other than the discovery of facts was involved.

Today almost everyone will agree that Piero's ass appears as one of the singers and that *Arnolfini Marriage* is symbolic. But since almost everyone sees the paintings this way, what is gained by adding that these are features of the artworks themselves? Some art historians have worried that my appeal to the consensus within the profession implies, unnecessarily, that these interpretations are not solid. This is incorrect. Of course it is possible that in the future they, like any interpretation, may be rejected. But since nearly everyone now agrees that they are plausible, what is gained by insisting that the consensus is grounded in facts about the artworks themselves? Steinberg's interpretations raise problems precisely because they are more controversial. If he discovered the truth about the Caravaggios in the Cerasi Chapel, then how can any unprejudiced person disagree with him? If, rather, I describe his account as an original, highly suggestive interpretation that gets us to see those works differently, then it is easier to understand why there is a controversy about the value of his work. This focus upon how the consensus is achieved better permits us to understand the nature of objectivity in art history.

Of course, such novel accounts are disconcerting only if we have reason to think they are correct. Burkean conceptual conservatives think the fact that an interpretation is original is sufficient reason to reject it. Baxandall has said that, properly read, Vasari tells *the* story of Renaissance art.[14] But how we read Vasari depends upon a controversial act of interpretation. Even conservatives cannot avoid this problem, for they must acknowledge that what they call tradition seems to involve constant revision of older opinions. Wölfflin rejected some of the claims of his predecessor, Burckhardt; Winckelmann's understanding of the High Renaissance takes issue with Vasari, whose view of the quattrocento would startle Alberti. Here, as in politics, the trouble with appeals to tradition is that it is not easy to determine when the tradition began.

Today some art historians criticize iconography for producing overly elaborate interpretations and urge that old-master paintings are altogether simpler than Panofsky and his followers would have us believe. Even if such revisionists would like to return to an older tradition, that itself is a novel interpretation now that iconography has, for half a century, been an ac-

14. In personal correspondence, responding to a draft of my "Piero and His Interpreters: Is There Progress in Art History?" *History and Theory* 26 (1987): 150–65.

cepted methodology. Such a rejection of the tradition Panofsky established acknowledges, in part, the importance of his claims. If Panofsky was misguided, then most of the recent literature on Flemish art is conceptually confused. But since Steinberg's studies of Caravaggio and Michelangelo have not yet been as influential, it is possible to think that he is wrong without taking issue with such a body of literature. To draw a political analogy, which is helpful, if dismissing Steinberg's account of the Cerasi Chapel is like refusing to support the Equal Rights Amendment, rejecting Panofsky's view of allegory is like calling for a return to Prohibition.

Of course, it may seem more startling to learn from a text published in 1959 that our view of Caravaggio is mistaken than it is to know that fifty years ago Panofsky published his account of Flemish allegory. But this is simply because, all things being equal, recent changes are more startling. Unless we believe that at some point in the past the best methodology was discovered, that a methodology is traditional shows little. And since the dominant methodology of art history was developed only recently, it would be surprising if new ways of interpreting artworks do not continue to be developed. It is hard to imagine an interesting noncircular argument showing that any traditional methodology is the best interpretative approach.[15]

Here we come back to the problems posed by my claim that important art historians have a style. Again and again, Panofsky shows that understanding the textual source of a picture determines its meaning. Repeatedly, Steinberg argues that earlier interpreters were mistaken because they did not take into account the site of a work. Panofsky demonstrates that Bronzino's *Allegory*, contrary to first appearances, shows the dangers of love, not its pleasures.[16] Steinberg argues that Guercino's *Saint Petronilla* has been misunderstood because interpreters failed to recognize that it was painted for a site in St. Peter's church.[17] A reader who knew only their other essays and who looked at these paintings would have some idea of what they would say about them.

Consider two more examples. First, "From the standpoint of classical canons of representation, they must seem ignorant and crude. . . . But forget the prejudice of classic style and look more closely at the forms. How strong and sure are the forms."[18] Second, "The subject . . . looks up from his

15. Some art critics believe, analogously, that the history of art has ended. See my review of Hans Belting, *The End of the History of Art? History and Theory* 37 (1988): 187–99.

16. Erwin Panofsky, *Studies in Iconology: Humanistic Themes in the Art of the Renaissance* (New York, 1962), 86–90.

17. Leo Steinberg, "Guercino's *Saint Petronilla,*" in *Studies in Italian Art and Architecture*, ed. H. Miller (Cambridge, Mass., 1980), 207–34.

18. Meyer Schapiro, "Ancient Mosaics in Israel: Late Antique Art—Pagan, Jewish, Christian,"

writing desk. . . . His outright glance implicates the mental vision he has of his addressee. The picture [is] an incomplete situation, interacting with real space."[19] It is easy to identify the authors of these texts. Meyer Schapiro's account of the Beth-Alpha Synagogue mosaics identifies the virtues of a seemingly inept, historically marginal work. Characteristically generous, he praises what a historian concerned only with masterpieces would dismiss, as when in discussing Fromentin's art criticism he says that the "imperfections" a reader discovers in that text "are at times as instructive as the perfect parts; they belong no less to the personality."[20] Steinberg's account of the Pontormo takes up his concern with the relation between depicted figure and spectator, with erotic relations between images and their spectators. He writes: "I suspect that all works of art . . . are definable by their built-in idea of the spectator."[21] It would be surprising to find these words in a text by Schapiro.

Looking at such different pictures as the van Eyck, the Poussin, and the Bronzino, Panofsky finds that each is an allegory. Studying such diverse images as the Caravaggio, the Michelangelo, and the Guercino, Steinberg observes that each is site specific. Is it the case that such different artists working at different times aimed at the same effect, and that this was unknown until the discoveries of Panofsky and Steinberg? This might be true, but it is easy to think of another explanation for these facts. Perhaps the two critics so often find these similarities because of their styles of interpretation. Whatever artwork they interpret, this is how they will describe it. They are thus like artists. Whatever Cézanne depicts, he depicts in his style, which differs from Gauguin's. Just as painters learn their favored motifs, so successful art historians learn which works they should interpret in their style. Panofsky refused in his *Early Netherlandish Painting* to discuss Bosch. Steinberg has published accounts only of early Johns and early Rauschenberg. Perhaps they wisely refuse to deal with works to which their styles of interpretation are not well adapted.

Claude and Poussin, though they both worked from the Roman Campagna, depicted that place in their own styles. "Poussin keeps light and form

reprinted in his *Late Antique, Early Christian, and Mediaeval Art: Selected Papers* (New York, 1979), 28–30.

19. Leo Steinberg, "Pontormo's Alessandro de' Medici; or, I Only Have Eyes for You," *Art in America* 63 (1975): 65 n. 12.

20. Schapiro, "Fromentin as a Critic," 28.

21. Leo Steinberg, "Other Criteria," reprinted in his *Other Criteria: Confrontations with Twentieth-Century Art* (New York, 1972), 81.

severely distinct from one another and gives almost no sensation of atmosphere. Claude . . . creates a very palpable 'atmosphere'; and this, irradiated by light, tends to merge with the forms."[22] It is not a fact about the Campagna that light and form are distinct; but it is true that the Campagna can be depicted in these two styles. Analogously, perhaps it is not a fact that van Eyck and Poussin compose visual allegories, or that Caravaggio and Michelangelo create site-specific works; but it is true that their work can be interpreted in the styles of Panofsky and Steinberg. There is one obvious problem with this argument. Landscape painters depict scenes in their style; art historians offer arguments for their interpretations. Panofsky and Steinberg, unlike Cézanne and Gauguin, produce arguments. The whole apparatus of professional art history—the comparison illustrations, the detailed account of the earlier literature, the supporting arguments drawn from literary sources contemporary with the painting—marks this distinction.

Steinberg can be criticized for not being true to the facts; an artist normally cannot. But how is the truth of an art historian's claims to be fairly evaluated? When the disputants stand too far apart, it is almost impossible for them to argue with one another.[23] In my writing I repeatedly return to this question: Where is the neutral point from which to evaluate competing claims? One answer is that there is none. Panofsky's arguments convinced the audience that mattered, the next generation of art historians, and so his work defined the dominant methodology of that discipline. Some art historians simply dismiss Steinberg; leaving aside personal factors, we may expect that writing which challenges some of the assumptions of established art history will meet resistance. But to speak of "personal factors" is too simple. His critics will say that since his methodology is flawed, his arguments are not worth detailed discussion.[24] Certainly there is something personal in his interest in images that appeal to the spectator's presence, just as his concern with eroticism in the art of many masters is personal.[25] But there is also something personal in *refusing* to deal with these aspects of imagery, if indeed they are present. In interpretation there is no escape from

22. Michael Kitson, "The Relationship between Claude and Poussin in Landscape," *Zeitschrift für Kungstgeschichte* 24 (1961): 143.

23. For example, an analytic philosopher has a difficult time arguing with Derrida. See Chapter 8 of this book, and my review of his *Truth in Painting, Journal of Philosophy* 85 (1988): 219–23.

24. See Charles Dempsey, "Mythic Inventions in Counter-Reformation Painting," in *Rome in the Renaissance: The City and the Myth,* ed. P. A. Ramsey (Binghamton, N.Y., 1982), 67.

25. See his essays on Picasso reprinted in *Other Criteria* and "The Sexuality of Christ in Renaissance Art and in Modern Oblivion," *October* 25 (19830: 1–222.

personal taste, though some tastes are more in tune with present-day art historians' dominant concerns than others.

When, in the late 1950s, the young Jasper Johns replaced Willem de Kooning as the dominant influence in New York, there was felt resistance by many second-generation abstract expressionists. These older artists were not willing to adopt his style, or even to take him seriously. Similarly, within art history, when older scholars now refuse to take an interest in novel methodologies, they quite understandably refuse to give up the style of interpretation with which they are familiar in favor of approaches whose value is difficult as yet to estimate. Steinberg quotes an art historian who wrote, "Michelangelo's sex life is, quite frankly, none of our business."[26] As he convincingly indicates, while this preconception reveals something about traditional art historians' methodology, it gives no reason to accept that limitation on inquiry.[27] No doubt the passage of time makes it easier to see when "personal taste" is not objective. Roger Fry's appreciation of eroticism in Indian sculpture and his distaste for baroque art shows the influences shaping a man of his generation.[28] In fifty years, a more measured judgment of Steinberg's importance may be possible. But that does not help us now to assess his "personal taste." Ruskin, famous in his day, was neglected in Fry's era and is now famous again; Winckelmann, famous in his century, remains somewhat neglected, though it is predictable that studies of the history of art history will draw increased attention to his work.

A history of these changes in their reputation would be analogous to a sociological account of the rise to fame of Piero, and the fall and partial revival of the Carracci.[29] While we can explain these changes, it would be overoptimistic to think that there are plausible ahistorical standards by which to judge the arguments of an art history or to measure the importance of an artist. And since the reputation of these artists and art historians has changed, at what time, past, present, or future, could the judgment of their importance be objective? Once we give up the pretense that the passage of

26. Leo Steinberg, "Objectivity and the Shrinking Self," reprinted in his *Other Criteria*, 315.

27. Similarly, a recent monograph on Matisse, which, after telling us what a reader of the earlier literature could suspect—that he "often had intimate relations with his models"—then indicates that these relations will not be discussed "except in the few instances where the personal relationship seems to have directly affected his work" (Jack Flam, *Matisse: The Man and His Art, 1869–1918* [Ithaca, N.Y., and New York, 1986], 12).

28. See Roger Fry, *Last Lectures* (Boston, 1962), chap. 9, and "The Seicento," reprinted in his *Transformations: Critical and Speculative Essays on Art* (Garden City, N.Y., 1956).

29. See Francis Haskell, *Rediscoveries in Art: Some Aspects of Taste, Fashion, and Collecting in England and France* (Ithaca, N.Y., 1976).

time provides an unproblematic way of judging an art historian's personal taste, then we can recognize the necessity of a personal response. No doubt, Steinberg's critics are being dogmatic; but so, unavoidably, are all of us when we choose to attend to one writer's arguments and not to another's. Because I admire Arthur Danto, I read him sympathetically. Because I usually find Derrida frustrating, I am a masochistic reader, though I have borrowed from him. A reader who finds Ruskin or Winckelmann stimulating will not be disturbed by the silly things they say; an unsympathetic scholar will be unlikely to attend closely to their interesting claims.

Just as a painter has a personal style, so too does an art historian. Parody teaches us that when authors have a style what they will say is predictable. "It was with the sense of a, for him, very memorable something that he peered now into the immediate future, and tried, not without compunction, to take that period up where he had, prospectively, left it."[30] The reader of James will recognize this famous parody. In reading original art historians, what we expect, and usually find, is that knowing their writings enables us to predict what they will say about new works.

Given what Michael Fried wrote about the opposition between theatrical minimalist art and modernism in the 1960s, his published work on eighteenth-century French painting, and his essays on Courbet, we can almost predict how in his most recently published book he will interpret Thomas Eakins's *Gross Clinic*: "But the primacy of absorption in *The Gross Clinic* is everywhere manifest . . . a motif comparable in its single-mindedness as well as in aspects of its content to one of the most compelling seventeenth-century images of collective engrossment . . . the probing of the open wound in Christ's side in Caravaggio's *Doubting Thomas*."[31] Just as studying Beerbohm's parody of James reveals the master's style, writing a parody of Fried could be instructive, for doing that would require working out explicitly a characterization of his style. Unlike James, Fried offers arguments: *Realism, Writing, Disfiguration* has footnotes; *The Golden Bowl* does not. But art historians who find Fried's approach misguided are unlikely to be convinced by this scholarly apparatus.[32]

30. Max Beerbohm, "The Mote in the Middle Distance," reprinted in *The Question of Henry James*, ed. F. W. Dupee (New York, 1945), 40.

31. On Fried's earlier work, see my *Artwriting* (Amherst, Mass., 1987), chap. 3; on Eakins, Fried's *Realism, Writing, Disfiguration: On Thomas Eakins and Stephen Crane* (Chicago and London, 1987), 44.

32. See Fried's response to Linda Nochlin's critical comments about his "Courbet's 'Femininity.'" In what he calls "a conflict of interpretations—and ultimately of approaches," what commentator could be fair to both parties (Sarah Faunce and Linda Nochlin, eds., *Courbet Reconsidered* [New Haven, 1988], 53)?

Matisse said: "I found . . . my artistic personality by looking over my earliest works. . . . I found something that was always the same and which at first glance I thought to be monotonous repetition. It was the mark of my personality which appeared the same no matter what states of mind I happened to have passed through."[33] Is this not a highly suggestive definition of style, that personal element which makes the result, whatever the starting point, seem to show monotonous repetition? Ad Reinhardt produced "black square paintings that were very much alike but, as they came from the same impulse, they were not duplicates of one another."[34] Just as Matisse, though he seems with each picture to start anew, always ends up creating something in his style, so does an art historian who has a distinctive style.

While I can only speculate why it is that Panofsky, Steinberg, or other art historians repeat themselves, in one case I have privileged information about the development of a scholar who writes about art history. Here we come to the point of my title; I, unlike Panofsky, Steinberg, or Fried, can offer additional information about these repetitions that constitute my personal style. I have only gradually come to recognize that in very different contexts I was repeatedly offering the selfsame argument. In studying the literature on Manet, Piero, and other artists I repeatedly identified two concerns. Only modern interpreters find van Eyck's *Arnolfini Marriage* a highly complex allegory, describe the symbolism in Piero's *Flagellation,* and speculate about the meaning of the mirror in Manet's *Bar at the Folies-Bergère.* (And imitations of such complex interpretations appear.) Only modern interpreters identify three mysterious figures in *Flagellation* and speculate elaborately about the meaning of the nonmatching mirror images in the two versions of *A Bar at the Folies-Bergère.* Once *Flagellation* and *A Bar at the Folies-Bergère* have been subject to the first elaborate reading, other equally complex interpretations will be offered.

Once art history is written by professors, not by journalists or other amateurs, it is unavoidable that the standards by which such artwriting is judged will change. Like parents, professors of art history reproduce themselves, which means that their research techniques must be teachable. Institutions like *Art Bulletin,* as well as graduate students and the other apparatus of professionalization, mean that once lots of research is done major

33. Quoted in Jack D. Flam, *Matisse on Art* (New York, 1973), 31.
34. Arthur C. Danto, *The Transfiguration of the Commonplace: A Philosophy of Art* (Cambridge, Mass., 1981), 204. To this account, which grounds style in what Danto calls the "artistic source," the personality of the artist, I prefer the analysis in Richard Shiff, *Cézanne and the End of Impressionism* (Chicago, 1984).

painters will be studied in ever-more detail and monographs will be devoted to minor artists. Once someone seriously asks who are Piero's figures, then these institutions guarantee that there will be an elaborate literature. When research is thus institutionalized, graduate students want thesis topics, younger professors need to publish, and Slade lecturers must find original ways to describe familiar works.

These claims, which I have made repeatedly, now seem commonplace to me. But since art historians, unlike literary critics, do not write about the institutions of their discipline, it is not obvious to me whether they share this view. When an art historian recently wrote that "today only one younger scholar . . . is working full-time on" Corrado Giaquinto (1703–1766) this seems to me an inadvertently comic comment on academic specialization.[35] A century ago, nobody was working full-time on Caravaggio. Now that so much has been written about him, it is natural to turn to relatively minor baroque artists. Once one scholar is working full-time on Giaquinto, soon her students will do more research.

Then there will be a major Giaquinto exhibition, for just as research is governed by the academic market, so exhibitions depend upon the art market. In the famous pioneering exhibition of 1951, the greater body of Caravaggio's known work was gathered in Milan. Although he had been seriously studied since World War I, only this exhibition really established his modern reputation. When another Caravaggio exhibition was held in 1985 in New York, some of his works were too valuable to travel; and due in part to the stimulus of the art market, some hitherto lost Caravaggios reappeared. A number of the attributions by Roberto Longhi had been rejected by younger specialists. A Giaquinto exhibit is now timely, for few Caravaggios remain on the market, and his works are so valuable that arranging loans for exhibitions is difficult.[36] The bibliography in the Milan catalogue is relatively brief, and a good half of the entries had appeared since 1924, more than three centuries after Caravaggio's death. In 1951 it was relatively easy to read all of the literature on Caravaggio. The New York catalogue has a much longer bibliography, and now only specialists can master that literature and so do research on the painter.

35. George Hersey, *A Taste for Angels: Neapolitan Painting in North America, 1650–1750* (New Haven, 1987), 289.

36 The Milan catalogue has 150 pages of text and black-and-white full-scale illustrations of the paintings (*Mostrea del Caravaggio e dei Caravaggeschi* [Florence, 1951]). The New York catalogue, *The Age of Caravaggio* (New York, 1985), has more than three times as many (much larger) pages and many color reproductions with a number of details.

Which came first, the institutions or this sort of argumentation? Perhaps the question cannot be answered. Unless or until such argumentation was produced, there could not be professionalized art history; once it exists, those institutions guarantee that ever-more-elaborate interpretations will be produced. That so much has been written about Piero's figures and Manet's mirror means that anyone who wants to discuss them needs to say something new. If detail photographs were not available, and if there were not journals and conferences devoted to such problems, then they would not be studied intensively. Certainly, institutions of this sort do not determine everything. Just as some unsuccessful painters keep on painting, so a scholar may write texts that attract little attention. But in my experience, at least, the interest shown by others in my concerns made it easier to do such work. My initial ideas about art history's history were vague. That some journals published my work and that I was invited to give lectures gave me reason to work out a detailed analysis. The response of critics stimulated me to refine my arguments.[37]

Whether I describe the literature on Manet or Piero or Caravaggio, I find the same structures. Had I studied the literature on other artists I might have arrived at different conclusions. Perhaps I find the same structures repeated, not because they are there in the literature, but because they are my creation. Just as Matisse's repetitions, which define his artistic personality, are to be understood by studying his life, so my repetitions are better understood by knowing something about me as an author. A critic complained that my "claim to self-consistency excludes us from direct engagement with" me.[38] I am, I think, easier to argue with than Fried or Steinberg, but what this critic is correctly identifying is the natural result of any artwriting that has a style.[39] Just as there is both a personal and a historical approach to understanding Panofsky's and Steinberg's interpretations, so the same ought to be true of mine. Just as Panofsky interprets in the same way whether he studies van Eyck or Poussin, and Steinberg finds the same appeal to the spectator whether he studies Caravaggio or Michelangelo, so in the literature on these different artists *I* find repeatedly the same structures. I too have a personal style.

37. See Robert Grigg, "Flemish Realism and Allegorical Interpretation," and S. J. Wilsmore, "Unmasking Skepticism about Restoration," *Journal of Aesthetics and Art Criticism* 46 (1987): 299–300, 304–6.

38. I quote from Donald Brook's review of *Artwriting, Leonardo* 22, no. 2 (1989) 98; see also my "Response to Donald Brook," *Leonardo* 22, no. 2 (1989) 198–99.

39. After making inaccurate remarks about my text, he presents what we might expect from his earlier publications, a defense of Gombrich's position.

Once Panofsky allegorized a number of artworks, and Steinberg demonstrated how many paintings appeal to the spectator's presence, it was very hard to imagine them accepting any counterarguments. They then applied their methodology to other works. And yet, there are real unsolved problems with Panofsky's account of *Arnolfini Marriage.* Why is the man holding the woman's left hand in his left hand? If this is a naturalistic image, then this is a left-handed, a morganatic, marriage; but if so, the painting cannot depict the Arnolfinis, who were not such a couple. This unresolved problem did not deter Panofsky from giving this interpretation or his followers from accepting it. Since he had found an exciting way of looking at the picture that explained many of the details, probably only the development of a sweeping new analysis would lead to the abandonment of Panofsky's approach.

When Steinberg produced his highly complex account of the composition of Michelangelo's *Last Judgment,* and then said that the alternatives were either to accept his plan or believe that all the ordered features to which he had called attention were merely accidental, the situation was similar. Given those alternatives, many would choose to believe him, for we think that order in art must have a cause. Of course, these may not be the only alternatives. We might find a wholly different order in the composition, or another explanation for the order Steinberg observes. But merely saying that it is *possible* to do this is uninteresting.[40] Similarly, I doubt that one counterexample would convince me to abandon my view of art history's history, although an accumulation of such examples would certainly worry me. A single seventeenth-century proto-Steinbergian description of Caravaggio or proto-Panofskyian account of Flemish allegory or discussion of Piero's mysterious trio will not disturb me. If a counterexample is not discussed in the literature and is not influential, maybe its very isolation supports my view of art history's history.

Those repetitions in my texts ought to make a believer in objectivity of interpretation suspicious. Since I repeatedly find the same structures in the literature on many artists from different periods, maybe those structures are not in that literature itself but come from my authorial personality—maybe I find the same structures repeated because they are my creation. Then it might be worth speculating about why my personality as writer leads me to repeat myself. Matisse's repetitions, which define his style, are understood

40. See Nehamas, *Nietzsche,* 63–64; the claim that a better interpretation of romanticism than M. H. Abrams's account *could* be written is uninteresting until that actually is done.

by art historians through studying his life and the historical context in which his art was created. Likewise, perhaps my repetitions are better understood by knowing something about me as an author. If one style of analysis consists of offering knockdown evidence for a particular interpretation, another involves demonstrating that every possible approach has some interest and that no single analysis presents *the* correct account. I am interested in all interpretations of an artwork, the highly original accounts as well as those that merely repeat clichés. As an authorial personality I am always conciliatory, always willing to find some interest in a wide range of points of view.[41] At the same time, the unavoidable consequence of being conciliatory is that I am unwilling to privilege any single interpretation.[42]

It was inevitable that once literary critics extensively discussed the problems of relativism in interpretation someone would apply their arguments to art history. Since art history has been methodologically conservative, it was predictable that an outsider, the literary scholar Norman Bryson, would be the first to systematically apply the fashionable structuralist and poststructuralist theories. Analogously, it was to be expected that another outsider, a philosopher, would be the first to develop a systematic account of the problems of relativism in artwriting. In ethics, the problem of relativism is of central importance, and nowadays to contribute to that discussion a philosopher needs to study a large literature. This is not the case in artwriting, and so once the problem has been identified it is easier to make original claims. All that was required was to observe that what had often been said about relativism in literature and morality applies to artwriting.

These observations, an antidote to authorial narcissism, are a natural interpretation of one passage in Steinberg's writing. Explaining how he tends to find "symbolic forms multi-storied," he notes: "I am conscious of belonging to *a generation* brought up on Freud and James Joyce. *Ulysses* and *Finnegans Wake* were the pabulum of my teens, and I am always ready to welcome another artist who conceives his symbolic forms multi-storied."[43]

41. But remember that for me an author—here I follow Foucault, Barthes, and Nehamas—is a fictional persona. See my "Art without Its Artists?" *British Journal of Aesthetics* 22 (1982): 233–44.

42. The reviewer of my *Artwriting* who remarks that "Carrier is murderously quick to dismiss his central figures" (*Print Collector's Newsletter* 19 [1988]: 30) understands one impliction of such relativism even while she or he fails to acknowledge that I express my admiration for everyone who is such a central figure in my history. But I am less charitable than Fredric Jameson, in whose Hegelian analysis even his ideological opponents have their essential role. See Fredric Jameson, "The Politics of Theory: Ideological Positions in the Postmodernism Debate," *New German Critique* 33 (1984): 53–65.

43. Steinberg, *Other Criteria*, 320 (my italics).

Anyone with the literary tastes of his generation, he implies, is likely to see old-master art as he does, and while that does not explain why he alone has systematically developed such an approach, it does make his work seem less anomalous. Since each future generation will approach the old-master works with novel interpretative techniques, it is likely that new approaches to those paintings will continue to be developed. A generation brought up on poststructuralism and Pynchon whose pabulum was *Gravity's Rainbow* may write about Caravaggio in ways that Steinberg cannot anticipate.

Once we see how an interpretation has both a period and a personal style, what remains of objective validity? The ideal of ahistorical, impersonal objectivity is highly problematic.[44] Style is inescapable in art history, and if objectivity in interpretation demanded a neutral style, that would be an impossible goal. But just as epistemic skeptics err by setting the standards for knowledge too high, so that what we ordinarily believe we know cannot satisfy their standards, so an art historian who sets a standard of objectivity that no one can satisfy has not correctly understood objectivity.

Nothing I have said about the institutions of professionalized art history is incompatible with thinking that they provide good ways of getting at the truth about art. But the relation between originality and truth is complicated. We can understand why in 1960 the followers of de Kooning seemed less interesting than Johns, who, however much he built on the past, had a very different style. But thinking of Steinberg as breaking with tradition in an analogous way seems to leave out one crucial point: unlike art, art history claims to be true. No doubt I am tempted by this analogy because I first wrote about art criticism, then about art history. But I am unrepentant about yielding to that temptation, for it suggests an original way of answering these questions about the apparent conflict between objectivity of interpretation and the crucial role of personal style in art history.

I asked: Is objectivity in art history possible? This parallel between art and art history shows that we would do well to change the question. We should ask: What *function* does objectivity serve? In Gombrich's example, for the German artists doing the same scene in their individual styles, talking of objectivity means that they can contrast their diverse ways of depicting the selfsame scene. In art history, analogously, the way to understand what counts as objectivity is to see what function that normative ideal serves.

44. See Norman E. Land, "On the Poetry of Giovanni Bellini's *Sacred Allegory*," *Artibus et Historiae* 10 (1984): 61–66. He informs me that his awareness of the institutions of contemporary art history led him away from writing, as he originally desired, in an entirely anachronistic manner. Like me, he admires Adrian Stokes.

What is essential for modern art history is that the claims of an art historian be debatable. Debate requires agreement about the rules of argument. If general agreement reigned, then there would be no reason to debate. If agreements were too extreme, intellectual intercourse would be impossible. At any given time, art historians proceed by ruling out some positions as eccentric, while allowing that a certain range of approaches is acceptable. Every text is in some period style, even if it is anachronistic. Every art historian has some authorial personality, whether it is highly personal, as in the cases I have discussed, or bland and seemingly anonymous. Every painting manifests some period style, whether it is in an outdated one or anticipates a future style. Although not every artist achieves a style, every painting can be classified stylistically, if only in the sense that it is identifiable in relation to the styles of artists. The same is true of the texts of art historians.

Today, to employ Panofsky's methodology is acceptable, and it is possible to follow Steinberg. But art historians who emulate Lacan or Foucault, like one who composes *ekphrases,* effectively admit that they do not seek to be part of the ongoing dialogue within their discipline.[45] Of course, they may have another goal, changing the terms of that dialogue. After Panofsky, the older accounts of van Eyck seem to be of merely historical interest; if Steinberg is equally successful, his view that art history remained too long tied to an outdated methodology may become commonplace. No one can altogether avoid institutional pressures, but once individuals cease to be graduate students and become professors, then they are in a position to change the standards of discourse.[46]

Such change may not occur even when a professor becomes well known. In his book on French painting and the revolution of 1848, Tim Clark mentions Lacan in the bibliography but not in the body of the text.[47] Although Clark's style of argument draws heavily on Lacan, I think that has not been appreciated among art historians, who are, understandably, not

45. A young Poussin scholar discusses Foucault, but he has a marginal place in her important unpublished dissertation (Sheila McTighe, *"The Hieroglyphic Landscape: 'Libertinage' and the Late Allegories of Nicolas Poussin"* [Ph.D. diss., Yale University, 1987]).

46. The reader familiar with Steinberg's style may suspect that his doctoral dissertation, published as *Borromini's San Carlo Alle Quattro Fontane: A Study in Multiple Form and Architectural Symbolism* (New York, 1977), shows that even he was forced by those pressures into something of a compromise.

47. T. J. Clark, *The Absolute Bourgeois: Artists and Politics in France, 1848–1851* (London, 1973). At that date, Lacan's books had not yet been translated, and so perhaps it was not unexpected that commentators had little to say about this aspect of Clark's work.

prepared to find Lacan a congenial influence. This portion of Clark's methodology has not been imitated. But of course in another decade references to Foucault and Lacan may be as common in the *Art Bulletin* as are footnotes to Panofsky.[48]

When a new iconographic account is published, there are generally agreed upon standards for judging such a text. The work may be skilled or inept, but it employs well-established strategies of argumentation. By contrast, when Clark, Fried, or Steinberg produce work that rejects the accepted methodologies, the critical responses tend to be radically divided. A few reviewers admire their originality; others are hostile, bewildered, or angry.[49] The same is true in painting. The abstract expressionists were at first, in the 1940s, scorned and then widely imitated; and when, in the 1960s, their style was radically rejected by Johns and the minimalists, many felt that something essential had been lost. But American art does not differ in this rapidity of innovation from Italian painting of the period 1480 to 1520, or from French art between 1860 and 1907; typically, such stylistic changes are rapid. Interesting artists work in the style of de Kooning; distinguished art historians employ Panofsky's methodology. And yet, just as it is hard to imagine much of a future for painting unless someone after de Kooning could be as radically original as he was, so it is unclear whether art history would continue to be interesting if Panofsky's iconographic approach was the model forever. In surveying the recent accounts of the three men in Piero's *Flagellation*, for example, it is hard to avoid feeling that these readings are variations on a familiar theme.[50]

Some people have feared that my interest in innovation and this focus on the institutions of art history mean that I relinquish the possibility of giving rational standards for evaluating argumentation. This is not true. When accepted principles of disputation change, rational argumentation plays an important role in that process. While I am skeptical about providing any ahistorical standards, I believe that my focus on the consensus within the profession provides the necessary, and only possible, justification for objec-

48. See my review of Norman Bryson, *Calligram: Essays in New Art History from France, Journal of Aesthetics and Art Criticism* 47, no. 3 (1989): 286–87.

49. My account here draws on Steinberg's "Contemporary Art and the Plight of Its Public," reprinted in his *Other Criteria;* I differ from him in the way I apply this same argument to art history, including his work.

50. Even such an original account as Carlo Ginzburg's *Enigma of Piero* is but a highly refined development of themes presented earlier in brief accounts; see my review, *Art Journal* 46 (1987): 75–79.

tivity. Some aestheticians believe that the test of time determines the importance of a painter.[51] Similarly, it might be urged, survival over time determines the strength of a methodology. I reject the claim that such a test provides a way of understanding this process. In investigating the history of taste and the history of art history, we can record the results of this process of study, which we then try to understand. In dealing with the immediate present, we collectively determine the consensus. The test of time is unduly optimistic, implying that the best artworks and the best methodologies will necessarily triumph. For working art critics, appeal to this standard is useless; what they must provide, right now, is an evaluation of new works. Similarly, art historians who ask that we wait to see whether some original methodology passes the test of time refuse to participate in the debate that may change the consensus within their discipline.

Evaluating such revisionist work is tricky. In response to Norman Bryson, some critics focus on his errors, while other scholars mention his work in footnotes or borrow from him.[52] If his findings provide exciting ways of describing familiar artworks, then art historians are likely to be charitable about his errors. Sidney Geist's recent *Interpreting Cézanne* offers elaborate argumentation unlikely, I predict, to be taken seriously.[53] He argues that Cézanne's paintings are filled with hidden images telling us about the artist's personal life. *The Railroad Cutting* depicts the womb of the painter's pregnant wife, with the hut standing for the fetus; *The Block Clock* celebrates the birth of his son, the proximity of the clock (a symbol for Cézanne) and the inkwell (standing for Zola) hinting that their relation "probably had homosexual overtones," while the lemon stands for Mme Cézanne. Geist, like Bryson, argues; but since I cannot take his starting point seriously, and find his conclusions absurd, his argumentation seems to me not worth much discussion. He is not worth arguing with, except insofar as his book tells us something about the methodology of art history. By contrast, I find Bryson worth taking seriously.

I state this distinction with dogmatic brevity. And yet, leaving Bryson aside, what is the difference in kind, an art historian sympathetic to Geist

51. See my critical review of Anthony Savile, *The Test of Time, Journal of Philosophy* 81 (1984): 226–30, and my *Artwriting*, 38–40.

52. See, for example, Malcolm Bull, "The Iconography of the Sistine Chapel Ceiling," *Burlington Magazine* 130 (1988): 599 n. 10; Linda Nochlin, "Watteau: Some Questions of Interpretation," *Art in America* 73 (1985): 73–80; and my *Artwriting*, 82–87.

53. Sidney Geist, *Interpreting Cézanne* (Cambridge, Mass., 1988); see my review, *Arts Magazine* (February 1988): 111–12.

might ask, between his account and those of Panofsky and Steinberg? Like Panofsky, Geist offers entirely new approaches to familiar works that, if accepted, radically change our estimate of those paintings. Like Steinberg, Geist rejects the accustomed interpretations, employing a novel methodology that is sure to be criticized by conservative art historians. If the past is any guide, one important difference between Bryson and Geist is that the former offers techniques that other art historians can apply, imitate, and criticize, while the latter does not. This is not to urge that Bryson is as important as Steinberg, Fried, or Clark, but only to point out the ways in which unorthodox writers challenge the consensus. Other historians of art history might disagree entirely with my judgment of the relative importance of Bryson's and Geist's work, which perhaps appears overly confident.

If objectivity in art history consists in agreement about standards of debate, then the present methodology might be radically revised. Radical change is likely to occur again. We may accept Gombrich's claim that there is no neutral naturalism, no single best way of depicting nature as it is, without thereby rejecting the claim that a naturalistic image may be true to the scene it depicts. Analogously, though there is no neutral interpretation, no single best way of interpreting a picture, still some art historians' accounts can be true to the picture. Gombrich tells the history of naturalistic painting; I want to tell the story of art history's history. Objectivity in interpretation is consistent with radical changes in standards by which interpretations are judged.

4

The Aesthete in the City

For Barbara Westman

One of the grandest passages in the art-historical literature is Ruskin's invocation, in the third volume of *The Stones of Venice*, of a traditional approach to that city. His prose, with its many subordinate clauses and repeated pauses, is a near equivalent to the layers of the history of the city that he aspires to uncover. If Ruskin thus seeks to represent his beloved Venice, it is because he believes that, after remaining essentially intact for so many centuries, the city has almost been destroyed within his lifetime. Entering by gondola, as everyone did when he was young, he observes the fatal "railroad bridge, conspicuous above all things." Within Ruskin's lifetime, the traveler's approach to Venice has changed. "In the olden days of travelling, now to return no more . . . there were few moments of which the recollection was more fondly cherished than that which . . . brought him within sight of Venice." If that "noble landscape of approach" is no more, still the imaginative viewer can "restore . . . some faint image of the lost city." That task can be accomplished, he adds, not "by the indolence of imagination" but only (as suits an obsessively hardworking, exhaustively thorough Victorian writer) "after frank inquiry."[1]

1. John Ruskin, *The Stones of Venice;* First, or Byzantine Period; chap. 1, The Throne.

Although Ruskin's Venice today seems almost as historically distant as that early Renaissance city he imaginatively re-creates, even the modern visitor who travels through Italy by car is aware of the connection between the artworks she sees and the color and light of that environment. Paul Hills, a sensitive art historian, reminds us that we too can, like Ruskin, seek to place Renaissance art in its environment: "Anyone familiar with the streets of Florence with their jutting caves will realize that Giotto's placing of shade beneath such projections was a response to the light and shadow of a familiar townscape."[2] Looking around in the streets of Florence as we approach Santa Croce is not irrelevant to our experience of the Giottos in the Bardi Chapel.

Hills is an admirer of Ruskin's greatest heir, another English Italophile: "I was prepared for Italy: I had been preparing from an early time. . . . I knew one word the first day, mensa, a table. . . . Of the table, for the table, by the table, each expressed by one simple word. . . . We arrived at Turin. . . . On the other side of the gangway . . . I again saw the mensa table."[3] As Ruskin tells how the approach to Venice changed in his lifetime, so Adrian Stokes (1902–1972) wrote of his first arrival in Italy, where immediately he found that "never before had I been so much at home." The London of Stokes's late Edwardian childhood seemed full of hidden menaces, threats unknown and unseen. In Italy, by contrast, as he recalled in autobiographical volumes published two decades later, there "was an open and naked world. I could not then fear for the hidden." Stokes built an entire aesthetic around this contrast between what he called carving art (most especially some sculptures and paintings of the Quattro Cento, which re-created such an open world) and those other, modeled artworks representing something that remained in part hidden. As he indicates, the distinction between his youthful experience of modeling and carving art can best be understood as a highly personal contrast between his youthful conceptions of the female (potentially nurturing, but at the same time hidden and so perhaps dangerous) and the male (safe because fully exposed to sight). Bolder and franker than many less subtle aesthetes, he acknowledged the primitive roots of his fascination with the environment of Renaissance art.

I have recorded both my enduring fascination with Stokes's ideas and my ultimate skepticism about his vision of Quattro Cento art.[4] What remains

2. Paul Hills, *The Light of Early Italian Painting* (New Haven and London, 1987), 51.
3. *Inside Out* (1947), reprinted in *The Critical Writings of Adrian Stokes*, ed. L. Gowing (London, 1978), 2:153.
4. *Artwriting* (Amherst, Mass., 1987), chap. 3.

attractive to me in his work is the Ruskinian notion that art can only be adequately understood by placing it in its social setting. What is problematic is his belief that the meaning of carved works is visually self-evident, immediately apparent to the eye of a sensitive viewer. This certainly is a puzzling view. Iconographers have elaborately studied Piero's work; Stokes thought that he could sense immediately the meaning of those carved artworks, without needing to analyze the texts that they illustrate.

Ironically, it was Stokes's autobiographies that led him to acknowledge this point, since it turns out that the seemingly self-sufficient carved works he so loved can only be understood by contrast to modeled paintings and sculptures. If his early writings thus provide a perfect model of our deconstructionists' claim that binary oppositions always valorize one term (the value of carving being marked by its contrast to modeling), what defines Stokes's maturity, and distinguishes him from Ruskin, is his awareness of precisely this limitation of his early account. What for me is most moving in his autobiographies is his awareness that these two sides of his own experience—England and Italy, female and male—cannot, as he initally thought, be so dramatically opposed. It is no accident that one autobiographical volume is about his own childhood, while the other tells of both his identification with Cézanne and the birth of his first son.

Stokes's visionary writings awakened my own interest in the visual arts when I was a graduate student in philosophy at Columbia University in the late 1960s. Perhaps because I, like many people, am only enchanted by what is not at hand, it was not until long after I had left New York that I grew fascinated with contemporary art and became, almost by accident so it seemed at the time, an art critic. It is a long story, one I will not tell here, how I learned from Stokes to love Italian art even while becoming skeptical of his aesthetic. Sandy Stranger in Muriel Spark's *Prime of Miss Jean Brodie*, lover of a married Catholic, in time "left the man and took his religion." Like her, I found inspiration elsewhere, in the art criticism of a Catholic Marxist, Joseph Masheck, who in the later 1970s was editor of *Artforum*. Only then, I suspect, was I prepared to acknowledge how much I had gained from my love of Stokes's texts. Stokes himself wrote less interestingly about modern art. Whether this was so because he knew only what was displayed in London, or (as I think) because he was more at home with his first love, the Quattro Cento, in any event his work did not provide any real starting point for my own art criticism.

Certainly it seemed that Stokes's account of art and its environment had little immediate relevance to New York art in the early 1980s. In his beau-

tiful essay "The Luxury and Necessity of Painting" (1961), he argues that
in its "palpable textures . . . modern painting express[es] the division and
disintegration of culture as well as the ambivalent artist's restitution."[5] Like
many infinitely less distinguished critics, he, however sympathetic to mod-
ernism, treats it as a symptom of disintegration. Ruskin marked the decline
of Venice early in the fourteenth century; for Stokes, too, the greatest art is
a thing of the past. And whether because his account reveals the bias of an
Italophile who, like Ruskin, idealized Venetian culture, or simply because
modern painting and sculpture has a very different relation to its environ-
ment than did Italian art, Stokes's writing seemed to have almost as little to
do with my experience of New York art in the mid-1980s as did Ruskin's
nineteenth-century vision of Venice.

Certainly reading about Ruskin's entrance by boat into Venice, or
Stokes's by train into Italy, did not prepare me to land at Newark Airport,
take the bus through the Holland Tunnel to the World Trade Center, and
then walk to SoHo or take the uptown subway to Fifty-seventh Street or
Madison Avenue. I wanted to see the paintings in the city, and for my pur-
poses that travel itself would have been time wasted but for the chance it
provided to read Zola. And yet even I, a modern would-be aesthete who
listened to Verdi's *Otello* on his Walkman to escape thinking about that re-
barbative airport I had to walk through, found myself speculating about the
relation between my experience of art in the museums and galleries of New
York and this visual environment. Ruskin and Stokes learned something
about Italian Renaissance art by thinking about their entry into Italy. Per-
haps I too could better understand the art I came to view by thinking about
that experience I dreaded, my entry into New York.

Once I rushed downtown through the crowds on Madison Avenue, late
for an appointment at the David McKee Gallery on Fifty-seventh Street. I
arrived to find that I almost could not, for some minutes even after I was
comfortably seated, focus on the paintings I had come to see. Such an ex-
perience must be familiar to many artworld people, who after almost schi-
zophrenically detaching themselves from the visually uninviting scenes of
the subway or the street enter the galleries, museums, or studios in which
they are to contemplate art. What is called for, it seems, is a switch between
two very different modes of visual attention. Sometimes, with luck, these
experiences can be reconnected. The abstract artist whose work I came to
see lives downtown, and so "on a number of occasions," I later wrote, "I

5. *Critical Writings of Adrian Stokes*, 3:148.

have found myself turning from studying his paintings to looking at those streets."[6] He lives on the Bowery, "one of those places in lower Manhattan where crosstown and uptown streets do not quite meet at right angles." My Stokesian insight about his paintings was that, without using any literal imagery, a similar structure was replicated within many of his recent works, in which a centered cruciform is displaced rightward.

The problems raised by this relation between art within the New York gallery space and the city was posed in its crudest form by an exhibit a few seasons ago at the Sidney Janis Gallery. Instead of the Giacomettis or Mondrians one might expect, works by graffiti artists were displayed. This was a short-lived fad, and only a mean-minded social commentator like Tom Wolfe could do justice to a situation in which art from the subway was displayed for sale to collectors who never need to ride it. The effect was less to suggest that riding the subway might be an aesthetic experience than to make a perhaps inadvertently ironical statement about collecting. But even more subtle art poses the same problem for viewers coming into the gallery from a visual environment that rebuffs attention prepared to appreciate fine distinctions.

There is no living artist I admire more than Robert Ryman, whose exhibit of May 1984 at the Galerie Maeght Lelong in Paris was for me an epiphany. It is marvelous to be struck speechless, but like Roger Fry—who, though he referred to himself before Cézanne's works as "like a mediaeval mystic before the divine reality," found ways of describing those paintings—I sought to verbalize my experience.[7] Seen in that elegant gallery space, Ryman's pristine white surfaces provided a utopia for the aesthete, a demonstration that the most banal-seeming materials may provoke the deepest pleasure of aesthetic contemplation. The contrast with a show of his several years later at the New York branch of this same gallery was revealing. In Paris, at least at 13, rue de Téhéran, in the *huitième arrondissement*, elegant art echoes the ambience provided by the streets outside. In New York, even on Fifty-seventh Street, the same works seem escapist, a welcome refuge from the space outside. I can sympathize with my New York cicerone, who wanted to lie down and sleep in that utopian space. How is it possible to focus closely on Rymans without contrasting his refined textures to those from the streets outside the gallery? Here it is natural to invoke Stokes's

6. David Carrier, "Harvey Quaytman's Recent Paintings" (Stockholm, 1987); republished in a catalogue for David McKee Gallery, New York, October 1988.

7. Roger Fry, *Cézanne: A Study of His Development* (New York, 1958), 2.

notion that one function of contemporary art is to offer a substitute for the textures that today's architecture cannot provide.

Like a concertgoer who wears earplugs for her subway trip to Lincoln Center, when an aesthete enters the gallery he must suddenly turn from a state of deliberate inattentiveness to the aesthetic qualities of his environment to a close-up focus on minute details. After the galleries close, I often have gone to Tower Records, downtown on Broadway at Fourth Street. From the sales desk of the classical-records section, while listening to the splendid stereo system, I see, in the loft across the street, rows of dancers moving to another tempo. Physically close, but out of hearing, they exist in a space seemingly inaccessible to a viewer in the store. They are a spectacle, apparently no more real than the video images downstairs in the store's pop-music section. New York City, uptown and down, is filled with displays of art, but they too are spectacles.

The city's galleries and museums appear set apart entirely from the larger urban environment, on which they seemingly make no impact, like the dancers. When the museums and churches of Venice or Rome close, the stroller still finds that those cities are apt sites for the art they contain; an after-dinner walk in Venice will teach one much about Giovanni Bellini. And in 1980s' Paris, for all of its very recent development, one may find images of Hausmann's city as it was depicted by Manet and the Impressionists. New York is *our* seicento Rome and late nineteenth-century Paris, but in this center of our artworld the art itself seemingly exists entirely apart from its larger urban environment. Nor has recent public art changed this situation.

Some tools for understanding these urban experience are provided by a little-known essay published the year after "The Luxury and Necessity of Painting" by one of Stokes's admirers, my teacher Richard Wollheim. Impressionism, he argues, takes an aesthetic attitude toward the city, "so that the sights of industrialization and commerce, the sprawling streets and factories, get treated simply as occasions of immediate and transient pleasure." And then there can be "no recognition . . . of the terrible price that in reality had to be paid . . . for these effects and impressions. . . . It is this that gives the painting, for all its fine sensibility, a kind of cold inhumanity." Impressionism, he argues, treats the modern city as if it were a spectacle—as if, that is, it really was nothing but "a succession of flickering images."[8]

Wollheim did not develop these ideas. Still, what was remarkably prescient in his essay was its anticipation of the highly influential arguments

8. Richard Wollheim, "Babylon, Babylone," *Encounter* 18 (May 1962): 36.

developed at length in two recent accounts describing late nineteenth-century Parisian painting. One is Walter Benjamin's book on Baudelaire, which appeared in English only in 1973; the other is Tim Clark's account of Manet's Paris, one of whose acknowledged sources is Benjamin's study.[9] Wollheim and Clark evaluate the spectacle of the city similarly. Where the former speaks of the "extreme malady" of "convert[ing] one's own day-to-day experience into something like the surface of an Impressionist painting," Clark asserts that in Manet's art things become "all part of the . . . disembodied flat show, the . . . spectacle." This last point is of great importance.

Benjamin and Clark are interested in how the modern city has become a spectacle. That seems an apt word to apply to contemporary New York, so rich in flickering images that, to a traveler at least, seem unreal. Ruskin thought that Turner "could endure ugliness which no one else . . . would have borne with for an instant" because he was attached to his childhood memories of Covent Garden.[10] But even he would, I think, be hard pressed to love much of New York. As a nonresident, however often I return, the city seems overpoweringly brutal in its scale and juxtapositions of wealth and poverty. At night, it lacks any genuine public spaces. The streets function merely as conduits between the private spaces, which are isolated from the street as effectively as is any Roman church or villa when its massive doors are closed for the afternoon.

And yet there is something perversely attractive in its very brutality. As Proust describes Marcel's daydreaming in Paris about his long-awaited trip to Venice, so I often find myself fantasizing about New York, thinking as much about the city's streets as about the art I have seen there. The great retrospectives of Manet and Caravaggio at the Metropolitan Museum, the occasions where, in studios or galleries, I first saw the work of artists who became friends; these memories are linked in my fantasies with images of utterly banal places. It may seem farfetched to compare the corner of Broadway and Houston, with its car wash and panhandlers, often my entry point to SoHo, to the northern entrance to historical Rome, the Piazza del Popolo. But SoHo, Fifty-seventh Street for a block east and west of Fifth Avenue, a few side streets in the East Village, and the seventies and eighties blocks of Madison Avenue seem magical places to me.

9. Walter Benjamin, *Charles Baudelaire: An Epic Poet in the Era of High Capitalism*, trans. H. Zohn (London, 1973); T. J. Clark, *The Painting of Modern Life: Paris in the Art of Manet and His Followers* (New York, 1985), 63.

10. Ruskin, "The Two Boyhoods," in *Modern Painters* (London, 1843–60), vol. 5, chap. 9.

No doubt my enthusiasm for these locales is naïve. Like the Roman who thinks of the Piazza del Popolo, not as the site of the Cerasi Chapel Caravaggios but as a busy intersection, so the New Yorker who daily passes through these places on the way to work will be bemused at my thinking them exotic. And even for the aesthete, Rome is something more than a museum. I recall being distracted from my musings on the Caravaggios as I left the Cerasi Chapel by the sight of a well-dressed man running after the tow truck removing his car, to the great amusement of the populace. "L'objet auquel s'applique une pensée comme celle de Ruskin," one of his disciples wrote, "et dont elle est inséparable n'est pas immatériel. . . . It faut aller le chercher là où il se trouve, à Pise, à Florence, a Venis, à la National Gallery." It is the power of Ruskin's prose, Proust continues, "de nous faire aimer une beauté que nous sentons plus réele que nous, dans ces choses qui aux yeux des autres sont aussi particulières et aussi périssables que nous-mêmes."[11] I came to think of some New York places in this way.

Unlike Venice, New York has not found its Ruskin. Unlike late nineteenth-century Paris, it has, to my knowledge, neither its Zola, a writer who adequately celebrates the vitality and brutality of street life and commerce, nor its Manet, a painter who can picture them. This lacuna may seem surprising, for like the Parisian life that in 1846 Baudelaire found "rich in poetic and wonderful subjects" the New York artworld provides a marvelous array of images waiting to be transcribed.[12] What more apt illustration of what Baudelaire called "the epic quality of modern life" than an opening on West Broadway? What better examples of dandyism, "the last flicker of heroism in decadent ages," than our artists and artwriters who have a "burning desire to create a personal form of originality, within the external limits of social conventions"? What more striking examples for the defense of fashion, that "taste for the ideal that floats on the surface in the human brain, above all the coarse, earthy and disgusting things that life . . . accumulates," than a dealer in a posh gallery with her clients?[13]

If nobody today aspires to thus describe the New York artworld, or to identify the environment of contemporary art—doing what Ruskin does for

11. Marcel Proust, "John Ruskin," in *Contre Sainte-Beuve précédé de Pastiches et mélanges et suivi de Essais et articles*, ed. P. Clarac (Paris, 1971), 138–39.

12. I quote from "The Painter of Modern Life," in *Baudelaire: Selected Writings on Art and Artists*, trans. P. E. Charvet (Harmondsworth, 1972), chap. 15.

13. The artist to whom this chapter is dedicated, known for her *New Yorker* covers and her book illustrations for Leah Komaiko's *I Like the Music* (New York, 1987), is someone for whom I will someday write a catalogue essay. Its title will be "The Painter of Modern Life."

Venice, Stokes for Quattro Cento Italy, or Benjamin or Clark for Baude-laire's Paris—perhaps that is because late modernism is generally thought to have made depictions like these impossible. Today the desire for such representations of art in its environment seems unrealistic. Early modern-ism turned toward abstraction, or, at any rate, away from public subjects; and if images reappear in postmodernism, this revival of representation has been accompanied by the belief that such images refer only to other images, not to the world they seemingly represent. Our art is supposed to be art about art; whatever the validity of this cliché, the very fact that it is so widely believed explains something about the relation of our art to the city in which it is displayed. If John Ashbery be our Baudelaire, the great poet whose words illustrate our shared sensibility, his verse seems to provide less an image of his city (such as Baudelaire gives of Paris) than a demonstration that present-day New York, like the art displayed there, cannot be repre-sented.

Strangely enough, recent artwriters have had little to say about these questions, which interested Ruskin, Stokes, and Benjamin. Apart from a brilliant trio of essays published in *Artforum* in the 1970s by Brian O'Doh-erty, I know of no contemporary American account that seriously discusses this relation of art to its environment. O'Doherty offers an invaluable his-tory of the relation between modernist gallery space, which aimed to isolate its contents from the environment outside, and the city within which those galleries exist. The formalists' claim that paintings should appeal to the eye alone, leaving aside any storytelling, made it possible, perhaps inevitable, that modernist art would find its natural setting in the windowless, white-walled gallery space. The artwork was to refer to nothing outside itself, and so the true environment of a Morris Louis painting or an Anthony Caro sculpture was not the cities in which they were shown but the gallery spaces in which they were displayed. Unlike Manet's paintings, the art of Louis or Caro did not aspire to echo its urban environment.

The error of this account, Barry Schwabsky has suggested to me, is that it situates the artwork in the gallery, not the artist's studio. And indeed, often a studio visit teaches the artwriter more than a trip to the gallery. The gallery, anyway, is merely a temporary location for the artwork, what Schwabsky calls a screen, into which the prospective buyer projects the conditions in which he or she would place that work. But in some ways a collector's home, or a museum, are modeled more after the gallery, with its neutral walls, than the studio. And when the artist shows works in the stu-dio, usually he re-creates in part the visual situation of that clean white

cube. As old-fashioned hanging arrangements like those found in the Frick, the Gardener Museum, or the Barnes Foundation remind us, in many ways the modern studio, gallery, and museum are visually similar.

To understand Tintoretto, we must go to Venice; to grasp Manet's goals, we must imaginatively reconstruct his Paris: but the modernist concern with the self-sufficient artwork foreclosed the possibility of understanding 1960s' New York art in such terms. What O'Doherty rightly observes, still, is that this very attempt to set the artwork apart from its physical setting involved a number of assumptions about the relation of that art to its environment. Paradoxically, the more strenuously modernists insisted that their art was about nothing but art itself, the clearer it became that such painting and sculpture was entirely dependent upon a peculiarly modern system of display, which in turn depended upon the social and political role of the gallery in the modern city. Color-field painting, he correctly remarks, "remained Salon painting: it needed big walls and big collectors and couldn't avoid looking like the ultimate in capitalist art."[14] The environment in which this late modernist art was exhibited deconstructed its claim to be art only about art.

But though modernists thus really were as intimately linked to the environment in which their art is displayed as Tintoretto is to Venice or Manet to Paris, what has changed is that the relationship of their art to its environment is not itself directly picturable. In rejecting the modernist claim that art could just be about art, O'Doherty offers, but does not really develop, a new way of answering my question: How do we understand the relation of contemporary art to its environment? We must now turn from art that provides images of its environment to painting and sculpture whose relation to the city can only be grasped by appeal to a text, a narrative such as he provides. The more recent development of postmodernism shows that this was a pregnant insight.

Most art history and criticism is concerned with the qualities internal to the artwork itself. This is appropriate. Since paintings and sculptures demand sustained aesthetic contemplation, we usually isolate them from other objects, attending to them alone, to the exclusion of what surrounds them. But a rare few writers—Ruskin, Stokes, Clark—are interested in the relation between those modes of attention that we bring to artworks and our experience of the surrounding world. I am not here concerned with studies

14. Brian O'Doherty, *Within the White Cube: The Ideology of the Gallery Space*, reprinted with an Afterword (Santa Monica and San Francisco, 1986), 26.

of patronage or traditional Marxist accounts of the social history of art, but with something much more concrete, the contrast between what might be called aesthetic and nonaesthetic modes of seeing. Even when we do visually isolate artworks from what surrounds them—and that practice is closely tied to the late eighteenth-century creation of the museum—that aesthetic viewing depends upon the contrast with the kind of perception concerned with the everyday practical viewing of the world. When Fry contrasted that "conscious attention" which "must frequently have been directed to spotting and catching the right 'bus" on the way to the gallery with the aesthetic experience we seek there, he made a familiar distinction.[15] Definitions of "the aesthetic" are linked, historically and logically, to this contrast.

Nowadays this very notion of contemplation and belief in "the aesthetic" seem positively antediluvian. Since even critics like myself who dislike the word "postmodernism" cannot avoid using it, I will for my present purposes define it by reference to two trends: the rejection of the purely visual art of modernism in favor of "texty" allegorical art, and the abandonment of the modernist belief in progressive historical development. If an allegory is a text with both literal significance and a deeper meaning, an allegorical image, analogously, is one we can only understand, not just by looking, but by reading the texts that explicate it. The self-sufficient modernist work that unambiguously communicates its meaning with purely visual techniques is thus contrasted to the postmodernist image that is ambiguous, even meaningless perhaps, until accompanied by a text.

I had never understood why such postmodernist art, which offered so little to my eye, attracted so much attention. The answer may be that this art mirrors the streets outside. In a world that itself seems unpicturable, there must be something comforting that attracts collectors who live with such images. The modernist thinks of the purely visual image as the natural historical culmination of the whole tradition of Western painting. The postmodernist rejects this conception of history. In place of the view that language and our sense of lived experience involve a past and a future, we have what Fredric Jameson describes as the "schizophrenic" experience of "a rubble of distinct and unrelated signifiers. . . . If we are unable to unify the past, present and future of the sentence, then we are similarly unable to unify the past, present and future of our . . . psychic life."[16] Aware of neither

15. Roger Fry, "Some Questions in Esthetics," in his *Transformations: Critical and Speculative Essays on Art* (Garden City, N.Y., 1956), 8.

16. Fredric Jameson, "Postmodernism; or, The Cultural Logic of Late Capitalism," *New Left Review*, no. 146 (July–August 1984):72.

past nor present but only what is here and now, the schizophrenic sees the world as a spectacle. Just as after reading Stokes I traveled in Italy to see the Quattro Cento works he admired, so in Los Angeles I parked opposite the Westin Bonaventure Hotel and rode up and down in the elevators while rereading Jameson's text. He claims that they "henceforth replace movement but also . . . designate themselves as . . . emblems of movement proper. . . . A transportation machine . . . becomes the allegorical signifier of that older promenade we are no longer allowed to conduct on our own: and this is a dialectical intensification of the autoreferentiality of all modern culture."[17] That hotel demonstrates that modernism is dead. No longer is it possible, as the modernists thought, to treat contemporary art as the logical development of art's traditions. If by history we understand a sequence of events that can be described in a narrative connecting past and present, then history is at an end.

This account of postmodernist uses of allegory and schizophrenia suggests that now painting and sculpture has a novel relationship to its environment. When Ruskin or Stokes described Renaissance art, and Wollheim and Clark analyzed Impressionism, the environment of this art, the context in which it needed to be placed to be interpreted, was constituted by the *visual* world of those societies. Ruskin tells us of the appearance of Venice in relation to Giorgione's painting; Clark, what Manet and the Impressionists repressed in depicting Paris and the surrounding countryside. But after modernism, it is no longer possible to link art to its setting in this way. The comparable environment of postmodernist New York art, that context which an heir to Ruskin or Stokes should seek to identify, is not given by a visual description of the city in which it is displayed and sold but by the system of *texts* in which painting and sculpture is described. This claim ought, I think, to seem unexpected. Certainly it took me years to understand its implications. What have Ruskin's ruminations about the appearance of Giorgione's Venice, or Clark's account of the cafés, arcades, and suburbs of Manet's Paris, to do with the texts published in *Artforum* that provided a context for our postmodernist art?

According to a long tradition antedating both Stokes's analysis and the modernist belief in the autonomous visual artwork, there is a basic distinction between painting, an art of space, and literature, which represents a temporal sequence of events. This tradition is ended by postmodernism, which claims that what we see in the visual artwork can only be understood

17. Ibid., 82. He consistently misidentifies the hotel as the "Bonaventura."

in relation to some system of texts. Of course, as iconographers remind us, it has often been the case, that only the viewer who brings to the painting sufficient knowledge of texts can identify its content. And there has always been art criticism. But what gives a special role today to that literary genre is that it constitutes the environment in which art is created and perceived. The truly radical claim of postmodernism is that now texts do not simply help the viewer see what is depicted in a work. Today, rather, the visual artwork is incomplete apart from those texts, which thus constitute the environment of the postmodernist artwork.

Often our aesthetic contemplation of works of the past is guided by a text. In present-day Rome or Venice, we walk through a church, guidebook in hand, looking for the baroque ceiling above a quattrocento altarpiece. And any visitor to the Museum of Modern Art in New York knows how skillfully juxtapositions may exhibit some stylistic connections while denying others. If on the second floor we see Matisse's work from 1914, on the third we walk past his *Swimming Pool* to get to the Newmans and Pollocks, which emphasizes how much they learned from late Matisse. Like an inept narrative, a poorly organized museum tells a story that is hard to follow. A carefully hung museum, like a lucid essay, makes its transitions seem effortless.

If the environment of postmodernist art is defined, not by its physical setting but by artwriting, what kind of texts provide that environment? Some postmodernists think that schizophrenic writing marks a liberating break with the conventions of bourgeois writing. Jameson, a Marxist, cannot accept this view. He argues that our present inability to represent a world in which there is a real connection between past, present, and future is to prematurely imagine ourselves come to that end of history which can be realized only after the real historical processes of class struggle have been worked out. But perhaps he is wrong. Maybe art, though not the larger society, has already achieved such a posthistorical condition, coming to the conclusion of its historical development within a culture whose temporal unfolding continues. This is the view of Arthur Danto. "When one direction is as good as another direction, there is no concept of direction any longer to apply." What for Jameson is the condition of schizophrenia, which can find no temporal ordering among events, and so no possibility of historical consciousness, is for Danto liberating. "Freedom ends in its own fulfillment";[18] now, freed from the need to think of itself as advancing historically, art becomes a form of play.

18. Arthur C. Danto, "The End of Art," reprinted in his *Philosophical Disenfranchisement of Art* (New York, 1986), chap. 5.

We can better understand the place of contemporary art in its urban setting by pursuing this debate. Leaving aside political differences, what is at stake is a deep disagreement about postmodernism. Danto calls disturbatory art that "art which seeks to induce a response to . . . mere representations which normally is produced only by experiencing real life events." In visual or written pornography (Danto's neologism "disturbatory" alludes "to its natural rhyme in English . . . masturbation"), "mere charged images climax in real orgasms, and induce a real reduction of tension."[19] He distinguishes disturbatory art from representations of disturbing things, to which we typically respond aesthetically; for us, a sculpted crucifix or a baroque martyrdom are merely representations. If any old-master picture ought to be disturbatory for us moderns it is Caravaggio's *David with the Head of Goliath*. So when Danto asserts that this David "is of the same breed as" Caravaggio's early pinups, "but utterly diseroticized: the flesh is luminous but opaque, the garment exposes his chest but is coarse. Victor and vanquished are locked together by the same mystical light and occupy the same enveloping darkness," then this horrifying image is but a beautiful work of art, a vision of a terrifying scene on which we may safely take an aesthetic distance.[20]

Still, today there are some artworks to which we cannot respond merely aesthetically. Disturbatory art, Danto says, characteristically involves "obscenity, frontal nudity, blood, excrement, mutilation, real danger, actual pain, possible death"; and these are the very qualities essential to one story in which he and I share a certain interest, that pornographic "masterpiece" which, the dust jacket on a recent edition informs us, has become the most popular French novel since *Le Petit Prince*. A reader who seeks such qualities will find them in *Story of O*. No mere artwork, he claims, can be disturbatory; but since it seems fair to claim that nobody can respond to this book merely aesthetically, it is natural to ask why there is today no equivalent visual art.

Of course pornographic photographs are common enough, but within the artworld the postmodernists' claim that all representations are only images of other images means that creating disturbatory art is seemingly impossible. David Salle is usually said to present mere images of women. Only a philistine, we are told by his admirers, would confuse his painted images of nude women with the selfsame images in the magazines sold at newsstands.

19. Danto, *The Philosophical Disenfranchisement of Art*, chap. 6.
20. Arthur C. Danto, "Art," *The Nation* (2 March 1985), 252.

As Jameson notes, today there is very little art that is found socially offensive. The most offensive forms are all taken in stride by society, and they are commercially successful.

And yet, if Danto's account of schizophrenic writing is at all plausible, perhaps we are looking for disturbatory art in the wrong place. What is disturbed is our very sense of self. Schizophrenic writing cannot be a narrative about a subject who knows personal identity in our sense, in the sense that we have when we organize our future, our actions, in relation to our past experience and present circumstances. But where Danto then concludes that it is no longer possible to create disturbatory art, Jameson argues that today art cannot be offensive because in its schizophrenic structure it mirrors all too accurately the larger society. If we cannot perceive that postmodernist art is disturbatory, that is because our public spaces and popular entertainments already are.

The goal of disturbatory art, Danto writes, is to erase the boundaries "between imitation and reality, and the art is disturbing because the reality it releases is itself disturbing."[21] That disturbatory artwork aims to blur the line between "art" and "life," forcing us to refuse to contemplate it aesthetically. Insofar as today no art succeeds in achieving such an effect, there can now be no disturbatory art. But this claim depends upon our capacity to make such a contrast between "art" and "life." Danto's idea that disturbatory art might blur the line between art and life presupposes that artworks are autonomous artifacts, an ideal actually realized, Jameson thinks, neither by art of the past nor by our postmodern art. I have discussed this debate elsewhere.[22] What interests me here is what this analysis suggests about the relationship between art displayed in New York City and its environment.

Ruskin's approach to Venice, Stokes's entry into Italy, and Clark's account of Manet's response to the spectacle of nineteenth-century Paris are relevant, we can now recognize, to my experience as art critic. Failing to understand that today the relation between art and its setting is no longer picturable, as it was when Ruskin described Venetian art in its environment, I imagined that an account modeled on his or Stokes's or Clark's might tell me how to understand that relation. No doubt, my failure was in part explained by the fact that I was still under the spell of Stokes's work, which implied that indeed we should be able to see, literally, the relation between

21. Danto, *The Philosophical Disenfranchisement of Art*, 122.

22. See my review of *The End of the History of Art?* by Hans Belting, *History and Theory* 27, no. 2 (1988): 187–99.

art and its environment. Stokes has never been influential in America, but one of his claims is familiar to Americans. The Stokesian ideal of the carved artwork, entirely open to the eye, is akin to the claim of the American modernists that now visual art becomes an autonomous art form. And whether postmodernism is thus understood either as a break with that Stokesian ideal or as a rejection of this modernist dogma; it renders both accounts obsolete.

Artwriting attempted to make sense of my experience as a critic, to orient myself in relation to the New York artworld. Its argument is that the history of American art criticism in the past four decades marks the development of a novel system, an artworld in which painters, curators, dealers, collectors, and writers all play essential roles. Apart from being a fragment of my bildungsroman, this chapter is both a postscript to that book and a partial reinterpretation of its claims. *Artwriting* was dedicated to Arthur Danto, and its starting point was a critical reflection upon a claim discussed in his *Transfiguration of the Commonplace*.[23] Danto begins with a dramatic example. Warhol's Brillo box in a 1964 exhibition—the origin for his reflections—was an artwork. But placed in a supermarket, the selfsame artifact would be merely what it appears to be, a Brillo box. What makes it an artwork, then, cannot be any inherent physical feature but must be its context; the existence of art depends upon such institutions as the art gallery. For Jameson, too, if the individual literary work can be properly interpreted only by "restoring to the surface of the text the repressed and buried reality of this fundamental history" (the story of class conflict), art cannot be understood apart from its environment.[24] Just as *Artwriting* extends that investigation of contexts one step by turning to the history of American art criticism, so in a different way this chapter takes up the same point. Now the context is extended from contemplating the isolated artwork to placing that work in its urban setting.

In turning from the focus on the isolated artwork to attend to the artworld system, Danto anticipated my present concern, the relation between the gallery or museum and the larger urban environment. In his preface, Danto remarks that the theorizing his earlier writing on art inspired was "quite alien to anything I believe: one's children do not always quite come out as intended."[25] Adrian Stokes has never interested Danto, and so when origi-

23. Arthur C. Danto, *The Transfiguration of the Commonplace: A Philosophy of Art* (Cambridge, Mass., 1981). An updated account appears in his review "Andy Warhol," *The Nation* (3 April 1989), 458–60.

24. Fredric Jameson, *The Political Unconscious: Narrative as a Socially Symbolic Act* (Ithaca, N.Y., 1981), 20.

25. Danto, *The Transfiguration of the Commonplace*, viii.

nally I studied Stokes's works it never occurred to me to think that they could have any relationship with Danto's theories of art. Even in *Artwriting* the connection between the discussion of Danto's work in the Overture and the last chapter seems unrelated to the discussion of Stokes in chapter 3. Like Stokes, with whom I can now acknowledge my identification, I have learned to bring together two parts of my life that until now seemed to exist in entirely separate compartments. In doing that I have come to understand my own book better, and so to my surprise (and perhaps his as well) I now find that Danto belongs with Ruskin, Stokes, Benjamin, Clark, and Jameson, becoming—in this reading of him—one of those rare few writers who have something to tell us about the relation between our experience of artworks and the surrounding urban environment. The lesson they teach is this: All aesthetics constantly aspires toward the condition of social criticism.

Part II

The Theory of Art Criticism in the 1980s

5

Baudrillard as Philosopher; or, The End of Abstract Painting?

Abstract painting has now existed for nearly three-quarters of a century; it is the dominant mode of modern art. Why then, after all this time, is there such skepticism about its continuing viability? Why the relentless attempts by naïve and sophisticated critics alike to allegorize it, reading every horizontal panel as a landscape, every expressive gesture as the representation of feelings from the inner world of the artist? An abstraction refers to nothing, and so depicts nothing. What could be more obvious than the distinction between a representation by Rembrandt and an abstraction by Reinhardt? But maybe that distinction will not survive scrutiny. A naïve way to undermine it is to look for depicted forms in abstract works. Reinhardt depicts a cruciform; Mondrian, a city grid; and Pollock, urban rubbish.[1] Jean Baudrillard's sophisticated, highly influential account argues for the same conclusion.

Like Derrida, Foucault , and Lacan, Baudrillard is a suggestive but maddeningly elliptical writer; and so I first aim to reconstruct his argument. I

1. See E. H. Gombrich, *Art and Illusion* (Princeton, 1961), 287.

introduce one key notion of holism by considering a more accessible writer, Fredric Jameson. In *The Political Unconscious*, Jameson asks: When we read a novel, what is the object that we should analyze? What whole are we studying? A formalist considers only features internal to the novel; a traditional social historian would place the book in the culture of the time. Both assume that the novel is a self-sufficient artifact. According to Jameson, both are mistaken; "the illusion or appearance of isolation or autonomy which a printed text projects must now be systematically undermined." Only in "restoring to the surface of the text the repressed and buried reality of this fundamental history," the story of class conflict, is the goal of criticism achieved. The word "restore" is crucial here, as Jameson emphasizes when he adds that the historical narratives "have inscribed themselves in the texts." For example, his reading of the Victorian novelist George Gissing aims, not to provide a social context for *The Nether World*, but to make explicit how that novel *already* contains such a context. Jameson's other key metaphor makes the same point; in modernism the political is "no longer visible" because it has been repressed, "relentlessly driven underground by accumulated reification [it] has at last become a genuine Unconscious."[2]

What is missing from Constable's landscapes, it has been argued, are the laboring poor who were driven off the land to become the industrial proletariat even as he was painting.[3] Of course, many things are not in Constable's scenes: no reclining Giorgionesque nudes; no trains, as in Turner's *Wind, Steam, Speed;* no decayed medieval churches, as in Caspar David Friedrich. But the significance of the absent laboring rural poor is that their historical role has been repressed by Constable. If this analysis is correct, we cannot accurately interpret Constable's paintings until we acknowledge this fact.

Jameson's holism is easily questioned. Even if we agreed with him that Marxism provides the best, or the only adequate, critical method, why appeal to holism? In a trivial sense, everything is connected with everything else. *The Nether World* describes countryside scenes a viewer of Constable's work could recognize; the cynical politics of Gissing can be contrasted with the views of Turner's champion, Ruskin. But unless we could identify such autonomous objects or artifacts as Gissing's novels and Constable's paintings, how could we interpret them? Jameson's holism makes claims that are

2. Fredric Jameson, *The Political Unconscious: Narrative as a Socially Symbolic Act* (Ithaca, N.Y., 1981), 85, 20, 34, 280.

3. John Barrell, *The Dark Side of Landscape: The Rural Poor in English Painting, 1730–1840* (Cambridge, 1980).

not trivial. For him, the contrast between restoring to Gissing's texts a social reality that was *already* there and placing them *in* a Marxist context is not a distinction without a difference.

Abstract paintings are self-sufficient entities, referring to nothing outside themselves. But if paintings, like novels as interpreted by Jameson, are irretrievably bound up with the social structure in which they are created, then there can be no abstract art. Hal Foster says this: "It is the abstractive processes of capital that erode representation and abstraction alike. And ultimately it may be these processes that are the real subject, and latent referent, of this new abstract painting."[4] A Rembrandt refers to what it depicts; so too, Foster is suggesting, today abstract paintings refer to the capitalist system in which they are commodities. Peter Halley makes an analogous point when he sees the bands in Stella's aluminum works as "like lanes on a highway . . . bands for movement or circulation" or gives his own abstract-looking compositions very literal titles like *Blue Cell with Triple Conduit*.[5] Holism collapses the modernist's distinction between representation and abstraction. Understood holistically, a Stella or a Halley, like any old-master painting, refers to something outside itself and so really is not abstract. These seem very strange claims. Paintings are commodities; but why should they refer to their status? Halley says that his images look like "the simulated space of the videogame . . . the microchip . . . the office tower"; why does that show that his paintings are not abstractions?[6] Paintings would not be valued as such unless they provided aesthetic pleasure. To the extent that the holist's analysis leaves aside this obvious point, it seems irrelevant.

Baudrillard answers all of these questions; the problem is understanding how his analysis can be consistent. When he writes that "truth, reference and objective causes have ceased to exist," is not his account simply self-refuting?[7] If he believes that there is no truth, how can he tell us that? How can he make truthful statements? Similarly, when he offers his three- or four-stage history of representation, according to which truthful representations were once possible but now there can be only simulacra, how, if that claim be true, can it be stated? "Simulacra" is an old, though not widely

4. Hal Foster, "Signs Taken for Wonders," *Art in America* 74, no. 6 (June 1986): 139. On Baudrillard's influence, see Kate Linker, "From Imitation to the Copy to Just Effect: On Reading Jean Baudrillard," *Artforum* (April 1984): 44–47, and John Miller, "Baudrillard and His Discontents," *Artscribe* (May 1987): 48–51.

5. Peter Halley, "Frank Stella and the Simulacrum," *Flash Art* (February/March 1986), 34.

6. Peter Halley, "The Crisis in Geometry," *Arts* (Summer 1984): 114.

7. Jean Baudrillard, *Simulations*, trans. P. Foss, P. Patton, and P. Beitchman (New York, 1983): 6, 83.

used, word. A good ostensive definition is provided in Nabokov's *Ada*, where a woman appears "bare armed, in her petticoats, one stocking gartered . . . loosening her hair in a wretched simulacrum of seduction."[8] A simulacrum is a fake that appears fake. So, to say that only simulacra exist, or that "illusion is no longer possible, because the real is no longer possible," ought to be self-refuting statements.[9] How can Baudrillard's thesis— We live in a world in which no truthful representations are possible—be stated consistently?

A good deal of traditional metaphysics makes such counterintuitive statements: time is unreal; there is no external world; there is no self. Making these claims, some philosophers think, is consistent with showing up on time for a meeting, checking the weather outside, and planning what to do tomorrow. Like metaphysicians, Baudrillard makes claims that seem exciting because they are extreme. "No contemplation is possible," he says.[10] Certainly many gallerygoers do not contemplate, and our crowded museums do not encourage contemplation. But since many of us do contemplate contemporary art, what he offers is less a description of the state of the artworld than a prescription. He is in effect saying, "Soon art will no longer be contemplated," or "Make art that does not demand contemplation." Baudrillard is making a historical point. Once, he allows, there could be truthful representations, but not any longer, not today in this postmodern era. Much of traditional aesthetics makes such prescriptive claims. Roger Fry's proclamation that Sargent is not an artist at all but merely an illustrator seems a strange assertion.[11] Duchamp's readymades are puzzling artworks, but surely Sargent made paintings. But of course Fry's real polemical aim is to argue that Cézanne is a greater painter than Sargent. Analogously, Baudrillard provides a vision, extrapolating from already visible trends, of how future generations will view art of our time. Still, two philosophical problems remain. How can he claim consistently that at one time the real could be represented? That seems to assume that in the Renaissance truthful representations did exist. And, if Baudrillard's thesis is true, how can it be exemplified in paintings? These two problems, we will see, are one.

Here again an example will help. Once an art historian told me that the paintings of an artist he admired were modeled on Bishop Berkeley's phi-

8. Vladimir Nabokov, *Ada or Ardor: A Family Chronicle* (Harmondsworth, 1971), 231.

9. Baudrillard, *Simulations*, 38.

10. Ibid., 96.

11. Roger Fry, *Transformations: Critical and Speculative Essays on Art* (Garden City, N.Y., 1956), 169–82.

losophy. Since Berkeley was skeptical about the external world's existence, the historian reasoned, it followed that paintings depicting an insubstantial, seemingly unreal world exemplified that philosophy. This argument was mistaken. Berkeley held that since we can never know from our representations themselves that what they represent exists, only God's existence guarantees that our representations are *of* the external world. For him, a filmy Monet is no more, or less, real than a robust Courbet landscape. He describes a feature of the relation between images and the world that cannot be represented *in* images of the world. A similar point applies to Baudrillard's thesis. Suppose that our world is unrepresentable. How could that be shown in any representation? Salle's images are often used as illustrations of texts about Baudrillard. But since those texts say that our world cannot be represented, then how can a picture by Salle exemplify that theory?

These problems were anticipated by Nietzsche, whose claim that truth no longer exists is, if correct, seemingly impossible to state.[12] Nevertheless, just as some commentators have found interesting ways of interpreting that claim, so too I think the discussion of holism provides a way of unpacking Baudrillard's paradoxes. His holism leads him to reject two traditional dualisms, Saussure's signifier/signified distinction, and Marx's contrast between use value and exchange value. Saussure says that there are signifiers and what is signified, and so his aim is to explain their relation. What could it mean to deny his signifier/signified distinction? Baudrillard says that Saussure's theory only solves a problem that it itself creates. Having arbitrarily split up language, Saussure then must produce a theory that puts the two back together; the arbitrariness he claims to find in the relation of language to the world is less a fact about language or the world than a function of the way he has chosen to analyze them. "The sign as abstract structure refers to a fragment of objective reality." And the error of Saussure is to fail to comprehend that these fragments can only be understood as part of that whole. Having split what is a whole, he then finds the relation between its parts arbitrary and constructs a theory to explain that fact. In truth, "his 'world' that the sign 'evokes' . . . is nothing but the effect of the sign, the shadow that it carries about."[13]

Now Baudrillard's claim that there is no reality should seem less paradoxical. "Reality" is an abstraction that exists only when we split apart lan-

12. Here I draw on Alexander Nehamas, *Nietzsche: Life as Literature* (Cambridge, Mass., 1985).

13. Jean Baudrillard, *For a Critique of the Political Economy of the Sign*, trans. C. Levin (St. Louis, 1981), 150, 152. His *De la séduction; L'horizon sacré des apparences* (Paris, 1979) extends this argument to feminism.

guage and the world and then ask how they are related. Unless we could split the whole into parts, how could we even think about it? Here Baudrillard makes a further point, one he borrows from the deconstructionists. An opposition such as Saussure's signifier/signified distinction is not simply a neutral analytical tool; it valorizes one of the terms. For example, as many feminist commentators have remarked, in the male/female opposition "female" signifies not just "not male" but, explicitly or implicitly, "less than male." Similarly, Baudrillard says, the deconstructionists' "critique of the primacy of the signified" privileges the sign, leading to "a long sermon denouncing the alienation of the system, which becomes, with the expansion of this very system, a kind of universal discourse."[14]

Baudrillard's criticism of the Marxist distinction between use value and exchange value makes a similar point. "A thing," Marx says, "can be a use value, without having value. . . . Such are air, virgin soil, natural meadows. . . ." A commodity is "a thing that by its properties satisfies human needs of some sort or another." But when commodities are exchanged, "their exchange-value manifests itself as something totally independent of their use-value." The social relation between men, the producers of commodities, thus appears in "the fantastic form of a relation between things," which Marx calls (by analogy to religious beliefs) the "fetishism of commodities."[15] Today, Baudrillard asserts, "use value no longer appears anywhere in the system." Marx's notion of needs is obsolete; as he remarks sarcastically, when Marx compares Robinson Crusoe, alone on his island, to workers in society, he projects into Crusoe's situation the abstractions "of political economy itself, that is the ascension of exchange value via use value."[16] Crusoe, Marx thinks, has needs and is a producer of artifacts, those "objects that form this wealth of his own creation." (Here, in fact, as he explains, Marx himself is being satirical. "Since Robinson Crusoe's experiences are a favourite theme with political economists," he writes, "let us take a look at him on his island.")[17]

This model assumes that needs simply exist, ready to be satisfied, rather than recognizing that they are always a social creation. To imagine Crusoe

14. Baudrillard, For a Critique, 160. This point is not a discovery of the deconstructionists. Freud makes it: "Even in a normal person the higher estimation of one sex is always thrown into relief by a depreciation of the other" (The Standard Edition of the Complete Psychological Works of Sigmund Freud, ed. J. Strachey [London, 1955]), 10:238.

15. Karl Marx, Capital: A Critical Analysis of Capitalist Production, trans. S. Moore and E. Aveling (reprt. New York, 1967), 1:40, 35, 72.

16. Baudrillard, For a Critique, 87, 140.

17. Marx, Capital, 77.

having needs is to treat him as if he were a man already living in society. This point becomes even clearer if we ask which commodities are necessities and which are merely things we have been convinced to believe that we need. We need a certain amount of food, water, and sleep; but an appeal to such biological needs will not take our analysis very far. Many moralizing Marxists are fond of distinguishing between those real needs, which would be satisfied in an ideal society, and needs that are artificially created by advertising. Their accounts rely upon Marx's distinction between the system of production and ideology (the superstructure), a distinction that Baudrillard thinks is now dated. And once we drop the notion of needs, then it is easier to understand the notion that what is manufactured in our culture are signs, commodities that possess exchange value. Perhaps a century ago Marx's analysis had some validity. But today the object of political economy "is no longer . . . properly either commodity or sign, but indissolubly both." When Baudrillard asserts that there is nothing that can "be decoded exclusively as a sign, nor solely measured as a commodity," he refuses to make a distinction that, he claims, the classical Marxist would need. An object such as a refrigerator only "finds meaning with other objects, in difference."[18]

I cannot judge the value of this critique of Marxist economics, but I can explain why it is relevant to art. The art market is a post-Marxist system of exchange. A Renaissance altarpiece served a religious function; an eighteenth-century English portrait showed the status of owners of country houses: but in our society artworks serve no such functions. A generation ago, modernist critics treated painting as engaged in a kind of applied epistemology; Noland's chevrons and Louis's veils, they argued, continued a research project inaugurated by Manet or Courbet. Today, such accounts are no longer plausible. Artworks, nonfunctional objects, nevertheless have exchange value. They have become nothing more than consumer goods, and only self-deception permits us to think that today there can be anything more to art.[19] Traditional aesthetics discussed beauty, art's evolution, and self-expression in art; Baudrillard's philosophy of art is concerned with what he thinks is the only significant remaining question about art, its role in the system of exchange, "that immense process of the transmutation of economic exchange value into sign exchange value."[20]

18. Baudrillard, *For a Critique*, 148, 64.
19. Jean Baudrillard, "The Beaubourg-Effect: Implosion and Deterrence," *October* 20 (Spring 1982): 8.
20. Baudrillard, *For a Critique*, 113.

His account relies upon what might seem an ambiguity in the word "sign." As an old-master work is a sign for what it represents, according to semiotic theories of art, so today an "abstract" painting is a sign that can be exchanged. That ambiguity makes an important point: in the modern art-market nothing matters about an artwork except that it be such a sign. A Rembrandt refers to what it depicts; a Halley refers only to its exchange value. This is why Baudrillard denies that there can be any abstract art. In the art market, all works are signs, objects that refer to their exchange value. Treated as such, artworks are not consumed because they have any intrinsic value or because there is any need that they satisfy or because they serve to legitimate the interests of the ruling classes. Indeed, to ask what function art serves is to make the error that Baudrillard accuses Marx of making, assuming that commodities satisfy needs. Once art satisfied needs; today nothing terribly interesting is learned by asking *what function it serves.* On the other hand, we learn a great deal by studying *how the art market functions.*

That art market is unpredictable; "the rules are arbitrary and fixed, yet one never knows exactly what will happen." There is no relation between supply and demand, nor between cost of production and exchange value. As anyone who has followed a suddenly successful artist knows, the works that one year were unsalable are in heavy demand the next. And yet the expense of producing those works has not changed. Some artists command high prices precisely because they are known to work slowly. But many other equally unproductive figures remain unknown, producing objects that have no exchange value. With old-master art, there *is* a relation between supply and demand. Few Raphaels can appear on the market, and so his works are extraordinarily valuable. When, however, we come to contemporary figures, the identification of a few "contemporary masters" from among so many artists seems highly arbitrary. It is often very hard to explain why certain figures have become famous. In our artworld, the collector counts as much as what he or she collects, for "*the social principle of exchange supports the fetishized value of the object.*" Finally, just as public banks guarantee the funds needed for private speculation, museums make possible the artmarket; "the fixed reserve of the museum is necessary for the functioning of the sign exchange of painting."[21] Some people still appreciate what traditionally were called "aesthetic qualities," but those qualities are important, all things being equal, only for those outside the world of the privileged collectors who control this process of exchange.

21. Ibid., 116, 118 (italics in original), 121.

This account does explain much about the structure of the current art-world and about the nature of some fashionable works. One historically novel feature of our artworld is that the system of production, promotion, selling, and display can be as fascinating as much of the art that it distributes. This was not true in the past. Studies of baroque patronage show that investigating that art market provides only very limited ways of understanding the art of Caravaggio, Poussin, and Bernini.[22] This is why traditional Marxist accounts of art are ultimately so unsatisfying; in general, the social history of art does not teach a great deal about art itself. By contrast, we can learn much about some currently fashionable art by studying the marketing system. Arthur Danto, in a review of a Schnabel exhibition, observes that "the one really interesting question for the future of art . . . is, What will happen to the market when its principles are widely understood?"[23]

Not accidentally, Baudrillard, like Danto, has been heavily influenced by Warhol. Baudrillard believes that art, like immanence and transcendence, "can neither be absorbed into the everyday . . . nor grasp the everyday as such."[24] In Danto's view, some of Warhol's creations are physically indistinguishable from nonartworks. Danto concludes that the history of art thus has ended; Baudrillard asserts that "the value peculiar to the 'work of art' " appears nowhere in the current art market. Warhol's creations are hardly conducive to aesthetic contemplation; their interest *as* art lies in what they tell us about the nature of art.[25]

Baudrillard is concerned with the artworld system, but analyzing it permits him to describe the individual artworks that are exchanged in that system. Suppose it were true that now artworks are only simulacra. What would such art be like? I begin with an example from literature. The traditional naturalistic novel creates a sense of reality by relentless accumulation of details. In this respect, Ian Fleming's James Bond mysteries are but the late descendents of Balzac's works. Fleming's plots are extremely mechanical, all variations on the simple theme of a Manichaean opposition between good and evil. But "what is surprising," a recent commentator notes, "is

22. Francis Haskell, *Patrons and Painters: Art and Society in Baroque Italy* (New Haven and London, 1980).

23. Arthur C. Danto, *The State of the Art* (New York, 1987), 47.

24. Baudrillard, *For a Critique*, 109.

25. But Thomas Crow's account, an exercise in connoisseurship, undermines this view by making subtle distinctions between Warhol's less and more successful works; see his "Return of Frank Herron," in *Endgame: Reference and Simulation in Recent Painting and Sculpture* (Cambridge, Mass., and London, 1986), 26. Danto made similar distinctions in conversation.

the minute and leisurely . . . descriptions of articles, landscapes and events apparently inessential to the . . . story," which covers "the most unexpected and improbable actions" very quickly.[26] Fleming takes time to convey the familiar with photographic accuracy.

By comparison, though Delacorta's *Diva*—source of a well-known film, to which many of my comments also apply—likewise is filled with descriptions of commodities, those objects, and the plot structure, are very different.[27] Unlike Bond, Delacorta's "hero" and "heroine," Gorodish and Alba, are not good figures; though pitted against evil men, they themselves are essentially amoral. (The book is clearer about this point than the movie.) Bond is an old-fashioned seducer; Alba and Gorodish have an erotic, but seemingly precoital, relationship. Delacorta treats violence and sadism as he treats commodities; he discusses them without lovingly dwelling on details. *Diva* is filled with the names of operas and compositions for classical piano; record companies; cars, trucks, and motorcycles; hotels; movies; pianists; newspapers; Paris stores; and, most especially, recording equipment. And yet they do not make the story more real, as in a classical novel. In part, they ingeniously relate the content of *Diva* to its "form." The story is about an illicit recording of a soprano who refuses to make records, and its subplot involves the exchange of a purloined tape of her performance with another containing a "truthful" record of a criminal's career; Poe's "Purloined Letter," another narrative about such exchanges, is straightforward by comparison.[28]

Diva thus is the converse of a James Bond novel. The plot is complex; the distinction between good and evil is blurred; and the "name-brand" references both place the story in "reality" and make it seem inherently unreal. Fleming's novels involve relatively straightforward reworkings of classical myths—the virtuous warrior, the wicked enemy, and the fatal woman all reappear in modern dress. Delacorta's novels appropriate the shells of myths or well-known works (his *Nana* is a take-off on Zola's classic) while refusing to provide even the illusion that the reuse of those forms commits the reader to belief in the reality of his fictional characters. We might apply to his novels Baudrillard's comment: "Here the referent is only 'symbolic,' the principle of reality having passed over into the code."[29]

26. Umberto Eco, *The Role of the Reader: Explorations in the Semiotics of Texts* (London, 1981), 165, 167.

27. See Fredric Jameson, "On *Diva*," *Social Text* 6 (1982): 114–19.

28. See the complex commentaries by Lacan, "Seminar on 'The Purloined Letter,' " *Yale French Studies* 48 (1972): 39–72, and Derrida's response, "The Purveyor of Truth," *Yale French Studies* 52 (1975): 31–113. A discussion of *Diva* drawing on this debate would be illuminating.

29. Baudrillard, *For a Critique*, 162 n. 21.

A strikingly similar comparison can be made in the visual arts. The older literature on Lichtenstein identifies his sources and discusses modifications of them, as if he, like Rubens, depends upon such modifications of earlier imagery. "Lichtenstein has found his content in a fresh examination of the shocking new commonplaces of modern experience that had previously been censored from the domain of art; and in that tradition, he has suddenly rendered visible what familiarity has prevented us from really seeing."[30] Whether he uses cartoons, advertisements, Loran's book on Cézanne, works by early modernists, or abstract-expressionist brushstrokes, he always flattens and simplifies; in his style, a Picasso equals a cartoon equals an advertisement. The contrast of Salle with Lichtenstein is revealing. Salle's diptychs float representational images alongside and/or in front of abstract backgrounds; and the "content" of his images is both regressive, when he uses "bad drawing," and more threatening. Lichtenstein stands to Salle as do the James Bond novels to *Diva*. Baudrillard's works suggest a way of understanding that development. Lichtenstein can paint a picture of any picture in his style, for his sources are always identifiable; Salle shows images whose provenance is as mysterious as it is unrevealing. "My work is about 'no world' in painting."[31] Like Fleming, Lichtenstein dwells in loving detail on commonplace commodities, his detail compensating for the banality of the plot devices by which these things are transfigured into art. For Salle, as for Delacorta, popular and art-historical references function less to refer to real things than to constitute deliberately unreal artworks.

The word "represent" has an ambiguity on which Baudrillard often plays. As a naturalistic picture represents its subject, so a member of Congress represents her constituents. To say that no representation is possible is both to claim that no images can depict what they show and that the public's will is unrepresentable. "Tests and referenda," Baudrillard says, "are . . . perfect forms of simulation: the answer is called forth by the question."[32] Surveys of public opinion do not give any knowledge; they show, rather, that the answers received depend upon the questions asked. Just as there are no needs independent of what consumers have been trained to desire, so there is no independent public opinion apart from what the public is taught to think. The assertion that no visual representation is possible is part of

30. J. Coplans, ed., *Roy Lichtenstein* (New York, 1972), 135–36.

31. Quoted in Rosetta Brooks, "From the Night of Consumerism to the Dawn of Simulation," *Artforum* (February 1985): 77.

32. Jean Baudrillard, *In the Shadow of the Silent Majorities . . . or the End of the Social*, trans. P. Foss, P. Patton, and J. Johnston (New York, 1983), 31; Baudrillard, *Simulations*, 117.

Baudrillard's puzzling metaphysics. Would he deny that his passport photo represents him? Surely in everyday life he, like all of us, must use such representations. He is really making a political point: no image can do justice to the irrationalities of our society.

Hal Foster is a very intelligent artwriter, and so his desperately misconceived, hopelessly failed attempts to place Baudrillard's account within his own late-Marxist framework are very revealing. As Harold Bloom has noted, nothing is more edifying than the spectacle of a strong misreading, which is what Foster provides when, in an essay filled with references to Baudrillard, he asks how criticism can "re-apprehend in the (historical) work of art the revolutionary conflicts (between sign systems and ultimately perhaps between classes) that the work of art resolves"; he wants "art to expose rather than reconcile these contradictions . . . indeed to intensify them."[33] But Baudrillard says (How much more explicit can he be?) that "modern art . . . is exactly an art of collusion vis-à-vis this contemporary world. . . . It can parody this world, illustrate it, simulate it, alter it; it never disturbs the order, which is also its own." He adds that "the masses . . . are given meaning: they want spectacle . . . they idolise the play of signs."[34] Contradictions are precisely what cannot exist in the world as Baudrillard describes it (though conflicts can), because that supposes that there is some "reality" outside the system of representations of reality. Ironically, elsewhere Foster gets the essential point exactly right: signs "make meaning and produce value in differential relation to other signs, not as human expression or representations of things in the world—not in relation to the referent (or, finally, to the signified)."[35] So why does he think that anything exists outside this system of signs?

An example will make Foster's problems clearer. Barbara Kruger claims to analyze signs critically, and so, when she recently moved to Mary Boone's gallery, the Sunday *New York Times* asked: Can her art remain genuinely critical? Is she still a radical feminist? I think that she has moved from a good store to a better store; just as gifted Marxist literary critics deserve prestigious chairs at good universities, so the artists who attract attention, whether they be radical feminists or Schnabels, will be represented by the

33. Hal Foster, *Recordings: Art, Spectacle, Cultural Politics* (Port Townsend, Wash., 1985), 179. For Baudrillard, the only escape from "the system" lies in terrorism, which can "deny all the institutions of representation" (*In the Shadow*, 54); but its ultimate effect, he says, is but to reinforce the status quo.

34. Baudrillard, *For a Critique*, 110; Baudrillard, *In the Shadow*, 10.

35. Foster, *Recodings*, 173.

best galleries. Just as only well-endowed universities can afford the famous Marxist critics, so only the most successful galleries will represent the most famous radical feminists. It is absurd to claim that Kruger can be a radical feminist if she is at a good gallery, but not at Boone; as absurd as arguing that a Marxist literary critic could be a radical so long as she was an associate professor at a state university, but not when she won promotion and moved to Yale. To his credit, Foster anticipates this situation. Since Kruger's work is celebrated, "it has had to be reflexive . . . her recent pieces are concerned as much with the economic manipulation of (her own) art as with sexist subjection."[36]

Baudrillard's writings suggest one way of understanding this situation. Understood allegorically, critical art is like those Communist societies whose existence serves to criticize bourgeois capitalism. Here we return to Jameson's holism; the history of art cannot be understood apart from the society in which it is created. The history of modernism is the story of such radical criticism of the existing order. When Foster asserts that some progressive works "recall a repressed or marginal sign-system in such a way as to disturb or displace the given institutional history of an art or discipline," he offers but a variation on a theme (circa 1965) of Michael Fried, who got from the political writings of Lukács and Merleau-Ponty the ideal of "perpetual revolution—perpetual because bent on unceasing radical criticism of itself"—realized, however, not in politics but in modernist painting.[37] In 1965, American political radicals could find alternatives to their society: as the USSR captured their fancy in the 1930s, so then Castro's Cuba, Mao's China, or Ho's Vietnam were, it seemed, alternatives to capitalism. Today that is no longer true. This is not to say that capitalism has solved its problems or improved the quality of everyday life, but simply to observe that just as for Baudrillard there is nothing outside our sign systems, so these former Communist countries are no longer outside the capitalist world.

Baudrillard's interpretation of the 1960s is bizarre, but not implausible. The Vietnam War marked what he describes as "the advent of China to peaceful coexistence"; further, "when finally the war passed from the resistance to the hands of regular Northern troops, it could stop." Once alternatives to the dominant order had been liquidated, it mattered not whether Americans or North Vietnamese ruled. If we are holists, this account— which would surely scandalize Jameson—implies that the concerns of the

36. Ibid., 115.
37. Ibid., 123; Michael Fried, *Three American Painters* (Cambridge, Mass., 1965), 8.

SoHo-centered artists, so seemingly parochial in the context of world politics, can only properly be understood in relation to that whole. Politically critical art is possible only when critical politics is possible. When there is no real ideological opposition between capitalist America and post-Maoist China, though those states have conflicts, there is no real opposition between the conformist art of Schnabel and the radical art of Kruger, which coexist in the art journals, prestigious collections, and our museums. Political radicalism is but a variation on what Baudrillard denounces as "the nostalgia for a natural referent of the sign . . . in spite of the revolutions that have come to break up this configuration."[38]

Abstract art can exist only in a society in which the development of art is relatively autonomous, relatively independent of the art market. Greenberg described these social preconditions for the creation of abstract art while arguing that art can evolve independently of the larger society. His analysis was convincing where the art market for contemporary art was undeveloped. But now the belief in the self-sufficient development of art is no longer acceptable. By definition an abstract painting refers to nothing outside itself; abstract paintings are signs that are *not* part of some larger code. Now such signs can no longer exist—there can be no more abstract art. A semiotic theory of art treats the elements within the work as signs, indicating how they refer to what that work represents. For Baudrillard, the entire artwork is the sign. And though this nontraditional usage may be puzzling, it is not necessarily inconsistent. For what counts as a sign depends upon conventions. And in the present art market what is exchanged is the artwork as sign.

This argument is grounded in the holistic theory that I sketched earlier. For the holist, everything is connected with everything else—in Baudrillard's terms, every sign is part of the sign system. And the inevitable consequence is that there can be no abstract art. An individual painting seems to be a self-sufficient object. Yet just as (if Jameson is right) Gissing's novels and Constable's paintings are incomplete until related to a larger whole, the society in which they were produced, so too an individual abstract painting is incomplete until placed in its social context. This counterintuitive claim will seem more plausible if we note how, in more mundane ways, we all sometimes adopt holisitc views. An individual work is part of the artist's oeuvre, and that oeuvre is comprehensible only within its historical context. Often, without some text to guide us, we literally cannot know what we are

38. Baudrillard, *Simulations*, 67–68, 86.

seeing. Baudrillard's radical extension of these commonplace holistic ideas can be defended by observing that the theorizing of the great modernist theoreticians—Greenberg and Fried—no longer is accepted, and has not been replaced by any other master-narratives, historical accounts that place the development of postmodernist abstraction in relation to the history of art.

I do not believe that this suggestive theory gives the only possible account of art today. Because Baudrillard interests influential critics and artists, his interpretation is worth discussing. But that it is worthwhile does not show that other interpretations are not possible. Ironically, his partisans share the belief with their modernist precursors that there can be such a uniquely correct interpretation. Since plausible, opposed interpretations of Piero's paintings are possible, why should not the same be true of contemporary artworks? When Baudrillard says that now "signs refer no longer to any nature, but only to the law of exchange," he offers one interpretation of contemporary paintings.[39] Just as methodologically conservative art historians criticize readings of Piero's pictures that find them full of symbols, so I will criticize this position. Unlike Baudrillard, I am a relativist about interpretation; more than one good reading, experience teaches us, is usually possible. Ironically, Baudrillard's own account could but gain in strength from recognizing this point.

Although I do not accept the fashionable views of the postmodernists, I do grant one of their claims: the end of modernism has been marked by the demise of master-narratives. When it was possible to trace the development from old-master art to the self-consciousness of early modernism, and to continue that genealogy to describe cubism and Pollock, abstract painting had an identity because it had a place in that master-narrative. The trouble with this formalist master-narrative is that it tells a story that seems to end with the generation of abstractionists that came after Pollock. And although, on reflection, we recognize that the end of that story about painting by no means implies the end of painting, so strong is the influence of such historical narratives on our thinking that it is natural to ask how the development of art can continue when our story about its development has ended. What postmodernism centrally involves, I believe, is neither the creation of radically new forms of art nor the existence of a very different postindustrial society, but the loss of effective art-historical narratives. So influential are theories for our thinking about art that we confuse the mere end of a nar-

39. Ibid., 86.

rative with the end of art's history as such. On reflection, this confusion should not seem absurd. Just as it is disorienting to be in a strange city without a map, so it is hard to think about history without some master-narrative. Until we construct one, history perhaps is unthinkable. Since postmodernism involves the idea that now everything is possible, it should be no wonder that the lack of such a conceptual map might be disorienting.[40] There is a historically important precedent for this situation, and we may learn something about our situation by considering it.

Vasari's *Lives* provides a simple, highly convincing, and convenient theory of the development of art from Cimabue to his own time. The history of art consists in the gradual perfection of the techniques of naturalism. Vasari provides a master-narrative in which Giotto, Masaccio, Raphael, and Michelangelo all take their places. But in his story, art's history came to an end with Michelangelo, and so it was very hard to see what could come next. If anything, Vasari's model—which identifies four stages in art's development, "birth, growth, age and death"—implies that the next stage could only be another cycle of decay and rebirth.[41] This was why artists after Vasari lost interest in theories of art; Caravaggio and the Carracci could not be fitted into his historical model.[42] Obviously their art was different from that of Vasari's hero, Michelangelo, but Vasari gave later theorists no way of constructing a narrative linking their painting to earlier art or identifying its novel features. Only in the late nineteenth century, when Wölfflin developed his contrast between the classical and the baroque, was there an adequate master-narrative giving a conceptual order to this period.

Our present situation, I am suggesting, is analogous to that of Roman artists circa 1600. There is great abstract painting, but no adequate theory of this art. Until a convincing narrative explains how present-day abstract artists develop further the traditions of earlier abstraction, Baudrillard's account, which implies that no such tradition can exist, will—by default—be influential. One interesting question is why no convincing alternative has been provided. Another, why Baudrillard's Nietzschean nihilism is so attractive to so many people, who seem to have a real need to believe that the

40. This claim has been argued for repeatedly by Hayden White, most recently in his *Content of the Form: Narrative Discourse and Historical Representation* (Baltimore and London, 1987).

41. Giorgio Vasari, *The Lives of the Painters, Sculptors, and Architects*, trans. A. B. Hinds (London, 1963), 1:18.

42. See Denis Mahon, *Studies of Seicento Art and Theory* (London, 1947). As art of antiquity went through these four stages, so, Winckelmann concluded, the same would be true of "modern art"; and, for him, the art of the baroque marked just such a decline. I discuss his account in my *Principles of Art History Writing* (University Park, Pa., 1991), chap. 6.

end of history is at hand. It may be relevant to observe that just as popular interest in Nietzsche developed at the same time as early modernist abstraction, so now Baudrillard's work is seductive when the tradition of abstraction is under attack. A Nietzschean explanation of his popularity can appeal to *On the Genealogy of Morals*. We can no longer believe in truth, Nietzsche wrote, but since we cannot abolish the will—in my terms, our need to interpret, to narrate—we "would rather will *nothingness* than *not* will."[43] Today, it seems, many people would rather accept Baudrillard's nihilism than admit that we have no theory of art at all. To believe that we live in a world that is unrepresentable is strangely comforting, for at least that provides some way of structuring our experience.

If Nietzsche, like Marx and, to some extent, Freud, did not apply his critique of civilization and morality to art also, that (as we can now see) is only because it has taken a century to fully work out the logic of his argument. As Baudrillard says, "Although Marx's thought settled accounts with bourgeois morality, it remains defenseless before its esthetic . . . [it] inherits the esthetic . . . virus of bourgeois thought." But today art can no longer be placed in the superstructure, safely isolated from the system of production. What is seductive about holism is that it provides a framework in which everything is meaningful. But apart from his nihilism, which not everyone can admire, the obvious weakness of his holism is that Baudrillard makes empirical claims that often are not obviously correct. "The fact that there are two" towers in the World Trade Center, he says, "*signifies* the end of all competition, the end of all original reference."[44] For all I know, there is some mundane reason, having no obvious link with deep changes in the nature of capitalism, why there are two towers. I have not questioned an architect, but neither, so far as I know, has Baudrillard.[45] Similarly, his vision of a society in which public opinion can play no real role is not obviously compatible with actual political life. Nietzsche was widely admired early in this century less because his claims were critically evaluated and judged plausible than because many people found his writings to be immensely suggestive. Similarly, Baudrillard is less a philosopher who offers arguments than an *écrivain* who expresses feelings that are "in the air." Indeed, as we

43. Friedrich Nietzsche, *On the Genealogy of Morals*, trans. W. Kaufmann and R. J. Hollingdale (New York, 1967), 163.

44. Jean Baudrillard, *The Mirror of Production*, trans. M. Poster (St. Louis, 1975), 39; Baudrillard, *For a Critique*, 114.

45. On the architecture, now see a discussion taking up just this point; Wayne Andersen, *My Self* (Geneva, 1990), 142–43.

have seen, the result of Baudrillard's holism is to discourage the very idea of analysis. And yet, just as the philosophers Arthur Danto and Alexander Nehamas have found in Nietzsche's writings a philosophy, so my goal has been to identify and evaluate Baudrillard's arguments.

Baudrillard's analysis is less a description of our artworld as it is than a prescriptive account, a description of an artworld in which there is no contemplation and where artworks have value only insofar as they are commodities. One man's prescription is another's nightmare; for me, nothing could be more repulsive than an artworld that Baudrillard's theory accurately describes. This must seem an ironical conclusion, since in many ways the closing argument of my *Artwriting* is—I now recognize—uncannily Baudrillardian. For me, in any event, the ultimate value of his analysis is to project with nightmarish consistency a vision of art that I find repugnant. In that sense, even Baudrillard's bitterest critics are indebted to his working out of this extreme position. Speaking of the artists influenced by Baudrillard, Sean Scully has said: "We have geometry in the painting that is very aggressive. And a surface in the paintings that is completely empty. It's like food that you can't live on. . . . Neo-Geo paintings . . . are not abstract paintings. They are simulations of abstract paintings. The notion of transcendence doesn't exist."[46] I agree entirely. At the same time, I recognize that what is called for by those who reject Baudrillard's vision is not moralizing, but the construction of an alternative interpretation.[47]

46. Quoted in *Sean Scully/Harvey Quaytman* (Helsinki, 1987).
47. I am indebted to Arthur Danto, David Reed, and Nicholas Wilder for discussion of these issues.

6

The Fake Artwork in the Age of Mechanical Reproduction

Accustomed to realizing the Distant (in space and in time) through almost "carnal" reproduction, how will the average American realize the relationship with the supernatural?

— *Umberto Eco*[1]

This chapter was originally published as "Le opere d'arte false nell'era della riproduzione meccanica" in the catalogue of a 1988 exhibit, in Florence, organized by Aldo Rostango. (Umberto Eco, Jean Baudrillard, Federico Zeri, and various other French and Italian commentators also contributed essays.) The exhibit, which contained modern reproductions of works from Cimabue to Morandi, did not indicate on the wall labels that these were copies, and so some tourists probably gained the impression that they had stumbled upon a wholly unexpected group of masterpieces.[2] In an odd way, my examples anticipate the problem of these tourists: How is one to respond to an exhibition of copies? My goal was to introduce the arguments of analytic philosophy to an Italian public, as I imagined it, showing that the concerns of Danto and Goodman are not so distant from those of Benjamin, Sartre, and Heidegger as they sometimes seem.

1. *Travels in Hyper Reality: Essays,* trans. W. Weaver (New York, 1987), 53.
2. I did not see the show. My remarks here draw on Mary Davis Suro, "Counterfeiting of Old Masters Provokes Outrage in Florence," *International Herald-Tribune,* 29–30 October 1988, an account based in part upon a telephone interview with me.

* * *

The Metropolitan Museum of Art unfurls its banners above the main entrance, and a new exhibition opens. Recently they've shown Manet, Caravaggio, and van Gogh; this year it's . . . well, someone equally exciting. I have anticipated the show and have read up on the artist; how exciting it is to see all these works gathered together. If the crowds are so thick that I must push our way to the front, well, that's part of the excitement. In the last room, however, on the far wall just before the shop selling catalogues and reproductions, there is a small notice: "Due to difficulty in arranging loans, all of the works in this show are copies."

I feel dreadfully disappointed. Maybe ignorance is bliss; had I not read that notice, I would have gone away fulfilled. As it is, I feel cheated. Is my reaction justified? Since I admit that I couldn't tell these very good copies from the originals, why isn't viewing them as good as seeing the real things?

The Metropolitan arranges another show. The first room contains two paintings, one an original and the other a very good copy. The former leads to the show of genuine works, the latter to the exhibition of fakes, and I can choose to see only one of these shows. Fair enough: those who know enough to tell an original will see the show of originals; those who don't will know that they won't know the difference between originals and good copies. Since exhibitions are overcrowded, this is a good way of making the paintings easier to see. At this show, there is no notice on the wall in the last room of fakes indicating that they are fakes.

Still, I feel that something is wrong. Is my reaction justified? I may fear that I have missed seeing the works I came to look at. But either I have been able to identify the originals, in which case I have seen only authentic works, or I cannot tell copies from originals, and so have missed nothing. What difference does it make whether I saw the originals or the copies?

Imagine that the Metropolitan arranges this exhibition differently. After going through one show, if I am unsure whether I have seen the genuine works I can walk through the other show as well. Now I have seen the genuine paintings and, also, some very good copies. Once again I feel uneasy. I do not know which paintings are genuine. Why am I so hard to please? I cannot complain that I may have missed the genuine paintings. If I still cannot tell them apart from the copies, why do I feel dissatisfied? I would be happier, I feel, knowing which show contained the originals. Why? These simple-sounding questions are not easy to answer. Copies have been discussed both by American-type analytic philosophy and by Continental-style Marxist aesthetics. Usually these approaches are so different that an-

alytic philosophers can barely comprehend what their Marxist comrades say, and vice versa. But seeking answers to these questions points out some important, unexpected connections between these different philosophical traditions.

Two decades ago the analytic philosopher Nelson Goodman presented an argument that has been much discussed in English-language aesthetics.[3] He proposed a thought experiment. Consider an artwork and a very good copy that, when placed side by side, are impossible to tell apart. If we cannot now distinguish between them, why should we value the original more than the copy? He then made a basic distinction between arts such as painting, where there can be forgeries, and arts like the novel, where there cannot. I am perhaps unable to tell merely by looking whether the panel before me is Caravaggio's *Basket of Fruit* (Ambrosiana, Milan) or a very good copy without knowing its history. But only that object physically made by him is the real work. By contrast, any text of *La Storia: Romanzo* with the right words in the right order *is* Elsa Morante's novel, whether it be printed, photocopied, or handwritten in black, blue, or red ink. Her novel cannot be forged. Goodman's distinction between what he thus called autographic and allographic arts, which he uses as the basis for a far-reaching semiotic theory, points to the different relation visual artists and writers have to their creations. Allographic artworks can be copied because they possess what he calls a notation; Morante created a sequence of words that can be reproduced. Because autographic artworks lack a notation, a genuine Caravaggio painting or Morandi print can only be identified by knowing how they were made by these artists. Autographic artworks can be forged.

Many philosophers argued with Goodman in unconvincing ways.[4] Some suggested that if we looked closely enough with a magnifying glass we could always tell an original from a copy; others, that if we could observe no difference between copy and original, then we should accept the copy as an equivalent. Still others argued that even if we cannot detect forgeries, what is wrong is that they leave us with the feeling of being cheated. These discussions missed Goodman's crucial point, the distinction in kind between autographic and allographic artworks. Even if we cannot tell *Basket of Fruit* from a very good copy, that visually indistinguishable object is still a forgery; and making such a copy takes skill. But anyone with paper and pencil, or a photocopier, can produce a copy of Morante's novel.

3. Nelson Goodman, *Languages of Art* (Indianapolis and New York, 1968), chap. 3.
4. See *The Forger's Art*, ed. D. Dutton (Berkeley and London, 1984).

The next real advance occurred thirteen years later, when Arthur Danto gave an unexpected answer to Goodman.[5] Since Andy Warhol's *Brillo Box* (1964), he observed, was visually indistinguishable from a Brillo box in the grocery, there need be no visual difference whatsoever between an artwork and a nonartwork. And now the lesson of Duchamp's readymades became apparent: *Fountain* was a urinal; by choosing it, Duchamp made it into an artwork. Roberto Longhi and his fellow connoisseurs debated whether the genuine Caravaggio *Boy Bitten by a Lizard* was that painting now in the National Gallery, London, or the version owned by Longhi. But such close scrutiny is not how we distinguish between the artwork *Fountain* and a replica of that porcelain utensil. There need be no visual difference between them because Duchamp's goal was to demonstrate that anything could be an artwork.

Danto is not arguing against the importance of connoisseurship or rejecting Goodman's distinction between autographic and allographic arts. He is urging that the acceptance of the readymades as artworks shows that no theory defining art by reference to its visual qualities can be successful. Now a long tradition of aesthetics comes to an end. Until early in this century, it seemed that a visual artwork must represent something. Early modernists showed that an artwork might use totally abstract expressive images. The more radical move came when Duchamp, and then Warhol, recognized that any object whatever could be an artwork, playing the same role in our museums as do traditional representative or expressive works. Now the history of art is over, which is not to say that artworks of all sorts (including representational works) will not continue to be made, but that it will no longer be possible to believe that new works advance the development of art. Vasari thought that Michelangelo depicted the body more accurately than Giotto; Gombrich, that art from Giotto to Constable involved more accurate illusionism; and Greenberg, that modernist abstraction achieved a self-consciousness about the medium of painting unavailable to the old masters. None of these theories of art's evolution extends into this time of what Danto calls our "post-historical era."

The tradition of analytic philosophy within which Danto works is distant from Marxism, even if, as Danto has noted, his analysis is a variation on a theme by Hegel. Walter Benjamin's essay "The Work of Art in the Age of Mechanical Reproduction" has attained something of a canonical status among contemporary critics influenced by Marxism; and so, not surpris-

5. Arthur C. Danto, *The Transfiguration of the Commonplace* (Cambridge, Mass., 1981).

ingly, the well-known American artwriter Rosalind Krauss has used it as the staging point for an attack on Danto's claims.[6] Photography is not just a new artistic medium; it changes "both the meaning of art and its use." The result of mechanical reproduction is to "change, historically the conditions of the work of art," placing it in "relationship . . . to the processes of commodification." Now the very notion of creativity is changed. "As we have constantly been reminding ourselves ever since Walter Benjamin's" essay, she writes, "authenticity empties out as a notion as one approaches those mediums which are inherently multiple."[7] Or, as Benjamin puts it, "for the first time in world history, mechanical reproduction emancipates the work of art from its parasitical dependence on ritual," that is, from its religious function or from the successor of that function, "the cult of beauty." Now, "instead of being based on ritual, it begins to be based on another practice—politics."[8] It is essential, then, that the readymade, like the photograph, is a mechanically reproduced object. *Fountain* or *Brillo Box* can be artworks only when traditional notions of artistic originality are no longer relevant. Duchamp's work "is not intended to hold the object up for examination, but to scrutinize the act of aesthetic transformation itself. . . . Because maker and artist are evidently separate, there is no way for the urinal to serve as the externalization of the state or states of mind of the artist as he made it."[9]

The painter who continues to make paintings by hand is a reactionary who refuses to acknowledge that the ways by which artworks are made have changed radically. Handmade images are replaced by mechanically reproduced images; as Benjamin says, "for contemporary man the representation of reality by the film is incomparably more significant than that of the painter" (234). Danto's error, not unexpected in a philosophical tradition that Marxists criticize for being apolitical, is to fail to recognize that a change in the nature of art thus reflects changes in the system of production. One limitation of *Art and Illusion*, Gombrich's critics have noted, is that it discusses the end of the history of naturalistic painting without any explicit reference to photography, as if that history merely reflected a devel-

6. "Post-History on Parade," *The Nation*, 25 May 1987, 27–30.

7. Rosalind E. Krauss, *The Originality of the Avant-Garde and Other Modernist Myths* (Cambridge, Mass., and London, 1985), 152.

8. Walter Benjamin, "The Work of Art in the Age of Mechanical Reproduction," in *Illuminations*, trans. H. Zohn (New York, 1969), 224. Further references to quotations from this essay will be cited parenthetically in the text of Chapter 6.

9. Rosalind E. Krauss, *Passages in Modern Sculpture* (New York, 1977), 80; Krauss, *Originality of the Avant-Garde*, 259.

opment within art. One omission of *Art and Culture,* Greenberg's critics have observed, is that it discusses the birth of modernism without any reference to photography, as if the development of abstract art had nothing to do with the rivalry between painting and photography. Analogously, Krauss is saying, Danto's argument fails to acknowledge that culture, the superstructure, reflects changes in the means of production.

As given, this is an incomplete argument, assuming that, because Danto's interpretation of the readymade differs from this Marxist analysis, they are incompatible accounts. I have argued elsewhere that, typically, there can be multiple interpretations of the selfsame artwork; if I am correct, there is no reason that Danto and Krauss cannot offer differing, not incompatible, interpretations of the readymades.[10] Nor is Krauss's account of Danto's position—which is, he tells us, drawn from Kojève's Marxist reading of Hegel—correct. How, then, does the argument of "The Work of Art in the Age of Mechanical Reproduction" relate to Danto's account?

"That which withers in the age of mechanical reproduction is the aura of the work of art." Once artworks were unique originals; with photography we have, rather, "a plurality of copies" (221). Benjamin gives a succession of definitions of an aura. The original has an aura because it is unique. How can we make this point in a way that is neither trivial nor false? To argue, as Benjamin does, that "even the most perfect reproduction" lacks one quality of the original, "its unique existence at the place where it happens to be" (220), is merely to say that a reproduction of Caravaggio's *Basket of Fruit* is not the same object as the original; that nobody would deny. His more interesting argument is that the destruction of the artwork's aura changes our spatial relation to it. Standing near to Caravaggio's painting I remain, still, distant from the artwork; viewing a copy or a photograph changes that sense of distance.

Here both the sacred function of traditional artworks and Proustian ideas about memory are relevant. A sacred work presents the unapproachable deity, "distant, however close it may be" (243). "To perceive the aura of an object we look at means to invest it with the ability to look at us in return."[11] By contrast, an aura-less image is just a thing we perceive. So, a play has an aura, for we are present to an actor who also can perceive us; but a film does not, for the film star is seen by, but cannot see, us. Proust, whom

10. See my *Artwriting* (Amherst, Mass., 1987).

11. Walter Benjamin, *Charles Baudelaire: A Lyric Poet in the Era of High Capitalism,* trans. H. Zohn (London, 1973), 148; see Andrew Benjamin, "The Decline of Art: Benjamin's Aura," *Oxford Art Journal* 9, no. 2 (1986): 30–35.

Benjamin translated and wrote about, makes a fundamental distinction be-tween voluntary memory, which inadequately attempts to re-create a past (remaining always at a distance), and involuntary memory, which abolishes the distance between present and past. When Marcel dips his madeleine in tea, he experiences again exactly the same sensation that he knew as a child. "If we designate as aura the associations which, at home in the *mémoire involuntaire*, tend to cluster around the object of a perception, then its ana-logue in the case of a utilitarian object is the experience which has left traces of the practised hand."[12]

Like involuntary memory, the camera places us so that there is no dis-tance between us and what we experience, exhibiting a "thoroughgoing per-meation of reality with mechanical equipment, an aspect of reality which is free of all equipment" (234). A painting is something we contemplate; "be-fore it the spectator can abandon himself to his associations" (238). Con-templation is impossible when experiencing involuntary memory or viewing a film. And this reflects life in industrialized society: "The film corresponds to profound changes in the apperceptive apparatus—changes that are ex-perienced on an individual scale by the man in the street in big-city traffic, on a historical scale by every present-day citizen" (250). Moving through traffic involves a series of shocks and collisions. Tactile experiences of this kind are joined by optic ones, like those supplied by the advertising pages of a newspaper.[13] Industrialization creates a changed visual environment, the nineteenth-century Paris described in Benjamin's essays on Baudelaire: it is the city of the department store, the anonymous crowd, the Salons, and the new literary forms (the novel, the newspaper) consumed by a mass au-dience. The more recent development of film is merely the logical culmi-nation of all these trends.

The very brilliance of this account has perhaps prevented commentators from approaching it critically; it is helpful to define the historical context of this essay. Benjamin's was not the only view possible within Frankfurt-school Marxism. His friend Adorno criticized the identification of film as a progressive artform; the mechanical reproduction of music with the pho-

12. Benjamin, *Charles Baudelaire*, 145.
13. Ibid., 132; see also David Frisby, *Fragments of Modernity: Theories of Modernity in the Work of Simmel, Kracauer, and Benjamin* (Cambridge, Mass., 1986), 258–63, and Richard Shiff, "Handling Shocks," *New Observations* 47 (1986): 14–19. Richard Wollheim (*Art and Its Objects* [Cambridge, 1980], 175) argues that Benjamin's account would "have been better if he had distinguished be-tween those cases where it is the spectator who assimilates the work of art to its reproduction . . . and the cases where the assimilation is effected by the artist."

nograph might seem an equivalent to the photograph, but it made authentic experience of music even in the concert hall difficult or impossible. "The performance sounds like its own phonograph record. The dynamic is so predetermined that there are no longer any tensions at all. . . . It never arrives at the synthesis, the self-production of the work, which reveals the meaning of every Beethoven symphony."[14]

Benjamin's admiration for film and the detective novel contrasts with Adorno's elitism; and so, not surprisingly, they read Proust differently. Adorno says: "For Proust . . . it is only the death of the work of art in the museum which brings it to life. . . . It is not coincidental that it is something objective, the abrupt act of production in which the work becomes something different from reality, that Proust considers to be preserved in the work's afterlife in the museum. . . . Proust, in his unfettered subjectivism, is untrue to objectifications of the spirit."[15] The end of the artwork's aura, Benjamin argued, means that anyone can be a film star. "The newsreel offers everyone the opportunity to rise from passer-by to movie extra"; even "newspaper boys" become "something of an expert" (231). This Adorno dismisses as "romanticism" — "I very much doubt the expertise of the newspaper boys who discuss sports."[16] He held, rather, that "the sound film . . . leaves no room for imagination or reflection. . . . Hence the film forces its victims to equate it directly with reality."[17]

Benjamin was a very strange Marxist, whose materialism coexisted with his mysticism.[18] Here again, however, his highly personal analysis is less exotic if placed in historical context. His essay "Hashish in Marseilles" demonstrates that "to stress the essential sameness of the technologically rationalized world it is necessary to profile all the remnants of difference within it."[19] He writes: "I saw only nuances, yet these were the same. I immersed myself in contemplation of the sidewalk before me, which . . . could have been, precisely as these very stones, also the sidewalk of Paris.

14. Theodor W. Adorno, "On the Fetish-Character in Music and the Regression of Listening," reprinted in *The Essential Frankfurt School Reader*, ed. A. Arato and E. Gebhardt (New York, 1978), 279, 294.

15. Adorno, "Valery Proust Museum," reprinted in *Prisms*, trans. S. and S. Weber (London, 1967), 182–83.

16. Adorno to Benjamin, reprinted in *Aesthetics and Politics*, trans. and ed. R. Taylor (London, 1977), 123.

17. Martin Jay, *Adorno* (Cambridge, Mass., 1984), 126.

18. Richard Wolin, *Walter Benjamin: An Aesthetic of Redemption* (New York, 1982), 258.

19. Howard Stern, *Gegenbild, Reihenfolge, Sprung: An Essay on Related Figures of Argument in Walter Benjamin* (Bern and Frankfurt am Main, 1982), 69.

. . . These stones were the bread of my imagination, which was suddenly seized by a ravenous hunger to taste what is the same in all places and countries."[20] This epiphany is remarkably similar to the one in *Nausea* in which Antoine Roquentin stares at a tree: "Knotty, inert, nameless, it fascinated me, filled my eyes, brought me back unceasingly to its own existence. . . . I could repeat in vain: it exists, it is still there. . . . *Existence is not something which lets itself be thought of from a distance.*"[21]

This experience that nauseates Roquentin is, in turn, a variation on what Sartre's philosophical master, Heidegger, called the Spatiality of Being-in-the-world: "De-severance amounts to making the farness vanish—that is, making the remoteness of something disappear, bringing it close. Dasein is essentially de-severant: it lets any entity be encountered close by as the entity it is."[22] Modern technologies, he adds, expand this de-severance, whose "meaning . . . cannot yet be visualized."[23]

What, in their very different vocabularies, Sartre is discussing when he talks about "nausea" and Heidegger means when he talks about "de-severance" is what Benjamin experienced when he immersed himself in those paving stones of Marseilles. Stimulated by hashish, he saw the world as if in a movie or in Proustian involuntary memory, its aura abolished. He, Sartre, and Heidegger all make this contrast between things that remain at a distance, however physically close they be, and what (in their different jargons) lacks an aura, is nauseating, or is at-hand. Goodman says a near-perfect forgery may be visually indistinguishable from the original; Danto, that the status of the original is not defined by its visual qualities; and Benjamin, that the forgery destroys the aura of the original.

Danto finds it "striking as a matter of concealed bias on Goodman's part that he should spontaneously have assumed that all *aesthetic* differences *are*

20. *Reflections: Essays, Aphorisms, Autobiographical Writings*, trans. E. Jephcott (New York and London, 1978), 143.

21. Jean-Paul Sartre, *Nausea*, trans. L. Alexander (New York, 1964), 129 (my italics). Without mentioning Benjamin, Danto's commentary on this passage makes this point: Roquentin "recognizes that the distance between the tree and any description of it is hopeless. . . . The tree is logically external to words as words . . . nausea is the vivid pathological symbol of the utter externality between words and things" (Arthur C. Danto, *Jean-Paul Sartre* [New York, 1975], 4).

22. Martin Heidegger, *Being and Time*, trans. J. Macquarrie and E. Robinson (New York, 1962), 139.

23. Heidegger's example of a modern artwork is van Gogh's painting of shoes, described as part of a timeless world totally unconnected with the age of mechanical reproduction: On the leather lies the dampness and richness of the soil. Under the soles slides the loneliness of the fieldpath as evening falls. In the shoes vibrates the silent call of the earth" (Martin Heidegger, "The Origin of the Work of Art," in *Basic Writings*, ed. D. F. Krell [New York, 1977], 163).

perceptual differences." This bias shows that Goodman's analysis lacks a historical awareness: "Certain artworks simply could not be inserted as artworks into certain periods of art history. . . . Duchamp's snowshovel . . . would have been . . . a deeply mysterious object in the thirteenth century; but it is doubtful that it could have been absorbed into the artworld of that period and place. . . . One of the components [that] must be central to the identity of works of art was their historical location."[24] As Krauss writes in arguing—so she mistakenly thinks—against Danto, "art has no essence apart from the specific circumstances of its making."[25] But this point applies also to Benjamin's text, which now, fifty years after it was written, can only be understood by grasping its historical context. In the 1930s Marxists and conservatives alike sought to understand how novel technologies had changed everyday life; in the debate between Benjamin and Adorno it seemed much was at stake. Today, when Brecht's plays are classics and recordings are made of the complete works of Adorno's "difficult composers," Schoenberg and Berg; when Benjamin's chiliastic hopes for a cinema that might, like Kafka's *Amerika*, have a role for everyman seem hopelessly dated: then the terms of the debate have shifted. Now themes from popular culture are prominent in serious art, and there is a large audience for highbrow art. "The simultaneous contemplation of paintings by a large public" in the nineteenth-century Salon, Benjamin argued, "is an early symptom of the crisis of painting" (234). But since that crisis has been going on for a long time, and since ever more museums collect an ever wider range of works, it is hard to believe Benjamin's claim.

This is not to imply that his concept of the aura is useless. Let us return to our opening question: What is wrong with the fake? In his "Art and Disturbation" Danto discusses art that, by being "disturbing in the traditional sense in which it was always open to art to be—namely, through representing disturbing things even in disturbing ways," seeks to escape the boundaries of the museum. His neologism, "disturbatory," identifies the nature of this art by alluding "to its natural rhyme in English, 'masturbation,'" an activity in which, as he puts it, "mere charged images climax in real orgasms and induce a real reduction in tension."[26] He refers to Nietzsche, whose *Birth of Tragedy* describes such a situation, in which the

24. *The Transfiguration of the Commonplace*, 43, 44–45; Arthur C. Danto, *The Philosophical Disenfranchisement of Art* (New York, 1986), xi. See the review by Alexander Nehamas of the latter book, *Journal of Philosophy* 85 (April 1988): 214–19.

25. "Post-History on Parade," 28.

26. *The Philosophical Disenfranchisement of Art*, 119.

spectators see, not "the awkwardly masked human being" on the stage, but rather "in his metamorphosis . . . beholds another vision outside of himself," viewing "a visionary figure, born as it were from their own rapture." Euripides brought "the spectator onto the stage. . . . Through him the everyday man forced his way from the spectators' seats onto the stage; the mirror in which formerly only grand and bold traits were represented now showed the painful fidelity that conscientiously reproduces even the blotched outlines of nature."[27] Who is he, then, but an Athenian Brecht? Abolishing the aura that permitted the merely human actor to play the god, he creates a theater in which everyman can see himself represented.

Disturbatory art, which aims at "restoring to art some of the magic purified out when art became *art*," is for Danto inevitably a failure, "perhaps because I am always outside it and see it as pathetic and futile."[28] What cinematic representations of violence and terror really display, I would add, is not the violence of war or of everyday life but our skill at creating these representations. *Psycho* is for us a demonstration of Hitchcock's skill with montage; *Apocalypse Now* exhibits our filmmakers' creativity in assembling images. Just as Manet could not create real history paintings or religious scenes (his *Execution of the Emperor Maximilian* or *The Dead Christ and the Angels* remain mere demonstrations of his skill as a painter), so there is nothing our filmmakers can show that does not inspire the fatal question for disturbatory art of how it was made. Once what we see at the movies is not blood spurting from the gunman's victims but evidence of the technician's skill; not the irresistible beauty but the actress who played a different role in her previous film: then, it seems, there can be no disturbatory art. Contrary to Benjamin, the destruction of the aura has not produced an art that could bring us closer to reality, an art in which the members of a revolutionary class can "reproduce the world in their own image—in the image that they themselves produce."[29]

Just as, according to formalists, the history of representational art leads to a self-conscious display of the techniques of representation, so, I am suggesting, the history of cinema leads to a self-awareness of the ways in

27. Friedrich Nietzsche, *The Birth of Tragedy* and *The Case of Wagner*, trans. W. Kaufmann (New York, 1967), 66, 64, 77.

28. *The Philosophical Disenfranchisement of Art*, 131, 132–33.

29. Joel Snyder, "Benjamin on Reproducibility and Aura: A Reading of 'The Work of Art in the Age of Its Mechanical Reproducibility,'" *Philosophical Forum* 15, no. 1–2 (1983–84): 143. See also Terry Eagleton, *Walter Benjamin; or, Towards a Revolutionary Criticism* (London, 1981), 25–42, and my "Learning from Walter Benjamin," forthcoming in an anthology edited by Malcolm Gee (Manchester, 1993).

which films give us the illusion of mechanically reproducing reality. What this parallel demonstrates is that one variety of disturbatory art remains possible. Benjamin was pleased that André Malraux discussed "The Work of Art in the Age of Mechanical Reproduction."[30] But whether because it seems a mere popularization of Benjamin's analysis, because Malraux's purple prose is out of fashion, or because his own career from revolutionary to Gaullist is an unhappy reminder of the history of the European Left, Malraux's *Museum without Walls*, unlike Benjamin's work, is now little discussed. This fate is undeserved, for in some ways Malraux is a better guide to the present situation of art than is Benjamin. "Reproductions but increase our esteem for the work," he writes, "because we feel a need to rediscover the . . . real or imagined soul that belongs only to the original"; "to love painting is, above all, to feel that this presence is radically different from that of the most beautiful piece of furniture of the same period; it is to know that a painting . . . is not an object, but a voice." That work has, he adds, "a presence" like that "possessed . . . by a saint to whom one prays."[31] This religious language, like Benjamin's, emphasizes the link between art as such and sacred art; but, unlike Benjamin, Malraux argues that the painting's aura is enhanced by photographic reproductions, which, however closely they duplicate the original, remind us that they are mere copies.

Today, no depicted scene is sufficiently shocking to create the aura that, if Nietzsche is correct, was realized in Greek tragedy before Euripides or achieved, if Benjamin is right, by the sacred images of the old masters. Still, one kind of artifact can achieve what Danto describes as the goal of disturbatory art, taking "off the protective and powerfully dislocative atmosphere of theatrical distance . . . making contact with a reality."[32] But this reality cannot be the reality reproduced in neoexpressionist painting, or in film or television. If, as I think, Malraux is correct, it is the reality of the original artwork. We have a seemingly boundless appetite for originals; not only a sculpture by Michelangelo or a painting by Raphael, but baroque figures hitherto known only to specialists, drawings by minor modernists, or a retrospective of an artist but recently out of art school. These attract us because they show us the originals. Nor do attempts to abolish the notion of originality change this situation, for Duchamp's originals take their place alongside Michelangelo's, and *Brillo Box* is as collectible as a sketch by An-

30. Susan Buck-Morss, *The Origin of Negative Dialectics* (New York, 1977), 287 n. 99.

31. André Malraux, *Museum without Walls*, trans. S. Gilbert and F. Price (Garden City, N.Y., 1967), 233, 232.

32. *The Philosophical Disenfranchisement of Art*, 131.

nibale Carracci. Disturbatory art, though it be impotent to move us by depicting shocking scenes, can still disturb us by demonstrating that artworks still have this quasi-sacred status. Recent experience shows that the effect of mechanical reproduction, contrary to Benjamin's argument, is not to destroy the aura of the original but to confirm its value.

This is why, to return to the examples in my introduction, we find the experience of forgeries disturbing; not because we, like the connoisseur, are worried that the catalogue raisonné might contain mistaken entries, but because the forgery lacks that presence which we attribute to the original. What thus is disturbing about the near-perfect copy is that it attacks this special status that we give the original. How ironic, then, that almost nobody is shocked by the sexuality of *Olympia*, the violence of Caravaggio's *Judith and Holofernes*, or even by the drama of *Crows Over the Wheat Field*, but that everyone would be shocked to discover that museumgoers had not been viewing the originals by Manet, Caravaggio, and van Gogh but near-perfect copies. However earlier generations perceived the content of these pictures, for us they are just artworks. Learning that these three paintings had been replaced by visually indistinguishable copies would be disturbing. How strange, how very surprising that we can respond aesthetically to the content of these pictures, which was intended to be disturbing, but not to the possibility that the images we view might be fake. What Benjamin could not anticipate fifty years ago was this consequence of the easy availability of mechanical reproductions of art; however familiar the work be in reproduction, we still have not given up the belief in the special status of the "original." This is why forgeries still function as disturbatory art, perhaps the only remaining examplars of that artform.

7

Art History in the Mirror Stage: Interpreting *Un Bar aux Folies-Bergère*

"Der liebe Gott steckt im Detail."
—*Ernst Gombrich, quoting Aby Warburg*[1]

Much traditional art history treated paintings in formalist ways, isolating them from the context in which they were produced, purchased, and displayed. T. J. Clark's highly controversial work has been one important model for postformalist art historians. An older Marxist tradition urged that analysis of the class structure of the society in which paintings were produced could help explain their content and composition. Clark's approach involves placing the artwork in the context of critical commentary by contemporaries of the artist. Such commentary displays the values of a culture; reading it to learn what critics see, and fail to see, in a painting is immensely instructive.

"Clark's various statements on modernism have probably received more comment than any other recent body of art-historical writing."[2] This is not surprising. Often identified, somewhat misleadingly, as a Marxist, he has

1. E. H. Gombrich, *Aby Warburg: An Intellectual Biography* (Chicago and Oxford, 1986), 13–14 n. 1. As he explains, there has been dispute about the source of this phrase.
2. Richard Shiff, "Art History and the Nineteenth Century: Realism and Resistance," *Art Bulletin* 70 (1988): 45 n. 84.

written about Impressionism, much-loved art that he does not altogether admire, employing a methodology most art historians will find alien and embracing a political position conservatives, liberals, and some leftists find repugnant.[3] But the resulting discussion of his work, focused mainly upon partisan criticism (or praise), has failed to do justice to the complex methodological issues involved. It is by focusing on those issues, and not upon the narrow political debate, that discussion can best be advanced.

Because Clark's work has been so much discussed by art historians, his texts deserve such commentary. What is at stake, ultimately, are questions of broad concern for art history, and for interpretation in general: How are we to evaluate radically original interpretations of familiar artworks? How may such new accounts get us to see artworks differently. How may we compare and contrast conflicting interpretations? For the most part, Clark presents his explanations without devoting much explicit attention to these methodological problems. And so, a reader who seeks answers must go beyond Clark's own texts.

I do that by arguing that the key to understanding his approach is provided by one book mentioned in the bibliographies, but not in the body of the texts, of his two works published in 1973, *Image of the People* and *The Absolute Bourgeois*. Since this chapter focuses on another, later text by Clark, I sketch this claim only briefly, without offering a reading of these complex books. When they were published in 1973, Jacques Lacan's *Écrits* (1966) had become enormously influential in France. (A book-length selection from it was not published in English until 1977, although some essays appeared earlier.) Since most of the items in Clark's bibliography deal with art history or with French social history, the inclusion of Lacan's book, not discussed in the body of the text, ought to have been a mystery. *Écrits* contains no discussion of visual art. Lacan does say a great deal about language and its interpretation, and it is here, I believe, that his account influences Clark. In these two earlier books, as in *The Painting of Modern Life*, Clark

3. Judging by the references in his *Painting of Modern Life: Paris in the Art of Manet and His Followers* (New York, 1985), 271 n. 3, his most important political influences are the writings of the Situationist International, a group in violent opposition to the European Communist parties. See Guy Debord, *Society of the Spectacle*, trans. anon. (Detroit, 1977); *Situationist International: Anthology*, ed. and trans. K. Knabb (Berkeley, 1981); Guy Debord, *Commentaires sur la socété du spectacle* (Paris, 1988); and the articles in the issue of *Arts Magazine* (January 1989) focused on the Situationist International. The reader of these stimulating, highly elusive texts is soon aware that tracking their influence in Clark's published work is not an easy task; see T. J. Clark, "Preliminary Arguments: Work of Art and Ideology," *Caucus for Marxism and Art* (Los Angeles, 1977), 3–6.

repeatedly adopts the same strategy.[4] What we find in the confused contemporary commentaries on Courbet by both leftists and conservatives is "an unsureness which the language of aesthetics can hardly articulate, a kind of critical vertigo."[5] The same is true of the writings of Delacroix and Baudelaire.[6] Clark claims that such confusions inadvertently reveal the shared ideology of these commentators. In his analysis of the contemporary criticism of Manet's *Olympia*, he treats such texts "as evidence in which *the real appearance* of *Olympia* can be made out, in however distorted a form."[7]

I take this phrase "the real appearance" to be of great importance. Like the neurotics to whom Lacan listened, these critics are incapable of saying what they really mean because doing so would require them to articulate what in their culture almost inevitably remains repressed. What is repressed reveals their ideology. Thus, their commentaries might be called neurotic texts.[8] The analogy between neurotics and critics must be made with great care. To say that a text is neurotic is not to imply that its author is neurotic. The speech of neurotics reveals their unconscious neurotic ideas; the texts of these art critics, as read by Clark, reveal shared worries about class conflict and sexuality. Freud's analysis of his patients uncovers what they are unable to say, and it reveals why they repressed these beliefs. Analogously, Clark's interpretation of the critics' neurotically confused writings recovers what they cannot say, that ideology which explains why their texts are confused. An ideology might be described as a shared neurosis. Insofar as Clark's goal is to see through that ideology, what he claims to provide is

4. I discuss only Clark's art-historical writing; for his view of American art criticism, see *Pollock and After: The Critical Debate*, ed. F. Frascina (London, 1985). Since Clark's art-historical writings depend upon their sensitivity to visual details, it is not surprising that this debate is uninteresting and that Clark offers no convincing response to Fried. (See my review in the *Burlington Magazine* [November 1985]: 817). Unlike Clark, Fried is—or was—a working art critic. What perhaps is most winning in Clark's contribution to this singularly frustrating volume is the admission that since he wrote the original version the Guggenheim exhibit *Kandinsky: Russian and Bauhaus Years* appeared, and "no doubt an exhibition of Matisse in the 1920s could be arranged that would leave me looking similarly silly" (quotation, 83–84).

5. T. J. Clark, *Image of the People: Gustave Courbet and the 1848 Revolution* (London, 1973, 138).

6. T. J. Clark, *The Absolute Bourgeois: Artists and Politics in France* (London, 1973, 124–77).

7. Clark, *The Painting of Modern Life*, 98 (my italics). Further references to this work, abbreviated *PML*, will be included parenthetically in the text of Chapter 7.

8. Freud's account of the Rat Man is neurotic in its obsessive concern with establishing the objective reality of that patient's primal scene, particularly when after much discussion Freud suggests that for his purposes it may not matter whether the scene was real or fantasy. These muddles may be explained when Freud himself says both that the scene is banal and that it is disagreeable "for many of us" to imagine "that the parents copulated in the presence of their child" (*The Standard Edition of the Complete Psychological Works of Sigmund Freud*, ed. J. Strachey [London, 1955], 17:58). In the case of the Wolf Man, Freud is clearer about the chronology of the childhood scene he reconstructs.

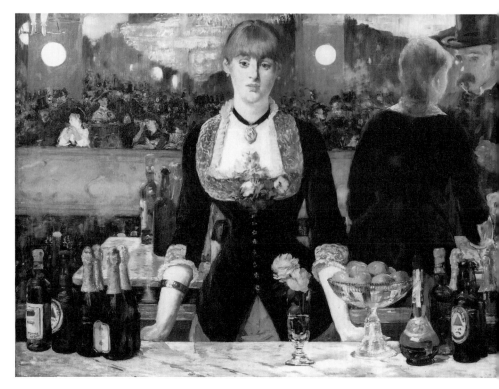

Fig.1. Edouard Manet, *Un Bar aux Folies-Bergère*, 1881–82. Courtauld Institute Galleries, London

both a clearer view of the paintings and the ideology of the critics. In analyzing the ideology, we learn not only about the artworks but also about the society in which they were created. This parallel between neurotic speech and such neurotic texts is, if correct, a pregnant analogy.

In his account of *Un Bar aux Folies-Bergère* by Edouard Manet (Fig. 1), Clark applies this procedure to the comments by contemporary critics on this work, shown in the Salon of 1882 (*PML*, 239–45). Manet depicts the barmaid facing us and shows her at an angle facing a man in the mirror. The picture cannot be consistent, not if the same barmaid appears in both places. (The space is not big enough to contain two barmaids, and so this must be the same woman.) If we do not believe that Manet was merely inept, it is natural to ask the meaning of this obvious inconsistency in his image. The mirror "on its own did not seem to provoke any great uncertainty in

Manet's first public: it was either straightforwardly a failure or sketched in boldly enough for the job it had to do" (*PML*, 241). But modern commentators have looked more closely. The older accounts suggest that Manet was not very good at composing pictures. If the perspective in many of his paintings is defective, that was because he was inept. But now commentators find a method in these seeming errors, which are seen as intentional.[9] Manet was not an inept artist. Or, if he was inept at composition, he intentionally used this weakness to good effect.

When thought about in that way, what now seems fascinating about *Un Bar aux Folies-Bergère* is the questions it raises about the identity of the spectator, who, standing before that painting, sees the barmaid shown twice, once facing him or her and once at an angle. As Clark writes, "in order to confront 'the beholder' with the unity of the picture *as painted surface* all the other kinds of unity which are built into our normal appropriation of the work of art—including the unity of ourselves, the 'beholder'—have to be deconstituted."[10] Even some commentators who do not accept his account agree that there is some problem here.[11]

Manet painted two versions of this picture. All the commentators I have read, Clark included, treat the preliminary study as an unsatisfactory version of the final picture. Describing the first version as a preliminary study assumes as much. If a painter does the same scene twice, the first time as a study, then it is natural to suppose that he resolved in the second version the difficulties of the first.[12] Very often painters (and writers) believe that the later picture (or text) they create is the better one. We all like to believe that we are progressing, though of course this is not always true. Sometimes penultimate drafts of texts are better than final versions; occasionally artists spoil paintings by reworking them. This assumption that Manet was pro-

9. See my "Manet and His Interpreters," *Art History* 8 (1985): 320–55.

10. Timothy J. Clark, "The Bar at the Folies-Bergère," in *Popular Culture in France: From the Old Regime to the Twentieth Century*, ed. J. Beauroy, M. Bertrand, and E. Gargan (Saratoga, Calif., 1977), 237 n. 9. Further references to this work, abbreviated BFB, will be included parenthetically in the text of Chapter 7.

11. "The reflections of the two figures in the study become implausible in the painting, where they propound a more complex poetic truth" (Françoise Cachin, catalogue entry in *Manet: 1832–1883* [New York, 1983], 484). "Poetic truth" means literal falsity. The obvious limitation of this account is its failure to explain why such error creates poetic truth.

12. Of course, sometimes an artist's first version of a picture he or she goes on to repeat may be judged better. Maybe Poussin's second version of *Seven Sacraments* is inferior because, when he was asked to do those seven pictures again, he was weary of repeating himself (Christopher Wright, *Poussin Paintings: A Catalogue Raisonné* [London, 1985], 196).

gressing plays an important role in the way the later version of the picture is understood.

Just as Manet created two versions of his painting, so Clark has published two accounts of it. The first was an essay appearing in 1977; the second, his 1985 book *The Painting of Modern Life*. Often, of course, an author will incorporate into a later book essays published earlier. But since Clark says that his second account "largely disagrees with" the early version (*PML*, 303 n. 2), clearly he thinks these two accounts different. Since he does not himself spell out how they disagree, that is a task left to the reader. And doing that is not easy, for in some important and obvious ways the two texts adopt the same approach. Both offer a great deal of sociological evidence to show why such an image of a café was hard for contemporary writers to interpret. Classes mingle in the cafés, "but it was not clear whose class *was* secure" (*PML*, 238). Hence "the critics' unconscious way of thinking" is to assume that "an image which seems in many ways to us so plain and straightforward . . . must also provide an equally uncomplicated set of expressions and exchanges" (*PML*, 243).

Both accounts ask the same two questions: Where are the depicted figures? Where are we in relation to the man in the mirror?

> Where does he stand in relation to her, in relation to us? . . . "We" are at the centre, he is squeezed out. . . . His transaction with the girl who leans towards him taking his order cannot be the same as our transaction with the girl who gazes back at us. (BFB, 236–37)

> His transaction with the barmaid cannot, surely, set the tone for ours. (*PML*, 250)

In his earlier version of the picture, Manet gives "a readable, eye-catching relation between the barmaid and man in the mirror" (*PML*, 252). In the later one the mirror reflects "Manet's attitude toward . . . modern life in Paris" (*PML*, 253), a conflict between that orderly, solid world and the play of appearances of the society of the spectacle.[13] Clark's absolutely crucial assumption in both accounts is that the two figures stand as if in a determinant relation to the spectator.[14] The picture revealingly mirrors bourgeois

13. Here I borrow from Shiff, "Art History": 45—"[I]deological mirrors still reflect when cracked, although they can do so only imperfectly. . . . Whenever . . . 'literal' reading of an image proves unrewarding . . . the image can still be read metaphorically."

14. He adopts what in another context has been called "a peculiarly transparent view of the work of art, according to which a painting becomes like a pane of glass which we look through to detect

society because "what begins as a series of limited questions about relation-ships in space is likely to end as scepticism about relationship in general" (*PML*, 251).[15]

How exactly, then, do the texts differ? I identify this as a problem because when I read and reread them I had difficulty asking this simple question, and answering it. Looking back, the source of my problem is clear. Both accounts argue that we cannot find a place for ourselves before the mirror. Both place the picture in its social context, mentioning the role of class in the dance hall, citing T. S. Eliot's account of Mary Lloyd (BFB, 245; *PML*, 216–17). When Clark describes the painting as a mirror image of alienation (BFB, 252), he states in a simpler way what he later says in the more elab-orate description. But his basic claim seems unchanged.

The one obvious difference between Clark's two narratives is the position in which the painting is placed within them.[16] Although both versions in-clude a good deal of the same material, the order differs. Clark's earlier analysis begins directly with the account of the painting, and only then gives a social history. The second version has a thirty-page discussion of social classes in the cafés, lighting, songs and their censors, and the commercial-ization of leisure, and then it gets to the painting. A formalist art historian will be puzzled at the surrounding material. Why discuss café songs when no one is singing in this picture? But for Clark the content of the painting can only be properly understood when it is situated in this cultural context. Looking back, perhaps the felt limitation of his earlier account was that by placing this social history after the reading of the picture proper he too abruptly comes to the painting.

a compositional source or a hidden theme" (Richard Wollheim, "Poussin's Renunciations," *The Listener* 80 [22 August 1986]: 247). Wollheim is not discussing Manet.

15. Compare Mark Roskill's older account, which failed to find any paradox in the picture: "[T]he barmaid stares directly out at the spectator, in his imagined role of a customer. . . . [T]he painting . . . sums up and epitomizes the whole technique which Manet had evolved in the seventies for the depiction of urban subject-matter" (Mark Roskill, *Van Gogh, Gauguin, and the Impressionist Circle* [Greenwich, Conn., 1970], 230). We have here a synthesis of Manet's early 1860s women, who challenge the male gaze, and those of the 1870s, who engage men. In this picture, then, "Manet offers a version of the first alternative at center, a version of the second to the right, and deliberately chooses not to provide any reconciliation or mediation between" (personal correspondence, 7 Au-gust 1988). Where Clark treats the picture as an Albertian window containing figures whose rela-tionship to us either is clear or, when puzzling, mirrors a larger ideological conflict, Roskill thinks of it as a symbolistic composition that need not be interpreted literally. Like Herbert, whose account I discuss later, he assumes implicitly that the painting should be read from left to right.

16. What is needed in the exegesis of this work, I believe is an "engagement with the whole." I apply to texts an observation about images in Leo Steinberg, "Velázquez' *Las Meninas*," *October* 19 (1981): 46.

There is also a second, less obvious difference between the two texts. In Clark's book Manet's earlier painting is contrasted to the later, better-known work to show "how easily things might have been sorted out . . . if that had been what Manet had wanted. . . . He might have put the barmaid and her reflection together, back to back, with the mirror established between them. He could have pushed the counter back in space. . . . But of course he did not: he seems to have worked instead to discover and exacerbate inconsistencies in his subject" (*PML*, 252). The preliminary version seems less skilled, but since, as Clark says, in both paintings the barmaid faces us as well as the man reflected in the mirror, why does he describe the second version thus? Why assume that Manet might have so easily dealt with these problems in the composition?

Now, what is important for Clark is one further point: the exact place and role of the mirror. It "must . . . be frontal and plain, and the things that appear in it . . . laid out in a measured rhythm" (*PML*, 253). Many of the contemporary commentators, almost like Clark in his earlier account, found no puzzle here. Either the picture was a failure or the mirror image a muddle, which in their cartoons was straightened out in "corrected" versions of the image (*PML*, 241). And yet the second picture *is* different. It both "delights in flatness" and "offers . . . a form of explanation . . . a form built into the picture's visual structure," which explains this flatness (*PML*, 253).

Just as the mirror image both duplicates and does not match the scene before its surface, the picture as a whole both shows in a literal way the Folies-Bergère and, because it does not accurately depict that scene, marks the difficulty (for Frenchmen of the time) of bringing such a scene into focus. "It is plain as well as paradoxical, fixed as well as shifting" (*PML*, 253). This complex statement brings together opposites in a way that is hard to sort out. The seeming untruthfulness of the picture, Clark is saying, is an essential truthfulness. How can one picture be both truthful and untruthful at the same time?[17] Perhaps we can think of it that way only by comparing it with the earlier version and setting it in the social history that Clark provides. In that account, Manet's literally untruthful perspective provides a way in which his picture can reflect bourgeois ideology. Since the picture actually depicts a mirror, here the word "reflects" is used in both its literal and metaphorical senses. Clark flirts with paradox when he says that the picture "lacks an order" (*PML*, 253), since of course he thinks that this

17. See Mark Roskill and David Carrier, *Truth and Falsehood in Visual Images* (Amherst, Mass., 1983).

apparent lack of order is, when properly understood, but a revelation of the deeper order that *is* truthfully displayed in his text. Earlier Clark focused on the uncertainty in the image, upon "that uncertainty of surface [that] infects our whole relation to the girl, to the exterior that stands there at the centre, offered to us" (BFB, 250). Now he finds the image more ambiguous. "It is plain as well as paradoxical, fixed as well as shifting" (*PML*, 253).

In the later analysis, the social history comes before the account of the painting, and the first, unsatisfactory version of the picture is contrasted with the second, successful version. These changes in Clark's rhetorical strategies explain why he now interprets the painting differently. Just as Manet can only get the picture right—that is, can only express all the ambiguities of the Paris of his day that Clark's social history aims to reveal— the second time, so Clark's text only interprets the picture adequately the second time. He both rearranges the order of his commentary, so that the social history comes first, and brings into the interpretation the first and second versions of Manet's picture. Taken in isolation, the painting seems ambiguous; framed by the social history, its ambiguities fall into place. Considered in relation to the early version, whose indefiniteness makes it a less-adequate mirror of this social world, the second version resolves Manet's uncertainties by creating these unresolvable ambiguities. It is hard to state this claim without flirting with paradoxes like those Clark finds in the picture. The painting seems ambiguous, but it really is not when it is placed in the right textual context. The unit of art-historical discourse is not just the painting in isolation, but that painting as it may be placed in an account such as Clark's. Manet's picture can be called both ambiguous and unambiguous only when it is set in a narrative.

I am only applying to Clark's account the approach he himself adopts in analyzing the earlier commentaries. Just as he thinks that "the real appearance of *Olympia* can be made out, in however distorted a form" in the critics' early commentaries (*PML*, 98), so I think that the real appearance of *A Bar at the Folies-Bergère* can be seen in distorted form in his texts. Unlike Clark, I deny that there is any neutral narrative describing the picture as it actually is, apart from how it is contextualized. I think it is mistaken to speak of "the real appearance" of such an artwork apart from how it is presented in an art historian's commentary. Any interesting interpretation of that artifact must make controversial claims about how to describe its appearance.

Here I come to much-discussed problems of relativism. Some writers think that an objective viewpoint on texts, pictures, and social institutions is

possible. Others believe that every individual perspective carries with it assumptions that, from another viewpoint, may be questioned. Conceptual conservatives ask that we not go outside the pictures, but let them speak for themselves.[18] Paintings, this metaphor implies, have a self-evident meaning when looked at properly. Such conservatives think that Clark goes outside Manet's picture when he places it in his social history. The critics of conceptual conservatism deny that it is possible for a picture to speak for itself. What, they ask, is the real distinction between what is within a picture and what is outside it?

These spatial metaphors are not easy to interpret. Since pictures are placed in some context by every commentator, the real question concerns the nature of this context. Sometimes conceptual conservatives appeal to connoisseurship. Art history, they say, should talk about pictures, not the social history that lies beyond the frame. Connoisseurs are interested in Manet's body of work; they study his changing styles of picturemaking. But when we go beyond that practice, understanding the principle that upholds their criticism of social historians is not easy. The difference between a connoisseur who urges that we focus on the picture itself, relating it only to other pictures by Manet, and a social historian like Clark is that they have different ideas about how to place paintings in context. For that connoisseur to compare *A Bar at the Folies-Bergère* to other works by Manet requires relating it to the body of his art. For Clark, we understand that painting by learning about the place it depicts. In either case, the commentary goes beyond the bounds of the individual picture.

What is striking to a reader who notes the apparent importance of Lacan's thinking in Clark's earlier work is the combination of a Lacanian reading of the contemporary texts describing *A Bar at the Folies-Bergère* with a resolutely un-Lacanian analysis of the image. Lacan's essays on painting collected in *The Four Fundamental Concepts of Psycho-Analysis* under the title

18. For example, when Michael Brenson writes in the *New York Times Magazine* (11 September 1988, 62) that "the scholarly emphasis on [Courbet's] social philosophy has tended to blind the American public to his pictorial imagination and achievement," he attempts to divide what he thinks of as coming from outside, the social philosophy, from what really counts, the pictorial imagination and achievement. But since for more than four decades commentators have argued that Courbet's pictorial imagination is essentially linked with his social philosophy, a major revisionist analysis would be needed to undo this way of contextualizing the pictures. (I date this approach from Meyer Schapiro's "Courbet and Popular Imagery: An Essay on Realism and Naïveté (1941)," reprinted in his *Modern Art, Nineteenth and Twentieth Centuries: Selected Papers* (New York, 1978).

"of the gaze as *Objet Petit à*" offer a sustained attack on the model of the relation between picture and viewer that Clark adopts.[19] ("*Objet Petit à*" may initially be understood as a codeword referring to that anonymous "other" described in Sartre's philosophy.) Of course, there is no reason that Clark need be consistent in this way, especially in dealing with so highly elusive a writer. Lacan's view of texts may be separable from his analysis of pictures. For Clark's purposes, what Lacan's *Écrits* provides, I have suggested, is a way to read texts.

But when Lacan writes that "in any picture, it is precisely in seeking the gaze . . . that you will see it disappear" (*FFC*, 89), what he says is relevant to *A Bar at the Folies-Bergère*. Since Lacan's theory has not yet been much discussed by English-language art historians, it is useful to sketch it briefly, focusing on its relation to *A Bar at the Folies-Bergère*. I discuss solely the part of his theory relevant to this picture, saying only enough to suggest that the theory might be intelligible. The child first forms an idea of its own identity, Lacan argues, by perceiving its mirror image, which thus "symbolizes the mental permanence of the I at the same time as it prefigures its alienating destination."[20] The infant discovers its body in that imaginary space behind the mirror that is at once visible and inaccessible; the self—paradoxically!— is located "out there" in this imaginary space. Though presented in a psychoanalytic context, this account develops out of a Hegelian tradition that laid great emphasis upon the link between alienation and self-discovery.[21]

This seems a developmental account, a story about how the child becomes an adult. At a certain stage in its life, the child comes into the mirror stage: "A description of the Imaginary will . . . require us to come to terms

19. Jacques Lacan, *The Four Fundamental Concepts of Psycho-Analysis*, trans. A. Sheridan (New York, 1978), chaps. 6–9. Further references to this work, abbreviated *FFC*, will be included parenthetically in the text of Chapter 7. This book was originally published as Jacques Lacan, *Le Seminaire*, ed. J. A. Miller (Paris, 1973).

20. Jacques Lacan, *Écrits*, trans. A. Sheridan (New York, 1977), 1–7 (quotation, 2). The difficulty with Lacan's suggestive account, as the many expositions of it reveal, is that it is not easy to explain his analysis in so many words. See Catherine Clément, *The Lives and Legends of Jacques Lacan*, trans. A. Goldhammer (New York, 1983), 84–96; Jane Gallop, "Lacan's 'Mirror Stage': Where to Begin," *Substance* 37–38 (1983): 118–28; J. Laplanche and J.-B. Pontalis, *The Language of Psycho-Analysis*, trans. D. Nicholson-Smith (New York, 1973), s.v. "mirror stage," 251; and Anne Norton, *Reflections on Political Identity* (Baltimore and London, 1988), 16–19. For a skeptical view, see Noël Carroll, *Mystifying Movies: Fads and Fallacies in Contemporary Film Theory* (New York, 1988), 63–66.

21. Lacan's views diverge radically from those of the Situationist International. See "La personalité selon l'expérience commune" in his doctoral thesis, reprinted as Jacques Lacan, *De la psychose paranoïaque dans ses rapports avec la personnalité* (Paris, 1980), 32–36.

with a . . . space . . . *not yet* organized around the individuation of my own personal body, or differentiated hierarchically according to the perspectives of my own central point of view."[22] But the notion of discovering the self during the mirror stage is highly paradoxical. "The mirror stage is a turning point. After it the subject's relation to himself is always mediated through a totalizing image which has come from the outside."[23] How can this stage be a turning point if it is also the origin of the awareness of self, "the moment of the constitution of that self. What precedes it?"[24] Before, there was no subject, and so we cannot contrast the self as it was and the self as it becomes after that moment. Since Lacan aims to tell the story of how persons discover themselves, he needs to explain how they think of themselves prior to when they look into the mirror. Before the mirror stage, the child has a body, but no conception of self.

The self, it thus seems, is created in the mirror stage. But how then can we speak of what happened to that person *before* that moment?[25] Perhaps thinking of the mirror stage as a developmental stage is mistaken. Lacan is describing the nature of perception, not a moment in real time. And the concept central to his account of perception is the split between the eye and what he calls the gaze: "I see only from one point, but . . . I am looked at from all sides. . . . Consciousness, in its illusion of seeing itself seeing itself, finds its basis in the inside-out structure of the gaze" (*FFC*, 72, 82). When I see the external world, I am aware that it contains other perceivers.[26] (That

22. Fredric Jameson, "Imaginary and Symbolic in Lacan," reprinted in his *Ideologies of Theory: Essays, 1971–1986* (Minneapolis, 1988), 85 (my italics).

23. Jane Gallop, *Reading Lacan* (Ithaca, N.Y., and London, 1985), 79.

24. Ibid.

25. Some origins are a matter of degree. Lacan's mirror stage seems rather to mark a difference in kind between an inability to know a unified self and an identification of that self with the mirror image of the body. But when the subject achieves that self-awareness, it cannot think of itself as continuous with that being who existed before the mirror stage. Its body, it is true, did exist continuously; but this subject, who only discovers its existence in the mirror stage, cannot be identical with its body. How then can that self conceive of itself as coming to self-awareness in the mirror stage?

Some art historians find an analogy between the discovery of the self in the mirror stage and the development of perspective through the use of mirrors. Perhaps, then, Manet's inability to create a consistent perspectival image shows that with the birth of modernism we reach the end of that tradition which began when Brunelleschi used a mirror to create the first perspectival image. See my "Painting and Its Spectators," *Journal of Aesthetics and Art Criticism*, 45, no. 1 (1986): 5–17, and Hubert Damisch, *L'origine de la perspective* (Paris, 1988).

26. A Cartesian philosophy of mind begins with self-consciousness and only then deduces the existence of those other embodied consciousness who can perceive my body. For Lacan, my relationship to the gaze of those other beings must be brought into the analysis of perception right at the start.

much is obvious to anyone but solipsists.) What Lacan adds is the more complex idea that I always think of myself as seen by these other perceivers.[27] He is not just making the trivial point that sometimes I am seen by others. His more interesting (and obscure) claim is that I always think myself potentially exposed to the gaze of these others. This claim provides the connection between his approach to psychoanalysis and visual art. When I perceive, "I turn myself into a picture under the gaze . . . I am looked at, that is to say, I am a picture" (*FFC*, 106).

The mirror stage reveals that I, the perceiver who views my own image, am at a position I can locate only in the imaginary space of the mirror, a place—like that marked by pigment in an illusionistic picture—that I can see but not physically reach. (I can touch my image in the mirror. But that no more counts as reaching *into* that imaginary space than touching the pigment on a painting counts as reaching into the illusionistic picture space.) Common sense tells me that I am located where my eyes are (at least approximately; when I stumble, I am reminded that I am a spatially extended entity). But Lacan gives up this commonsense view. This split between the eye and the gaze has further consequences. Alone, the embodied self is in one sense incomplete. My awareness that I exist in an intersubjective world is built into the very structure of perception. I cannot think of myself apart from knowing that these others see me.

Lacan presents his theory of the self by using two intersecting triangles, the gaze placed in the base of that triangle at whose apex the subject is positioned. The line formed by joining the points where these triangles intersect, a plane perpendicular to a line joining the gaze to the subject, forms the screen. Perception involves three elements: between the *gaze* and the *subject* stands that *screen* on which the image is cast. Although Lacan never mentions Manet in this text, his diagram of perception looks very much like a model of *A Bar at the Folies-Bergère.* This is not surprising; both Lacan and Manet are interested in the relation of the self to a mirror image. (Lacan notes that his image is very much like the image of a painter making a painting.) "If I am anywhere in the picture, it is always in the form of the screen" (*FFC*, 107). But this picture is not the traditional Albertian painting, the perspectival construction containing viewer, image, and represented

27. Here, as often with Lacan, the problem is to state his claim in a way that is neither false nor trivial. I am not always seen by others; but still, I can perhaps always imagine that they are seeing me. For my purposes, Lacan's work, whatever its plausibility, is of interest because of its relation to the interpretation of *Un Bar aux Folies-Bergère.* Even if his account of pictures is unconvincing, a Lacanian analysis of what I have called neurotic texts might be valuable.

scene. Rather, Lacan's diagram looks like two such paintings superimposed, one marking the position of the viewer who looks at the world, the other defining the place of that gaze out in the world looking back at the viewer.

One reason Lacan's analysis is hard to understand is that it is difficult to visualize. Common sense tells us that we are where our eyes are, and that others (who reason similarly) are also where their eyes are. When Lacan seeks to undermine this intuition, how would he have us think of perception? Common sense takes a Cartesian view: the world is centered on the perceiver. In a literal way, common sense is egocentric. What it neglects, for Lacan, is the essentially social dimension of perception. The world I look at from my viewpoint is a world in which other viewers perceive me. Perception is not a dualistic relation between perceiver and perceived, but a triangular structure in which the three positions are occupied by the subject, the gaze looking at the subject, and the screen (or image) that comes from superimposing the dualistic relationships of subject looking at gaze and gaze "looking" at subject. When I look at another person, I see them seeing me. Only such a triangular structure does justice to the mutuality of seeing. For Lacan, unlike Descartes, the social dimension of perception is built in from the very start.[28]

If a triangular arrangement is central to perception, then in *A Bar at the Folies-Bergère* we find stand-ins for his three picture elements: the barmaid at the center facing us; the couple at the right; and the mirror between them. On Clark's reading of the picture space, the man standing in our place before the picture is an apparent contradiction. In Lacan's reading, however, this involves a juxtaposition of the gaze before the subject, the barmaid who is engaged with a man at the right, projected onto the screen, here shown as a mirror. It is hard to compare this Lacanian interpretation to Clark's account. As given, this abstract appeal to the "other" does not tell us how to link this painting to the social history of Manet's Paris. For my present purposes, we need not pursue this interpretation, which deserves development. My interest is what this account teaches us about Clark's well-worked-out analysis.

I would apply to his own accounts of *A Bar at the Folies-Bergère* those strategies of critical interpretation that he uses in reading the texts of Ma-

28. Descartes's dualistic model of perception immediately involves him in the problem of other minds. Everyone is in the same position, aware of only the contents of her or his own mind. Hence I must reason by analogy. If I am aware of others who appear intelligent beings, then they must also have minds like mine and so, similarly, be aware of me. Descartes encountered problems that the history of post-Cartesian philosophy of mind shows are not easy to solve.

net's contemporaries. When Clark reads these neurotic texts, he assumes that his methodology permits him to identify their confusions. He is able to use interpretations of paintings to read the ideology of the commentators who write them. I agree that all art criticism reveals ideology; but unlike him, I doubt that his text, or mine, can escape from the problems that he finds in the accounts of others. What is neurotic about Clark's texts commenting on *A Bar at the Folies-Bergère* is his need to begin the analysis twice. In the commentary of a bourgeois art critic, such a repetition would provide the natural point for a critical analysis. Repetition often manifests genuine uncertainty. In one of *his* neurotic texts Freud writes, "A man who doubts his own love may, or rather *must*, doubt every lesser thing."[29] Ironically, doubt enters into his text, and causes him to repeat himself, precisely at the point where we would expect him to be decisive. Freud, it is natural to believe, has some doubts about this assertion. A suspicious reader will wonder what Freud is inadvertently saying about his own love.

"Perhaps writing must always lead one astray."[30] So writes Richard Shiff. Since my argument seems to lead in the same direction (which is hardly surprising, since I have learned much from his earlier work), it is but just to consider how to respond to his rhetoric. On the same page he describes Robert L. Herbert's *Impressionism:* "One is tempted to say—and without irony—that Herbert's writing is itself a work of art and a pleasure to read."[31] I agree. A great deal of art history, I find myself thinking, is not, like Herbert's book, pleasurable to read. But then, when I juxtapose Shiff's two statements, I puzzle over his rhetoric. Their visual proximity is important: just as art historians interpret the relation between Manet's two images of the barmaid in his picture, so I want to *see* the relationship between these two statements.

Often a distinction is made between nonfiction prose, boring but true, and pleasurable fiction, which does not aspire to make truthful claims. (That distinction has been questioned by Derrida and Paul de Man, whose work Shiff discusses.)[32] Shiff's praise of Herbert's book without necessarily questioning this distinction, tends to blur it. Certainly it suggests that *Impressionism* is an unusual art-historical study. The word "pleasure" in Shiff's description has complex implications. *A Bar at the Folies-Bergère* is a beautiful

29. *The Standard Edition*, 10:241 (italics in original).
30. "Art History": 47 n. 96, 47.
31. Shiff's essay appeared before Herbert's book was published.
32. See Paul de Man, "Semiology and Rhetoric," in his *Allegories of Reading: Figural Language in Rousseau, Nietzsche, Rilke, and Proust* (New Haven and London, 1979), 3–19.

painting, but if I admit to enjoying seeing the beautiful barmaid, am I not responding in a politically incorrect way, at least if we accept Clark's claim that she is a prostitute? Perhaps I then become divided, set—like the barmaid herself—in two worlds, torn between pleasure and guilt. (Maybe that is overdramatic, for, after all, I only see her in the picture.) Shiff's description hints at these ways that the study of modernism is self-consciously politicized right now. Herbert explains in his preface his sympathetic but ambivalent relation to use of poststructuralism by art historians, and the body of his book discusses the concerns of feminism. No doubt he is generally thought a less "radical" artwriter than Clark, a judgment that is, in relation to feminism, unfair. As Shiff notes, Herbert gives considerable attention to Mary Cassatt, not in Clark's index, and to Berthe Morisot, reproducing thirteen of her works to the two that Clark presents.

Can I then legitimately read Shiff's praise of Herbert's *Impressionism* ironically?[33] Certainly his sincere praise, which describes the book convincingly, raises these questions. (Earlier, Shiff said that Herbert's "knowledge, generosity, and modesty make him an ideal teacher.")[34] Were Shiff an old-fashioned writer, such a reading would bring alien ways of thinking to his text, revealing concerns he had probably not thought about. But since I know him to be interested in rhetoric, I look closely at such details, understanding that he is aware of these problems. Here we are readily led to issues much discussed by the deconstructionists and their critics. I can think of two different ways of dealing with them.

First, we may reject Derrida's claim, which tempts Shiff, that we can never mean exactly or merely what we say. (Clark implicitly adopts this procedure.) Perhaps some authors, at least at some times, say without ambiguity what they mean. This is one way to deal with the inconsistency that I find in Clark's use of Lacan. Although it may be that some texts (and pictures)

33. I owe this argument to Richard T. Vann, who, in response to my ironical reading of Foucault's account of *Las Meninas*, asked a good question. I argued that Foucault's description is deliberately untrue to the facts, and not simply factually incorrect. Vann wondered how he could know that *my* essay aimed to be unironically truthful and was not itself untrue to the facts. My revised essay attempts to answer his question; see my *Principles of Art History Writing*, chap. 11.

Hayden White gives a more accessible version of the claim that Shiff attributes to Derrida: "Our discourse always tends to slip away from our data towards the structures of consciousness with which we are trying to grasp them: or, what amounts to the same thing, the data always resist the coherence of the image which we are trying to fashion of them" (Hayden White, *Tropics of Discourse: Essays in Cultural Criticism* [Baltimore and London, 1978], 1). If White believes that, how can he say so using words that, if the claim they make be correct, themselves must resist the coherence of the image he is trying to fashion?

34. Richard Shiff, *Cézanne and the End of Impressionism* (Chicago, 1984), xii.

distort the evidence under the pressure of ideology, others do not, but are truthful to what they represent in a straightforward way. Perhaps a clear vision of bourgeois ideology permits a writer to compose unneurotic texts. If Clark knew that he could write an objective account, then his text would not be subject to the problems of bourgeois commentary that he has analyzed.

Alternatively, acknowledging that this problem always exists, we may proceed to interpret both Clark's and Shiff's texts, keeping in mind the possibility that all discourse, including my commentaries on them, may be misleading in this fashion.[35] We may, for example, read ironically Shiff's more recent essay describing the relationship between Roger Fry's successful art-writing and his unoriginal painting: "Fry . . . could not match the artistic liberation of his idol Cézanne. . . . His writing was expressive enough to help us see this."[36] In context, this introduction to a new edition of Fry's *Cézanne* seems to make a straightforward contrast between Fry's good books and boring paintings.

That is plausible, for most people think that Fry was a bad painter and a good critic. But since Shiff's essay is titled *Painting, Writing, Handwriting*, maybe it undermines that binary opposition between painting and writing. Bringing handwriting into the account makes this opposition seem problematic. Handwriting is how texts like Fry's 1927 book were originally produced, but it also appears *within* paintings. Perhaps Shiff's title questions this way of thinking about Fry's achievement as painter and writer. Just as his praise of Herbert's book invokes, and perhaps also criticizes, the prose/poetry distinction, so this title deconstructs any simple binary opposition between writing and painting. Because Shiff's texts are carefully constructed, it is possible, indeed inevitable, for a suspicious reader to be led astray.

Having asked this question about how to interpret art historians' texts,

35. Christopher Norris offers one way to deal with this problem in his "Deconstruction, Post-Modernism, and the Visual Arts," in Christopher Norris and Andrew Benjamin, *What Is Deconstruction?* (London, 1988), 7: "To 'deconstruct' a text is to draw out conflicting logics of sense and implication, with the object of showing that the text never exactly means what it says or says what it means." On this view deconstruction is a practice, an activity that can be performed on any text. If so, it would be better to avoid giving this general characterization of that activity. The obvious problem Norris faces is that here he, like Clark and Shiff and White, makes a statement that seems to undermine itself. I discuss this problem in Chapter 8, below, and in my review of Jacques Derrida, *The Truth in Painting, Journal of Philosophy* 85, no. 4 (April 1988): 219–23.

36. "*Painting, Writing, Handwriting:* Roger Fry and Paul Cézanne," introduction to Roger Fry, *Cézanne: A Study of His Development* (Chicago, 1989), xxvi.

which I think is a deep problem, it would be unfair for me to leave it unanswered. Since it is a central concern of the last chapter of all of my recent books, I will extend the analysis in a new way.[37] One goal of those books is to avoid an obvious problem pointed to in this chapter. If I take Shiff's side in this argument, and allow that perhaps all writing must lead us astray, how can I say that unironically, without calling into question my capacity to make the statement unambiguous?

We find in Herbert's book, which I admire greatly, a commentary on *A Bar at the Folies-Bergère* that subtly argues with Clark's earlier account. The barmaid's "frontal image is correct, even distant from us; nothing hints at her availability after hours. . . . It is precisely because Manet first establishes a cold dialogue between the statuesque barmaid and the viewer that the second dialogue in the mirror gains its peculiar force. We can't really be that man, yet because we are in the position he would occupy in front of the bar, he becomes our second self."[38] Herbert assumes the picture does unambiguously provide some clue that we are to *first* look at the barmaid as she appears at the center of the picture and *then* move our eyes rightward to find her reflection before the man in the mirror, with whom we might identify.[39] The order of chapters in a novel is determined by its author, and if we read the last one first we are not reading the book as it was intended to be read. But a painter normally has no similar way of determining in what order we are to see an image.

In general, European painting assumes that the viewer reads paintings like texts, from left to right.[40] And so it is natural in looking at Manet's painting to first see the barmaid as she if frontally facing us, and then turn to the figure on the right. But neither of these claims determines decisively that we must look at the picture in this way. Since Manet frequently employs the conventions of European painting ironically, why must we believe that in this work he employs a traditional technique? Although the image of the barmaid in the center may catch our eye first, that does not necessarily show that in a narrative description of the picture she should come first. In some

37. See my *Artwriting* (Amherst, Mass., 1987), chap. 5, *Principles of Art History Writing*, chap. 11, and *Poussin's Paintings* (University Park, Pa., 1992), chap. 7.

38. Robert L. Herbert, *Impressionism: Art, Leisure, and Parisian Society* (New Haven, 1988), 81. The preface discusses Clark.

39. See my "Tropics of Artwriting: Winckelmann, Pater, Morelli, and Freud," *History of the Human Sciences*, 2, no. 1 (February 1989): 19–38.

40. The classical statement of this idea is Heinrich Wölfflin's "Über das Rechts und Links im Bilde," reprinted in his *Gedanken zur Kunstgeschichte: Gedrucktes und Ungedrucktes* (Basel, 1941), 82–90.

pictures a figure in the background, which we initially identify only after prolonged inspection of the composition, may change our sense of the meaning of the entire painting.

Herbert is constructing a novella about this picture, a story that makes it intelligible. It is particularly important to do this, for *A Bar at the Folies-Bergère* is hard to put together. Like Diderot in his readings of Greuze's domestic melodramas, Herbert seeks to stabilize a seemingly ambiguous picture by providing one reading of its content.[41] One central aim of artwriting from Vasari to Clark *and* Herbert is to translate pictures into words in this way. But to the extent that the meaning of a text may always be ambiguous, subject to different (and perhaps incompatible) interpretations, does this not necessarily imply that the same is true also of pictures, insofar as we can only grasp their meaning by reading texts about them? Certainly it is possible to understand the different ways Clark, Herbert, and the earlier commentators interpret Manet's picture by identifying the different textual contexts in which they place it. But this does not permit us to definitively identify the meaning of the picture, which, even after it is described in such an account, remains ambiguous. Herbert could narrate the story differently. It is slightly misleading to say that what this shows is that Manet's picture is ambiguous. What it shows is that when that picture is described in a text, the narrative must involve controversial choices about how to identify the story taking place in Manet's painting. There are many ways of telling that story.

My own view, which differs from those of Clark, Herbert, and the other commentators on this picture to whose accounts I have referred, is that *A Bar at the Folies-Bergère* is, or has become, a highly ambiguous image.[42] I see

41. That the painting Clark calls *Un Bar aux Folies Bergère* is identified by Herbert as *A Bar at the Folies-Bergère* hints at one difference in the way they think of the audiences for their texts. Some art history books quote foreign-language sources only in the original; others quote the original with a translation either in the notes or in the body of the text; and still others include only English-language texts. These differences imply expectations about the intended audience.

42. My neurotic hesitation in this sentence reveals an important conceptual problem. Should I say that Manet's picture always was ambiguous, though its ambiguity has been perceived only recently? Or, rather, do I mean that it has become ambiguous after being interpreted by these commentators? My claim is that this is a distinction without a difference. Linda Nochlin describes the picture very differently, focusing on the "detached legs . . . dangling from a trapeze," and links the presence of the mirror to narcissism, cropping, and Roman Jakobson's "assertion that the rhetorical device of *synecdoche* . . . is fundamental to Realist imagery" (Linda Nochlin, *Realism* [Harmondsworth, 1971], 164–65). She does not develop these ideas, which suggest a feminist interpretation at odds with both Clark's and Herbert's accounts. A feminist would not describe this woman as a "girl," as does Clark (BFB, 250). In his more recent account, Clark calls her "the woman" and "the girl" in successive sentences, a kind of neurotic writing to whose ambiguities feminism has

no noncircular way of arguing that any one of these interpretations is *the* correct account, superior to all others. In pointing to problems with Clark's account, and Herbert's, my aim is not to show that their claims are false. It is, I believe, possible to discover problems such as I find in their texts in any account. That is why the interpretation of pictures is an open-ended process. Clark's work has generated so much interest because he makes the older accounts seem too simple. Once such an analysis has been brought forth, unless dramatic new archival evidence is published it would be anticlimatic to simply revive those older views. This is not to argue that Clark's account is correct, or even plausible; on the contrary, I have noted the difficulties in it. But this does emphasize how, as debate about interpretations like these proceeds, it becomes difficult to simply urge that such novel readings be rejected. Conservative critics of Clark are inevitably forced into the position of arguing that the meaning of the picture is really straightforward. My belief that such a rhetorical strategy is rarely convincing is one reason I turn to a Lacanian interpretation, which treats the picture as a highly complex image.

The debate over the value of Clark's account of Manet has been embroiled in a controversy about his political claims. But similar debates occur frequently in many other cases where no immediate political concerns are so obviously at stake. Critics who reject Clark's methodology are unlikely to be won over by his analysis. A conservative or a methodological conservative is sure to reject that account. Certainly such writers may change their minds. But if a conservative accepts Clark's interpretation or a Clarkian becomes a conservative, then that change is so radical as to be akin to religious conversion. Abandoning a style of interpretation is a dramatic change. This is not to imply that there can be no argumentation among art historians who offer competing readings. On the contrary, what is suggestive about Clark's interpretation of Manet's painting is how much dispute it has inspired. How difficult it is to offer a definitive account, or even to find a neutral way of comparing interpretations.

We may like to believe that definitive readings are possible and that we can compare interpretations. But are either of these situations really desirable, or even possible? Were a definitive interpretation presented, then in the future no one would be able to offer an interestingly original account of the picture. Of course, sometimes one interpretation may become definitive,

made us sensitive (*PML*, 250). (In correspondence, in response to the original published version of this chapter, Clark said that he was describing her as people would have in Manet's society.)

at least for a time. Now that this one Manet has been so thoroughly analyzed, perhaps nobody would find any interesting new way of discussing it.[43] But we need only consider what would happen were this situation to occur throughout art history in order to appreciate the practical problems. If everyone agreed that the existing accounts were essentially adequate, then it is hard to imagine such a field remaining intellectually challenging. All that would be left for younger scholars to do would be filling in the gaps, describing artworks that were too minor to be discussed by their senior colleagues.

My sketch of a Lacanian reading of Manet's picture suggests how interpretation is an ongoing enterprise. Once Clark had drawn the attention of art historians to the importance of Lacan's way of thinking about neurotic texts, then it was natural to look at another portion of that psychoanalyst's writings, his account of pictures. Since Clark's commentary on *A Bar at the Folies-Bergère* has attracted so much attention, it seems worthwhile to develop an analysis that extends his approach. Because Lacan's work is fashionable, it was almost inevitable that someone would apply his account of the mirror stage to this image containing a mirror. The institutional framework of our intellectual life provides a place for such commentary. Just as painting depends upon the artmarket, which provides a support system for original artists, so the modern university provides the material basis for extended critical discussion such as mine. Just as Manet's painting could only have been made in a society with a sophisticated tradition of artmaking, so my commentary would only have been offered after that painting has been so much discussed by my precursors. Nineteenth-century critics did not write commentaries on Manet like Clark's, Herbert's, or my own.

In offering this Lacanian approach, I do not deny that other interesting readings of the picture are possible. One such account was offered earlier by Richard Wollheim.[44] Following an approach he has developed in a number of essays in his work on psychoanalysis, Wollheim argues that we identify with the man reflected in the mirror; we think of ourselves as soliciting the barmaid. This seems a very plausible idea, for it suggests how Manet

43. When I wrote this chapter as an essay, I did not anticipate that it would be republished, in a forthcoming volume edited by Bradford Collins, containing a dozen commentaries on Manet's painting.

44. Richard Wollheim, "Babylon, Babylone," *Encounter* (May 1962): 36, discussed in my *Artwriting*, 6. Wollheim has informed me that he learned this interpretation in Meyer Schapiro's lectures. His own account of Manet, in his *Painting as an Art* (Princeton, 1987), chap. 3, offers a challenging account of the spectator's role, without returning to *A Bar at the Folies-Bergère*.

brings us into the picture. It does not require assuming that the painting is both consistent and inconsistent. And it offers a good way of thinking about the sexual politics of the image. When we stand facing the picture, we see ourselves in the right place, as that man in the mirror. (A modern man, I would expect, thinks of that identification differently than does a woman.) If Wollheim's account, which is more intuitively plausible than Clark's, has not been much discussed, that is probably because it occurs in an out-of-the-way reference, not in an art-historical journal, and is not part of a systematic analysis of Impressionism. Wollheim offers a suggestive observation that the art historians have not taken up, although doing so would provide the starting point for one alternative interpretation.

The differences between his view, mine, and Clark's are ultimately bound up in a disagreement about the value of Lacan's work and, also, in a different reading of the political background.[45] How readily it is possible, once many writers pay close attention to Manet's picture, to develop a variety of such interpretations. To compare and contrast such varied interpretations of the same painting may seem a modest goal. Unless we can compare the accounts of Clark, Herbert, Roskill, and Wollheim of *A Bar at the Folies-Bergère*, how can intercourse among art historians be a rational enterprise? And if we cannot do that, how can we understand the process in which styles of interpretation change? Putting the questions in this manner implies that there is some straightforward way of answering them.

It would be nice to find some neutral, mutually agreed-upon way of comparing these very different accounts. But that is very hard to do, for the disagreements among these art historians about this particular painting are

45. See Chapter 4, above. In his response to the 1980 version of Clark's paper published in *Screen*, Peter Wollen ("Manet: Modernism and Avant-Garde," *Screen* [Spring 1980]: 15–25) argues that a study of nonstandard logics can explain the way in which Clark treats the picture as inconsistent. According to Wollen (21), Clark sees in the painting "an endless oscillation between a fantasy of the *femme fatale*, dominating and ruthless, and . . . the *odalisque*, compliant, open and abject." In reply, Charles Harrison, Michael Baldwin, and Mel Ramsden ("Manet's 'Olympia' and Contradiction," *Block* 5 [1981]: 34–42) reject this way of talking: "if contradictions are not resolvable in social life they are not resolved in art" (39). Wollen usefully notes that Clark adopts a view of realism very much like E. H. Gombrich's, and he is provoked to offer this fascinating Baudelairean reading of the painting. Wollen's account deserves attention even if it is not completely plausible as a reading of Clark's text. (In a perhaps apocryphal story, Sir Alfred Ayer is said to have tried to persuade some Red Guards that contradictions exist only between propositions, not in the world. Wollen captures something of the spirit of that approach to dialectic.) Whatever view we take about such a Hegelian logic, it seems odd—here Harrison, Baldwin, and Ramsden are correct—to think that art history need appeal to such a notion of contradiction. But this dispute, not taken up in *The Painting of Modern Life*, provides an interesting link between de Man's deconstruction readings and Marxist art history.

bound up in many larger disputes. Focusing on those disagreements may make art history seem a contentious enterprise. Just as Christians, Muslims, and atheists have difficulty finding some common ground, so too, in a more parochial way, do art historians. But in art history, these disagreements are not the whole story. Observe how much implicit agreement there is. Today, most art historians concur that the seeming inconsistency in the mirror image is intended to be meaningful. (The older claim that Manet was just inept will, I predict, be revived by an art historian who argues that all of these writers overinterpret the picture.) The disagreements come when they provide different explanations of Manet's intentions. It is because the genuine disagreement that I have described exists that such argumentation is exciting. Once we recognize that the unit of discourse is Manet's painting as it is embedded in the various art historians' texts, then we can see why any attempt to achieve unanimity is unlikely to succeed. Were we comparing different accounts of the selfsame entity, it would seem surprising that there could be so much disagreement. How can Clark, Herbert, and Wollheim describe the same artifact so differently? Once we recognize that what they are dealing with is that artifact as they place it in context, then their differences are less surprising.

Manet's painting is an object in a London museum. But once that object is interpreted, it is placed within the context of an art historian's text. And once we allow that there are many different ways of placing it in context, then the claim that there is *one single best way* of interpreting that picture becomes highly problematic. The painting is an object before which Clark, Herbert, Roskill, Wollheim (and Carrier) have stood. But insofar as they say something about the picture, they must find a way of enplotting the narrative of the scene Manet presents. And since there are at least five different ways of presenting that story about the picture, the painting itself now seems highly complex. Is that to say that there can be only one best way to tell that story? If so, how can we determine which way is best? In real space, persons and things must have a definite position. But the space in *Un Bar aux Folies-Bergère* is an illusionistic pictorial space. Thus, how we conceive of the place of the barmaid in relation to the viewer depends upon how we contextualize this picture in a text that may identify this visually ambiguous space as reflecting ideologies found in Manet's society.[46]

46. I am indebted to Elizabeth Carrier, my daughter, who when "in the mirror stage" posed for a marvelous picture; to Richard Shiff, who helped me to see one important error, and a number of problems of detail, in the earlier version of this chapter published in *History and Theory* 29, no. 3 (1990): 297–320; and to Albert Elsen, who asked the question that in part inspired this chapter— How could an art historian legitimately discuss what is *not* in the picture?

8

Derrida as Philosopher

In a given sentence you can hardly see the words for the senses.
　　　　　　　　　　　　　　　　　　—Dana Scott[1]

Most philosophers will find my title paradoxical, as literary critics, likely enough, will think it patronizing. For Derrida deals with some issues, at least, familiar to us philosophers in ways that we find unintelligible, while for many critics his work is obviously important. Those who believe in paradigm shifts will know how to understand this situation. What counts is not the quality of Derrida's arguments, but that he has changed the standards of discourse.[2] Since he wants to change the ways we talk, attempts to critically understand his "philosophy" are a waste of time. After any such shift, those who still talk in the old ways have difficulty. That does not matter, for their paradigm is obsolete. The vast literature of Derrida exegesis seems a mordant illustration of this thesis, for when highly intelligent commentators tell us that Western metaphysics is bound to idealism, that "nothing is ever simply present," that there is no "pure presence . . . in which we come face

1. Dana Scott, "On Engendering an Illusion of Understanding," *Journal of Philosophy* 68, no. 21 (November 1971): 78.
2. Here I draw on and argue with Richard Rorty's "Philosophy as a Kind of Writing: An Essay on Derrida," reprinted in his *Consequences of Pragmatism* (Minneapolis, 1982).

to face once and for all with objects," or that Austin's theory of speech acts lends support to fascism, then argumentation seems beside the point.[3] Mill argued for what Marxists call bourgeois democracy, and to think of Marx as offering philosophical counterarguments is an approach that only a philosopher would adopt. With Derrida, similarly, perhaps no philosophical reconstruction of his arguments can explain why his work is fashionable.

Anyone who believes such claims will find this chapter perverse, for my title is not meant ironically. I read Derrida as presenting interesting arguments about representation, mental states and the nature of the self, and language, issues central to "normal" philosophy. Since I want to use his work, I discuss it in terms, not his, that are inconsistent with some of his claims. Sometimes the difference between French and American philosophers is said to be that they are interested in texts and we in issues; that distinction is surely itself problematic, and not a helpful starting point, though in the end I will return to it. Text reading requires some theory of interpretation, and according to my account Derrida's contribution consists in a theory and practice of that activity. Let us begin with the theory.

Representations such as mental states, texts, spoken words, and pictures signify, and to interpret is to explain what such signs mean. I will use all these words, whose analysis constitutes a large portion of analytic philosophy, carelessly, eliding important distinctions that in a longer account would need to be worked out. Usually such signs are iterable;[4] for example, the letter *a* may be repeated in many different contexts.[5] Because representations have this property, Derrida argues, we always say other than what we mean and want to say.[6] The conventions of a sign system are never entirely adequate to establish meanings unambiguously.[7] We can never know whether a speaker is talking about what is later or what when later is the same; the differ/defer ambiguity remains unavoidable.[8]

Since this is an important argument, best to begin by discussing the rea-

3. Rosaline Coward and Jack Ellis, *Language and Materialism* (London, 1977), 125; Jonathan Culler, "Jacques Derrida," in *Structuralism and Since*, ed. J. Sturrock (Oxford, 1979), 163; Fredric Jameson, *The Prison-House of Language* (Princeton, 1972), 173; Michael Ryan, *Marxism and Deconstruction* (Baltimore, 1982), 46. For similarly problematic philosophical discussion, see Jonathan Culler, *On Deconstruction* (Ithaca, N.Y., 1982), and Vincent B. Letich, *Deconstructive Criticism* (New York, 1983).

4. Jacques Derrida, "Signature Event Context," *Glyph* 1 (1977): 179.

5. Nelson Goodman, *Languages of Art* (Indianapolis, 1968), chap. 4.

6. Jacques Derrida, "Limited Inc.," *Glyph* 2 (1977): 200.

7. Jacques Derrida, *Speech and Phenomena*, trans. David Allison (Evanston, Ill., 1973), 130.

8. Jameson, *The Prison-House of Language*, 174.

sons it seems obviously false. Given that a sign might have different meanings in various contexts, why should it follow that in some particular context its meaning is indeterminant? Derrida wants to say, were a sign in another context, its meaning would be different. What does that show about its meaning here? Were Alexander in Sofia, he would not be in Athens; it does not follow that he is not in Athens. Admittedly, words, unlike persons, are types with indefinitely many tokens, but since each token is in some particular context, this fact does not aid Derrida.

(1) I know more beautiful women than Miss America.[9]

That sentence is ambiguous, we come to realize, when we consider another sentence incorporating it:

(2) I know more beautiful women than Miss America although she knows quite a few.

Here the alternative reading of (1), "I know women who are more beautiful than Miss America," is blocked. (1) is ambiguous, and (2) not; why claim that ambiguity is inescapable? Leaving aside questions about the careless way I have spoken of (1) as incorporated in (2), what such examples fail to show is that all signs are indeterminant in meaning. Granting Derrida's point that any sign may be cited or quoted, and so has different meanings than when used literally,[10] what interesting claims follow? Told to "go jump in a lake," some people get their bathing suit; to be ironical is to say something one does not literally mean. But wondering whether any statement at all—the previous sentence of this chapter, for example—could be read ironically seems an uninteresting form of skepticism.

 A more promising strategy explores the very ways that reference of signs gets established. When we ask "What does this sentence/picture mean?" we seek to add to that representation itself some further statement.[11] This supplementation, we think, explains that sign as it is; adding nothing, these additional words or pictures make perspicuous the meaning already present. For only when the meaning is not clear or obvious does an interpretation need to be added. Poems by Pound or paintings by Botticelli usually require

 9. Example borrowed from John R. Anderson, *Cognitive Psychology and Its Implications* (San Francisco, 1980), 413.
 10. Derrida, "Limited Inc.": 155.
 11. Jacques Derrida, *Of Grammatology*, trans. G. C. Spivak (Baltimore and London, 1976), 208.

interpretation; most sentences uttered in everyday conversation do not. If someone asks, "What do you mean, 'The dinner is on the table' "? as if I had just read aloud from *Of Grammatology*, I am baffled. Interpretation begins by assuming that many cases are unproblematic; unless I made that assumption, how could I say anything at all about the cases where interpretation is needed? Systematic questioning about the possibility of meaningful reference, furthermore, seems one of those positions impossible to state without contradicting oneself. Were the meaning of statements never determinate, then what could this statement mean? As a sympathetic Derrida commentator says, "If there is no immediacy that 'founds' meaning, then there is nothing from which to be at a distance, and the very idea of distancing loses its sense."[12]

Consider a parallel from epistemic skepticism. To argue against Descartes that were there an evil demon, then we could know nothing, is unhelpful; that is just his point. Analogously, to say that were Derrida correct, the meaning of all discourse would be problematic, is to restate his claim; our conventions for establishing meaning are not entirely adequate. Once we define signs as written, spoken, or painted elements that stand for something, then we have opened up a space between the material sign itself and what it signifies. Epistemic skeptics ask some questions about that space: for example, "Do my perceptions correspond to reality?" or, "Does language map the world?" Derrida's concerns are at right angles to these; according to him, such skeptics and their critics share some assumptions that he is at pains to deny. But his novel argument for skepticism about reference can be introduced in part by considering the concerns of epistemologists.

A sign that required no interpretation would be an impossible sort of entity; it is only nonsigns, these things that just are what they appear to be, that do not require interpretation. (Possibly everything could be a sign: a theologian might see meaning in the fall of a sparrow; a neurotic might fear that his steps on a sidewalk crack might signify the breaking of someone's back.) The notion of "presence" tries to get around this dilemma by imagining the logical or spatial distance between sign and signifier as reduced to nothing. Such philosophers want to have it both ways: to represent the world; to treat those representations as the full equivalent of what they merely stand for. Hence that " 'transcendental signified,' which in and of itself . . . would refer to no signifier, would exceed the chain of signs, and would no longer itself function as a signifier."[13] Questioning the belief in

12. Newton Garver, "Derrida on Rousseau on Writing," *Journal of Philosophy* 74, no. 11 (November 1977): 672.

13. Jacques Derrida, *Positions*, trans. A. Bass (Chicago, 1981), 19–20.

such reference is also to question the reality of the traditional self, that Cartesian subject to whom the signs are present. That subject, Derrida says, is a function of language, the sign/signified opposition standing for that of self/nonself.[14] For reasons I give in my conclusion, I am unable to explore these broader implications of Derrida's analysis. What is worth a brief note, yet, is the reasons that Derrida's account of representation includes a critique of mental representations. For the fallacies he finds in the notion of a self-interpreting sign appear, in important ways, in traditional philosophies of mind. Consider how I hear my own voice or perceive. I hear another person at some distance; my own voice is at no distance from me. (Hearing voices of others as if they were present is a mystical or schizophrenic or dreamlike experience.) What I perceive is at some distance from me, but sense-data are signs immediately present to me. Like my voice, they seem so immediate as to require no interpretation.

How could such signs seem to thus abolish this distance between themselves and what they signify? Derrida explores this issue mostly within the context of his interpretation of Husserl—though his exchange with Searle indicates how that analysis could be translated into a discussion of speech acts—but another, more accessible starting point is provided by Wittgenstein's discussion of ostensive definition. "That is from Istanbul," I say, pointing to my *kelim;* I expect the viewer to know that I am not pointing to the vinyl floor, nor the box below in the basement, nor a spot of dirt on my rug. Any such gesture is understandable only given many such shared assumptions. Phrases such as "I am pointing" and "Look at what I point to now" would be intelligible only to someone who already knew a good deal of English.[15] The critical force of this claim is to deny that some inner gesture, some "act" of intending, could establish meanings, a point Derrida makes, perhaps in a more limited way, when he discusses the relation between intentions and speech acts.[16] Since such gestures necessarily require interpretation, what is misleading about the notion of an inner gesture is the implication that I might intuit inner signs whose meaning would be self-evident. Such sort of person, Derrida and Wittgenstein are saying, is impossible.

In another connected way, too, we can criticize the belief in such signs. Suppose we know how someone, another person or ourselves, correlates

14. Derrida, *Speech and Phenomena,* 145; Derrida, *Of Grammatology,* 3.
15. See the argument in Peter Geach, *Mental Acts* (London, 1957).
16. Derrida, *Of Grammatology,* 208.

signs with what they signify. How can we know what they will do in the future? We may think that so doing requires no act of interpretation. "Even now as I write, I feel confident that there is something in my mind—the meaning I attach to the 'plus' sign—that *instructs* me what I ought to do in all future cases."[17] Such inner states, we come to recognize, cannot have any explanatory value. "Well, suppose I do . . . feel a headache with a very special quality whenever I think of the 1 + 1 sign. How on earth would this headache help me figure out whether I ought to answer '125' or '5' when asked about '68 + 57' "? If such inner "intentions" cannot explain the meaning of signs, then the most obvious alternative is an appeal to their context in use. (This move is, I believe, akin to Wittgenstein's talk about "ways of life"; I will not explore that point here.) Instead of considering a sign in isolation, let us understand it by looking at what surrounds it. Let us take the etymology of context, *com* (together) plus *textere* (weave) seriously. How is the meaning of a sign established by the pattern into which it is woven?

How, for example, can I know that a photograph depicts a Parisian street? That a sentence is meant literally? That a painting portrays some saint? In each case I ask for information about the context of that sign. The photograph appears in a French journal; the writer seemed uninclined to irony; the painter's patron asked him to depict that saint. Still, if we found the sign in some larger context, its entire meaning could change. The photograph may be a forgery; the writer, we may learn, was slyly ironical; the painter perhaps failed to follow his patron's instructions. Debates about epistemic skepticism and an inner language are strictly philosophical worries. These arguments about interpretation, as the history of biblical exegesis, political journalism, and art history shows, involve practical concerns. How we interpret a text, action, or painting depends upon our beliefs about its context. And those beliefs are changed by new knowledge.

I sketch this problem in these broad strokes because I want to underline its very general character. To identify a sign is to isolate one part of the world from all the rest. The critical question is whether so doing allows us to determine its meaning. If we knew enough about a photograph, a man's life, or a painter's oeuvre, then the meaning of one image, sentence, or painting would, we hope, be determinate. Every sign, Derrida says, is re-

lated to something other than its unique signified; difference makes the presence/absence opposition possible.[18] Meanings, he is arguing, cannot be made determinate.

Consider an example of argumentation that may support his claims. As often happens, in his debate with Searle the complaint is made that words are taken out of context. How is fairness of quotation established? Searle writes, "The relation of meaning is not to be confused with instantiation"; quoting him as saying "the relation is . . . to be confused with instantiation" is obviously misleading.[19] But in spelling out rules for fair quotation we easily reach a slippery slope. Fairness demands preserving meaning, but when meaning is in dispute that test is not easy to apply. Searle refers to his earlier work, which is in part an Austin commentary, and Derrida mentions others of his texts. To understand the debate, a reader must know these publications, which thus form the context of the articles published in *Glyph*. As Derrida jokes, since Searle acknowledges the assistance of their mutual friend, Dreyfus, "authors" as well as texts proliferate; perhaps Derrida too assists Searle in writing his attack on Derrida.[20] For when so many texts are involved, no single author can claim to unilaterally determine the meaning of his words. Searle draws on Austin, and Derrida puts their work in context. Texts proliferate, and the more we try, as I am doing, to explain what exactly Derrida and Searle are saying, the more we supplement their texts. In another decade, Searle and Derrida might write more; work of their students, or a history of late twentieth-century philosophy, could help explain their views. An indefinitely large number of texts would be relevant to interpreting what they wrote some time ago. If an impatient reader of my account asks, "But cannot a philosopher just mean what he says," then his words add to that system, reminding us of the title of Cavell's book about, among other topics, Austin on speech acts. Donald Davidson's spoken comment, "The answer to *Must We Mean What We Say?* is, 'yes,' " then too becomes part of the context of this discourse, as does my epigraph from Dana Scott. Even had they never heard of Derrida, or wanted to, now their words become part of a commentary on his.

One critical question is whether thus introducing new texts justifies skepticism about meanings. I am supposing that creating new contexts changes

18. Derrida, *Speech and Phenomena*, 140; Derrida, *Of Grammatology*, 143.
19. John R. Searle, "Reiterating the Differences: A Reply to Derrida," *Glyph* 1 (1977): 203.
20. Derrida, "Limited Inc.": 164–65, 216.

how we interpret. Perhaps, rather, an interpretation should be called true relative to all of the evidence so far available. New information may suggest a new meaning; that does not show the present interpretation to be false. Just as some arguments against epistemic skepticism say that certainty is too high a standard for knowledge, so maybe being consistent with a full knowledge of context is too high a standard for truth of interpretations. Truth of interpretation means, this alternative proposal asserts, truth relative to evidence to date.

Derrida's conclusion can be avoided by this argument, but the question, still, is whether such a conciliatory approach correctly describes what we mean by interpretation. Truth relative to the known evidence is not what we mean by truth; if new evidence contradicts an old interpretation, then that account, we say, is and was false. A critic like Stanley Fish who takes issue with this claim is thought to be a sophist.[21] Derrida thinks that the goal of restoration of the full original meaning of a sign is impossible, but he agrees that this demand, which makes, he says, no sense outside the traditional talk about presence, defines the ideal of interpretation.[22] For him the problem cannot be avoided by a pragmatic theory of truth of interpretation.

Derrida's argument, on my interpretation, is not that of a traditional epistemic skeptic. I am not saying that however much we check, there is always the possibility that we have failed to understand the correct meaning of a sign. Rather, I assert that such a sign can be supplemented in different ways, for that process is not totally determined by the sign itself. Hence a multiplicity of interpretations will always exist. Appeals to intentions of writers attempt to close off such an open-ended interpretative process. What is in principle fallacious about that procedure, Derrida is arguing, is its assumption that these further signs themselves have an unambiguous meaning. Here a parallel with epistemic skepticism is relevant. The certainty of some merely probable judgments cannot be established by appeal to other, no more reliable judgments.

For Derrida, an abstract statement of the theory of interpretation is less interesting than the practice of that activity. Baldly stated, his theory may seem false or even self-contradictory; better that—in this respect he is like the Wittgenstein of the *Philosophical Investigations*—he give enough examples to enable us to learn to interpret for ourselves.[23] Consider, then, three

21. Stanley Fish, *Is There a Text in This Class?* (Cambridge, Mass., 1982), part 2.
22. Derrida, *Of Grammatology*, 246.
23. Here I take issue with Geoffrey H. Hartman, *Saving the Text: Literature/Derrida/Philosophy* (Baltimore, 1981), 28–29.

examples: his critique of Foucault on Descartes; his discussion of Heidegger and Meyer Schapiro on van Gogh; and his analysis of one sentence by Nietzsche. We best understand Rousseau, he says, by carefully weaving together one piece of *Emile* and another from his essay on language.[24] In these cases, similarly, he proceeds by weaving together a variety of texts. I discuss only his procedures, not the plausibility of his claims.

Foucault says that Descartes's encapsulation of madness within reason in the First Meditation is a prelude to that historical drama in which mad people were contained.[25] The mad refuse to follow rules, and since they accept no linguistic rules, they cannot speak for themselves. How then can they be represented, and how could Foucault speak for them? These become questions about how to read Descartes. I might, he says, be mad, or dreaming, or deceived by the evil demon; what consequences follow from each of these hypotheses? Foucault, Derrida argues, misreads Descartes. Meaningful discourse is not and cannot be mad; Descartes does not intern madness, but excludes it in the first stage of the argument. To perform the cogito is already to show that I am not mad. Foucault's would be a good interpretation of that later moment in the text when the cogito argument is explicitly presented as an argument against the claim that the evil demon might deny me access to knowledge; then, but not earlier, madness is interned.

According to Heidegger, some shoes painted by van Gogh are those of a woman in touch with her native soil.[26] For Meyer Schapiro, that is a naïve projection; the shoes are of a sophisticated city man, the artist himself. Like many disputes about iconology, this is an argument about the meaning of depicted objects; like a saint painted by Piero these shoes need to be identified. Derrida introduces the context of Heidegger's philosophy to undermine both these interpretations. This is a debate between a country dweller and an emigrant Jew teaching at Columbia and publishing his critique of "Professor Heidegger" in a festschrift for a refugee from Germany. (Derrida is of course in these ways closer to Schapiro than to Heidegger; still, he argues with both men's interpretations.) If Schapiro is correct to see naïve projection in Heidegger's reading, he in turn is mistaken to fail to grasp Heidegger's context. Unlike an art historian, Heidegger is not interested in picking out one of many shoe paintings by van Gogh; and Schapiro

24. Derrida, *Of Grammatology*, 221.
25. Jacques Derrida, "Cogito and the History of Madness," in his *Writing and Difference*, trans. A. Bass (Chicago, 1978), 44, 53, 55, 58.
26. Jacques Derrida, *La vérité en peinture* (Paris, 1978), 293–362.

thinks of the picture as showing some real shoes, which is just the claim that Heidegger's aesthetic denies. One might, finally, place this artwork in a different context, and then reread the debate. Shoes are fetishes, Freud says, a theme nicely illustrated by some Magritte paintings Derrida discusses, and which relate to the symbolism of van Gogh's self-mutilation. Perhaps the Heidegger/Meyer Schapiro dispute can be taken as an argument about the sex of the shoe owner.

In the complete edition of Nietzsche's writings the words "I have forgotten my umbrella" occur, and perhaps "we never will know *for sure* what Nietzsche wanted to say or do when he noted these words."[27] But even if we think that this is a note asking for the return of the umbrella, the sentence can be read in other ways; for the usual interpretative assumption is that an author's work is a totality, which means that we place all of his sentences within some larger unity. Most Nietzsche commentators are interested in what he says about truth, and embarrassed by his crazy ideas about women. Why not, Derrida proposes, bring these themes together. An umbrella is a pointed instrument, and that, as everyone who knows the etymology of "style" will recognize, is suggestive. "*Stilus,* we recall from our Latin dictionaries meant originally simply the pen as the tool for writing."[28] Nietzsche plays these connections when he discusses truth, women, and philosophers. Women lack the phallus; hence "it could be said that if style were a man . . . then writing would be a woman." Female feminists, women who aspire to be like men (according to Nietzsche), lack style. Women, he adds, are not interested in truth; they are like actors, Jews, and artists. In his otherwise thorough analysis of Nietzsche's texts, Heidegger leaves out the discussion of women; that omission tells us something about the limitations of his analysis. Perhaps Nietzsche's statements about women show his fear of them, his identification with them, his love of them, or all three. And Derrida's own text supplies a further (inadvertent?) illustration of these problems. It is dated "1.4.1973," which for a Frenchman means 1 April 1973 and for an American January 4, 1973. Since Derrida has lived in America, it would be nice if this date, which perhaps the translator failed to "translate," referred to April Fools' Day.

All these pranks are meant seriously, but evaluating the result is difficult; what counts, ultimately, anyway, is Derrida's method, not his (probably un-

27. Jacques Derrida, *Spurs: Nietzsche's Styles,* trans. B. Harlow (Chicago, 1979), 123.

28. Willibald Sauerländer, "From Stilus to Style: Reflections on the Fate of a Notion," *Art History* 6, no. 3 (September 1983): 253–70.

even) success in applying it. To evaluate that method let me introduce another example, one which comes from a writer no one would call a deconstructionist. Just as, for Merleau-Ponty, there were phenomenologists before Husserl, so there were pre-Derridian deconstructionists; for example, Gombrich.[29] *Wivenhoe Park* requires interpretation, he says, to be properly seen.[30] We learn to see the fishing men and a donkey cart, and go on to place Constable's work within the whole history of naturalism. The boundary between that work's meaning, in a narrow sense of the word, and its general significance is difficult to determine. We may discuss the rural poor, who are effectively excluded from the depiction;[31] the ways Constable modifies schemata from earlier landscape artists; how photographs of his site help us understand his naturalism. Even if we think of the work's meaning as determined by the artist's intentions, all of these concerns may help determine its meaning. Photographs help us understand his search for an illusionistic image; psychoanalysis may help explain why he depicted slimy posts and scenes like that shown in *Wivenhoe Park;* knowing that he excludes the poor tells us, so his biographers confirm, something of his politics. So it seems impossible to limit discussion of the work's meaning in any nonarbitrary way. Many new texts, perhaps this one as well, may help explain Constable's painting. *Art and Illusion* has a first chapter that begins and an eleventh chapter that concludes by putting Constable's painting in context, and so each good interpretation of that book adds, perhaps, to our understanding of the painting.

Deconstruction, this example suggests, is first critical and then constructive; and it inevitably involves ideological concerns. The deconstructionist takes issue with some established interpretation. For many earlier art historians, Constable's landscapes break with the traditions of High Renaissance art; and a defender of landscape like Ruskin concedes this point when he argues that that new genre is well suited to the times. Gombrich's genius consists in showing how the making and matching procedures employed by Constable are traditional, in demonstrating how that artist works in the tradition of Giotto, Raphael, and Rubens. Gombrich offers a constructive alternative to earlier interpretations, and his account is interesting because worked out in such elegant detail. To merely say that an alternative inter-

29. Maurice Merleau-Ponty, *Phenomenology of Perception*, trans. C. Smith (London, 1962), viii.

30. See the full bibliography and discussion in my "Gombrich on Art Historical Explanations," *Leonardo* 16, no. 1 (Spring 1983): 91–96.

31. John Barrell, *The Dark Side of the Landscape* (Cambridge, 1980).

pretation is possible would be uninteresting. What counts is the practical demonstration showing how such an alternative account can be written.

Such interpretations blur the traditional line between creative artists and faithful commentators, but it would be mistaken to think that therefore anything goes. For deconstruction offers its own standards for evaluating interpretations. Again consider three examples.

Nietzsche, Henry James, and the Artistic Will has a suggestive title, but since the author's goal is to discuss the relation of these writers in a literal way, and he can only establish that the master knew people who read Nietzsche or stayed in houses where he might have read Nietzsche, one feels teased, bored, and disappointed.[32] *The Literary Speech Act* interweaves the Don Juan legend and the theory of speech acts—as the subtitle, "Don Juan with J. L. Austin, or Seduction in Two Languages," indicates—and that elegant presentation is perhaps limited only in being too obviously derivative from Derrida's *Glas* and its play between Hegel and Genet.[33] Since deconstruction aims to upset our expectations, the trouble with Derrida imitators is that their readings are all too often all too predictable. Heinrich Wölfflin explicitly opposes the classical to the baroque; what I expected—and, alas, found—in a deconstructionist's essay was the claim that Wölfflin's classical is the baroque.[34] In general, then, such interpretations are judged by their originality, thoroughness, and suggestiveness, which is to say that the deconstructionists' standards are not unfamiliar to traditional critics.

Such, at least, is how I would interpret Derrida's claims. But not everything he says is consistent with such an account, and it should be noted that some portions of his work cannot thus be placed in context. He says that the system of meanings of a word like "différance" are referred to "not only when it is supported by a language or interpretative context . . . it already does so somehow of itself."[35] The words "so somehow" cover up, I think, a bad argument; these contexts exist, I contend, only when constructed. Nor is this just a verbal slip, for elsewhere Derrida spells out this point at some length. "These differences . . . are neither inscribed in the heavens, nor in the brain, which does not mean that they are produced by the activity of some speaking subject."[36] This statement baffles me. While I welcome "the

32. See the discussion in my review of *Nietzsche, Henry James, and the Artistic Will*, by Stephen Donadio, *Philosophy and Literature* 3, no. 2 (Fall 1979): 240–41.

33. Shoshana Felman, *The Literary Speech Act*, trans. C. Porter (Ithaca, N.Y., 1983).

34. See Marshall Brown, "The Classic Is the Baroque: On the Principle of Wölfflin's Art History," *Critical Inquiry* 9, no. 2 (December 1982): 379–404.

35. Derrida, *Speech and Phenomena*, 137.

36. Derrida, *Positions*, 9.

death of the author," that fictional construct whose life makes his texts meaningful, I am puzzled by the notion that these contexts are somehow there prior to being constructed. Perhaps my problem is related to the fact that other parts of Derrida's work involve, as far as I can understand them, different concerns than I have discussed. Here, briefly, are two examples.

The problem with Freud's models of the mind, Derrida says, is that they treat dream reports as transcriptions of some earlier nontexts; but what is thus interpreted can only be another text.[37] And this contradiction appears when Freud imagines the slate that both preserves and erases traces. Those traces seem both present and absent, but to be operated that model requires not just a perceiver, but also two hands to mark and erase the pad. This argument, though drawing on a general discussion of signs, does not depend upon placing Freud's texts in context.

Derrida aims to undermine the distinction between literal and metaphorical language use, a procedure consistent with his general insistence that all such oppositions are derived from the sign/signifier contrast, and so ultimately untenable.[38] But his argument that truth itself is a metaphor, dependent upon the sun, which makes all that we see first present and then absent, is, if I understand it at all, unconvincing, and in any case not a result of playing with contexts, the procedure that interests me.

Faithful followers of Derrida, I have said, too easily become predictable, and so boring. Apply this complaint to my account. A sympathetic reading of Derrida that makes him out to be the reasonable advocate of interpretative procedures most of us already accept; who would doubt that such a presentation of him was overdue? But since Derrida's lesson is that any philosophical system, even his "anti-system," can and should be deconstructed, let us now criticize his theory of interpretation. To do that I turn to the texts of another philosopher whose account is built around exactly those iterable examples that Derrida employs, as if Arthur Danto's books, contrary to his intentions, were written to serve my present polemical purposes.

Consider pairs of identical-seeming entities: two arm movements; two instances of belief; two would-be artworks; two sentences about the past. Danto's strategy, always, is to first get us to think of these things as absolutely identical, then place them in a larger context where they turn out to be absolutely different.[39] So, lifting my arm differs from a reflex movement;

37. See Derrida, "Freud and the Scene of Writing," in his *Writing and Difference.*
38. Derrida, *Writing and Difference,* 251, 270.
39. Arthur C. Danto: *Analytical Philosophy of History* (Cambridge, 1968); *Analytical Philosophy of*

believing that my wife approaches because I see her car differs from believing that because I see an identical-looking car as she approaches on foot; a painting made by an artist differs from an identical paint configuration produced by a random process; a fossil differs from an identical-looking bone created by God six thousand years ago. Danto examples are familiar in traditional philosophy; Descartes's skepticism can be phrased in such terms. Compare and contrast two identical perceptions, one of something outside my mind, the other the product of a dream, hallucination, or evil demon. The general goal of philosophical analysis is showing how such identical things are to be understood. Philosophy is not an empirical investigation; "in providing theories of truth or theories of knowledge, [it] adds nothing to the body of truths we possess or knowledge we have."[40]

Most of the interest of this account lies in its details, in showing how exactly action, knowledge, and art are interrelated. Here, however, I concentrate only on the general principle that relates this to Derrida's argument. Danto needs, always, two things that first appear identical and then can be shown to be different. No violation of Leibniz's law is intended; he says not that these two things are and are not identical, but that they appear but are not identical. Danto examples are always funny. The Japanese aesthete who removes the splotched room divider to replace it with a rare, visually identical masterpiece "dense with depth and mystery"; the man who prepares to shoot his aunt's seducer as a falling chandelier hits the gun and causes that enemy's death. Here, as to any fine undoing of our expectations, we respond with that symptom of bewilderment, laughter.[41]

How can such things appear to be identical and not be? Danto's various cases differ. We see the would-be representation, but learn that it is not an artwork when we are told that it was made by chance; we reinterpret a painting by learning that is is a forgery; we see the snowshovel but recognize that it is not a readymade by realizing that it is not in a museum. In each of these cases, we in different ways place things in context. Two things look identical, but because they are made in different ways, they are different. Like the fossil forged by God, these differences would be visible only if we could look into the past and see how the object was made. Some cases from the theory of action are different. The difference between the pressing of a switch that turns on the lights and the identical-seeming pressing of a non-

Knowledge (Cambridge, 1968); *Analytical Philosophy of Action* (Cambridge, 1973); *The Transfiguration of the Commonplace* (Cambridge, Mass., 1981).
 40. Arthur C. Danto, *What Philosophy Is* (New York, 1968), 10.
 41. Danto, *The Transfiguration of the Commonplace*, 100; Danto, *Analytical Philosophy of Action*, 75.

functioning switch just at the moment when the lights go on because the electrician replaces a fuse would be visible if we could see into the basement.

Sometimes, then, the relevant context is temporal, and in other instances it is spatial, but always, once we see how a representation or action is so placed, we can unambiguously interpret it.

Derrida's iterable signs that can be placed in different contexts are Danto examples, and so the interesting question is why from such a similar starting point he reaches such different conclusions from Danto. To know the meaning of a text, Derrida places it in context; and since this can be done in different ways, those words are irreducibly polysemous. Like words or pictures, arm movements, would-be artworks, or mental states can be imagined to be in such different contexts; but how we describe such hypothetical entities tells us nothing about the significance of the actual arm movements, would-be artworks, or mental states we are considering. Either my present arm movement is a basic action or not, and nothing we learn about an identical-looking movement tells us how to describe this movement occurring here and now. Texts differ from the world they represent, then, in possessing multiple interpretations in ways that that world does not. To this extent, I follow Danto, whose text "Knowledge and the World" has a title that to what he calls an internalist, someone who believes that language is in the world, would make no sense.[42] This conclusion, still, is only partly consistent with Danto's aesthetic, for he, I think, believes what I deny, that unambiguous interpretations of artworks are possible.

There is, yet, one way that Derrida might respond, and this position, which I can only mention but am unable to offer any interesting argument for, should be recorded in this text, which perhaps some other, more ingenious commentator will supplement. Suppose we take very seriously Derrida's slogan, "There is nothing outside the text."[43] Just as for Berkeley the world is made of ideas, and for Nietzsche of will, so for Derrida it is a system of signs.

When for example he says "there is no subject who is agent, author, and master of *différance*," or that "reading . . . cannot legitimately transgress the text toward something other than it, toward a referent," he means very literally what he then adds: "there has never been anything but writing."[44] So,

42. Danto, *Analytical Philosophy of Knowledge*, chap. 10.
43. Derrida, *Of Grammatology*, 158.
44. Derrida, *Positions*, 28; Derrida, *Of Grammatology*, 158–59.

when in the spirit of G. E. Moore arguing against idealism, I write, "But here is my hand; it is not a text," Derrida can reply that what I have produced is but yet another piece of writing. The world on this account *is* representation, and the task of the deconstructionist is to explain why philosophers thought that this representation was of something. But having made this interesting idea explicit, I shall say nothing further about it. My argument is that Derrida has a very interesting theory of texts and an unpromising metaphysics, which may explain why it is just that he be more highly regarded by literary critics than by philosophers.[45]

45. This chapter builds on my arguments in "Art without Its Artists?" *British Journal of Aesthetics* 22, no. 3 (Summer 1982): 233–44, and in "On Narratology," *Philosophy and Literature* 8, no. 1 (April 1984): 32–42.

9

Postmodernism Is Dead!
(Long Live Leo Steinberg)

According to the endlessly repeated, sometimes rejected, but never effectively challenged dominant doctrine of our day, since sometime in the early 1960s (or late 1950s) we have lived in a postmodernist era. The canonical text making that claim, Leo Steinberg's justly famous "Other Criteria," given as a lecture in 1968, published in 1972 in his book of that title, is my target. Steinberg's essay deserves such attention, for it is not only the best but also the most influential account of the agenda of art criticism. This is why the flaws in its central argument have led many artwriters to a disastrously misguided conception of painting.

In artwriting, as in art, it would be a poor master teacher who did not teach his readers to reject his influence. One reason writing this chapter was complicated is that I continually borrow from Steinberg's rhetorical strategies even as I criticize his ideas. What interests me in his writings on Leonardo, Velázquez, and Pontormo, as well as on Johns, is his concern always to orient himself physically in relation to the artwork.[1] And when the

1. See my *Principles of Art History Writing* (University Park, Pa., 1991), chap. 6.

orientation of the viewer to the work changes fundamentally, as for him it does in the early paintings of Johns and Rauschenberg, then—so he claims—a fundamental change has occurred in the artistic culture.

The origin of what now is called postmodernism involves a turn of ninety degrees from an orientation looking at a windowlike panel, intended (whether representational or abstract) to be looked through, to a flatbed. Thus Rauschenberg's flatbeds hang on museum walls, as do Islamic carpets, but like such decorative works they really suppose a different orientation toward their viewer. In Islamic culture, the carpet was a simulacrum of the garden, for sitting on it was a substitute for dwelling amid live vegetation. "The idea of a garden in perpetual springtime," a historian writes, "has remained especially pleasing to the peoples of Islam, many of whom dwell in relatively arid climates."[2] One way to trace the history of the orientation of artworks is to observe the changing relationships of Europeans to carpets, moving from their representation in the school of Venetian painting to employment of their decorative qualities in Matisse's work, which was influenced by Islamic decoration. Rauschenberg's flatbeds, analogously, are dumping beds for information, sites for image gathering in the postmodernist city, where looking out the window to learn the weather is no more done than going uptown in a horse-drawn carriage.

One reason Steinberg's conception is deservedly influential is that it suggests a way of understanding lots of otherwise diverse art from the 1970s and 1980s. I never thought of criticizing this theory until I reviewed the 1990 Whitney retrospective of Rauschenberg's silkscreen paintings.[3] What frustrated me about these famous, often-reproduced works was that they were collectively so disappointing. Rauschenberg's ways of thinking and his working methods make it seem highly unlikely that, as some of his champions have claimed, these works have a highly complex iconography. At this point heretical doubts arose in my mind. Could works Steinberg places at the center of his attack on formalism really be so dull? When I then thought about the paintings, the problem became clearer. It is true, as Steinberg says, that often Rauschenberg collages his images so that they are not vertically placed. But usually the effect is to preserve verticality as a norm, since we read turned or upside-down images as deviating from that norm. This visual observation led to me to wonder why Steinberg found these paintings, and some related works, so important.

2. Donald King, quoted in *Rugs and Carpets of the World*, ed. I. Bennett (London, 1981), 70.
3. See my "Robert Rauschenberg: The Silkscreen Paintings, 1962–1964," *Burlington Magazine* (March 1991): 218–19.

Perhaps the limitations of Rauschenberg are predicted, unintentionally, by Steinberg's essay. Once artists had made this fundamental transition, "the most radical shift," he calls it, "in the subject matter of art," what further moves were possible? Steinberg thought that "this post-Modernist painting has made the course of art once again non-linear and unpredictable."[4] I read the implications of his analysis somewhat differently. It is very hard to see what could come next, for another such equally important movement in the orientation of painting is all but inconceivable. Art could not shift its orientation another ninety degrees. The course of art has not so much become unpredictable as effectively ended, which I think is why Steinberg's followers were ready to talk about the end of art.

One reason that Steinberg's essay had such revelatory influence is that so many of claims made only en passant are immensely suggestive. When he says that Greenbergian painters like Noland were involved, not with a Kantian conception of self-critical art, but with what he calls a "corporate model of artistic evolution," he anticipates the plausible way Carter Ratcliff describes Stella's recent productions. When he refers to the "picture conceived as the image of an image" he prepares for accounts of postmodern image appropriation. When he speaks of the "deepening inroads of art into nonart" he prophesies the many discussions of high art in relation to popular culture that came after Greenberg.[5] Most of the truly interesting things said about art in the 1980s were suggested, sometimes only elliptically, by Steinberg in 1968.

This is why even points of detail deserve close attention. Steinberg quotes Baudelaire's account of pleasure in Delacroix's "limbs of a flayed martyr" or "body of a swooning nymph," which, "if they are skillfully drawn, connote a type of pleasure in which the theme plays no part, and if you believe otherwise, I shall be forced to think that you are an executioner or a rake."[6] This he calls a kind of formalism. But in context, the sense of this text is different. Since Baudelaire's poetry often presents narrators responding as if executioner or rake, this passage, far from suggesting that we ought to look at such depicted figures formally, is ironically playing on our awareness of those poetic texts, on our expectation that here, too, perhaps we might carry those roles into our response to his artwriting.[7]

4. Leo Steinberg, *Other Criteria* (New York, 1972), 84, 91.

5. Ibid., 78, 91; Carter Ratcliff, "Frank Stella: Portrait of the Artist as Image Administrator," *Art in America* 73 (February 1985): 94–107.

6. Steinberg, *Other Criteria*, 64; he indicates elsewhere in the book (406 n. 15) that Baudelaire was not always a formalist.

7. See Leo Bersani, *Baudelaire and Freud* (Berkeley, 1977).

I focus on this detail because now it becomes apparent that the central flaw in Steinberg's entire argument is his blindness to the function of rhetoric, especially his own. A strange blindness in so self-conscious a writer. Not the least of the oddities of his fame is that his argument has been taken up by various critics, many associated with the journal *October*, who as good postmodernists are obsessed with rhetoric. "Now and then it is possible to observe the moral life in the process of revising itself, perhaps by reducing the emphasis it formerly placed upon one or another of its elements, perhaps by inventing and adding . . . some mode of . . . feeling which hitherto it had not regarded as essential."[8] I cannot conceive of a better expression of the situation of the present-day artwriter than these, Lionel Trilling's words. The emphasis we now place upon the literary aspect of such narratives adds to our experience of artwriting a mode of feeling that hitherto had not been given its proper importance.

One reason Steinberg is such a good artwriter is that he is prepared to be shocked, to indicate in elaborately crafted detail the response of his sensitive consciousness to works before which he has difficulty orienting himself. What then could be more shocking than the movement of the orientation of pictures a full ninety degrees? It is as surprising as reading that Johns's refusal to make paint "a medium of transformation" separated him from the tradition in which "one suddenly saw how Franz Kline bundles with Watteau and Giotto."[9] Of course, we artwriters all are shocked on occasion, pretending that some artwork breaks dramatically with tradition; but it is important to be aware of the function of such writing. To suggest that Kline is really more similar to Watteau than Johns is an (understandable) exercise in hyperbole.

Turning gently around a curve is a manageable transition. Making a ninety-degree turn requires stopping, and so a complete change of direction, a movement familiar to citydwellers that seems more traumatic on a field, where a gentler turn is possible. I could no more change my ways of writing, a friend once said to me, than I could change my sexual orientation, a parallel that captures something of the sense of shock that "Other Criteria" finds in postmodernist art. Such a change in how we orient ourselves toward the world or the artworld would be shocking, but in a text shocks are but those transitions that occur when two different experiences, or artworks, are brought together. Creative literature suggests how to deal with

8. Lionel Trilling, *Sincerity and Authenticity* (Cambridge, Mass., 1972), 1.
9. Steinberg, *Other Criteria*, 42.

these experiences of artworks. John Ashbery's "Self-Portrait in a Convex Mirror" shows a marvelous ability to move almost continuously, without— it might seem—ever adopting a stable resting point. But saying that those movements are therefore shocking is plausible only if we think that the text represents actual movements of a fictional subject in the world.

Is this to say, then, that texts by artwriters are not accurate records of real experiential shocks? Certainly sometimes I experience artworks as shocking. But the question of whether the shocks presented in my writings, or in any artwriter's text, are real or merely the product of fictional techniques is, I think, unanswerable. What makes a commentary a truly authentic account is not whether it be true to the writer's experience, which is unknowable to us, but whether it be moving and convincing to the reader. Experiences within and without the art gallery are shocking, but when we turn to their representation within a text those shocks may not be replicated. "Just now," I wrote some time ago, "I experienced a shock" like those described by Walter Benjamin. Not, I hasten to add, something like his experimentation with hashish in Marseilles; rather, the more humble, but very real, shock that occurs at twilight when, turning on the light, suddenly the relation of my study to the out-of-doors changes dramatically. Well! Someone would have to be pretty blasé not to be shocked by Bret Easton Ellis's novel *American Psycho*, the response to which shows that it is still possible to go too far in our postmodern culture, but it is safe to say that no one would be shocked by that narrative of my life. And yet such humble experiences have important lessons for the art critic.

Just as Steinberg's identification of a shocking break in art's history that marks the birth of postmodernism now seems overly dramatic, so does his claim to have broken with formalism. This is not surprising, for novel artworks or narratives never seem so shocking after they have been much imitated. What is now obvious—though this must have been hard to see in 1968—are the shared concerns of Steinberg and the formalists. Greenberg's late summation of his aesthetic, the 1968 lecture "Avant-Garde Attitudes," begins: "The prevalent notion is that latter-day art is in a state of confusion."[10] Krauss's 1976 "Notes on the Index" begins: "Almost everyone is agreed about '70s art. It is diversified, split, factionalized. Unlike the art of the last several decades, its energy does not seem to flow through a single channel."[11] What we soon expect, and get, is a demonstration that

10. Clement Greenberg, *Avant-Garde Attitudes* (Sydney, 1969), 2.
11. Reprinted in Rosalind E. Krauss, *The Originality of the Avant-Garde and Other Modernist Myths* (Cambridge, Mass., 1985), 196.

latter-day art *is not* in a state of confusion, that the energy of seventies' art *does* flow through a single channel. When they look below surface confusion, what Greenberg and Krauss find, of course, are real structures. Like philosophers, they think the variety of appearances only a mask for a deeper structure. We enjoy discovering that behind the chaos of styles mentioned in passing in the opening paragraphs of their texts there is an order. That act of discovery is comforting.

Or at least we experience that illusion. Once we understand how such texts begin with this depiction of disorder only as a means of showing that behind the appearances is a real order, we ought to become suspicious. Krauss's machinery for deriving that order is, as befits a postmodernist, more elaborate than Greenberg's. He relies upon his now familiar idea that artistic tradition depends upon maintaining the standards of the old masters, and so he rejects the Duchampian moves of Johns and his heirs. Krauss appeals to Jakobson's linguistics, Lacan's view of the self, and Benjamin and Barthes on photography. Greenberg's insistence on the oneness of art in the 1960s is consistent with his view that all successful art of every place and time is ultimately concerned with one issue, quality; Krauss's textual monism is deeply at odds with both the position she presents elsewhere and the concern of the theorists she admires with the fragmentary and the incomplete, with texts and pictures which lack that traditional virtue of art, organic wholeness. What now makes Steinberg seem more akin to Greenberg is his refusal to use such elaborate theories.

Knowing how these two essays begin, we can predict how they will conclude. In his last paragraph Greenberg says that "the variety of nominally advanced art in the 60's shows itself to be largely superficial."[12] Krauss says that photography "shapes the sensibility of a large number of contemporary artists . . . whether they are conscious of it or not."[13] Like Greenberg, she is not interested in artists' intentions, which for her, too, merely belong to the world of appearances.[14] If at the beginning it seems amazing that such different critics, applying such different aesthetic theories, structure their texts so similarly, by the end of this section of my narrative that is no surprise. Not when we realize that what is really shared here are familiar rhe-

12. Greenberg, *Avant-Garde Attitudes*, 12.

13. Krauss, *Originality of the Avant-Garde*, 219.

14. Her later defense of the importance of surrealist photography extends this argument, for surrealism is an artistic movement that plays no constructive role in Greenberg's formalist history. See Rosalind Krauss and Jane Livingston, *L'Amour fou: Photography and Surrealism* (New York, 1985).

torical structures—the opening of a narrative with seemingly many possibilities, which yields to a conclusion with a satisfying unity. Like modernists, postmodernists like to tell convincing stories.

Here we arrive at issues of self-reflexivity, which, so the study of rhetoric teaches, will not go away. My own narrative is using exactly the same structure whose presence it criticizes in the texts of Greenberg and Krauss, moving from the initial confusing multiplicity of opinions to that satisfying unity which results when it becomes clear that the real structure behind the appearance of multiplicity is this simple rhetorical one. Recognizing that any artwriting must thus be enplotted is one way of signaling the limitations of their theorizing, and so one step toward a more satisfying account. Steinberg's essay has a structure that will seem particularly complex if one does not just depend upon memory of the central argument, but looks at how that analysis is motivated. The essay has many stray threads, themes that do not entirely come together or have any obvious relation to the central argument. When, for example, Steinberg criticizes Greenberg's reliance upon Kantian aesthetics by suggesting that a Kantian view of women would leave them committed only to what he quotes Betty Friedan to define as "the fulfilment of their own femininity," it is hard to see what that means. Maybe somehow formalism is linked with sexism, but exactly what that claim has to do with Steinberg's argument I cannot say. Here we certainly touch upon much-discussed political concerns, but in "Other Criteria" I mostly sense Steinberg's distance from, and hesitation to pronounce a judgment upon, American culture. What today is striking is his identification of postmodernism as concerned with "the shift from nature to culture," rejecting the tradition in which the picture evokes the experience of a "normal erect posture,"[15] invoking issues of the politics of gender that Steinberg himself has not, to my knowledge, pursued in his published work.[16] When he describes Rauschenberg's earliest canonical work, *White Painting with Numbers* (1949), as done in "a life class . . . the young painter turning his back on the model,"[17] it would be natural to consider the implications of *that* turn away from nature.

The exact sense in which Steinberg's view is an antiformalist one is complex. If formalists look at pictures without considering their content, we would expect "Other Criteria" to deal with what pictures depict. But that is

15. Steinberg, *Other Criteria*, 68, 84.

16. He has discussed feminism in an essay I read only after this chapter was completed, "Steen's Female Gaze and Other Ironies," *Artibus et Historiae* 22 (1990): 107–28.

17. Steinberg, *Other Criteria*, 85.

not exactly Steinberg's procedure. He says that antiformalist analysis "demands consideration of subject and content . . . of how the artist's pictorial surface tilts into the space of the viewer's imagination."[18] What really counts is *how* the postmodern picture presents its content, not *what* it presents. Some abstract paintings are pre-postmodern because they address a viewer who stands before the picture. Various critics after Greenberg sought to revive figurative painting. Steinberg's more subtle concern is to champion postmodern art, not because it necessarily has content of a traditional sort, but because it contains picture elements that permit us to identify our position in relation to the painting. Here, when Steinberg's argument transcends the traditional form-content distinction, it points the way to the more recent concern with pictures of pictures, which, because they may refer to both "abstract" and "representational" imagery, are neither abstract nor representational.

This was a central concern in a remarkable essay by the young Craig Owens, "The Allegorical Impulse: Toward a Theory of Postmodernism."[19] Inspired by the recent translation of Benjamin's book on German allegory and by de Man's account of allegorical interpretation, he applied such theories to contemporary visual art. Recognizing that the formalist theories treating the artwork as a perfect unity—a symbol—were outmoded, he claimed that from Manet, Courbet, and Baudelaire onward modernism was involved with his very postmodernist play with art as an impure (i.e., allegorical) mixture of text and image. The break in art's history that Steinberg finds in the late 1950s is now displaced backward historically. Owens constructs a counterhistory, in which Manet, Rauschenberg, and the then-young artists he admired (Laurie Anderson, Cindy Sherman, and Sherrie Levine) constitute an alternative tradition. Insofar as Owens himself allows that the theories of allegory he admires are essentially antidevelopmental, refusing to read into the world the structures of one-thing-leading-to-another of formalism, what seems oddly blind is his refusal to consider the inevitable consequences of any such analysis.

Sensitive to a double (i.e., an allegorical) reading, how could he fail to recognize that his text, in which unknown artists were linked with figures of a great tradition—in a narrative that aspires to replace Greenberg's famous writings—served a promotional function? "Other Criteria" was potentially more sensitive to these issues, which Steinberg did not pursue. It begins

18. Ibid., 82.
19. *October* 12 (1980): 67–86, and *October* 13 (1980): 59–80.

with some remarks about the artmarket, ideas that perhaps had less influence than the account of the flatbed because their connection with that more memorable part of the essay is not developed. Steinberg contrasts speculators, who, by treating art as investment fail to deal with it as art, with those other "Americans who assimilate art by actively changing it, by . . . adapting it to native criteria. Theirs is the opposite of the investor's game."[20] Here, we now know, he could not have been more wrong, for nothing was more likely to make the work of Johns, Warhol, and Rauschenberg good investments than to claim that they are the most important artists of the early 1960s because their postmodernist art radically breaks with the past. Like successful capitalist entrepreneurs, they succeeded because they were good innovators. Again Steinberg finds discontinuity where in fact we can now see continuity. His chosen artists succeeded because they were as original as were the abstract expressionists Greenberg championed.

An instructive example of such problems (which are built into the tricky, very misleading concept of postmodernism) appears in Fredric Jameson's elegant, highly influential essay "Postmodernism; or, The Cultural Logic of Late Capitalism." He defines postmodernism by the development of what he calls schizophrenic prose, "a breakdown in the signifying chain," which makes "this present of time . . . overwhelming, which effectively dramatizes the power of the material . . . signifier in isolation." Unable to "unify the past, present and future," the schizophrenic can only experience pure present; and something like that occurs also in postmodernist writing, though Jameson is at pains to note that these writers are not themselves schizophrenics.[21] Postmodernism thus is not what comes after modernism, in the way that post-Impressionism comes after Impressionism and before cubism—it is the necessary end point of tradition. It is hard to see what could emerge next from art that demonstrates so profound an inability to think temporally.

To the extent that such postmodern art really has an impoverished sense of experience, one true to the life-style of what Jameson calls late capitalism, we would perhaps at most hope that it could be succeeded by more authentic artmaking. Jameson focuses on one example, Bob Perelman's poetry. When I read his essay some years ago, I wrote to Perelman, who kindly provided me with an exegesis for a number of the texts in his book *7 Works*.

20. Steinberg, *Other Criteria*, 82.

21. This 1984 essay is now reprinted in his *Postmodernism: or, The Cultural Logic of Late Capitalism* (Durham, N.C., 1991); quotations, 26–27.

Perelman did not mention Jameson, but what struck me is how his book is full of precise references to particular texts, and so can only be understood by someone who is willing to go outside the present. His "Essay on Style," for example, has two narratives, Mozart teaching composition to the daughter of a duke mixed with a description of an orchestra, into which, he wrote to me, "I slowly molt into the ducks quacking." I grant that the beginning, "Above all, odor enables an animal to convey messages which can be deciphered in its absence and after a considerable lapse of time," seems initially unconnected with the account of musical performance and composition, in which Mozart complains: "Everything has to be done by rule. She has no ideas whatsoever—nothing comes." But surely it then becomes clear that Mozart's frustrations ("at last, with great difficulty," he is quoted as saying, "something came, and indeed I was only too glad to see something comes for once") are connected with the last line, which I like a lot: "Courage is the strength to endure a clump of trees."[22]

Here the appearance of chaos merely reflects an inability to see the structure of this poem, which is in its way as formal as one of Baudelaire's. Perelman's so-stylish essay is concerned with both the theory of style and its exemplification. Jameson, like many infinitely less-gifted commentators faced with an artwork whose ordering principles are unfamiliar, prefers to find no order rather than search for some unfamiliar ordering principle. In criticizing Steinberg's classical essay, I have not offered any detailed alternative position. This discussion of Jameson's essay explains that omission. What I believe characterizes art criticism today is a deep suspicion of such grand plans.

Of course, it is possible to claim that my desire to avoid grand theorizing of the kind I have criticized amounts in the end to taking the same position. But what I am trying to do is not to offer such a counterproposal, but to suggest that right now art criticism can more profitably turn to other concerns. Plans like Steinberg's and Greenberg's always threaten to confuse the rhetorical structures of artwriters' texts with the real order of events in the world. The need to construct a plausible narrative is a very real one, and so how natural it is to think that our texts describe an actual order in the world. The very contrast upon which Greenberg and Krauss rely, that between the superficial appearance of multiplicity and the reality of unity, indicates this problem. While it is easy to understand how a text can move from description of that confusing multiplicity to the revelation of the order

22. All quotations from Bob Perelman, *7 Works* (Berkeley, 1978), 13–20.

behind appearances, it is harder to know what is meant by their shared claim that this is how the world really is.

Why think that here the structure of a mere text must mirror that of the world? Much traditional philosophy argues that the structure of knowledge does mirror the structure of the world. This view of texts, a natural consequence of that tradition, is a belief artwriters would do well to give up. Texts have a structure, and the aim of rhetoric is to understand how they work. Students of creative writing are aware of these problems, which is why I believe, at this moment, art critics can learn from poets.

Baudelaire's writing is immensely suggestive for thinking about these issues. In his poetry, as in his art criticism, one crucial problem is how to handle transitions, a concern familiar from Benjamin's commentary on what he identifies as the poet's response to the shocks associated, so he believed, with contemporary urban life. By "transition" I mean either a temporal or a spatial movement. At the simplest level, transitions occur when I try to relate two different places, imagining how, for example, my study in Pittsburgh stands in relation to studios of friends in New York, or to Adrian Stokes's house in London, or to some frescoes I have seen in Italy. Another form involves thinking of how places that I return to appeared different when I was younger. Ultimately of course these two problems are almost the same, for what concerns me in looking backward is my present memory of places I visited at earlier times. To say we are at home in a place means that we can handle the transitions viewing it demands. To say, as some postmodernists do, that we are all, figuratively speaking, homeless in the contemporary world is to indicate in a very literal way the psychological consequences of being unable to orient ourselves.

The idea that modernist art invokes such shocks appears in one of Walter Benjamin's sources, Georg Simmel's 1903 essay "The Metropolis and Mental Life." Listing "the rapid telescoping of changing images, pronounced differences within what is grasped in a single glance, and the unexpectedness of violent stimuli," Simmel argues that "the metropolis creates . . . the sensory foundations of mental life" and therefore also, one might infer, the basis for Impressionist art and the poetry contemporary with it.[23] He is concerned with the formal aspects of modernist art, not merely its content.[24] Manet's *Olympia*, shocking to contemporaries because

23. Georg Simmel, "The Metropolis and Mental Life," in *On Individuality and Social Forms*, ed. D. N. Levine (Chicago, 1971), 325.

24. See Howard Stern, *Gegenbild, Reihenfolge, Sprung: An Essay on Related Figures of Argument in Walter Benjamin* (Bern and Frankfurt am Main, 1982).

she faces off the viewer, today has become just another masterpiece. Losing its alarming content, it could be placed among old-master nudes.

Writers interested in Benjamin's ideas might consider the relation between the experience of art in the galleries and museums of New York and its urban setting, focusing on the dramatic contrast between the streets, where there is some practical need to be alert, and the different experience of contemplating artworks.[25] One shock comes in moving from Broadway, covered with busy stores, to the SoHo galleries immediately above. This requires a transition as complex as (though very different from) that which concerned Adrian Stokes in going between the unaesthetic Edwardian London of his childhood and the paradise for aesthetes that he found in 1920s' Italy. When downtown artists attract recognition, they make their way into the Whitney Biennial, where the more rebarbative work does not ever seem to fit, not in that neighborhood of the haute bourgeoisie. By contrast, when on my way to Paris I saw at one of the grand art dealers of the Upper East Side a guillotine in an exhibit of Revolutionary French art, how could I not think it appropriately set among the befurred ladies who admired, as if it were a sculpture, this instrument linked to what eighteenth-century aestheticians called the sublime, terror pleasurable when the observer is at a safe distance.

Describing these transitions as shocks that stem from connecting works in unexpected ways to other art or to their setting may be somewhat misleading, for it implies that these experiences are unavoidable. But since experience without transitions is almost inconceivable, their shock is really necessary. This is one reason to be skeptical about Jameson's view of Perelman. Shocks are unavoidable in a text when a change of subject occurs, though successful writers, like successful classical composers, tend to make transitions seem inevitable. What is at stake in artwriting is finding ways of negotiating the shocks that necessarily occur when a text changes direction. Those negotiations are needed both when dealing with temporal movements, relating a contemporary artwork to earlier paintings, and in handling spatial movements, setting the work in its place within the city. In retrospect the 1940s through the 1960s seems the golden age of American art, a time in which the great achievement of abstract expressionism was extended by artists of the next generation. The crisis of American painting in the 1970s came because no one had a reliable model of how to think about such transitions.

25. See Chapter 4, above.

If it is a matter of fact that art changed its vantage point in relation to the spectator with the advent of postmodernism, then how could any intelligent person fail to see that? The inability to properly see such paintings that reorient the viewer would be absolutely inexplicable. When, however, we recognize that the reorientation really exists only in the texts in which the postmodernists have presented those pictures, then things appear different. Steinberg is trying to get us to see these artworks differently, to believe in his shocking transition that marks the origin of the postmodern. In his text that transition is indeed shocking, and so it takes some reflection to recognize that what "Other Criteria" provides is but one way of narrating experience of the art it describes.

This is why my criticism of Steinberg really is so closely bound to praise of his work. As I have said, this extraordinarily effective rhetorician failed only if we think that his text is describing the artworld as it really is, not as it is presented in his narrative. But does he really claim otherwise? Steinberg was absolutely right to see that color-field painting had no future, that the revival of figurative work had little interest, and that the young Johns had grand prospects. But from our vantage point, almost a quarter of a century later, things appear different. In the end, Steinberg anticipates my concern to put his work aside: "American art lovers come with built-in obsolescence. I think we all do."[26] He is right, for we have come to the end of his era. If "Other Criteria" inspired a generation of critics, today, when its power to inspire has been exhausted, we are as much in need of turning to other approaches as was Steinberg's audience in need of the alternative to Greenberg's formalism. Now that his conception of postmodernism is dated, it is time to move on to new ways of describing contemporary art. Postmodernism is dead! Long live Leo Steinberg.[27]

26. *Other Criteria*, 63.
27. I refer only to his vision of contemporary art. In art history the impact of his conceptions is only beginning to be felt. I am indebted to Leo Steinberg for commenting on the original version of this chapter in some detail; he has given me permission to reproduce the following portion of his comment:

Speaking of Baudelaire—one of my "errors in points of detail" (your p. 167). Your selective snippets from the Baudelaire paragraph I quote on p. 64, *Other Criteria* omit the crucial sentence: "Voluptuous or terrible, that figure owes its charm solely (!) to the arabesque it describes in space." It was this sentence and, above all, this "solely," that led me (I still think correctly) to characterize the passage as precociously "formalist." That Baudelaire elsewhere encourages the feelings of rakes and executioners is not relevant. But your omission of the above crucial sentence is relevant to your agenda.

In my reference to the "Feminine Mystique" (*Other Criteria*, p. 68), I was evidently too elliptical for comprehension. At least it seems pointless to you (your p. 171). The argument was simply as follows: According to Greenberg's reading of Kant, the advancing self-definition

of any discipline requires that it relinquish whatever is not uniquely its own. So painting has to jettison whatever it shared with other arts (narrative, sentiment, sculptural or spatial illusion, etc.) in order to define itself in its proper sphere. I called this a 'contractionist impulse' and suggested that you don't need to go back to 18th-century German epistemology to observe that impulse in action. "Nearer at hand," for instance, was the post–World War II advertisers' campaign to persuade women that what they needed for complete self-fulfillment was to cultivate only the quintessentially feminine. Self-fulfillment therefore demanded withdrawal from anything that women might share with the other sex, such as jobs and career. This program of self-definition, to be achieved by paring down to your essence, is what Betty Friedan called the "Feminine Mystique." And my point was that Greenberg's painterly mystique is, in its logic, not dissimilar. Of course, I was being ironic, trying to show only that the reductionist *pattern* of Greenberg's thought might be analogous to programs less remote and less exalted than Kant. Nowhere did I invoke even a hypothetical "Kantian view of women."

One final point. On p. 167 of your article, I find the phrase "Steinberg's followers." As my trusty assistant—typing this letter as I dictate—blurted out: "Who the hell are they?"

Part III

The Practice of Art Criticism in the 1980s

10

Painting into Depth:
Jonathan Lasker's Recent Art

Pressed to indicate in a phrase what was unique about Jonathan Lasker's art, I would say that he shows how purely abstract painting may be composed in layers to create a satisfying tension between surface and depth. Count forward from the rear of his space: (1) the deep background, a field of stripes or other allover decorative surface; (2) several object shapes placed before that background; (3) heavy, usually black, drawing on or in front of those objects. Modernists flattened the picture space so that even depicted forms (Klee, Dubuffet, Diebenkorn in his representational period) inhabit a place too shallow to contain more than the outlines of those figures. Lasker moves in the reverse direction. Because his space contains plenty of open room, he can place in a picture a whole array of nonrepresentational forms.

In one interesting way Lasker's work is like old-master art. Raphael and Poussin needed a deep space to place the stars, bit players, and landscapes of the stories they told, and the aim of formalist art historians was to spell out how that composition in depth tells a story, the formal elements amplifying the meanings of the illustrated text. My 1-2-3 movement through

Lasker's space already provides the bare bones of a similar discursive description, but the problem here is determining how the story of that looking is to be narrated. Compare Wölfflin's great analysis of Raphael's *Expulsion of Heliodorus:* "There is a great void in the middle, with the decisive action taking place at the extreme edge." The fallen Heliodorus at the extreme bottom right is balanced by the climbing boys in the middle background, who "lead the eye into the picture, towards the center, where we discover the praying High Priest." The void at center front is, we dramatically recognize, thus filled, and so the "theme of imploring helplessness" is given this happy resolution.[1] The High Priest cannot know, as do we who follow the movement into depth, that his prayer has been answered.

To explain that *Ascension* (Fig. 2) contains brown receding parallels on a yellow background, two windowlike forms on the far wall, three object shapes before this background, and drawing on two of those shapes is not to provide an equivalent account. This sequence of described eye movements by itself tells no such story. Because Raphael illustrates a text, his picture has a natural viewing order. I can talk about *Ascension* in similar terms only by allegorizing, identifying an image of a stage set that is occupied by "actors," Lasker's three object shapes. So doing may be unavoidable, for how may the otherwise unidentifiable forms be described except by reference to their resemblance to known things? Still, the risk here is that such identifications are highly personal and thus completely arbitrary. My identifications might be meaningless to you. Such allegorizing implies that abstraction as such has validity only because it suggests some imagined scene.

One tradition of formalist analysis confidently asserts that knowing the story behind a representational picture is irrelevant to judging it aesthetically. Analyzing a work he thought by Poussin, *Achilles Discovered among the Daughters of Lycomedon,* Roger Fry refused to even mention the story—Ulysses discovers Achilles "in drag" by his picking out of a sword from among the trinkets the women fondle—until he has described the formal arrangement of the figures composed in the interior of a great room.[2] Still, even though he denies that this story is aesthetically relevant, he can structure his narrative by first describing the formal composition and then telling the story. For Lasker's critics, no such story is available, which means that we

1. Heinrich Wölfflin, *Classical Art,* trans. P. and L. Murray (London, 1952), 101–3.
2. Roger Fry, *Transformations* (1926; repr. Garden City, N.Y., 1956), 23–26.

Fig. 2. Jonathan Lasker, *Ascension*, 1983

must find another way to tell of the eye's movements. This is not an entirely new problem.

The most important tool of the Renaissance critics was *ekphrasis*, that figure of speech which verbally evokes a painting by making its subject "as real for the reader as it is for the viewer."[3] Vasari tells us that Giotto's fishermen look patient and that Leonardo's Judas is obstinat, a procedure which presupposes that these paintings illustrate some already-known text. His philosophically interesting problem with Giorgione, while discussing a lost fresco, is that he has a hard time describing a composition lacking such

3. Svetlana Alpers, "*Ekphrasis* and Aesthetic Attitudes in Vasari's *Lives*," *Journal of the Warburg and Courtauld Institutes* 23 (1960): 193.

a text: "Here there is a man, there a woman, in different attitudes; one has the head of a lion beside him, another is an angel, but rather resembles a Cupid, so that one cannot divine what it all means. . . . [I] have never been able to understand what they mean."[4] Today also, critics need to tell convincing stories when the work being described resists easy categorization. "The eye starts to see a painting only when it has begun to recount to itself the story of its looking." Criticism guides the eye by telling an apt story, fulfilling the demand: "If the work wants to be fully visible, it must encourage the eye."[5] But our stories are narratives about the history of art.

Not only abstractions require such stories, as Wölfflin's account of the Raphael again illustrates. I presented that text as a reconstruction of one painting, but it is motivated by a historical analysis. A quattrocento painter would have first shown the praying High Priest and then, in another work, the prostrate Heliodorus. Raphael combines these scenes. For the public of that time, the greatest surprise must have been how he did so, since nobody expected to see the principal action anywhere but in the center, where Raphael creates a void. The drama in this painting is in part defined by this break with traditions of composition, which is to say that seeing the picture properly requires placing it in art history. What an *ekphrasis* for contemporary art requires, more generally, is constructing a narrative that points to such aesthetically relevant precedents. Meyer Schapiro is one master of such rhetoric, as when his account of a Mondrian tells of a Bonnard depicting verticals and horizontals on a Paris apartment, a Degas whose image of a woman viewing herself in a mirror "may be taken as a simile of the . . . self-consciousness that preceded abstract art and prepared its way," and a number of preabstract Mondrians. This account tells of Mondrian's place in history and thus encourages our eye to see what is happening in that Mondrian.[6] Let us tell an analogous story about Lasker's work.

We begin with his layering. Why do I see *Nature Study* (Fig. 3) as containing black line drawing on top of a layer of two standing forms placed before a brown and purple backdrop? One challenging answer to this question is given by gestalt psychology.[7] All things being equal, what we see in a painting is that imagined spatial arrangement which is simplest. A drawn line

4. Giorgio Vasari, *Lives*, trans. M. Forster (New York, 1896), 3:7.

5. Carter Ratcliff, "Fact and Fiction," exhibition catalogue for Jonathan Lasker, Tom Nozkowski, and Gary Stephan, Tibor de Nagy Gallery, New York, 1984.

6. Meyer Schapiro, "Mondrian," reprinted in his *Modern Art* (New York, 1978), 233–61.

7. Rudolf Arnheim, *Art and Visual Perception* (Berkeley and Los Angeles, 1969), chap. 5, "Space."

Fig. 3. Jonathan Lasker, *Nature Study*, 1983. Courtesy John Post Lee, Inc., New York

cutting through an enclosed form is viewed as a line standing before a sur-
face, and a series of lines of uniformly decreasing length mark parallel
planes in depth. Pictorial illusionism is thus a byproduct of our need to
visually simplify. So, in *Ascension*, the brown parallels mark out receding
planes parallel to the picture surface; in *Strawberry Fields* (Fig. 4), a purple
line appears to weave over one shape, bottom right, and behind another at
the top left because we assume that those shapes identify whole objects.

A change in eye focus is needed to move from the receding parallels in
Ascension to the black lines drawn on top, not just because of the different
positions of those forms in the illusionistic space but also because the eye is
grasping different sorts of things. One reason that Lasker's are "slow"

Fig. 4. Jonathan Lasker, *Strawberry Fields,* 1983

works is that we need time to make our way through these layers, synthesiz-
ing forms that seem physically distant and appear diverse. While Lasker's
backgrounds are expansive, his object shapes are compact and look solid;
the drawing typically is both larger in scale than those shapes and defines
open or hollow spaces, permitting us to look through to what we imagine as
the space beyond.

He paints works as small as *The Trophies* (12″ by 14″), as well as large
paintings. Since his object shapes and drawing tend to remain relatively
constant in absolute size, in the smaller works they may cover almost the

entire surface, while in the big paintings they become localized visual incidents. These object shapes appear as things we might heft using both hands, while the drawing is almost small enough to be the product of arm gestures; thus seeing how Lasker makes these marks gives us some hints about the implied scale of his spaces. Where Raphael or Poussin takes us into depth by indicating the scale of represented things, Lasker does so by appealing to this information about the making of his mark. Modernism is, of course, very often involved in calling attention to such literal qualities of its medium, but what is idiosyncratic in Lasker's work is his doing so in order to show us how to imaginatively traverse a deep illusionistic space.

Lasker is obviously a master of these gestalt laws, but what exactly is the artistic significance of works utilizing such visual effects? Here my *ekphrasis* draws on some examples from the history of early modernism. Matisse's most pregnant discovery was of the all-pervading nature of color, which, unconstrained by line, appears to expand indefinitely.[8] This self-sufficiency found in his subject matter and in what we infer of his personality—he said once, characteristically, "I am only interested in myself"—found its natural fulfillment in that American color-field tradition so influenced by him. Lasker's backgrounds are Matisse-like, expansive and decorative, but placing object shapes before these backgrounds breaks up that space and creates a visual tension as the eye moves forward between literal flatness and perceived pictorial depth. Such of course is the result produced by any drawing, but what is specifically meaningful in Lasker's composition is his refusal to aim for flatness.

Much postmodernist art (whose makers would be horrified to be called modernists) achieves the same effect as modernism in different ways. A quoted image, like a color field, tends to appear flat. We read any illusionistic depths in that image as if placed in quotation marks: we see not a deep space but a flat image of an image of such a space. Bringing together quotations from baroque sculpture, early Chagall, and the comics, all reproduced, collaged, and reassembled, creates an exercise in pattern recognition for the viewer. Identifying those quotations is somewhat like recognizing the face of a friend who has aged, taken up wearing glasses, and grown a beard.

By contrast, Lasker asks us to look into a deep space, like that of the Poussin as described by Roger Fry, in which all the specifically representational references have been excised. Thus characterizing such different kinds of works is neither to praise the one nor to criticize the other, but to

8. Lawrence Gowing, *Matisse* (New York and Toronto, 1979), 111–14.

indicate how the key division helps to bring Lasker's particular visual concerns into focus.

An *ekphrasis* requires not only visual contrasts but also parallels. Contrast to Matisse another artist, also a "representational" painter, whose visual concerns have deep affinities with Lasker's. Morandi varies the positions of his bottles with infinite care, and negative shapes frequently look as real as those depicted objects (as do, occasionally, the shadows). In several daring works the background comes forward until placed as if in front of the objects themselves. Morandi's color is color of forms, unlike Matisse's free-floating field color, which is why in a relatively shallow picture space these plays into depth carry such resonance. To identify a color area is simultaneously to imaginatively position the corresponding object; thus ambiguities of color also become ambiguities of spatial composition. As in Lasker's pictures, we see forms depicted as if in layers, and we must link together these seemingly distant elements. We are not engaged in the practical activity of identifying real objects or images of them, but in playing between depth and surface. In everyday perception one may of course see Morandiesque bottles, just as in Proust the women so often appear like those of Botticelli or the landscapes as if by Monet. But what is distinctively artistic, in Morandi and in Lasker as well, is the awareness that the identified forms have meaning only as elements in an artwork.

This observation takes us to an explicit discussion of the content of Lasker's paintings. So far, I have talked about how we look into his spaces, but now something must be said about what we see there. It may help to characterize his content in negative terms: we do not see whole or fragmented human forms; nor the floating biomorphic shapes of abstract surrealism; nor the straightedge things that may in other art refer to ideal geometries. Some abstract paintings, Thornton Willis's trapezoids for example, look portraitlike, while many others are landscapes of the mind; Lasker's suggest, rather, a man-made space, a proscenium in which his shapes and drawings are to be placed. This may explain why the link to Morandi is so suggestive. Unlike landscape painters, still-life artists are always involved with inherently artificial compositions. Chardin cannot, like Constable, pretend to present some already-existing scene. Lasker's works are too large in scale to be allegorized as still-life scenes, but the content of his work suggests not "nature" but the artificiality of a stage setting.

Lasker's contrast between lines and object shapes formed of color masses invokes some familiar "codes" of art relevant to his content. The contrast between line (which is rational, definite, and appeals to the learned who

know about self-control) and color (emotional and irrational, the subject of much discussion in the seventeenth-century French Academy) continues to be relevant to art today, as when color-field painting is found overly self-indulgent.[9] Lasker's layering in effect synthesizes these two apparently opposed ways of defining space, and thus makes this traditional contrast between line and color part of the content of his art. Bracketing his line and color elements within a stage-set background, he asks us to contemplate their art-historical significance.

Often enough, contemporary art is praised for its self-conscious use of its medium, an ahistorical judgment which absurdly underestimates the old masters. What were Raphael and Poussin if not self-conscious about their goals? More useful is the contrast between an art whose content tells the story (which criticism retells in the analysis of composition) and contemporary works like Lasker's whose content becomes a vehicle for depicting a scene rich in art-historical references. These ambitious and stylish paintings are very contemporary in their sophisticated understanding and appropriation of the traditions of art. Highly original in conception, they mark the emergence of one younger master of abstraction.

9. See Anthony Blunt, *Art and Architecture in France, 1500 to 1700* (Harmondsworth, 1973), 292.

11

Descriptive Abstraction:
Ron Janowich's Recent Paintings

Several years ago there was a revival of interest in abstract painting. But although some individual painters became well known and there were many groups shows, little serious thought about abstraction was in evidence. Indeed, apart from a sequence of unjustly neglected articles published a decade ago in *Artforum*, I know of no good sustained discussion of post-Greenbergian abstraction.[1] With one exception—the 40th Biennial at the Corcoran in Washington—none of the group shows I had the opportunity to see were effective, even when some of the individual works displayed were excellent.[2] Where Impressionist landscapes or baroque paintings mutually enhance one another, abstract works do not easily love one another. Most abstractionists do better when their works are seen in relative isolation. Why is this the case? Unless our artwriters can provide some ways of understanding abstraction, our artworld—whose attention span is never very long—will merely await the next fashionable movement.

1. I refer to Joseph Masheck's "Iconicity" articles reprinted in his *Historical Present: Essays of the 1970s* (Ann Arbor, 1984), chaps. 16–20.
2. See my review, "40th Biennial: Corcoran," *Burlington Magazine* (July 1987): 483–84.

These group shows and discussions with David Reed provoked me to think about the diverse ways recent abstraction uses the materials provided by art's history. While such very different figures demonstrate how rich and diverse contemporary abstraction is, artwriters have not found any really effective way of describing their achievement. There is something perverse in the fact that even as abstract artists aspire to work in the great tradition of American painting, the writings of the most fashionable theorist, Jean Baudrillard, have been interpreted by his best-known American followers as denying that there can today be abstract art.[3] But whatever the sociological interest of artworks that claim to "represent" the structures controlling the circulation of signs in postmodern society, few I have seen really deserve much attention as art. As Ron Janowich has said, "signs are not paintings," and if we accept this distinction then the real question is how to understand genuine contemporary abstractions. Nobody is willing now to return to a Greenbergian analysis, but whatever the defects of formalism it did provide a specifically visual analysis, which is missing in most recent artwriting.

One model for postformalist accounts that is sensitive to historical issues is Gilles Deleuze's reading of Francis Bacon. "The manner in which grand painting . . . recapitulates the history of painting is never eclectic. It doesn't correspond directly to periods of painting. . . . It corresponds rather to separable aspects in the picture."[4] My present discussion of Janowich's work, which both contrasts it to some earlier abstract art and links it with an earlier tradition of representation, borrows from Deleuze. If now abstraction is to be something more than just one of the almost endless number of styles open to an artist in this age of pluralism, then a historical perspective is needed. How can an artist like Janowich build upon and extend art's traditions?

Much can be learned about any abstract painter by asking what old masters she or he responds to most deeply. Posing this question is one way of providing the needed historical framework. Knowing of Sean Scully's interest in Duccio's *Maestà*, I could understand his concern with frontally placed, fundamentally flat images. His art has a lot to do with early Johns, and—contrary to what has been claimed—has no relation to what in bad reproductions it may slightly resemble, Stella's very early stripes. Reflecting upon David Reed's fascination with the colors and ambiguous space of Beccafumi

3. See Chapter 5, above.
4. Gilles Deleuze, *Francis Bacon: Logique de la sensation* (Paris, 1984), 87.

Fig. 5. Ron Janowich, *Hymnuss (VIII)*, 1987. Collection of the artist

and the Neapolitan baroque, I could grasp his fundamentally opposed conception of abstraction.

Such stylistic influences constitute what, following Deleuze, can be called the separable aspects or, as I prefer to say, the style of a painting. It is because contemporary abstract artists draw on such diverse styles that mixing their art in group shows is usually a mistake. No museum would willingly place its Venetian paintings in the same room with its post-Impressionist works. With those older masters, period labels provide a good indication of stylistic affinities: the works of Titian and Tintoretto go together, and even the paintings of such opposed contemporaries as Gauguin and Cézanne enjoy each other's company. With a contemporary abstraction this is not the case, for this art employs a diversity of styles.

The failure of these recent group shows thus demonstrates a failure to understand the nature of style in contemporary abstraction. Our abstract artists are influenced by art of many different periods, and so grouping their work under the rubric "recent abstractions" is not wise. When I speak of such influences I am not thinking of image appropriations, which almost always involve a trivial conception of what is to be learned from the past. I am interested in how an artist forms a style by learning from earlier art. Since the style of an artist's work is not defined by its appearance, stylistic affinities are not determined merely by visual similarities.[5] What counts, rather, is an artist's conception of how earlier masters have used the medium in ways that now are relevant to art. Were some museum to ask me to curate a show of recent abstraction, I would seek to display stylistic affinities and differences. Put Scully alongside Johns; place Reed next to a Sienese mannerist; juxtapose Quaytman to Malevich. Much could be learned about the quality of contemporary art and its range of stylistic possibilities from such an exhibition.

In this imaginary exhibition I would place Ron Janowich's work next to a late Rembrandt. When I first met Janowich a few years ago, he spoke with enough passion about Rembrandt to send me to Amsterdam to look at the works of an old master who had never especially interested me. I learned something about Rembrandt and, what here is more immediately relevant, came to understand what in him attracted a young painter working in New York. Since Janowich is not painting portraits, scenes from sacred history,

5. Here I borrow from Richard Wollheim, "Style Now," in *Concerning Contemporary Art: The Power Lectures, 1968–1973*, ed. B. Smith (Oxford, 1975), chap. 5.

Fig. 6. Ron Janowich, *Untitled,* 1987. Collection of Mr. and Mrs. George Baril

or landscapes, what meaning could the techniques of an old master have for him? The painterly technique of Rembrandt's later works will attract modern observers; our eyes have been trained on Soutine and de Kooning. But there is something more specific to Janowich's interest in Rembrandt: he is fascinated with Rembrandt's use of oil paint to create finely textured, glistening surfaces, and especially with *Slaughtered Ox.*

If Janowich uses paint to create textured light, his stretchers, which support symmetrical, visually stable compositions, suggest trecento altarpieces. This is especially true of the small works. Here again Deleuze's notion that we consider the separable aspects of painting is helpful. Certainly Janowich is aware of these precedents, and part of the richness of his own works consists in bringing together this "primitive" frontalism and Rembrantesque, textured light. But the resulting effect is certainly not additive. Just as he is not concerned with Rembrandt's interest as a history painter, telling a story, so there is nothing especially sacred, to my way of thinking, in this invocation of altarpiece format. It is true, I grant, that Janowich, like the trecento painters, wants us to attend closely to a shaped structure, but that parallel does not take us very far. Trecento sacred works echo their intended setting, the architecture of churches, while the natural home of abstract paintings is the visually neutral space of a gallery; for Janowich implied architectural references must function differently. Just as his abstract painting itself carries no specifically sacred references, though it may borrow techniques from sacred art, so the change in setting means that these allusions to the shape of altarpieces have art-historical but not religious meaning.[6]

A better way of understanding what is distinctive about Janowich's works comes from contrasting them to other recent abstract paintings that use shaped stretchers. Whether he uses a rounded semicircle at the top of the picture or a horizontal bar cutting across a diamond, his shaped frames have very little to do with the shaped frames used by Noland or Stella in the 1960s. They, Michael Fried observed, used the shaped frame to create a novel kind of illusionism. Where in a traditional painting illusionism involves ambiguous depth, here shape itself becomes ambiguous. What we seem to *see as* a triangle penetrating into a square in a 1960s' Stella *really is* an oddly shaped polygon. That frame draws attention to itself. Indeed, in a sense the painting is entirely defined by that frame. For Janowich this is not

6. Stella writes: "Caravaggio put architecture back into its antique place . . . he . . . moved it backstage so that it would not interfere with pictorial drama" (Frank Stella, *Working Space* [Cambridge and London, 1986], 33). In my opinion, this ahistorical misinterpretation of baroque art explains why Stella's own *literal* space in his art of this decade is generally unsuccessful.

the case. His shaped frames are good gestalts, symmetrical forms that, without dramatically calling attention to themselves, serve to enclose color.

Color in 1960s' color-field painting, Janowich has complained, lacks emotional or spiritual content. Leo Steinberg described Noland's late-sixties' pictures as "the fastest I know." That may help explain why this art lacked staying power.[7] Because the color was just a filler for a shape, it was not worth prolonged attention. A more interesting use of the frame, worth describing here because of the contrast with Janowich's, is provided by the recent work of Harvey Quaytman. He plays areas of color against the rectangular shape of his frames, which sometimes are turned ninety degrees to make diamonds. Quaytman uses the frame in order to illusionistically extend the implied picture space beyond the boundary of his frame. For Janowich, the frame itself can be visually inert because it is the boundary of color.[8]

Within that frame, there often appears a drawn semicircle echoing the shape of the top of the frame. And in the more recent works, and most especially in the monotypes, painterly gestures run across that space within the frame. The monotypes, Janowich has acknowledged, have had a major influence on his more recent painting. Because he could not glaze them, they allowed or forced him to learn to give his marks greater freedom. And so now the range of stylistic possibilities within the recent paintings has been enlarged. Some works use areas of color, such as a red-on-red square, within a polygon; a number of others allow white or black marks to run across the canvas in a very free way. *Shadow Dust* displays one of Janowich's most interesting stylistic possibilities, the use of an allover pattern with the shaped stretcher. His recent art opens up numerous directions for exploration.

Lines drawn inside and echoing the shape of the picture frame appeared in some earlier American abstract painting, where they played a different role. In Motherwell's images, Joseph Masheck has noted, a depicted rectangle serves as both "a pictorial reference to painting and an abstract allusion to the way a painting hangs down on the wall against the pull of gravity."[9] Janowich's paintings appear as heavy as they really are, and so have no need to allude in this way to the force of gravity. For him, this element of the painting has a different meaning. Whether his markings echo the shape of

7. Leo Steinberg, "Other Criteria," reprinted in his *Other Criteria: Confrontations with Twentieth-Century Art* (New York, 1972), 80.

8. See my "Harvey Quaytman's Recent Paintings," Galerie Nordenhake (Stockholm, 1987).

9. Joseph Masheck, "Pictures of Art," reprinted in *Historical Present*, 184.

the frame, or conversely, in some recent works, deny its shape, in either case they function to create a place within that frame which demarks light from darkness. Here is an element he borrows from Rembrandt. He renders abstractly working *across and into the surface* of his painting, where Rembrandt shows a movement of shadowed forms *into depth*. Janowich's frames are containers; they appear to hold that source of illumination which irradiates the entire picture space.

This effect is not unfamiliar in earlier old-master art. Describing light and texture in fifteenth-century painting, Gombrich writes: "The painter will have more scope for light-effects the darker he keeps the general tone of the picture. He must sacrifice his enjoyment of bright colours if he is to suggest brightness."[10] On the whole, Janowich too sacrifices bright colors to display his illuminated textures. Since his paintings look very different from those Gombrich is discussing, what does it mean to identify such relationships between Janowich's concerns and those of some quattrocento masters? Meyer Schapiro's friendships with the French and American modernists in the 1940s inform his writing. Discussing a seventh-century carving, the *Ruthwell Cross*, he replied to a critic who asked whether Schapiro's characterization of the carved figure as a secular image did not imply that it was merely decorative: "If by that he means to say that I deny to the figure any value or significance beyond the contribution of its form to the rhythm of lines and of light and dark on the Cross, he misunderstands me. . . . The alternatives are not . . . religious meaning or no meaning, but religious or secular meanings, both laden with affect."[11] Analogously, I am saying when I compare Janowich's paintings to Rembrandt's, the alternatives are not either to seek representational meaning or to find no meaning, but rather to look for explicit representational meaning *and* meaningful abstract forms, *both* laden with affect. Since the meanings of his stylistic elements are defined by the history of their use, here a more extended historical perspective is essential.

Starting with Vasari, a good deal of art-historical writing is concerned to distinguish Northern and Italian art. Within old-master art there are two ways of narrating the depicted story: the Italian manner, in which what is outward—gestures and facial expressions—expresses the inner emotion

10. "Light, Form, and Texture in Fifteenth-Century Painting," reprinted in E. H. Gombrich, *The Heritage of Apelles: Studies in the Art of the Renaissance* (Oxford, 1976).

11. Meyer Schapiro, "The Religious Meaning of the Ruthwell Cross," reprinted in his *Late Antique, Early Christian, and Mediaeval Art: Selected Papers* (New York, 1979), 179–81.

proper for a story; and the Northern tradition, which refuses to employ that manner of narration. If this contrast characterizes Northern painting in a merely negative manner, that too reflects a long tradition, as Gombrich indicates in his description of Wölfflin's lectures that he attended as a student: "Once and again an Italian work of classical poise appeared on one screen to be contrasted on the other with a German work which lacked these characteristics."[12] Because Vasari's account of Italian art is *the* model for art history, it is natural that his successors would employ such a contrast.

Here Rembrandt occupies a special role, for he, the most Protestant of Protestants, refused to travel to Italy. What his art reveals, it is commonly said, is an inner spiritual world whose depth is unknown to the Italians. "Rembrandt opened a new field . . . the world which lies behind visual appearances . . . the sphere of the spirit, of the soul."[13] The nineteenth-century painter and artwriter Eugène Fromentin expresses this idea: "For physical beauty he substituted moral expression . . . for clear, wise, simple observation, the visionary's glimpse. . . . Thanks to this somnambulist's intuition, he saw farther into the supernatural than anyone else."[14] Behind these two conceptions of pictorial narration lie deeper cultural differences. As Wölfflin writes in this published account of the lectures Gombrich attended, "every concept of form has a spiritual content."[15] The Italians love physical beauty. Perhaps they remain pagans at heart, since for them beautiful bodies express the beautiful soul within. The Northerns are unafraid of showing what is ugly.[16] Rembrandt's Northern Protestant interest in the spiritual world can then be contrasted to the manner in which his Roman contemporary, Poussin, worked.[17] Rembrandt is a portraitist of the soul it-

12. E. H. Gombrich, "Norm and Form," reprinted in his *Norm and Form: Studies in the Art of the Renaissance* (London, 1966), 92.

13. Jakob Rosenberg, Seymour Slive, and E. H. ter Kuile, *Dutch Art and Architecture, 1600–1800* (Harmondsworth, 1972), 112.

14. Eugène Fromentin, *The Masters of Past Time: Dutch and Flemish Painting from van Eyck to Rembrandt*, trans. H. Gerson (Ithaca, N.Y., 1981), 231.

15. Heinrich Wölfflin, *The Sense of Form in Art: A Comparative Psychological Study*, trans. A. Muehsam and N. S. Shatan (New York, 1958), 226. Similarly, consider the contrast of "two modes of sensibility . . . the Mediterranean and the Anglo-Saxon. . . . One favors a reserved and tight-lipped style . . . while the other gives way unashamedly to passionate outcries and vehement gestures" (Jonas Barish, *The Antitheatrical Prejudice* [Berkeley, Los Angeles, London, 1981], 245). Every modern tourist is aware of this contrast.

16. In his etching *The Good Samaritan*, Rembrandt shows a large defecating dog in the foreground. Goethe wrote an extended commentary on this work, "Rembrandt as a Thinker," which manages to avoid mentioning that dog; *Goethe on Art*, ed. J. Gage (Berkeley and Los Angeles, 1980), 207–9.

17. See my "Circa 1640," *New Literary History* 21 (1990): 649–70.

self; Poussin seeks outward bodily signs—gestures and facial expressions—which will best convey the inner feelings of his depicted figures. Gombrich makes this point when he observes that in Rembrandt's *St. Peter's Denial* "it is the absence of any 'theatrical,' that is, of any unambiguous gesture, which . . . makes us read this drama in terms of inner emotions. . . . We increasingly project more intensity into these calm gestures and expressions than we are likely to read into the extrovert gesticulations of the Latin style."[18]

This contrast between two techniques of visual narrative is relevant to contemporary art. Postmodernism—in the images of Fischl, Salle, and Sherman; in the texts of John Ashbery, Maurice Blanchot, or Bob Perelman—involves a refusal to present stories with a clear beginning, middle, and conclusion in the Italian manner. Narratives are elliptical, ironical deconstructions of a form that no longer seems viable. Poussin, he said in a famous letter, wanted his pictures to be read. He meant that literally. In *Israelites Gathering Manna in the Desert* we can read the responses of the people to the miracle. Some are thankful, others just greedily grasp the manna, still others do not yet comprehend the miracle.

Salle is our anti-Poussin. As many commentators remind us, the sequence of events in his narratives never becomes clear. The way in which postmodernism is engaged in the deconstruction of the traditional story is by now well understood. Offer clues that refuse resolution and do not allow narrative closure; display scenes whose relationship is intentionally ambiguous; present layers of almost meaningful imagery. What has, however, not been discussed is the possibility of a postmodernist extension of the anti-Italian, or Northern, tradition. This Janowich's art provides.

Just as we no longer believe that painting or literature can engage in such storytelling as Poussin provides, so also we doubt that any image can express inner states through outer expression. The soul or the mind is inside the body, and in that metaphorical way of thinking expression involves expressing, making outwardly visible what was hidden inside. The artwork can be expressive because it is akin to a person. What is on the surface expresses what is inward. In a person, that ex-pressing involves gestures and physiognomy.

"Just as the artist is made up of a physiognomic exterior and an inner psychological space, the painting consists of a material surface and an interior which opens illusionistically behind that surface."[19] Seeing Rem-

18. E. H. Gombrich, "Action and Expression in Western Art," in *Non-Verbal Communication*, ed. P. A. Hinde (Cambridge, 1972), 389.
19. Rosalind E. Krauss, *Passages in Modern Sculpture* (New York, 1977), 256.

brandt's portrayal of emotions, Gombrich implies, is like understanding the "inner world" of another person. For the contemporary reader, what now seems archaic or even incomprehensible in the older accounts of Rembrandt are the invocations of some higher inner or spiritual world. As such different commentators as Krauss and Fredric Jameson have pointed out, that concept of expression presupposes what Jameson calls "a whole metaphysics of inside and outside."[20]

How can we understand Rembrandt's art when we give up this model? The recent accounts prepare us to understand how Janowich's work draws on his style. In an article that deserves attention from art critics, Svetlana Alpers contrasts art of narration with what she calls art of description. Like Wölfflin, she is interested in contrasting Northern and Italian art. In opposition to the Italian narrative tradition, art of description involves "a suspension of narrative action . . . a deliberate suspension of action achieved through a fixity of pose and an avoidance of outward expression . . . combined with an attention to the description of the material surface of the world."[21] Courbet, Manet, and Rembrandt are involved with this tradition. In an art of description, the paint is the medium through which emotion is communicated. Now, as was not the case earlier with Wölfflin or even Gombrich, we have a *positive* characterization of Northern art. Alpers is telling us what Rembrandt does, not merely saying what he does not do.

For Rembrandt, paint is rather "something worked as with the bare hands. . . . Paint is acknowledged as that common matter, like the very earth itself in the biblical phrase, out of which the figures emerge."[22] Far from being spiritual, his art involves a materialist display of the qualities of that physical stuff. When we deny that the self is constituted by some inner world of the soul, this is a highly suggestive claim. Earlier commentators thought of his many self-portraits as displaying the rich inner world of his feelings. But far from thus displaying depth in his later works, Alpers argues, it is rather that Rembrandt "closes in—identifying self, himself, with his painting."[23] This claim interests Janowich.

The kind of literal presence that Alpers finds in Rembrandt attracts Jan-

20. Fredric Jameson, "Postmodernism; or, The Cultural Logic of Late Capitalism," *New Left Review*, no. 146 (1984): 61.

21. Svetlana Alpers, "Describe or Narrate? A Problem in Realistic Representation," *New Literary History* 8, no. 1 (1976): 15.

22. Svetlana Alpers, *The Art of Describing: Dutch Art in the Seventeenth Century* (Chicago and London, 1983), 225–27.

23. Svetlana Alpers, *Rembrandt's Enterprise: The Studio and the Market* (Chicago and London, 1988), 115.

owich, who wrote in 1981 that in these artworks "moments of elevated painting activity became meditations on the limitless potential of perceptual growth." Here, as in new abstract painting, he suggested, "the sensation of seeing is referred to as well as reconstructed on the canvas." I would explicate this comment by returning to his earlier complaint about color-field painting. "In a painting that has a flat color, where there is no surface variation of structural density, the specific area of a given color would be seen the same, be it with one eye or two." Janowich wants to get away from this essentially monocular abstraction. What he admires about Rembrandt is how he calls for a deeper response. His "paint itself did that in a completely abstract way."[24] If early abstraction is thus all too traditional in its use of depth, then perhaps art can now best proceed by looking backward. The trouble with Olitski's work, Janowich has remarked, is that the material is detached from emotion; his paintings have no "inner core." As we might expect from an admirer of Rembrandt, he finds this painting lacking in physical presence.

In a highly personal account, a remarkable anticipation of Alpers's discussion, Jean Genet wrote: "When our eyes rest on a painting by Rembrandt . . . our gaze becomes heavy, somewhat bovine. Something holds it back, weighty force. . . . Rembrandt no longer denatures the painting by trying to merge it with the object or face that it is supposed to represent: he presents it to us as distinct matter that is not ashamed to be what it is."[25] Contrary to what a false idealism would have us believe, mere matter itself possesses a dignity worthy of sustained attention. What Rembrandt's pigments demand is a patient viewer, one who is willing to let his or her eye probe into depth. That probing involves, first and foremost, a seeking out of the content of that picture. Here we come to a key question about abstraction: What value is provided by focusing attention on one separable element of old-master art? If Janowich uses one element of Rembrandt's technique, does that not mean that his work employs but one element of the many that concern that master?

24. I quote from his unpublished "Aspects of the New Painting: The Depth Phenomena" (1981).
25. I quoted the translation by Bernard Frechtman published in *Antaeus* 54 (1985): 113–16, which does not replicate the double columns in which Genet's discussion of his recognition that "every man *is* all others" is juxtaposed with his evocative narrative about Rembrandt. This parallel is all the more remarkable because, so Svetlana Alpers kindly informs me, she had not read this text when she wrote *Rembrandt's Enterprise*.

One good way to understand the mood of the artworld in the early 1980s is to refer to the concerns about anxiety of influence and belatedness as they have been described by the literary critic Harold Bloom.[26] Either an artist is stronger than his precursors, or they will crush him. (In his Oedipalized history it is natural to identify that artist as a male.) One response to this situation is to appropriate images. If we can create nothing new, then the most we can do is acknowledge the power of what went before. Janowich's different goal is to achieve a physical engagement as an "emotional complexity that will give the viewer something back." Is this possible with works that in one obvious sense seem to contain so much less than Rembrandt's: no depicted figures, no explicit sacred references, no storytelling?

Here I cannot do better than repeat what Greenberg wrote more than three decades ago. "More or less in art do not depend on how many varieties of significance are present, but on the intensity and depth of such significance, be they few or many, as are present."[27] Here artwriters, like artists, need to deal with the question of belatedness. In the 1960s, some artwriters became known as close followers of Greenberg, while others violently rejected his claims. Now, two decades later, a more measured view of his achievement is possible. It is easier for me to admit that I greatly admire Greenberg, and so am prepared to borrow from him, even as I explain why I do not think that all parts of his view of abstraction are still convincing. Just as Janowich can selectively use the history of art, so I propose to employ those artwriters' texts that still inspire conviction.

But since experience tells me that such historical comparisons as I here offer are readily misunderstood, the implications of this analysis need spelling out. The aim of my historical framework is to provide some categories that will help us to see Janowich's paintings. Unlike Bloom, I see the past not as a threat to the identity of the contemporary artist, but as a resource he or she can use. In this situation, nothing is gained by asserting that some younger artist is as great as an old master. That is merely a way of paralyzing discussion, and so of cutting us off from real experience of contemporary art. Janowich's small paintings and his monotypes ask us to look into a space momentarily accessible only to one viewer; his large paintings, reminiscent in scale and in the frontally shaped frame of Renaissance altarpieces, use similar textures to create a very different relation of spectator to work. These works deserve sustained contemplation.

26. See my *Artwriting* (Amherst, Mass., 1987), 105.
27. Clement Greenberg, *Art and Culture: Critical Essays* (Boston, 1961), 134.

12

Signification and Subjectification: The Recent Paintings of Tom Nozkowski and Gary Stephan

Most of Gary Stephan's commentators, Stephan himself included, talk about the relation of his art to power. What they are describing is in part the power of a "famous" painter and in part, also, what some think his problematic relation to early modernism. But, more interestingly, they describe the inherent power of images. These assumptions about art's power are reflected in the way that Stephan has, in interviews and in choosing analysts for his catalogues, commented on his own art. Like those of Jasper Johns, his commentators depends upon such privileged information. The shared assumption of his admirers and critics is that a crucial issue for an ambitious abstract artist in the late 1980s is self-consciousness about painting's power.

Tom Nozkowski's commentators, Tom himself not included, talk about the size of his paintings.[1] Smaller than coffee-table art books, his paintings

1. I once compared Nozkowski's images to book manuscripts ("Thomas Nozkowski's Paintings," *Arts* [October 1983]: 72–75); more recently, Joe Masheck ("Abstract Harmonies," *Art in America* [March 1988]: 138) more imaginatively compared them to the TV screen.

Fig. 7. Thomas Nozkowski, *Untitled (6-82)*, 1989. Courtesy Max Protetch Gallery, New York

rework sources from art history or nature until very often their source is forgotten, their origin impossible to determine. Whether they then be contrasted to "bad painting," or linked to a Northern tradition of manuscript illumination; whether his ceaseless search for an unpredetermined image be contrasted to the works of those artists who produce prefabricated images: in any case, his art is explained by contrasting it with what it is not. Whether because he has been less interviewed, is less famous, or desires to leave more to the viewer, Nozkowski's work seems more open to divergent commentary. Not that he is secretive. Nozkowski, the most sociable and open of painters, answers questions. But however much he says, his paintings remain hard to contextualize. No matter how intensely personal, his painting is not autobiographical.

Once Stephan's concern with the morality of art puzzled me. Today no paintings have real power, the kind of power that photographs can possess. And Nozkowski's felt affinity with abstract expressionism was equally puzzling. Neither the scale of his work nor its imagery linked it with that tradition. His art, unlike Stephan's, is obviously not concerned with power. If Stephan's power, as his commentators think of it, is sometimes believed to make his employment of the power of illusionism within pictures problematic, perhaps Nozkowski's relative lack of power permits him to avoid this issue in his art. Thus, this relative lack of power can be for him a source of strength.

In fact, Stephan and Nozkowski correctly describe themselves. But their claims need to be interpreted. The two painters are neighbors in the country, and this fortuitous contingency of geography provided me the opportunity to understand their artistic relationship. The crucial concept for Stephan is the system, or signification. The key for Nozkowski is the face, or subjectification. And the relation between Stephan's systems and Nozkowski's factlike images is revealed by Gilles Deleuze and Felix Guattari, whose writing has provided my title.

Formalist and Marxist critics ask: What did the artist intend? What sources influenced his work? How does an artwork reflect conditions of the larger society? If we think these are the right questions, then we should ask how Stephan and Nozkowski work with the traditions of abstract modernism. Do we praise them for refusing to be fashionable postmodernists, or condemn them for being insufficiently radical? But these are not the right questions to ask. To pose them leaves us stuck within a debate whose terms have not essentially changed since the 1960s.

Deleuze and Guattari ask other, better questions: How does the work produce meanings for the viewer? How does this production of meaning by the viewer draw on her knowledge of art's history? How is art's production of meaning related to the sign systems of the large culture? Judging by his writing, Stephan understands this change. Originally, I thought his 1983 article "Escher or Newman" ingeniously provocative.[2] What have Escher's so literal images to do with the works of Newman? Reading his recent interviews and looking at his recent paintings, I now see how I misunderstood his text. The artwork, he is saying, is not a self-sufficient thing of beauty that the viewer contemplates. It is a machine that calls upon the spectator to work it. Another admirer of Escher explains that his prints "compel us to adopt an initial assumption that cannot be

2. Gary Stephan, "Escher or Newman: Who Puts the Ghost in the Machine?" *Artforum* 21 (February 1983): 64–67.

Fig. 8. Gary Stephan, *On a Small Island Covered by Trees*, 1990. Courtesy Mary Boone Gallery, New York

sustained as we try to follow it through." Then Sir Ernst Gombrich says something that now seems more surprising: "This type of ambiguity will rarely trouble us in real life." "After all," he adds, "we experience the real world by moving about it, and our eyes are eminently suited to guide us."[3] But today,

3. E. H. Gombrich, "Illusion and Visual Deadlock," reprinted in his *Meditations on a Hobby Horse* (London, 1965), 144, 157.

when artwriters' theories about the indeterminacy of pictorial reference apply so aptly to the world of politics, Escher's images, and Stephan's, raise issues that do extend outside the gallery.

Deleuze's and Guattari's desiring-machines "represent nothing, signify nothing, mean nothing, and are exactly what one makes of them, what is made with them, what they make in themselves."[4] Like Stephan, Deleuze and Guattari are interested, not in what an artwork means, but in how it creates meanings. Stephan makes an interesting distinction between the way that "Newman grounds the experience in an object," as he puts it, "and Escher's refusal to do that." Where Newman asks us, the viewers, to do the work, in "Escher's systems . . . the active presence of the viewer's body is gone." Refusing to be subtly suggestive, Escher insists upon spelling everything out. In his paintings Stephan does not. "I have to make things that *you*, the viewer, find meaningful."[5]

Stephan's recent paintings are systems for creating an illusionistic space by literally presenting objects, his templates. These are not images (though when placed on the canvas they may look like represented objects), but flat forms. Traced directly upon the surface, they turn up, recombined, in every work. Reappearing in small panels, medium-sized works, and paintings on the scale of the abstract expressionists, the templates provide an unexpected link between such otherwise different works. In old-master art, scale is defined by the presence of human figures: the close-up subject of a portrait; the smaller but identifiable actor in a history painting; the anonymous figures in a landscape. For Stephan, scale is provided by these traced shapes. "These templates . . . function in the paintings as stand-ins . . . they function like the figure. They convey a similar kind of space."[6]

His templates are both akin to and different from the flags and targets of the artist whose studio assistant he once was, Johns. Like the flag, the template is a flat shape, but it is handmade and has a fixed (but arbitrary) predetermined size. Even when placed on the postmodernist flatbed picture plane, a flag defines its position immediately frontally in relation to any viewer. By contrast, a template can be set in any orientation. In this respect, it is like the quotations of figures from Grünewald's Colmar altarpiece that appear repeatedly rotated in Johns's recent work. But where those quotations, which are very hard to see, depict figures the meaning of whose pres-

4. Gilles Deleuze and Felix Guattari, *Anti-Oedipus: Capitalism and Schizophrenia*, trans. R. Hurley, M. Seem, and H. Lane (Minneapolis, 1983), 288.
5. Georgia Marsh, "Gary Stephan," *Bomb* 25 (Fall 1988): 23.
6. Ibid.: 25.

Fig. 9. Thomas Nozkowski, *Untitled (6-121)*, 1991. Courtesy Max Protetch Gallery, New York

ence in Johns's images is difficult to determine, Stephan's templates have only the meaning given to them by the viewer. When his template is repeatedly laid down, it can be used to construct new shapes. In *By the Edge of a Wood* (1987), for example, a grouping of negative and positive shapes drawn from templates creates a curiously formed enclosure.

Several artwriters speak of Stephan's affinity with surrealist painting. Perhaps a more interesting link is provided by the connection of his templates with certain procedures of a writer greatly admired by the surrealists, Raymond Roussel. He will use "two almost identical sentences which must be connected within the text. . . . It's as if the form imposed on the text by

the rules of the game took on its own being in the world . . . as if the structure imposed by language became the spontaneous life of people and things."[7] For Stephan the structure imposed by the template takes on its own being, creating an illusionistic space. Georges Perec's *La Disparition*, a novel in which *e*, the commonest letter in French, never appears, extends this tradition: "the formal constraint governs the story rather than the other way around."[8]

As an apparatus for image production, the template is a very Johnsian device. Its very rigidity gives the artist a surprising freedom. The hooks descending from top and bottom in the large (72″ by 24″), landscapey *Untitled* (1988) give an entirely different effect than the stacks in *The Stacks* (1988), which join top and bottom. In a small picture, the image is centered on the template; in a larger one, the template provides these links; and, in some large compositions, the template defines a shape that floats in an indeterminate space. One good description of its effect is provided by a critic who never cared for Johns. "Homeless representation" Greenberg identifies as "a plastic and descriptive painterliness that is applied to abstract ends, but which continues to suggest representational ones."[9] Stephan's templates carry all sorts of symbolic associations of represented forms, "telephones, Mickey Mouse ears, eye glasses, eyeballs," and indeed may be all of these things for a suggestible viewer just because what is involved is a flat pattern creating the framework for an illusionistic space.[10]

Comparing the paintings exhibited in October 1988 at Hirschl and Adler Modern with those at Mary Boone in May 1986 or at Marlborough in September 1984 suggests that the nature of this meaning-producing system only gradually became clear to Stephan. The earlier works use template-like shapes, cones and tubes, depicted in a painterly fashion. *The Father, The Son,* and *The Holy Ghost* (1984) are variations on one tubular structure, a rigid armature filled with varying colors. Johns gained something in his early

7. Michel Foucault, *Death and the Labyrinth: The World of Raymond Roussel*, trans. C. Ruas (Garden City, N.Y., 1986), 26.

8. See John Lee, *Times Literary Supplement*, 28 September 1986.

9. Clement Greenberg, "After Abstract Expressionism," *Art International* 6 (1962): 25. It is surprising that this phrase has not been used by other artwriters, for the affect it conveys, whatever Greenberg's intentions, describes that postmodernist art in which the traditional, "natural" relation of observer to image has been deconstructed. Recently Deleuze has taken up Steinberg's notion of the modernist flatbed, linking it to the baroque (Gilles Deleuze, *Le pli: Leibniz et le baroque* [Paris: 1988], 38).

10. Marsh, "Gary Stephan": 21.

Fig. 10. Gary Stephan, *By Day They Were Cheerful*, 1990–91. Courtesy
Mary Boone Gallery, New York

works, which now perhaps is in part lost in this recent flirtation with auto-
biographical painting, by refusing to exploit his gifts as draftsman and col-
orist.[11] Stephan has certainly gained much by moving in the opposite direc-
tion. After twenty years he now returns to a point seemingly prior to that
from which Johns started out thirty years ago; traditional ways of thinking
about development do not do justice to his evolution.

Barthes commented on this situation: "Doesn't every narrative lead back
to Oedipus? . . . Today, we dismiss Oedipus and narrative at one and the
same time."[12] His linking of a familiar psychoanalytic view of desire and
those texts that require narrative closure indicates what Deleuze and Guat-
tari would have us give up. Because they reject the psychoanalytic view that
desire involves lack, they abandon the traditional narrative, that linear tem-
poral ordering in which one event inevitably leads to another. To think of
Stephan as either carrying forward the techniques of earlier modernism or
breaking with that tradition is only to either affirm or negate this Oedipali-
zation of art history. Since "the dialectic does not even skim the surface of
interpretation, it never goes beyond the domain of symptoms," the aim of
artwriting should be to move outside this Hegelian way of thinking.[13] What
is most liberating in Deleuze's writing is his willingness to make connec-
tions, linking past and present, artworks and politics without observing
those conventions of traditional narrative.

This, I grant, makes his books hard to follow if a reader seeks to impose
upon them that traditional linear structure. What can that reader make of *A
Thousand Plateaus*, in which Deleuze and Guattari link signifying with the
destruction of the Temple and present subjectification in a chapter titled
"Year Zero: Facility," a meditation on Christ and the face-centered tradi-
tion of European painting? As little as an artwriter who treats Stephan and
Nozkowski as successors to early modernism. But now, when postmodernist
writing is leaving behind these outdated ways of creating narratives, artwrit-
ing that does justice to the art of this era must adopt novel strategies. My
aim is not to provide a genealogy for Stephan's work, as if Gary the son
carried further the tradition of the father figures of modernism, but to iden-
tify some of the meaning-producing machinery it borrows from older art.

Some artists I respect find Gary's art absolutely cold; they understand
something important about his work, even as they misapprehend his goals.

11. On Johns, see my "Robert Ryman at Dia, Johns at the Philadelphia Museum," *Burlington
Magazine* (January 1989): 66–67.

12. Roland Barthes, *The Pleasure of the Text*, trans. R. Miller (New York, 1975), 47.

13. Gilles Deleuze, *Nietzsche and Philosophy*, trans. H. Tomlinson (New York, 1983), 157.

Resembling Escher in his refusal to create appealing artifacts, he makes a meaning-creating apparatus that must be operated by the viewer, whose choices determine how that machine will be understood. Because Stephan, an unsentimental painter, is a cool professional, he is surprisingly catholic in his appreciations. "Renoir's paintings," he has written, "are not goal-directed pictures—they have no narrative intentions. They are consistent with the greatest modern work in that the viewer has to decide to believe them."[14] The same is true of his own recent large works, which, though they may appear empty if viewed as backgrounds for the templates, are full of activity for the viewer prepared to activate them.

Nozkowski seems a much warmer, more personal painter. His textures and his color, so hard to reproduce in photographs, involve a concern with obvious beauty that appears entirely foreign to Stephan's recent work. There are no empty spaces in his artworks—Nozkowski makes artifacts that can be aesthetically contemplated. And yet, for all his felt affinity in these respects with abstract expressionism, it is through its relationship to Stephan's art that his images can be understood. If the key to Stephan's work is the templates, what is crucial to Nozkowski's paintings is his facelike centered forms placed before a background field. Stephan's starting points, the templates, are always the same; what varies is the size of the field in which he draws that shape. One of Nozkowski's starting points is almost always the same; usually his paintings are on sixteen-by-twenty-inch canvasboards. (The drawings, and some few paintings, are larger.) What varies are the shape, number, texture, and position of his forms centered on that panel.

Rothko said something that provides one measure of the distance between him and the painters of Nozkowski's generation: "I paint very large pictures . . . precisely because I want to be very intimate and human. To paint a small picture is to place yourself outside your experience, to look upon an experience as a stereopticon view or with a reducing glass."[15] Nozkowski also wants to be very intimate and human, but today that is possible only for an artist who places himself outside his experience. Nobody of his generation has a more skilled "hand," or is more of a virtuoso with variations on his theme, the centered form placed against a field. Viewing his

14. "Renoir: A Symposium," *Art in America* (March 1986): 108.

15. Quoted in E. A. Carmean, Jr., and Eliza E. Rathbone, with Thomas B. Hess, *American Art at Mid-Century: The Subjects of the Artist* (Washington, 1978), 259.

pictures is like seeing a person's face. The face, not the body, for seeing the body implies the setting of a person in a landscape or what comes after literal depictions of the body are displaced from art: the sublime big pictures of Rothko; the homeless representations of body parts by Guston.

The face, not the body, is what is best adapted to being represented in that newer version of the stereopticon, the television screen, which, like Nozkowski's pictures, focuses on such a centered form. Seeing a face, our attention is centered on the eyes of another, which is why attending to a person is different from viewing a mere thing. We see the other in her eyes, and see her seeing us. Viewing a painting is like seeing such a face. Experiencing Nozkowski's pictures has been compared with listening to music, looking at architecture, or viewing small paintings. The artwriter who works at a personal computer will compare Nozkowski's processes of composition, in which a source is reworked until any memory of its being a source is almost inevitably lost, to writing on such a machine. This all but open-ended play and interplay of repetition and difference takes on life of its own when "the task of life is to allow all of the repetitions to co-exist in a space where they distribute all of the differences." And yet, if "the mask is the true subject of repetition," still Nozkowski's masks, his facelike images, "cover nothing but other masks."[16]

What is the difference between a picture system that places templates on canvases of many varied sizes and one that displays centered, facelike forms on a small canvasboard? Here we deal with what Deleuze and Guattari identify as two basically different types of semiotic systems. Structuralists discussed significance when they thought of language as the basic reality. Subjectification is associated with the appeal by phenomenologists and existentialists to the presence of the human observer, the subject. In significance, one sign refers to another sign; in subjectification, signs meaningfully refer to the conscious subject. If Stephan's is an art of significance, Nozkowski's is a painting of subjectification. These different sign systems are connected. What we find at their intersection is "a face: *the white wall/black hole* system." "Although the white wall . . . is the substantial element of the signifier, and the black hole the reflexive element of subjectivity, they always go together. . . . There is no wall without black holes, and no black hole without a wall." The system of signification supposes a speaker uses those signs; subjectification requires that there be some subject who speaks a

16. Gilles Deleuze, *Différence et répétition*, 4th ed. (Paris, 1981), 2, 28–29 (order rearranged).

language. "Significance is never without a white wall upon which it inscribes its signs and redundancies. Subjectification is never without a black hole in which it lodges its consciousness, passion and redundancies."[17] Stephan inscribes his templates, his signs, on white walls. Nozkowski places his centered, facelike forms on a background, the white wall. For Lacan and Sartre, as for Renaissance humanists, man *is* the measure of all things.[18] They take that face as a given; for Deleuze and Guattari it is but one kind of sign system, one kind of assemblage that produces meanings. Collections of signs compose things of all sorts—persons, language, artworks, a society— and so the goal is to explain how these assemblages function to produce what we artwriters call meaning. For them, "The inhuman in human beings: that is what the face is from the start."[19]

How difficult it is to give up this traditional subject! Baudelaire writes: "You have strewn your personality in all directions, and now, what difficulty you are having in putting it back together again!"[20] Nozkowski's placement "of figures . . . against flattish background" reminds Carter Ratcliff that "figure and ground always suggest a human presence against a backdrop, as on a stage."[21] In his pursuit of what Baudelaire calls romanticism, that is, "the most recent, the most up-to-date expression of beauty," Ratcliff remains nostalgic for a nineteenth-century role, that of the dandy.[22] But SoHo is not Baudelaire's Paris, and for all his gifts Ratcliff cannot be our Baudelaire. What, anyway, could be more Deleuzian than what Baudelaire himself wrote in 1846, "A picture is a mechanism"? This is a useful reminder that

17. Gilles Deleuze and Felix Guattari, *A Thousand Plateaus: Capitalism and Schizophrenia*, trans B. Massumi (Minneapolis, 1987), 167, 184, 167.

18. "In perceiving an eye as looking, I perceive myself as a possible object for that look. . . . But . . . to perceive a look need not entail seeing someone's eyes. Walking through . . . a deserted landscape, I can get the sense that someone is looking at me though I see no one" (Arthur C. Danto, *Jean-Paul Sartre* [New York, 1975], 121).

19. Deleuze and Guattari, *A Thousand Plateaus*, 171. This is not a novel position but the view of Spinoza, whom Deleuze acknowledges as a very important influence in his *Spinoza: Practical Philosophy*, trans. R. Hurley (San Francisco, 1988). Deleuze's first book, *Empirisme et subjectivité: Essai sur la nature humaine selon Hume* (Paris, 1953), deals with another philosopher unable to find the subject in either experience or reflection.

20. Charles Baudelaire, *Artificial Paradise: On Hashish and Wine as Means of Expanding Individuality*, trans. E. Fox (New York, 1971), 69.

21. Carter Ratcliff, *Fact and Fiction: Abstract Paintings by Jonathan Lasker, Tom Nozkowski, Gary Stephan* (New York, 1984), unpaged.

22. Charles Baudelaire, "The Salon of 1846," reprinted in his *Selected Writings on Art and Artists*, trans. P. E. Charvet (Harmondsworth, 1972), 52, 65. See also Carter Ratcliff, "Dandyism and Abstraction in a Universe Defined by Newton," *Artforum* (December 1988): 82–89.

in artwriting, as in art, what is called the new sometimes is but a refinding of what ought to be familiar.

We may understand how Stephan's concern with the power of images and Nozkowski's concern with redoing abstract expressionism are inescapably linked to the intrinsic qualities of their images. For the modernist critic these claims may seem puzzling. For the reader of *Anti-Oedipus* who knows that "the modern work of art has no problem of meaning, it has only a problem of use" my way of thinking is easier to understand.[23] "If desire produces, its product is real. . . . There is only one kind of production, the production of the real." The processes by which art is contextualized are as real as the artworks themselves. And as unreal, for as Ratcliff has often observed both art and artwriting must ultimately rely upon fictions. For traditional aesthetics, the artwork was an organic whole, a thing set apart from the textual commentaries on it and from the society within which it was produced. But once we give up that way of thinking—"the Whole itself is a product, produced as nothing more than a part alongside other parts, which is neither unifies nor totalizes"[24]—then we can understand that Gary Stephan's art *is* about power, as he says, and how Tom Nozkowski *is*, as he claims, dealing with the recycling of imagery from art and nature.[25]

23. Gilles Deleuze, *Proust and Signs*, trans. R. Howard (New York, 1972), 129.
24. Deleuze and Guattari, *Anti-Oedipus*, 26, 32, 43,
25. My discussion of the gaze draws on a remark by Arthur Danto. My account of subjectification is indebted to Casimir Nozkowski, whose VCRs helped me (and my daughter, Elizabeth) to understand Deleuze's "white wall/black hole system."

13

Artifice and Artificiality: David Reed's Recent Painting

A painting is *a world; a photograph is* of *the world.*
— *Stanley Cavell*

How we evaluate present-day painting, many critics are saying, is determined by our analysis of photography. From some thinkers with old-fashioned tastes, the personalized strokes of the painter signify "freedom" or "handmade" in the era of mechanically produced images; for more radical analysts, this fetishization of gesture marks a reactionary refusal to seriously reflect on novel ways of artmaking. All this debate was already anticipated a century ago: "If photography is allowed to supplement art, it will soon have supplemented or corrupted it altogether, thanks to the stupidity of the multitude which is its natural ally" (Baudelaire). Photographs are not like paintings, some critics say, and that is reason to condemn them; others agree, but conclude that this is reason to praise them; still others argue that photographs are mechanically produced paintings, and so will replace old-fashioned, handmade depictions. David Reed's abstract paintings suggest some novel ways of thinking about these now-familiar issues. Most of the older accounts ask whether photographs look like paintings; whether, for example, the fragmentary composition or apparent spontaneity of nineteenth-century

landscapes prepared the way for photography. Reed's images pose an entirely different question: How do we understand the making of an image?

Make a mark with pencil or brush. What is then visible may either draw attention to or hide that process by which it was made. Construct a painting from a sequence of such marks. That work may exemplify or efface the physical processes used to construct it. Twombly's "writing" reminded Roland Barthes of strokes he might make; painterly brushwork, whether in old masters or contemporary paintings, signifies that these are handmade works. Chardin's surfaces, and Marden's, by contrast, are deliberately unrevelatory. It seemed impossible that Chardin "could paint as he painted with the usual material means which were at the disposal of any artist" (the Goncourts). Marden's weighty wax surfaces, similarly, are hard to intuitively imagine making even when I learn how he built them up.

As with painting, so also with words. Deictic utterances carry an implied reference to the activity of saying the words. "I love you," she says, and the reference of the pronouns "I" and "you" is understood by appeal to the presence, in person or in the text, of the people who utter and hear the words. Diegystic narratives are uttered as if by no one. "Cleopatra was loved." These words appear as if told impersonally, the historian or novelist writing them thus effacing his own activity of text production. When in everyday talk we switch back and forth between those two modes of discourse, we gain some understanding of the equivalent distinction between deictic and diegystic images. The deictic image draws attention to the physical activity by which it was made; diegystic pictures eliminate that reference to the artist. An image representing something may be either deictic or diegystic. Cézanne and Morandi reveal in their still lifes the activity of picture making; Chardin hides his. Pictures thus have a double reference: to their content; to their means of production.

What seemed uncanny to nineteenth-century viewers about photographs, and what is puzzling today about Reed's paintings, is less that their images are unfamiliar than that it was, and is, hard to envisage how they are made. Only in mirrors, perhaps, could old-master artists view such images, so familiar to us, which seem absolutely removed from the world of pictures created by human hands. My artistically incompetent scribbles give me some sense, a very inadequate one, of Rembrandt's greatness; an amateur pianist understands something of Gould's greatness, as writing a diary gives some insight into a novelist's work. We appreciate artworks in part because our own everyday activities give some clues about how they are produced.

But however much I know about the history of photography, the chem-

Fig. 11. David Reed, # *283*, 1989–91.
Collection Rolf Ricke, Cologne

istry of the emulsion, and the mechanics of the camera, I cannot think of photography in quite the same way. The process in which light patterns are chemically fixed finds no analogue in my activities of producing marks. What I feel, could I touch a painting, would be those marks made by the artist's brush. The surface of a photograph, by contrast, is inert to my fingers. What was strange, we now can see, about Vermeer's art was his miming of this effect. "The grace of Vermeer's world is to wear to the last the garment of a retinal impression, to claim no greater depth than the play of light" (Gowing). This result a photographer achieves automatically.

A deictic image draws attention to the presence of the artist before the represented scene; a diegystic representation appears as if made without the intervention of the artist. This contrast suggests one highly influential way of thinking about painting. "Postmodernism neither brackets nor suspends the referent but works instead to problematize the activity of reference" (Owens). A photograph is always of some real thing; a painting represents some real or imagined scene merely conventionally. "It is only in the absence of the original that representation may take place" (Crimp). The seemingly direct relation of photographs to reality emphasizes how paintings, by comparison, whether they look handmade or impersonal, are the product of the artist's direct physical manipulation.

This discussion focuses on the relation of the image to what it depicts. What interests me in Reed's surfaces, rather, is the artificiality of his very textures, an effect of distancing from the handmade which is akin to the apparent distancing from the depicted thing achieved in art of image appropriation. Those artists show us images of images; Reed displays the processes of mark making that, unattached in his art to any use in actual depicting, thus becomes mysterious. A certain surreal or unreal effect is achieved by images which raise questions about the reality of what we see. Reed's paintings achieve a partly similar result by bracketing our knowledge of the origin of his markings. Photographic-like in their textures, his works, which depict nothing, thus seem to define a place for themselves between paintings and photographs. Oddly enough, they are less akin to the paintings, abstract or representational, of his contemporaries than to some seventeenth-century art.

Reed is fascinated with baroque painting, particularly with the recently revived Neapolitan follower of Caravaggio, Bernardo Cavallino (1616–1656); and the relation between darkness in Caravaggio and Cavallino and in Reed's abstract images is fascinating. Caravaggio's *tenebroso* marks the edges of solids as they are inserted into a background darkness. "Darkness

Fig. 12. David Reed, # *287*, 1989–90. Private collection, Cologne

in his pictures is something negative; darkness is where light is not, and it is for this reason that light strikes upon his figures and objects as upon solid, impenetrable forms" (Wittkower). What is dark in Reed's paintings is the very ground of the picture surface itself, as if brightness could only come into his paintings from some external source. Alfred Jensen's paintings, which sometimes are described as merely illustrations for an eccentric color theory, help describe this effect. *West Sun, Perpetual Color Motion* (1962) breaks the passage from positive (dark) to negative (bright) light into a series of discrete stages, as if illustrating the appearance of light coming around the edge of a solid. Jensen thought his color theory dramatically confirmed by the first astronaut's view of sunlight across the horizon. Seen thus as a representation, his painting diagrams the baroque master's use of darkness; viewed as abstract images, his paintings display the sequence, darkness to bright light, in a circular movement. Like Jensen, Reed is involved in using extreme darkness and bright piercing light which, now separated from any representational context, is thus disassociated from merely marking the edge of shapes.

The baroque artist used his darkness as background out of which figures appear under artificial lighting. The viewer is drawn into that scene by an eye-catching figure or gesture. In *Martyrdom of St. Matthew*, "the most distant figure is a self-portrait of Caravaggio; it provides a very specific reference point for the viewer, as if Caravaggio were participating in the tragedy" (Moir). His paintings in the Cerasi Chapel "are so conceived as to assume movement in the spectator; and they are so composed as to promote in him a sense of potential intrusion among its elements" (Steinberg). Walking toward the altar, I view the foreshortened images as if I were implicated in the scene. Often Cavallino appears depicted in his paintings as the figure making eye contact with me. He, elegantly dressed, is present within, while

not participating in the action he represents. The Caravaggesque *Narcissus*, in the recent Metropolitan exhibition, in effect internalizes this spectator, showing the boy as absorbed in viewing his own reflection as the viewer is caught in these theatrical works.

What does it mean to implicate me, the spectator, in some such narrated scene? Depicted figures who appeal to the spectator are said to originate in Italian theater, where sometimes the action was introduced by a figure "who remained on the stage during the action of the play as a mediator between the beholder and the events portrayed" (Baxandall). What then becomes complex is my relation to the action. In the theater, I stand in another space from the characters whose actions occur as I view them. I cannot walk forward and interrupt Othello—without, that is, disrupting the play—but his actions, though set in a fictional past, occur as I see them. Seeing the play, like reading a novel, calls for experiencing events as if in the present. The same is true in the art of Caravaggio and Cavallino; their depicted figures can catch my eye because I am imaginatively present at the depicted event. Certainly I do not have the illusion of being at St. Matthew's martyrdom; but neither do I suppose Caravaggio to have thought himself literally an actor in that scene. The fiction his painting asks me to entertain is that in the present he can appear, and I can see him, in that scene.

How does this distinguish such paintings from photographs? The photograph, the causal product of an image which depicts reality directly, may seem very different from these illusionistic theatrical narratives. "The reality in a photograph is present to me while I am not present to it" (Cavell). The best way to understand the presentness of such baroque scenes is by contrast to what might be called the pastness of photographs. Portraying himself in the painting of Matthew, Caravaggio makes it an image of a scene taking place now. He reminds me that the martyrdom is not merely a historical event, but a story now told in the present. By contrast, a photograph is irrevocably tied to its date of origin. Nadar's photograph of Baudelaire captures light whose traces only remain, which makes seeing it like viewing a star that is one hundred light years away. Looking at the photograph, I see into the past.

After describing a number of his favorite photographs, Roland Barthes asked what attracted him to these particular images. He contrasts the *studium*, the historical scene or everyday gesture which is merely interesting, with the *punctum*, that isolated element "which arises from the scene, shoots out of it like an arrow, and pierces me." His attention is attracted by "this wound, this prick," the detail which changes his view of the larger image.

To find the *studium* is to identify something familiar, and so slightly boring; getting caught by the *punctum* is a process "at once brief and active." The *studium* appears within the image; the *punctum* "is a kind of subtle beyond—as if the image launched desire beyond what it permits us to see." What better way of describing the outward gaze in Caravaggio or Cavallino or the effect of surface-breaking hands. Thus does their *punctum* involve me in the scenes.

Abstract painting, too, has its *punctum*. Reed's very dark background is the *studium* out of which arises unreal light, the cutting edge of his *punctum*. His artificial-appearing surface catches my eye at just those points where darkness is pierced by lines or fields of light. In some abstract paintings the *punctum* lies within the canvas. Look at the line where Thornton Willis's trapezoid or zigzag is pressed into the background; at the edge, where Sean Scully's vertical and horizontal stripes intersect; at the background immediately around Tom Nozkowski's centered forms. Other artists displace that *punctum* off the painting's surface. Ryman's *punctum* exists where he mounts the panels: on the brackets near the corners; struts behind the painting; solid supports at top and/or bottom. Lacking that cut, an abstract painting would be merely a decorative wall covering, an interesting artifact, perhaps, to which I remain indifferent. The *punctum* cuts that design and attracts my desiring look.

Thus understood, looking is both passive and active, a division of my activity as viewer which corresponds to those two ways of describing what I see. The gaze regards "the field of vision with a certain aloofness and disengagement"; the glance, "a furtive or sideways look which shifts to conceal its own existence," is that active process in which the *punctum* manifests its existence (Bryson). This opposition, *studium/punctum*, is more suggestive today, I believe, than the traditional contrast between looking into the depths of a picture and focusing on its surface. We are interested in how the artist's marks attract our eye, whether they take us into a deep space or define the surface. This the Goncourts understood in their delicious evocation of Chardin's textures: "Here is the shaffy velvet of the peach, the amber transparency of the white grape, the sugary rime of the plum, the moist crimson of strawberries, the hardy berry of the muscatel and its smoke-blue film, the wrinkles and tubercles of old apples, the knots in a crust of bread, the smooth rind of the chestnut and the wood of the hazelnut." How richly suggestive their list is of the pleasures of seeing Chardin. Reed's works provoke another such listing of techniques of picture making. A black ground has the white line cutting across; black runs through black-and-

Fig. 13. David Reed, # *289*, 1989–91.
Courtesy Max Protetch Gallery and Galerie
Rolf Ricke

white backgrounds; brightly colored rectangles are inserted into that dark field; handpainted-looking lines of color are worked from thick paint down almost to a transparent film; solid areas of eye-resisting surface are juxtaposed; triangles of color shape off into black backgrounds. Like the Goncourts, I enjoy compiling such a list.

In diegystic picture making, the image aims "at a discontinuity between itself and the scene it represents so extreme that its origin in fact becomes irrational" (Bryson). Reed's uncanny images, which represent nothing, fascinate by virtue of this artificiality. Effacing the traces of his own labor, he thus draws attention to these processes, which appear as if representations of photograph making. The grain of his surface textures has a strange and seductive artificiality; its source, and so its meaning, remain in question.

This provocative *epochē* of the mark finds a parallel, again, in earlier art. Kafka dissolves "happenings into their gestic components," his work thus constituting "a code of gestures which surely had no definite symbolic meaning for the author. . . . Each gesture is an event—one might even say, a drama—in itself" (Benjamin). These gestures he goes on to compare to photographs, in which we see unrecognizable fragments of our life "that are still within the context of the role." Pietro Bellori, who found Caravaggio's *Conversion of St. Paul* a "story entirely without action" (1672), or the modern commentator who says that his pictures "do not edify because they do not explain themselves" understand this problem. An isolated gesture becomes meaningful when integrated into a coherent sequence. Caravaggio shows his performers becalmed, their gestures isolated from any sequence of ongoing events; Cavallino, analogously, uses hands to demonstrate, importune, admonish, or express fear as if they expressed meanings in isolation, almost, from the larger picture.

"We no longer narrate." Barthes's claim about literature applies also to visual art. For us, the pleasure in viewing even representational images is no longer enjoyment in working out the story told. This change in sensibility from the seventeenth-century to the present, more recently influenced by photography, determines in part how we view baroque paintings. As spectator, I need not compose a Caravaggio or Cavallino into an organic whole but may rather break that picture down into eye-catching units. The *studium/punctum* contrast is an equivalent for visual image to the "edge" in literature, that line the reader cuts to find the textual fragments that are interwoven to create an apparently seamless whole. We read, Barthes argued, less to again learn the conclusion of the story than to savor the very materiality of the words themselves. Like seeing that edge, searching for the

punctum transforms us viewers from story readers to spectators of fragments. Barthes's aim was to turn our attention from the traditional focus on the artist, the creator of the unified work, to the spectator. If now "the text is read in such a way that the author is absent," what then is revealed "is the space on which all the quotations that make up a writing are inscribed" by the reader's activity. If, similarly, the painting now is viewed in the artist's absence, what is shown is the *punctum*, that point which catches my gaze.

"The birth of the reader," Barthes argues, "must be at the cost of the death of the Author." In painting, also, the contrast between deictic and diegystic images reminds us, we focus on what the viewer does somewhat at the expense of the artist. Photography marks already one stage in this process; the photographer does not create but merely copies his image. Then the traditional notion of the organic unity of the visual artwork becomes obsolete. Moving across Reed's surfaces, my glance catches a line of white, the ground or a field of artificially bright color, undistracted by the need to see them as surfaces of forms which tell some story. I enjoy that *punctum* without worries about its unity. Unlike traditional paintings, which rely on a rectangular format to create their unity, Reed will often use very long, narrow horizontal pictures or very narrow and high vertical works. As when Cavallino sometimes shows three scenes within one picture, the onlookers on the left and remonstrating spectators on the right framing the dramatic action in the center, these untraditional formats implicitly criticize these older ideals of composition.

Structuralist thinkers are fond of diagrams based upon binary oppositions. Consider, then, an imagined chart of deictis and diegysis, the *studium* and the *punctum*, which places Reed's work in relation to present-day visual art. Painting has killed photography, some *October* critics say; they contrast the immediacy of representation in photography with the coded, merely conventional images and brushwork in painting. But there is another way to understand our situation. Photography combines direct reference to reality in the image with opacity of reference to the image-making activity. It opens up two symmetrically opposed possibilities. Drawing attention to the processes of its own medium, the image becomes the subject of a Greenbergian modernist tradition which emphasizes the literal use of that medium. Alternatively, painters mime the artificiality of photography, making images which look artificial. Like some seemingly very different artists who paint images of photographs, Reed's absolutely artificial-looking images of processes of picture making catch the glance and provide a novel, still thoroughly mysterious, and so deeply attractive visual pleasure.

14

David Reed: An Abstract Painter in the Age of Postmodernism

What, exactly, can an abstract artist working in the late 1980s learn from the old masters?[1] Most artists have postcard reproductions of much-beloved artworks by the old masters in the studio next to their own paintings. The colors of those images will be suggestive to the artist, and certainly it is nice to think in a safely vague way that new art relates to older work. But since old-master works usually present storytelling narratives, and always are figurative pictures, it is hard to see how, exactly, they could really be very similar to the images of an abstract painter.

Roger Fry thought that Cézanne was redoing Poussin's compositions, leaving out those storytelling elements which that great formalist critic found so distracting.[2] More recently, another formalist has written of the

1. The best-known recent account of this problem by a painter, Frank Stella's *Working Space* (Cambridge, Mass., and London, 1986), is flawed by a narrow, formal approach to old-master art. Stella claims an interest in Sydney Freedberg's *Circa 1600*, but his account involves a strong misreading—in Harold Bloom's sense of that word—of Freedberg's book.

2. See "Some Questions in Esthetics," reprinted in his *Transformations: Critical and Speculative Essays on Art* (Garden City, N.Y., 1956), 23–26, and his *Cézanne: A Study of His Development* (Chicago and London, 1989). His account in "Some Questions in Esthetics" of a painting no longer

relation between modernist painting and the old masters in strangely Ruskinian terms. Someday "connoisseurs of the future may . . . say that nature was worth imitating because it offered . . . a wealth of colors and shapes, and . . . of intricacies of color and shape, such as no painter, in isolation with his art, could ever have invented."[3] For Greenberg, there is continuity between the concerns of modernists and the old masters. "Modernist art develops out of the past without gap or break, and wherever it ends up it will never stop being intelligible in terms of the continuity of art."[4]

Today neither Fry's nor Greenberg's views of art and its history inspire conviction. Most of us can no longer believe that the formal parallels which Fry saw between compositions by Poussin and Cézanne are convincing.[5] Nor do we believe in the kind of continuity between contemporary and old-master art that Greenberg finds. Fry links Cézanne to Poussin only by denying that the latter was concerned to use his compositions to tell stories. Greenberg establishes a genealogy for abstract expressionism, relating it immediately to old-master art, only at the price of a very selective reading of the sources of that movement. Nowadays all such claims of formalist critics seem highly problematic. What Arthur Danto has called deep interpretations show that two seemingly unconnected things, such as two paintings that are visually very different, do in fact have some real relationship.[6] A deep interpretation shows that we must look beyond appearances to identify the order of things. When Fry argues that Poussin and Cézanne are involved in the same artistic goals and when Greenberg claims that "Pollock's 1946–1950 manner really took up Analytic Cubism from the point at which Picasso and Braque had left it" they see an intimate connection between seemingly dissimilar artworks.[7]

According to the most fashionable theorizing, art in the 1980s is involved in a kind of endlessly prolonged postmodernist endgame, unable either to continue the tradition or to establish a living relation with the old masters.

attributed to Poussin is discussed in my *Artwriting* (Amherst, Mass., 1987), 27–29, where that work is reproduced.

3. Clement Greenberg, *Art and Culture* (Boston, 1961), 137–38. Ruskin thought that an artist ought to represent nature rather than mere things of her or his own creation because what God created is more majestic than anything a mere mortal can imagine.

4. Clement Greenberg, "Modernist Painting," reprinted in G. Battcock, ed., *The New Art* (New York, 1966), 109.

5. See Richard Shiff, *Cézanne and the End of Impressionism* (Chicago and London, 1984), chaps. 10 and 12.

6. See his *Philosophical Disenfranchisement of Art* (New York, 1986), chap. 3.

7. Greenberg, *Art and Culture*, 218.

Art may appropriate from that tradition, which it is powerless either to contribute to or to continue. I cannot accept this vision of contemporary art, whose seeming bleakness and would-be political radicalism hides a certain complacency.[8] The postmodernists usually make the very notion of abstract art seem highly problematic. How, if these accounts be rejected, may we understand the concept of abstract art? And how can an abstract artist build upon the traditions of painting?[9]

David Reed is centrally concerned with such problems. While commentators have been willing to accept his claim, repeatedly made in interviews, that he is deeply interested in some late Renaissance and baroque painters, none of them have indicated exactly how a painter today may learn from that art.[10] This is understandable, for most art criticism tends to adopt a short-range historical perspective. Critics have been more interested in sorting out Reed's relation to American art of the 1960s and the 1980s than in dealing with problems larger in scale. But now that these concerns have been thoroughly discussed, the time has come to take seriously his claim that art like his may draw an old-master tradition.[11]

What kind of connection may we find between abstract painting and old-master art? The best approach is to look, not for formal parallels between the use of space in such paintings (which will lead, always, to an ahistorical and so reductionist view of the old-master art), but for relationships between the narratives, implicit and explicit, of the old masters and the implicit narratives in Reed's painting. Consider the narrative inherent in the color relationships of the del Sarto Borgherini *Holy Family with the Infant Saint John* (Fig. 14), as described in the majestic prose of Sydney Freedberg: "The three chief hues in the picture approximate a color triad. But these relations, though perceptible, remain approximate: they do not mesh like the conjunctions of a classical color system but, instead, make a slight dissonance. . . . The color . . . has been given an unnormative complexion . . . not quite consistent with our expectation of natural experience."[12] Such color relations reappear in many Reeds. As he has noted, the

8. See my "Art Criticism and Its Beguiling Fictions," *ArtInternational* 9 (1989): 36–41.

9. See Tiffany Bell, "David Reed: Baroque Expansions," *Art in America* (February 1987): 126–29.

10. See Michael Kimmelman, "New from David Reed, a Modern Traditionalist," *New York Times*, 27 October 1989, C-31.

11. The best account is Joseph Masheck, *Point 1: Art Visuals/Visual Arts* (New York, 1984), 116. Much has been said about his alleged relationship to Lichtenstein; a more revealing parallel would be to note the connection between such recent Reeds as *No. 268* or *No. 254* and Hans Hofmann's "push-pull" paintings.

12. S. J. Freedberg, *Andrea del Sarto* (Cambridge, Mass., 1963), 79–80.

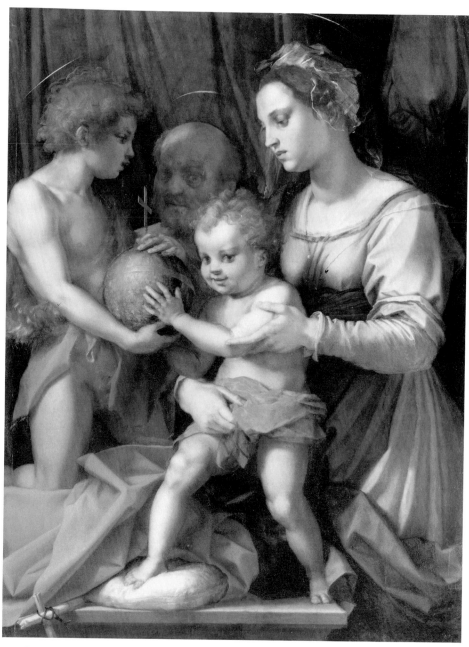

Fig. 14. Andrea del Sarto, *Holy Family with the Infant Saint John*. The Metropolitan Museum of Art, New York

central drapery of this painting, Christ's loincloth, is modeled with hue rather than value, even though the rest of the picture uses strong value contrast.

Juxtaposing hues is a technique suggestive for the abstract painter, if only because it provides a way to use different types, even levels, of color relations. Value gradations suggest descriptions of volumes in the physical world, while complementary hues suggest video and movie images, which usually provide a more unnatural or artificial description of what they depict. When I say these are unnaturalistic, something more than mere conventions of representation are involved. On a motion-picture or television screen, things that are near and far away appear as if they are all at the same distance, projected onto that surface.

One weakness of much art history, most especially of formalist art criticism, is its focus upon the spatial structures of paintings rather than upon the structure of color relationships. In Greenberg's criticism, the movement from the old masters to early modernism to abstract expressionism is defined by changing uses of space as such. Little is said about the different ways in which Manet's paintings, and those of the cubists and Pollock, use color. As Stephen Bann has accurately noted, the weak point in Greenberg's analysis comes in his conception of color in Manet's art.[13] Ideally, "even primary hues, used pure, are compelled to reveal something of their constituent colors at the evocative call of other colors in a picture."[14] Any imaginative abstract painter would be inspired by the color relations in old-master art. But insofar as that art is used by dismantling it piecemeal, the result is merely a deconstruction of tradition, using elements from works whose storytelling concerns are inaccessible to an abstract artist, or, indeed, to any painter working in the 1980s.

Identifying the content of this older work explains why these color relations are of especial interest for Reed.[15] Del Sarto's Christ child is playing with the globe as his mother holds his genitals in the loincloth. Freedberg identifies the primary narrative: "The Child . . . accepts the sphere as if it were a toy, and shows his pleasure to the spectator." He recognizes the

13. See Stephen Bann, "Adriatics—À Propos of Brice Marden," in *Twentieth Century Studies: Visual Poetics* 15/16 (December 1976): 116–29, and his "Abstract Art—A Language?" in *Towards a New Art: Essays on the Background to Abstract Art, 1910–20* (London, 1980), 125–45.

14. Adrian Stokes, *Colour and Form*, reprinted in *The Critical Writings of Adrian Stokes* (London, 1978), 2:60. When Reed and I initially met, Stokes was the first artwriter we discussed.

15. Leo Steinberg discusses a related del Sarto, the *Tallard Madonna*, in "The Sexuality of Christ in Renaissance Art and in Modern Oblivion," *October* 25 (Summer 1983): 1.

burden he will shoulder, as from behind "Joseph looks out at us . . . like ourselves . . . a spectator."[16] Joseph is very much in the background, an effect reinforced by the dark color of that portion of the picture that also involves Christ's right hand. The implicit narrative of the erotic relation of mother and child, whose exact meaning is hard to understand, seemingly has no connection with this straightforward story.

The colors of the drapery below Christ on left and right are synthesized in the color of his loincloth, reminding us that he is man incarnate. What is odd and complicated in relation to this center area of the picture is the arrangement of hands. The Virgin's curiously long right hand extends around her son, who reaches backward to grasp the globe. Part of the implicit story is told by these color relations, which thus cannot be appreciated merely abstractly, as a formalist would seek to appreciate the spatial relations. Color carries narrative meaning in part because it is always identified as color of form.

This del Sarto has influenced the color in Reed's recent art. The other old-master paintings I consider have a more general influence on the implicit narrative of his compositions. It is no accident, we shall see, that all of these examples also involve, in one or another way, images of eroticism. Artemisia Gentileschi's Detroit *Judith and Her Maidservant with the Head of Holofernes* shows an unusual moment in the story. It differs dramatically from Caravaggio's and Gentileschi's earlier *Judith Slaying Holofernes,* which show the violence itself. Here standing in the tent, Judith holds her hand over the candle, putting her eyes into shade so that she can see beyond the light of the tent. She and the servant are frozen, as if waiting to be discovered. The "artist avoids . . . the bloody moment of the slaying . . . choosing to focus . . . upon the moment just after the decapitation. The women are still in Holofernes' tent . . . and as Abra gathers up the head from the floor, Judith . . . turns from the act completed to face an implied intruder."[17]

Here, as in the del Sarto, we find a secondary narrative. Ostensibly the picture is about the triumph of Judith over her enemy, the man whose head lies on the floor. The pictures depicting Judith beheading Holofernes focus on the moment of physical violence, which it is natural to relate to the sexual violation of the artist herself when she was raped by a pupil of her father. In

16. Freedberg, *Andrea del Sarto,* 79.

17. Mary D. Garrard, *Artemisia Gentileschi: The Image of the Female Hero in Italian Baroque Art* (Princeton, 1989), 328, 336. "Artemisia's Judiths, poised between the death blow they have delivered the patriarch and their potential capture by his lieutenants, . . . embody the only kind of heroism realistically available to women in a patriarchal world."

this picture we see a Judith different from the figure most male artists depict. She is neither the sexually attractive figure of Rubens and many artists who present this theme nor the actor who does the violence, as in the earlier Gentileschi. Judith is, rather, a calculating warrior who looks ahead to the next moment of this story, which is not yet completed. Compare Mattia Preti's *Herodias with the Head of John the Baptist* (Sarasota), in which Salome's mother shows the head of the prophet, another picture that asks us to look forward in the ongoing action and to imagine what will happen.[18] In different ways, both these paintings treat the violence as one inevitable stage within the continuing story.

In a related picture, Bernardo Cavallino's Stockholm *Judith with the Head of Holofernes*, Judith's arm is holding the sword, which would have been held by Holofernes. In a strange way she appears to gain strength through him. They seemingly are united, becoming one in an almost sexual way. Judith cradles his head as a lover might hold her beloved. She does not grasp the sword by the hilt but holds it by the blade. It is signed on the hilt, as if a reminder, or an image, of their sexual relation; and her face is flushed: "her wide-eyed, unseeing gaze; slightly parted lips; and weary hands, one grasping the sword loosely and the other resting limply, almost caressingly, upon the severed head of Holofernes."[19] Again the implicit narrative takes us back to an earlier stage of the action. The idea that she loved him, we might think, has still not passed from her mind. She thinks back, while Gentileschi's Judith is concerned with the future, a difference easy to understand in relation to the personalities of these artists. (It would be surprising to learn that Cavallino's picture had been painted by a woman.) Gentileschi's Judith is worried that she will be discovered. This implicit narrative is seemingly at odds with, or independent of, the explicit story.

The narrative, explicit or implicit, in an old-master painting may be identified as the part of that painting which relates it to something outside the picture. The narrative has a temporal dimension. These two seemingly different ways of characterizing that implicit narrative are closely connected. It is by organizing our experience of the painting as a temporal one that the narrative of what is depicted in a picture involves such stories. One way of organizing our temporal experience of the painting can be at odds with another. The Madonna's erotic gesture in the del Sarto has nothing obvious

18. See John T. Spike, *A Taste for Angels: Neapolitan Painting in North America, 1650–1750* (New Haven, 1987), 93–96.
19. Ann T. Lurie, *Bernardo Cavallino of Naples, 1616–1656* (Cleveland and Ft. Worth, 1984): catalogue entry, 216.

to do with the primary message of that scene; Cavallino's idea that Judith loved Holofernes is at odds with the explicit moral of that image. The implicit narrative apparently contradicts the primary story.

But such a secondary narrative may also be supplemental. Comparing the Caravaggio *Repose on the Flight into Egypt* with his *Magdalen Repentant* (Fig. 15), also in the Galleria Doria of Rome, Stephen Koch observes that they were painted in the same year and use "the same woman as a model." The Magdalen's "arms are in precisely the position to rest the baby's head. . . . The emblem of the prostitute's simultaneous penance and redemption is an absent child, whom she simultaneously embraces and grieves over."[20] (This claim, he adds, not recorded in the earlier literature, appears to be Reed's discovery.) If the explicit story in *Magdalen Repentant* tells of her repentance, the implicit story is about this loss. And identifying the latter story shows how these two seemingly very different scenes are connected. Two works with ostensively different subjects in fact are visually similar.

Such stories are found in all images, representational as well as abstract, insofar as all pictures demand to be experienced one part after another, in temporal succession. When we turn from *Judith with the Head of Holofernes* to Reed's *# 283* we move from a work that has an explicit and obvious story, as well as the implicit one I have identified, to a painting that also engages us in a temporal experience because it too is involved in storytelling. This notion that a story can be implicit in an abstraction may explain why abstract art encounters resistance. For when such a story depends upon the viewer's capacity to creatively respond, then viewing becomes an active process. Of course the viewer is always active, but we may tend to forget that when, identifying the explicit narrative quickly, we fail to look closely. Properly seen, any complex composition, whether abstract or figurative, contains such an implicit narrative. What we (re)discover, in strange parody of Greenberg's definition of modernism, is that abstract painting involves a self-consciousness about its medium. This quality does not concern its formal use of space, as he thought, but the capacity of abstract painting to use color to create implicit narratives. But it may also be true that paintings like Reed's sensitize us to dimensions of old-master painting that earlier generations of viewers had difficulty identifying, or even seeing.

Reed's usual practice, unlike that of many younger abstract painters, is to

20. Stephen Koch, "Caravaggio and the Unseen," *Antaeus* 54 (Spring 1985): 103–4. See also my "Transfiguration of the Commonplace: Caravaggio and His Interpreters," *Word and Image* 3, no. 1 (1987): 41–73.

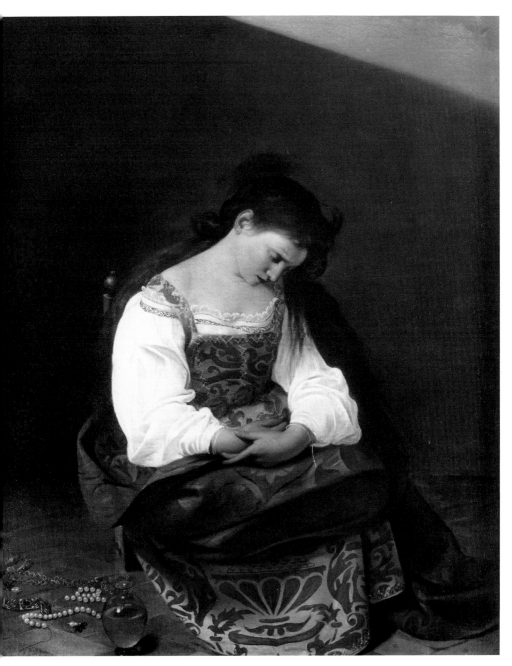

Fig. 15. Caravaggio, *Magdalen Repentant.* Galleria Doria, Rome

provide only numbers for his paintings, not evocative titles. The omission of a title, forestalling facile readings of the implicit stories, puts a small obstacle before the viewer in order that she may seek out these stories. Reed's recent pictures are mostly vertical or horizontally oriented rectangles in proportions of three or four to one, encouraging us to read them as narratives. For example, # 283 involves an implicit narrative when I move from looking at the emerald green stroke extending downward at the left corner, in a seemingly spontaneous gesture, to the two inserts around the center. In the upper half of the picture I see a complex subdivision of space. The lower portion is homogeneous in color, apart from that stroke and part of one insert that extends downward, unifying top and bottom. I see that my eye is to move from left to right, not from above to below; while it is hard to know how to describe, that movement in so many words, I am aware that it identifies and so implies a story, an implicit narrative.

In one obvious way, Reed's implicit narratives differ radically from those I identified in old-master works. Within the paintings of del Sarto, Gentileschi, and Cavallino, we see that story told by the depicted figures. Reed's artworks contain no represented figures, and so no explicit stories—narratives are always implicit. The tale Reed tells us is a story about the process of making a painting, though it can only be identified, I would argue, by relating it to these narratives in old-master artworks. The best way to understand how an artwork can present such an implicit narrative in entirely abstract terms is to consider another example, an old-master work whose narrative is in part about the medium of painting.

Guercino's *Samson Seized by the Philistines* (Fig. 16), in the Metropolitan, New York, has both explicit and implicit narratives: "Guercino . . . gives massiveness to the figures by allowing them to occupy a high proportion of the picture space . . . bringing them forward toward the spectator. But . . . he attenuates that massiveness by suggestions of vigorous movement."[21] For a painter, or a viewer passionately interested in painting, this story about blinding is sure to have an especial emotional resonance. But if the explicit narrative is the story about blinding, the implicit narrative is about how Samson seems to stand for the canvas when he is pressed forward as if he were projected into our space. Such an outwardly projecting person appears in many baroque works; but here, when we consider the identity of the

21. Denis Mahon, *The Age of Correggio and the Carracci: Emilian Painting of the Sixteenth and Seventeenth Centuries* (Washington, 1986), 469.

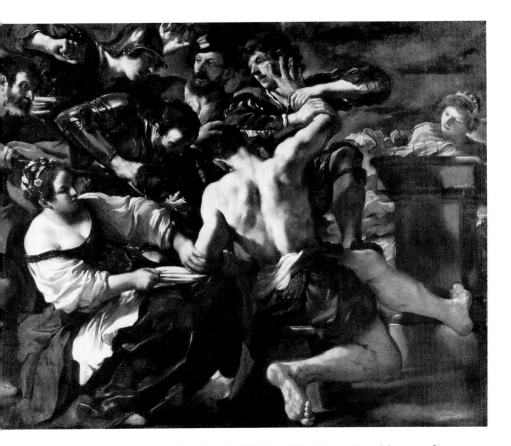

Fig. 16. Guercino, *Samson Seized by the Philistines*. The Metropolitan Museum of Art, New York

figure who is pressed forward, this device has an especial significance. The space in which the action occurs, that place in which Samson is being blinded, extends outward to include where we are standing. At the next moment of the ongoing action the picture space would extend to encompass our place before the image. Just as it is hard for the male spectator to respond in a neutral way to the acts shown by Gentileschi or Cavallino, so it hard for him to take an aesthetic distance on this scene.

We see an image of violence against Samson that thus also implies an act of violence against painting. For since his figure cannot really extend into our space, by implying that he might fall forward Guercino asks us to think

how, when the action proceeds to its next inevitable stage, it will no longer be paintable. Like Gentileschi and Cavallino, he presents a narrative about violence linked to eroticism, a painting about the power of women.[22] Their pictures showed the revenge of a wronged woman; this one shows an act of violence on a once-powerful man, who later will regain his powers. That later moment is anticipated already in this narrative, for as Samson resists vainly he is pushed down, as later he will bring down the temple.

Art historians are familiar with the question, *Where* is the depicted image? Fry identifies the position in space of Poussin's depicted figures; Greenberg links the spaces of Manet, the cubists, and the abstract expressionists. Another, less frequently asked question is, *When* is the depicted image? This question gets us to think about the narrative, implicit or explicit, in a picture. An image that appeals to the immediate presence of the spectator, as do those that I have discussed, appears as if in the temporal present of the viewer. *When* is such a painting that depicts a historical event? It is of the time, the distant past, of the depicted scene. But it is also of our immediate present. We see it as if it were taking place right before our eyes.[23] Of course this is only an illusion. But so, too, is seeing the pictures as presenting these terrifying scenes. The blinding of Samson or the beheading of Holofernes are terrifying because these happenings of the historically distant past are presented as if they were occurring right before us. It is our eyes that seem threatened when we view Guercino's picture of Samson.

Reed's brushstrokes, initially readable as spontaneous or free gestures, appear as if they were not made by human hands.[24] Of course, this too is an illusion, but it is of central importance for understanding his work. There is a strange contrast between the initial appearance of spontaneity and the highly calculated effects of Reed's compositions. When, for example, in *# 283* I see the green line I mentioned earlier at the far lower left running downward, what at first appears a spontaneous gesture is seen as a carefully thought out way of linking the top and bottom panels.

There appear frequently in Reed's paintings rectangular elements of color within the larger field—mirrors, as I will call them—that are equiva-

22. Here I borrow from Leo Bersani and Ulysse Dutoit, *The Forms of Violence: Narrative in Assyrian Art and Modern Culture* (New York, 1985). See my "Gavin Hamilton's *Oath of Brutus* and David's *Oath of the Horatii:* The Revisionist Interpretation of Neo-Classical Art," *The Monist* 71, no. 2 (April 1988): 197–213.

23. See my *Principles of Art History Writing* (University Park, Pa., 1991), chap. 11.

24. In a short talk taped at the Max Protetch Gallery, New York, during Reed's November 1989 exhibition, Arthur Danto drew attention to the relationship between Reed's brushstrokes and drapery in baroque art.

lents in his style to the pictures within pictures or the images that show the making of the painting in some old-master works. In his pictures these rectangles provide the starting point for his implicit narratives. When Guercino's late Kansas City *Saint Luke Displaying a Painting of the Virgin* shows the portrait of her on his easel, the painter gives her and her son the same blue and red garments as he wears. As the painter has his inner blue and outer red, Christ in red is in the arms of his mother, her outer blue matched by the inner red that shows from her sleeve. That mirror is thus implicitly about the larger painting. In Caravaggio's *Boy Bitten by a Lizard* (National Gallery, London) we see an image of his studio reflected in the vase.[25] In his Uffizi *Bacchus*, similarly, we see a reflection on top of the wine in the carafe that the pseudo-Bacchus has just set down. It shows Caravaggio at his easel painting the very painting we see.[26]

In these works, the product, the finished picture, cannot be seen apart from, and so cannot be detached from, the painter's act of telling. Literary critics and historiographers note that a narrative may erase reference to its origin, pretending it is told as if no one were telling it.[27] Such impersonal-seeming pictures and texts pretend to be objective. Other texts and pictures, including these old-master pictures and Reed's paintings, acknowledge that they are created by a person whose subjectivity is in evidence in the finished work. The implicit narratives in such old-master pictures and in Reed's works are ways of calling attention to the spectator's presence. Drawing attention to the making of the text is one way of pulling the reader into a work. We, the viewer (or reader), feel momentarily that the artwork is our creation.

A secondary narrative is a story implied by, and perhaps complementary to, the main story that a picture tells. In each case, then, going beyond the story told, we find another story, defined by the composition and the color. Our familiarity with abstract art makes it easier for us than critics or historians of an earlier generation to turn from the primary story to these implicit narratives. Whether because we turn aside from the primary narrative when it is too obvious; or because we see color and spatial relations differently

25. This reflection, hard to see in most full-scale photographs, is captured clearly in the detail in *The Age of Caravaggio* (New York, 1985), 240.

26. For a detail reproduction, see ibid., 245. This observation has not been recorded in the art-historical literature.

27. "Narrative effects are circulated when their product, the told, can be detached from the telling" (Sande Cohen, *Historical Culture: On the Recoding of an Academic Discipline* [Berkeley and Los Angeles, 1986], 323).

than critics trained within the formalist tradition; or because the poststruc-
turalists make us more concerned with the importance of all narratives,
implicit as well as explicit: in any event, we seem to be sensitive to these
aspects of paintings. Perhaps we now see pictures differently because our
concept of the self has changed. When Reed constructs his implicit narra-
tives, he demands that they be understood by a different viewer, a different
kind of spectator, than that figure Fry, Greenberg, and most traditional art
historians think of as standing before the painting.

Looking for implicit narratives in old-master and abstract painting con-
nects the concerns of art historians and critics. For Steinberg, the history
of art is the history of changing notions of the self. This pregnant idea
deserves development. Television creates a new sense of the relation of self
to image, which viewers surely bring also to painting. Trained by such novel
visual media, we now see baroque painting differently than did the contem-
poraries of the Carracci. (Are we better able to identify their visual subtle-
ties, or do we project into them our modern concerns? Perhaps that is a
distinction without a difference.) Present-day anxieties about the power of
painters to sustain art, one source of the postmodernists' belief that the
tradition cannot be continued, reflect these changes in the identity of the
self. Recognizing that the spectator is as if scattered in many positions, il-
lusionistically not present at any single place before the artwork, is liberating
for Reed. Released from the need to place herself in a rigid way, the viewer
is open to a richer experience of painting in which, within a single isolated
panel, we find imaginary spatial and temporal relations that are as rich as,
though very different from, those produced by walking through the del
Bono Chapel.

The primary narrative is what the traditional art historian is looking for
when she or he seeks to study the iconography of a picture. That pictures
have such determinate sources that can be unambiguously identified is a
basic presupposition of traditional art history.[28] How, Fry asks, "can *we* keep
the attention" fixed on both the story and formal relations?[29] Looking at the
shallow space in a modernist painting, Greenberg writes, "*we* may feel a
certain sense of loss."[30] Who is that "we" of whom they speak? When *I* see
Cézanne's pictures differently than Fry, or Pollock's in ways unlike Green-
berg, I observe that their "we" is a fiction, a way of trying to pretend that

28. See my *Principles of Art History Writing*, chaps. 1–4.
29. Fry, "Some Questions in Esthetics," 30 (my italics).
30. Greenberg, *Art and Culture*, 130 (my italics).

their accounts are more objective than they really are. This is why my narrative tends to employ first-person pronouns. My interpretation of these pictures is subjective, as Reed and I would both admit. Another viewer might read these pictures by Annibale, del Sarto, Artemisia Gentileschi, Mattia Preti, and Bernardo Cavallino entirely differently than we do, though we hope that this viewer would able to understand our analysis. Since these examples involve erotic images and violence, how a viewer responds will depend upon her individual sexuality, as feminist art historians have reminded us. Focusing on these implicit narratives seems to open the way to subjective responses to art. I think this is to be welcomed, for it provides a way of responding more fully to the highly subtle content of these works.[31]

In the recent rejection by almost all critics of Greenberg's (and Fry's) formalism, something has been lost, and much has been gained. What has been lost is the possibility of understanding contemporary art in relation to old-master painting. What has been gained is the opportunity to understand in a richer way the differences and similarities between these artforms. My goal in interpreting Reed's paintings is to reconstruct Greenberg's most important insight, in a way that is accessible to a 1990s' sensibility. "The connoisseurs of the future may be more sensitive than we to the imaginative dimensions and overtones of the literal, and find in the concreteness of color and shape relations more 'human interest' than in the extra-pictorial references of old time illusionist art."[32] Greenberg could not have foreseen, perhaps, that his prediction is already coming true:

> Baroque artists introduced a lot of tactile qualities as a way of getting around the figures, to break them down and make them disappear as you look at the paint surface. Since I don't have the tradition of figuration hanging over me, I have the opposite problem: I need to bring back within the all-over structure a sense of variety of the parts. . . . An effect I want in my paintings [is] a sense that something

31. The movement I describe here from the would-be objectivity of formalism to the obvious subjectivity involved in identifying implicit narratives appears in Barthes's development. This moves from his early semiotic theorizing, which treated image interpretation as a kind of science, to a contrast in his book on photography between the *studium* and the *punctum*, which involves an open recognition of his own subjectivity. "A photograph's punctum is that accident which pricks me (but also bruises me, is poignant to me)" (Roland Barthes, *Camera Lucida: Reflections on Photography*, trans. R. Howard [New York, 1981], 27).

32. Greenberg, *Art and Culture*, 137.

has just happened, or is about to happen, and if you look carefully you'll be able to see it. . . . The changes that you notice in the paintings . . . will be that event. The viewer and the paintings are the event, together.[33]

33. "David Reed: Interview with Jonathan Seliger," *Journal of Contemporary Art*, no. 1 (Spring 1988): 74.

15

Color in the Recent Work
of Sean Scully

According to the most influential theories of the day, our younger artists are one and all latecomers, able to quote, appropriate, or otherwise repeat what has gone before but incapable of doing anything new. In this "postmodernist" era—a word used as long ago as 1956 by Arnold Toynbee to identify a time of weakening religious beliefs—the era of innovation is past and creativity such as that of the great modernists no longer possible. If one pleasure of late twentieth-century life is that museums collect works from more diverse cultures than ever before, our bad luck is that so rich a stock of images shakes our confidence in contemporary art. What we have not viewed in museums, we have seen in reproductions. And having seen so much, we wonder: Is anything new possible?

Some of my most memorable viewing experiences have been efforts to match preconceived images to the actual artworks. Writing of Piero della Francesca's color, Adrian Stokes noted: "No form accepts sacrifice to the emphasis of another. Perspective separates, color and form bring together in family circle."[1] I drove to the little chapel outside the village of Monter-

1. Adrian Stokes, *Art and Science* (London, 1937). Thanks to Ann Stokes Angus for help with this example.

chi, prepared by photographs and such observations to see the *Madonna del Parto*. Even so, my imagination was wholly inadequate to the miraculous work I found there. Many art lovers enjoy that pleasure of finally seeing a long-thought-of work. A rarer, and so more special, experience is encountering for the first time major work by an artist one has not previously known. Taking the BMT subway to Queens will never equal driving through the Italian landscape near Monterchi, but what I found upon making the trip to the exhibition space at P.S. 1 in the bitter, midwinter cold of 1982 was Sean Scully's twenty-foot-long, eleven-panel *Backs and Fronts* (Fig. 19). The creation of an already mature artist, whose work of the decade 1971–81 has been the subject of a major retrospective, this painting marked an important new stage in Scully's development, a starting point for the more recent work displayed in this exhibition. What was it about *Backs and Fronts* that made it seem as memorable as great and much-loved work from the past? Sean Scully is a colorist, and the self-evident beauty and obvious order of his recent painting shows that genuinely new art *is* possible today.

Color ought to tempt abstract painters, because it is one of the most literal elements available to the artist. When line closes back on itself, it marks out shape and so always carries representational connotations, even when what it thus depicts is not some recognizable content. Color, however, is always literally itself. The blue cloak in *Madonna del Parto* is, and depicts, something blue, and so one aspect of Piero's composition is the relation between the Madonna as depicted figure and her blue seen against the red enclosing that form. Alberti's *On Painting* (1435) identifies the literal qualities of colors in a way that at first ought to be surprising. "Red is the color of fire, blue of the air, green of the water, and gray and ash of the earth."[2] Water is green because it sustains green things, which makes sense if we think of color words as literally identifying things themselves. Artists thought this way, as when Sassetta, by using an expensive ultramarine pigment to depict that luxurious garment, aptly showed Saint Francis discarding a splendid cloak.

I evoke this early Renaissance conception of color because in some important ways Sean Scully's color has more affinities with it than with the later tradition, running from the late Renaissance through to modernism, in

2. John R. Spencer, ed., *On Painting* (New Haven, 1956). I borrow from Stephen Bann, "Brice Marden: From the Material to the Immaterial," in Whitechapel Art Gallery, London, *Brice Marden: Paintings, Drawings, and Prints, 1975–80* (1981), exhibition catalogue, and "Couleur, délire et langage: Ruskin et Stokes," *Documents sur* (September 1980).

Fig. 17. Sean Scully, *Tiger*, 1983

Fig. 18. Sean Scully, *No Neo,* 1984

which color became what philosophers call a secondary quality, a property of surfaces of things, not of material objects themselves. An apple *is* heavy and round, and its surface *appears* red; and this notion of the relative un-importance of color, part and parcel of a larger view of perception, affects how color in painting is described. Poussin said that painting "must not bother with trivialities such as glowing color"; the seventeenth-century French Academy concluded that drawing is superior to color because color appeals only to the eye, drawing to the mind as well; the late eighteenth-century philosopher Kant thought of color as merely serving to make visible the forms it fills; and in our time Ad Reinhardt found "something wrong, irresponsible and mindless about color," which explains why in his later

Fig. 19. Sean Scully, *Backs and Fronts*, 1981.
Collection of the artist

works color is almost eliminated. In representational painting, color may show the color of surfaces, but in abstract works color becomes disembodied, untainted by any relationship to surfaces. Morris Louis's very beautiful color marks the natural conclusion of this tradition, for when color is no longer attached either to depicted things or to line it appears weightless, floating in space.

Nothing is taken away from Louis's ultimate importance by observing that his work marks the end of one way of thinking about color. The young painters of the 1970s looked elsewhere for inspiration, and describing Scully's place among these figures indicates how the early Renaissance conception of literal color is again relevant to some artists. The two most important painters of the early 1970s to deal with literal color were Brice Marden and Robert Ryman, and a look back at their art suggests why Scully's present work makes a new and important move.

In the 1970s Scully often painted grids, but what—at least in retrospect— seems problematic for the colorist is those points in the grid where horizontals and verticals cross. If the lines cut through one another, color is dematerialized, as it was for Louis; but if one line crosses on top of another, a shallow warp and woof is produced. Marden made his first single-color

work by painting out such a grid, his not-disembodied color composed of solid layers of paint, so that we can imagine burrowing beneath his surface into the solidly pigmented core of the artwork. Scully's recent vertical and horizontal stripes suppose a complementary transformation of the grid. Lift the verticals out and place them alongside the horizontals: now you have a diptych, and the crossing points of lines in the grid have been moved to that edge where verticals meet horizontals. Look carefully at that line between panels, always the one hard-to-see point in a Scully. Concentrate on the verticals and the horizontals blur; attend with care to those horizontals and the verticals are hard to focus. The effect of varying colors complicates this process still further, and adding other panels elsewhere multiples the line.

The literary text "always has two edges," Roland Barthes argued. What "pleasure wants is the site of a loss, the seam, the cut, the dissolve which seizes the subject in the midst of bliss."[3] Sean Scully's internal edges provide the visual equivalent to that break in a text. Where one line of indefinitely expansive color meets an opposed stripe there is just such a cut, and we the viewer are drawn to that line. Ryman's paintings are all white; and so, since his panels lack any internal divisions, they must be composed from the edges. For him composition involves choices about how to mount the panel, which may be flush on the wall, or held vertically or even horizontally like a table, facing that support. Scully's color is *in* stripes, and so for him the equivalent points, the places where color is composed, are the internal lines where one color meets another.

What is so marvelously complex about his recent work is the extreme flexibility of his format. Stripes may be attenuated until they become lines, or broadened almost into rectangles of color. Three or more panels may be joined together, verticals against verticals against horizontals. A smaller panel may be inserted at the center, or close to the edge of a larger field of stripes. The stripes are always shown frontally, totally present to the eye. Nothing is hidden from us, or could be, and the world of perfect and self-sufficient order that we glimpse satisfies an ancient fantasy about art. Piero shows, Stokes wrote, "the mind becalmed, exemplified in the guise of the separateness of ordered things"; and I cannot write a more apt description of the expressive effect that Scully achieves.

During the 1970s the best original painting undertook a radical simplification, a clearing away of much that seemed, and so was, superfluous. The end product of that activity, an undivided and seemingly indivisible surface

3. Roland Barthes, *The Pleasure of the Text*, trans. R. Miller (New York, 1975). (This paragraph, I now [1993] realize, is wrong about Ryman.)

that achieved perfect unity by avoiding composition altogether, may then have seemed the last move in an artistic endgame. Any division of that monochrome rectangle could, it appeared, only impoverish; one factor, no doubt, in the postmodernists' belief that nothing new remained to be done. But what the more recent work of Ryman and Scully teaches us, rather, is that this clearing operation has now prepared the way for a new complexity in painting. Composition, Scully's panels show us, must be understood in new ways.

According to a venerable aesthetic theory, a fully achieved artwork is an organic whole, a unity that nothing can be subtracted from or added to without diminishing the whole. Insofar as a painting is thought of as a flat rectangle, the artist's subdivisions of that space must preserve or re-create an order as obvious as that of the undivided canvas. Representational artists can do this more easily than abstractionists, for their subdivisions of that space may play images in depth against the surface, as when Piero's *Madonna* is depicted within a picture edge echoing her shape. Just as the theory of the organic whole itself borrowed its concept of unity from biology, so much abstract art achieves its unity by abstracting depictions of nature, seeking an image that has a natural-looking order.

I admit that Scully's verticals and horizontals have some such naturalistic connotations. Verticals both refer to our upright posture and, by pointing upward, suggest the sacred, as when Barnett Newman's vertical stripe connotes both God's creative gesture and us who walk upright. Horizontals mark a horizon, the opposed direction, as when an artist so obsessed with order as Poussin adds horizontals to his landscapes to create that ideal order which, in a modernist context, Mondrian achieved by abstracting verticals and horizontals out of landscape scenes. But what is new in Scully's recent work is the recognition that pictorial order need not be bound to that traditional painting format, the windowlike rectangle that the artist subdivides. Just as a virtuoso storyteller can create convincing narratives from the most unlikely materials, so Sean Scully can make a convincing whole from the most unlikely combinations of individual elements. He can join several large rectangular panels horizontally; insert a small panel inside a larger one; notch one edge of a field of stripes; juxtapose panels of differing heights and widths. Here we have a very rich array of possibilities, and even as I survey the many ways that Scully composes his stripes I realize that nothing I have seen of his work enables me to predict what he will do next. Unbound by any need to mimic a preexisting natural order, Scully composes works whose very beautiful, seemingly self-evident order is richly expressive in

part because an ensemble of paintings in an exhibition such as this demonstrates how many choices are now open to him.

"Plastic art will inspire the most direct emotion possible by the simplest means."[4] These words of Matisse point to another aspect of Scully's art. Most critics think Matisse's work from the second decade of this century his greatest or most revolutionary art. The allover color of *Red Studio* (1911, Museum of Modern Art) floods that space, anticipating color-field painting. By comparison, his interiors from the 1920s and 1930s seem both less revolutionary in technique and somewhat escapist in their show of decoration. Since they contain so many fabrics, wallpapers, and garments, it is natural that they depict stripes, which play a complex role in the composition. These stripes may flatten the whole picture when part of the model's garments; emphasize some plane at angles to that picture surface if used to cover a table in the foreground; or, as if in anticipation of Stella's 1960s' work, occasionally fill frontally one quadrant of the actual picture surface. In *Purple Robe* (1937, Cone Collection, Baltimore Museum of Art), for example, the gridlike patterns on the back wall, the robe, and at the picture botom have a highly complex spatial relation, identifying three different planes within the picture.

Scully's transformation of this motif, moving from such depicted stripes to a direct frontal composition, modifies the expressive significance of stripes in ways that point to some differences between his artistic goals and Matisse's. Matisse organizes his color by composing depictions of decorative elements; Scully creates images by dealing directly with stripes themselves. He transforms the Matisseian ideal of harmony and perfect tranquillity, for we no longer look into such an ideal world, an Arcadia, but see color panels standing within the real space that we also occupy. In thus moving away from small-scale easel paintings to larger works, Scully honors his debt to an artistic tradition that has been of great personal significance to him. "As with all successful systems of proportion, simplicity and ease of operation never entailed a stereotyped end product."[5] These words, which sound like an account of Scully's panels, in fact come from an art historian's description of Duccio's *Maestà*, reminding us of Scully's kinship with a work for which he has named a major painting. Like that Sienese master, he is involved with multipanel compositions visually unified by color.

"I prefer that all types and every sort of color should be seen in painting

4. Lawrence Gowing, *Matisse* (New York, 1979).
5. John White, *Duccio: Tuscan Art and the Medieval Workshop* (London, 1979).

to the great delight and pleasure of the observer. Grace will be found when one color is greatly different from the others near it." As I began with Piero and the notion of literal color, here I conclude by quoting from his contemporary, Alberti, whose words evoke the grace both Duccio and Scully achieve. Like every critic today, I am engaged in telling a story about art history, re-creating a narrative in which my favored painter is the central figure. Ideally such a story, which takes us from Piero to Reinhardt and Louis, adding Marden and Ryman and turning finally to Matisse and Giotto, provides a sequence of examples that permit us better to see Sean Scully's works. Ultimately, still, such stories always are fictions, mere didactic devices that should be discarded when they have served their purpose. Scully gives the best description of his work: "I think that painters must turn to painting because they are dumb-struck by the tragedy and splendor of life—and to paint is all that is left as a response. To paint abstractly is to paint pure feeling and to try and let the spirit free in a totally direct way."[6]

6. This chapter borrows from Joseph Masheck, "Stripes and Strokes: On Sean Scully's Painting," *Sean Scully: Paintings, 1971–1981*, exhibition catalogue (Birmingham, 1981), and his *Historical Present: Essays of the 1970s* (Ann Arbor, 1984).

16

Piet Mondrian and Sean Scully: Two Political Artists

Unless the artist die to the successes of his old work he cannot live in his new.

— Clement Greenberg[1]

Mondrian and Scully, could they be political artists? Many critics believe that a political artwork is an image implying an attitude toward what it depicts. *Guernica* is their model of political art, and, in different ways, such painters as Kiefer, Golub, and Fischl imitate it. A viewer of Kiefer's scenes of German landscapes understands his attitude toward the Third Reich; Golub's mercenaries criticize American political intervention in the Third World; Fischl's suburban scenes look critically at middle-class life. Much recent art aspires to be political, and art that does not is criticized for failing to be. I mistrust such art.[2] It cannot compete with news photos or films. A book can assemble historical evidence, explaining events. *Guernica* does not tell why that city was bombed, or how Franco came to power. It shows people suffering, without explaining why they suffer.[3]

1. Clement Greenberg, review of Mondrian's *New York Boogie Woogie*, reprinted in his *Collected Essays and Criticism*, vol. 1, *Perceptions and Judgments, 1939–1944*, ed. John O'Brian (Chicago, 1986), 153.

2. See my "Art Criticism and Its Beguiling Fictions," *ArtInternational* 9 (Winter 1989): 36–41, and my *Artwriting* (Amherst, Mass., 1987), chap. 5.

3. Picasso's *Massacre in Korea* (1951) is an interesting test case. See John Berger, *The Success and Failure of Picasso* (Harmondsworth, 1965), 114.

Could it succeed, what might such political art accomplish? Pop music, novels, and the film reach large audiences; visual art in the galleries or museums does not. Little art there challenges the viewpoint of most of its audience. Neither Kitaj's Jewish themes nor Golub's assassins do more than express an attitude that the audience already shares. This is why what Arthur Danto calls disturbatory art, in which "the insulating boundaries between art and life are breached," fails.[4] Some modern commentators think Caravaggio a political artist; David, Courbet, and Manet did produce political works. But today political artists cannot, so far as I can see, effectively play this role.

I am neither a conservative nor a formalist. Art can be political, and some of the best art today is political, but not in a literal-minded way. Because Scully develops Mondrian's concerns in a different political environment, the best way to understand how they both are political artists is to identify connections between their work.[5] Some formalists treat artistic style as influenced by nothing but artworks. That approach is unnecessarily narrow, for whatever influences an artist's work becomes part of his style. The aim of stylistic analysis is to explain how an artist's successive works are related. Historians of old-master art are familiar with the need to identify an artist's style. Scully restates this view: "Changes have never come about because of play or from pure experimentation. I am not particularly interested in that."[6]

After 1920, Mondrian created his classical rectangular canvases; used the lozenge on a number of occasions; and, in his last years in London and New York, did magnificent, innovative work. His was a complex stylistic development. "Few artists in our century have displayed so ardent a growth."[7] A revealing failure to understand Mondrian's style occurs when his argument with Theo van Doesberg about that painter's addition of diagonals is described as showing "the sectarian zeal with which he combated any deviation from the correct path."[8] If we treat Mondrian's compositions of the 1920s as decorations, rectangles bounded by black lines, then adding diagonals is a small change. But this is not how Mondrian thought.

Scully employs diagonals in *Amber* (Fig. 20) and in *Diagonal/Horizontal* (1987) and *White Light* (1988). These earlier works depend upon the inter-

4. Arthur C. Danto, "Art and Disturbation," in his *Philosophical Disenfranchisement of Art* (New York, 1986), 121, 133.

5. On "style," see Richard Wollheim, *Painting as an Art* (Princeton, 1987), 26–30.

6. Unpublished lecture, Albuquerque Art Museum, 12 February 1989.

7. Meyer Schapiro, "Mondrian: Order and Randomness in Abstract Painting," reprinted in his *Modern Art: Nineteenth and Twentieth Centuries* (New York, 1978), 235.

8. Hans L. C. Jaffe, *Piet Mondrian* (New York, n.d.), 42.

Fig. 20. Sean Scully, *Amber*, 1973. The Whitworth Art Gallery,
University of Manchester

section of two (or more) fields of stripes, horizontals against verticals, cre-
ating a cut in what otherwise would be an indefinitely large field.[9] His early

9. See Chapter 15, above. Joseph Masheck has made a related point, noting that *Overlay No. 2*
(1973) "evokes the segmentally interrupted bands of the 'boogie-woogie' motif in Mondrian's last
paintings" (Joseph Masheck, "Stripes and Strokes: On Sean Scully's Painting," in *Sean Scully:
Paintings, 1971–1981*, exhibition catalogue (Birmingham, 1981), 5.

Fig. 21. Piet Mondrian, *Broadway Boogie-Woogie*, 1942–43. Collection The Museum of Modern Art, New York

Red (1972) looks like Mondrian's grid *New York City I* (1942), but these works are in different styles. Mondrian's *Broadway Boogie-Woogie* (Fig. 21) rejects his earlier use of line, interweaving red and blue lines. In 1941 he said that "the visible expansion of nature is at the same time its limitation; vertical and horizontal lines are the expression of two op-

posing forces."[10] Even then he thought of painting as mirroring the structure of nature. That idea is alien to Scully. His plaids shown in 1973 anticipate Noland's. "Mondrian's Dutch 'burden,' " his origin within a visual culture as idiomatic as his native Dutch, gave him more of a starting point than English art could provide Scully.[11] Mondrian's early landscapes show his native country, and his abstractions are influenced by a very Dutch iconoclastic tradition. There are no similar specifically artistic English influences on Scully.[12]

Some commentators focus on Mondrian's early development, the movement from the naturalistic style of the work in the Netherlands to his understanding and transformation of the lessons of cubism.[13] Robert Rosenblum, for example, claims that "Mondrian constantly sought in the real world some motif that could be translated into a metaphor of the spiritual. . . . Mondrian seemed to be searching for the mysterious skeleton of nature, rejecting matter in favor of immeasurable voids, and enclosing beneath the surfaces of the seen world a unifying structure of elemental, almost geometric clarity."[14] This makes him seem a landscape painter, not the citydweller whose last works pay homage to Paris, London, and New York. Rosenblum describes Mondrian's early style, but not his later paintings. His early landscapes are unadventuresome; his abstractions advance beyond cubism. If we do not take Mondrian's writings seriously, then it is tempting to analyze his stylistic development in formalistic terms. Kermit S. Champa's *Mondrian Studies*, from which I have learned much, expresses a common view: "The paintings are products of a positive and confident will; the theoretical writings are defensive, self-justifying, often creatively dull, and very much after the fact."[15]

Sometimes in his writings Mondrian is merely a man of his time. But

10. *The New Art—The New Life: The Collected Writings of Piet Mondrian*, ed. and trans. H. Holtzman and M. S. James (Boston, 1976), 339.

11. Kermit S. Champa, "Mondrian—De Stijl and After," unpaged catalogue essay for an exhibition in Venice and Salzburg.

12. Whatever the importance of Wyndham Lewis or David Bomberg for the young Scully, as Masheck suggests in his "Stripes and Strokes," I see no connection between their art and Scully's ongoing concerns.

13. Here I was aided by a splendid exhibit, "The Early Mondrian," Sidney Janis Gallery, New York, 1985.

14. Robert Rosenblum, *Modern Painting and the Northern Romantic Tradition: Friedrich to Rothko* (London, 1975), 184, 194.

15. Kermit Swiler Champa, *Mondrian Studies* (Chicago, 1985), xiii. See the review by Yve-Alain Bois (*Art in America* 74, no. 9 [September 1986]: 19), which does not explain how those texts might inform our perception of the paintings.

although the spiritualism of his "New Plastic in Painting" is dated, his marvelous "Two Paris Sketches" (1920) is a reminder that he was a contemporary of Walter Benjamin.

> Is the stroller moved or is he the mover? The artist causes to move and is moved. He is policeman, automobile, all in one. He who creates motion also creates rest.
> What is brought to rest aesthetically is art.[16]

These texts anticipate his cityscapes of two decades later, *Place de la Concorde* and *Broadway Boogie-Woogie*. Scully said, "I would have found it difficult to have made [Mondrian's] classical paintings, [but] I could have made his late ones."[17] For Scully, "one of the things that shuts you out sometimes [from these classical works] is that they are so right . . . there is no room for us."[18] Mondrian's goal in the 1926 *Painting I (Composition in White and Black)* was to extend his image beyond the frame. The classical Mondrians appear elegant because he wanted to avoid "the past," which "has a *tyrannic* influence which is difficult to escape. The worst is that there is always something of the past *within us* . . . memories, dreams . . . we see old buildings everywhere."[19] Picasso and Matisse had a greater range of stylistic resources than Mondrian, who (in part for that reason) broke with that past he dreaded more dramatically.

Scully's earlier paintings—the diagonals with overlapping stripes like *Amber*, the plaids like *Red* (1972), or the juxtaposed panels like *How It Is* (1981)—do not appear to extend beyond the frame. He does not build directly upon the achievement of Mondrian's classical works; any stripe can be imagined as extending outward. But neither *Tyger, Tyger* (1980), which opposes two fields of stripes (horizontals against verticals), nor the recent *White Window* (1988), with the field of stripes broken by that window, suggests extension of the stripes. Scully opens up his picture from within. "Now I have paintings with windows in them," he has said; "the inset is suspended in the field." No longer dependent upon the edge, it ceases to be an independent panel and "becomes a figure in a ground . . . an inset."[20] Scully's pictures have become walls.

16. *The New Art*, 127. On Benjamin and Paris, see Susan Buck-Morss, *The Dialectics of Seeing: Walter Benjamin and the Arcades Project* (Cambridge, Mass., 1989).

17. Kazu Kaido, "Sean Scully Interviewed," *Sean Scully*, exhibition catalogue (Tokyo, 1988), unpaged.

18. Mari Rantanen, "Interview with Sean Scully," *Scully/Quaytman*, exhibition catalogue (Helsinki, 1987), 13.

19. *The New Art*, 325.

20. Sean Scully, interview by Constance Lewallen, *View* 5, no. 4 (Fall 1988): 6.

Mondrian's panels are never windows. Although it seems that his paintings are easy to reproduce, the originals reveal what photographs usually do not show, how far his lines extend over the edge of the front of the canvas. Scully's numerous interviews point to the obvious differences between the concerns of early modernist artists and 1980s' painters. Scully says his horizontals carry landscape references, and the diagonal "doesn't have the symbolic weight . . . of the horizontal and vertical."[21] Unlike Mondrian, he is not willing to attribute any esoteric symbolic meaning to his works. But neither painter is a formalist. In Mondrian's view, "Art is the aesthetic establishment of complete life—unity and equilibrium—free from all oppression."[22] His work provides a model for the world outside art. *"The essential value of each individual entitles him to an existence equivalent to that of others."*[23]

"New York painting continues at its upper levels," the critic Carter Ratcliff says, "to show how the aesthetic touches the political. Scully's part in this demonstration has been central during the 1980s."[24] Meyer Schapiro made a similar point about Mondrian when he described his vision of "the beauty of a big city as a collective work of art and its promise of greater freedom and an understanding milieu." But today it is natural to ask whether this "perpetual movement of people, traffic, and flashing lights" actually shows freeeedom.[25] Scully's earliest work picks up where Mondrian left off, but it offers a more pessimistic view of the modern city. In place of Mondrian's extension of his image beyond the frame, Scully's (much larger) picture functions as an architectural element.

Scully's *Backs and Fronts* (Fig. 19), a very large sequence of panels, has the place in his stylistic evolution that the lozenges had for Mondrian. When he adopted that format, "Mondrian [found] himself able to entertain a number of structural options that have no . . . prior existence in his . . . work."[26] Likewise, once Scully did *Backs and Fronts* he was able to develop. At a time when there was little interest in his art, Scully chose not to retreat,

21. Kaido, "Sean Scully Interviewed," unpaged.

22. Quoted in E. A. Carmean, Jr., *Mondrian: The Diamond Compositions*, exhibition catalogue (Washington, 1979), 66.

23. *The New Art*, 267.

24. Carter Ratcliff, "Sean Scully and Modernist Painting: The Constitutive Image," in *Sean Scully: Paintings and Works on Paper, 1982–88*, exhibition catalogue (London, 1989), 11.

25. Schapiro, "Mondrian," 257, 258. Joseph Masheck supplements that account: *"Broadway Boogie-Woogie* suggests either a map or the facades of skyscrapers . . . it refers back beyond the cubist involvement to Mondrian's lighthouses and church towers of 1909–1910" (Joseph Masheck, *Historical Present: Essays of the 1970s* [Ann Arbor, 1984], 85).

26. Champa, *Mondrian Studies*, 71.

Fig. 22. Sean Scully, *Pale Fire,* 1988. Modern Art Museum of Fort Worth, Texas

but made this big, very ambitious work. Looking back, slightly earlier paintings like *Untitled No. 6* (1979) appear to simplify his style, as if in preparation for that leap forward. Here his concern with architectural scale first emerges. Although Scully had by 1981 long lived in this country, only in *Backs and Fronts* does he draw the full implications of his move from London. Now he is influenced less by the style of American painting, and Mondrian's classical work, than by his urban environment. He incorporates reference to the outside world directly inside the painting.[27] Once this move was made, the direction of his development in the 1980s could be anticipated. *Heart of Darkness* (1982) and *Paul* (1984) juxtapose three panels horizontally. *A Happy Land* (1987) and *Pale Fire* (Fig. 22) place inserts within a

27. Carter Ratcliff has earlier made this point: "I believe that he intends his compositions to be understood as emblems of order in Western culture generally—in its facades, its . . . boulevards . . . its interiors" (Carter Ratcliff, "Sean Scully and Modernist Painting," 27–28).

field of stripes. In *Without* (1988) and *White Light* (1988), the stripes on the inserted panel are set on a diagonal.

Scully's art of the 1980s helps explain Mondrian's strange-sounding statement, "From the very beginning, I was always a realist."[28] Mondrian responded to the grid of Manhattan, seeing it as a realization of that vertical and horizontal order which appeared in his art made in Paris, a place which could not give him that model of a modernist city. Compare Scully with another artist who, when young, was also a poor boy in London. This painter "could endure ugliness which no one else . . . would have borne for an instant. Dead brick walls, blank square windows, old clothes, market-womanly types of humanity . . . had a great attraction for him."[29] Turner, Ruskin goes on to say, "devoted picture after picture to the illustration of effects of dinginess, smoke, soot, dust, and dusty texture . . . all the soilings and stains of every common labor." Scully said of New York, "You can tell from the way a large plywood sheet has been nailed into place on a construction site that no one is reverent."[30] He, like Turner, learns from the environment. In this way he is like Mondrian, whose "realism," his desire "that his works present reality as directly as possible," is derived from another urban artistic tradition, Impressionism.[31] It is in "Monet, Degas, Seurat" and not in cubism, Schapiro argues, that we "find precedents for the pronounced asymmetries in Mondrian's paintings and his extension of foreground lines to the boundary . . . with their implied continuation beyond."[32]

Mondrian's and Scully's abstract works are the product of very immediate visual experiences. Scully says: "There are certain parts of London . . . in which I don't feel comfortable as an artist. I prefer the coarser parts . . . the docks . . . railway arches. They're the places that reveal the most beautiful abstract compositions."[33] His experience supports Mondrian's claim that "it is precisely from . . . visual reality that" the nonfigurative artist "draws the objectivity which he needs in opposition to his personal subjectivity."[34] In turn, such artists teach us to see that world differently. Initially uninterested in Mondrian's art, after Charmion von Wiegand met him in

28. *The New Art*, 338.
29. John Ruskin, *Modern Painters* (Boston, n.d.), 2:364.
30. Ratcliff, "Sean Scully and Modernist Painting," 20.
31. Carmean, *Mondrian*, 48.
32. Schapiro, "Mondrian," 239.
33. Scully, interview with Paul Bonaventura, 8 December 1988, in an unpaged handout to accompany *Sean Scully: Paintings and Works on Paper, 1982–88*.
34. *The New Art*, 299.

his studio "my eyes were transformed. When I went out into the street again, I saw everything differently from before: the streets, the buildings, my total visual environment."[35] As Scully says about his work: "I want it to leak out into the world. . . . What one has to do is tie abstraction into one's life in the way that Rothko managed . . . in the way that Suprematism was tied into the utopian political outlook of the Russian Revolution. That connection must be rebuilt."[36] But for Mondrian, as for Rothko, abstract painting could embody a utopian social vision, a critique of the present social order. For Scully this is not a viable option.

Mondrian was excited by the grid of New York, which five decades later seems oppressive. Scully, for all of his visual pleasure in New York and London, is aware of the problems of those cities, which cannot be solved within the studio. But unless abstract painting possesses the power to demonstrate awareness of those problems, projecting a vision extending beyond the frame, it will be what its worst enemies falsely accuse it of being: mere decoration. Mondrian thought of the grid as liberating, a belief unlikely to be shared by most office workers in midtown Manhattan. Of course, he was aware that Times Square was no utopia—"How beautiful," he said, "if only I couldn't read English!"[37] But it is his hope that art might have such a power, as much as his theorizing about that problem, which sets him apart from most artists of Scully's generation. Nowadays it is impossible to believe that art could have liberating power, and hard to imagine the artworld in which that quality was attributed to it. "While not a conventionally political person, Mondrian was very much a social idealist who saw art working ultimately to celebrate human betterment."[38] The same is true of Scully.

In Saenredam's *Interior of St. Bavo's Church, Called the "Grote Kerk,"* at *Haarlem* (Fig. 23), we find "an intricately controlled compound of precise reference to the actual building and cunning contrivance for the sake of artistic effect. . . . The patterns of light and shade caress forms into three-dimensionality and enhance the crystalline space, yet at the same time their delicate reticence prevents them from working against the linear design . . . on the surface."[39] This picture, whose exaggerated height conveys the feel

35. Interview with Charmion von Wiegand, *Mondrian: 1872–1944*, 78. She goes on to indicate how in his last work "he transgressed his classical European heritage by integrating the American environment" (85).

36. Unpaged handout to accompany *Sean Scully: Paintings and Works on Paper, 1982–88.*

37. Carmean, *Mondrian,* 57.

38. Champa, "Mondrian—De Stijl and After," unpaged.

39. Martin Kemp, "Construction and Cunning: The Perspective of the Edinburgh Saenredam," in *Dutch Church Paintings: Saenredam's Great Church at Haarlem in Context,* exhibition catalogue (Edinburgh, 1984), 30–32.

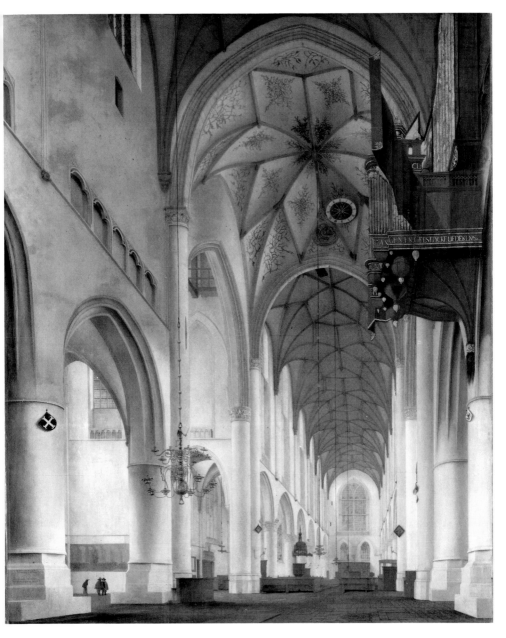

Fig. 23. Pieter Jansz Saenredam, *Interior of St. Bavo's Church, Called the "Grote Kerk,"*
at Haarlem. National Galleries of Scotland, Edinburgh

of that Gothic interior, and whose breadth, with the three men far left isolated from the nave, presents a space that both extends far beyond what we view and, since it is the interior of a building, must be bounded. Saenredam worked in the Calvinist Netherlands, where the "vacant untrammelled spaces where windows let in clear sunlight, to be reflected from white walls" replaced religious pictures in the churches.[40] In that iconoclastic environment, he faced the same problem as did Mondrian in the era of early modernism. How was it possible to make images when the traditions of narrative art no longer are viable?

Scully faces another problem. How is it possible to make abstract painting in an age of postmodernist art? Mondrian dedicated his *Le Neo-Plasticisme* to "the men of the future," seemingly the only audience today for his, and Scully's, political art.[41] Mondrian's art presents a "great and touching utopia . . . based not on political or social tenets but on aesthetic experience."[42] Painting does not change the world. But painting has another power. As has happened in the past, it can change how we see the world. Revealing to us how our world might be, art offers a radical critique of our world as it is. For Mondrian, "in our disequilibrated society, with its antiquated surroundings, everything drives us to search for that pure equilibrium which engenders the *joie de vivre.*"[43] When in *Composition in White and Black* we see the crossed lines, "We are induced by that single crossing to imagine a similar completion of the other bars and their continuity beyond the square. . . . We complete the square."[44] Mondrian provides the premises, leaving it to the viewer to draw the conclusions. To respond properly to his art, and to Scully's, we also must be active.

In Baudelaire's Paris, "The interior was the place of refuge of Art. The collector was the true inhabitant of the interior. He made the glorification of things his concern. [He] dreamed that he was in a world which was . . . a better one . . . in which things were free from the bondage of being useful."[45] During Mondrian's time it was possible to think of the artwork as a model for the larger social world. That is not so today. Most of Scully's paintings are much bigger than Mondrian's works, but the scale of Scully's

40. *Dutch Church Paintings,* 5.
41. *The New Art,* v.
42. Jaffe, *Piet Mondrian,* 54.
43. *The New Art,* 200.
44. Schapiro, "Mondrian," 236.
45. Walter Benjamin, *Charles Baudelaire: A Lyric Poet in the Era of High Capitalism,* trans. H. Zohn (London, 1973), 168–69.

art is smaller. His use of architectural elements implies no belief in art as a mode of utopian social planning. And yet, he too aims to get us to see our world as it is, and as it might be. After remarking on his pleasure in Victorian London houses, he describes American windows: "A window set in a concrete wall is so beautiful, unlike a skyscraper, a Mies van der Rohe type building which is all window, and eliminates that play between keeping you out and letting you in."[46] His paintings, too, both keep us out and let us in, showing us how to see our urban world.

46. Lewallen interview, *View:* 12.

17

Frances Lansing

How does an American who became an Italian make paintings in her adopted country? In the past few years, visitors to New York have had many opportunities to see recent Italian painting. And contemporary American art certainly is known in Italy. So it may be surprising to suggest that the situation of painters is very different in America and in Italy, and that to understand Frances Lansing's work we need to know something about the Italian context of her work. Yet I am convinced that this is the case.

For Americans, and for painters especially, Italy may hardly seem an exotic place. What New York artist does not have pinned up in his or her studio postcards of Italian painters, souvenirs of summer trips. But our "Italy" is less that real place inhabited by the Italians than a highly overdetermined cultural stereotype, a verbal and visual cliché. Richard Shiff has noted an interesting connection between the concept of the cliché and photography: "A photographer's negative (in French, the cliché) acquires aura as a kind of plenitude of handling." Like the photograph, the cliché is a product of the era of mechanical reproduction, when pictures and texts are produced for mass consumption. For non-Italians, from sightseers on bus

Fig. 24. Frances Lansing, *Cipressi*, 1990

tours to the sophisticated visitor, Italy has a certain aura, a product of clichés (which may, of course, be not altogether untruthful) that determine how we see Italy.

"The world of the Italians is not a phenomenon that needs to be subdued, reshaped, arranged in logical patterns. It is not a challenge to be won. It is there simply to be enjoyed, mostly on its own terms." Thus does Marcella Hazan, in her *Classical Italian Cookbook,* define that cliché in a manner relevant to visual art. For an American, at least, an Italian landscape comes as

if prearranged, its so picturesque (restored) village church with the della Robia in the chapel a seemingly natural part of the scenery, as "natural" as the olive trees on the surrounding hills. In that world, everything already appears to have historical significance, as if even nature itself were the product of cultural traditions. When, for example, Lansing represents the Boboli Gardens, she is not just painting an attractive park, in itself little different from one to be found in any city. She is painting the site that inspired Henry James: "I have always felt the Boboli Gardens charming enough for me to 'haunt' them. . . . You may cultivate in them the fancy of their solemn and haunted character, of something fainty and dim and even . . . tragic, in their prescribed, their functional smile."

Take an essay revealingly titled "One Always Fails in Speaking of What One Loves," the last written by Roland Barthes. In the "cold, dark, dirty" Milan station he saw a train headed for Lecce. "I began dreaming: to take that train, to travel all night and then wake up in the warmth, the light, the peace of a faraway town." It did not matter, he adds, "what Lecce (which I have never seen) is like." How can an artist represent a place that comes to us (to us foreigners at least) already a site of such familiar meanings, a hopelessly overdetermined signifier? Thinking of the development over many years of Lansing's art—from photographs, to etchings that in their almost photorealistic objectivity exclude the "picturesque" side of Italian cities, to landscape paintings, to recent works that introduce representations of human figures—I imagine her working through these clichés and coming ever closer to that actual place which she has chosen as her home. Looking through the camera viewfinder; making etchings; painting in an almost expressionist manner, where now she seemingly touches the pigment, physically immersing her fingers in that material stuff which will constitute her actual representation—it is as if stage by stage she moves closer to what she represents in her art, as if that art showed how she was incrementally coming closer to the Italy she represents in her images. Her Italy, the country I think of in America when viewing her images, is thus a place that acquires even for me as a foreign viewer a tangibility as real as her pigment. It is as if in coming to be at home in the place she paints, Lansing has gone beyond the clichés to discover an "Italy" that now can be the subject of her art. This is, I believe, the goal of every real artist—to create images whose reality transcends that of whatever place or things they depict. I came to love Morandi's endlessly imaginative rearrangings of his elongated bottles, which I thought of as his invention. It was a positive shock to discover pho-

tographs showing him sitting behind those bottles, which I had taken to be as mythical as the unicorns represented by some late-medieval artist.

This question of the relation between images and the external reality that they depict has recently been the subject of many discussions. According to the reigning postmodernist doctrines, all pictures—"representational" as well as "abstract"—refer to other pictures, and images can never make contact with external reality. It is hard to understand how this theory, so strangely reminiscent of the views of old-fashioned idealism, could be true. Still, in an odd way, it has become the inspiration for much recent American painting. Nature here is depicted in works with thick antique frames, as if it could only be presented between visual quotation marks, or in pictures in which images are superimposed upon images, as if paintings never really could connect with the outside world.

Lansing's development, as I have imagined it, suggests to me another way of thinking about the relation of representational images to what they depict. Could the relation between picture and external reality be a function, not just of an artist's historical place, but also of her visual environment? Might it be the case that the postmodernist doctrines, true as they may be to the everyday "life experience" of the New York artist, have little to do with making art in Italy? Here I return to my earlier discussion of clichés, to the account of what (in "scare quotes") I refer to as "Italy."

"*Italy*. Should be visited directly after one's marriage. Is very disappointing. Isn't as beautiful as they say." The true precursor of Barthes's *Mythologies*, Flaubert's *Dictionary of Received Ideas* points to the ways that, even as we try to speak authentically, we find outselves repeating those clichés that sound so stilted when we hear them uttered by others. Because Stendhal found Italy so astonishingly beautiful, Barthes writes, the novelist "is, literally, speechless. . . . Such a dialectic of extreme love and difficult expression resembles what the very young child experiences. . . . It is the still-shapeless shape of fantasy, of the imagination, of creation." Is this not the situation of all non-Italians who experience that culture as tourists? We project our fantasies onto the country, which we can know only through a set of clichés. And if we are Americans, then we read "Italy" in terms of our beliefs about images, perhaps thinking that there exists nothing outside these clichés, no real Italy beyond our "Italy."

What I see in the development of Lansing's art, then, is a rejection of the cliché, a turn to that Italy she as painter creates. Her photographs and etchings show me the "Italy" I know, the "Italy" that I would know had I never left America. Her recent paintings reveal a tantalizingly private world acces-

sible only in her art. Who are the figures in the grouping on her screen? The woman putting on lipstick, is it her? Why is the man running through the Boboli Gardens? Whatever the visual sources for these images (and Lansing has spoken of her interest in mannerist coloring, Parmigianino's portraits, Monet's textures, and even Bonnard's sensibility) here she has used them to create something of her own, artworks that transcend their sources. Because her art now becomes private in its references, Lansing is in a position to use these sources, not just appropriate images of artists she admires. And as her images become more private, they also are more difficult to read. Without stepping outside the boundaries of representational art, her works achieve what one commentator on Manet, Jean Clay, identified as that artist's disassociation of "the constituent elements of painting . . . surface, border, color, texture, gesture." Earlier on, Lansing showed landscapes filled with that so-beautiful Mediterranean light, which seduces all us non-Italians. Now, as she works into her textures, it is as if we were beneath one of Monet's scenes of water lilies, enjoying that very surface revealed to us. Manet, as Clay goes on to say, painted not women, but the way women are painted; "not the structure of the model (bones, muscle) but the surface areas . . . render[ing] these sprinklings of powder by the powder of the pigment." Lansing thus enters a heavily contested territory, dealing with the borderline between abstraction and representation that concerns many contemporary artists. Leaving "Italy" behind, she has become a painter of Italy; and it will be exciting to see how she develops these rich themes.

In the 1960s, we expected artists to make works that could not yield what was taken to be that reactionary aesthetic experience, visual pleasure. Today, the beliefs of those puritanical times seem as distant from our present interests as Barthes's very beautiful late book, *The Pleasure of the Text*, seems from his early Marxian proclamations. "We have entered a period of post-historical art," Arthur Danto writes, "where the need for constant self-revolutionization of art is now past." What the approaching "more stable, more happy period" we are entering demands, he adds, is an art that can be responsive to our need for pleasure and joy in our everyday surroundings.

"Italie! Italie! Italie!" (*Les Troyens*, fifth act). Like the Trojans in Berlioz's great opera, we can hear this magical name and fantasize about the place it names. Frances Lansing's "Italy" is a richly textured place, a fabulous garden of visual wonders. Liberated from cliché, Italy signifies for the Ameri-

can painter that incredibly rich visual culture from Cimabue to Mario Sironi and, what for the visitor is naturally associated with it, the ideal landscapes of tourist Italy. But what can a modern artist make of these materials? These large, resolutely unpicturesque landscapes by Frances Lansing (shown at Philippe Daverio Gallery, New York, 27 February–30 March 1991) have little connection with that beautiful Italy and its art. *L'Arno* depicts the river that flows through her adopted city, but it is not a scene the foreigner will recognize. *Natura naturata* might well be in upstate New York; *Grey Twilight* has more in common in color (though not in scale) with Ryder than the nineteenth-century landscapes in the Pitti Palace.

Lansing's 1987 show at the Galleria Schema in Florence contained figurative images, and one painting showed a recognizable tourist site, the Boboli Gardens. Now, whether because she has lived in Italy longer or because such was the destiny of her art, she eliminates the figure. For her, a city person, the landscape is very much an "other," in the way (she has suggested) that for nineteenth-century male painters the female nude was an other. Perhaps painting requires such an other, a vehicle for the artist's fantasies, inevitably inseparable from the artist's conception of her self. Lansing's landscapes are neutral subjects, containers for what she describes as "a vast amount of meanings that can't be pinned down."

Gradual Clarity beautifully merges field below with clouds above, a merging carried further in the allover color of *Earthy Order*. But Lansing's real concerns have less to do with figurative landscape painting, Italian or American, than with Brice Marden's *Grove Group* recently exhibited at Gagosian. Both artists use encaustic, but he presses it flat while she leaves it rough to contrast the appearance of the surface at a distance and its view close up. The last couple of abstractions in his series naturally read as abstractions from Courbet, the hard edge marking the horizon between land and water. Bothered by such horizon lines, Lansing often avoids them by close-in focus on one small area of her landscape. *Grey Twilight* has a high horizon, but that line does not divide the picture, as do Marden's hard-edged horizontals. Lansing needs images, less because what she depicts is itself meaningful, than as a way to get the viewer to step back. Her new paintings are best seen with people in front of them, because her essential concern is the contrast between the near view, which focuses attention on the abstract encaustic surfaces, and that far view where the images come into focus.

Lansing when very young saw the end of abstract expressionism, whose concern with gestural brushwork seemed more or less irrelevant to her earlier work. In *Art and Illusion* E. H. Gombrich discusses the effect of moving

close and stepping back, focusing first on the pigment and then on the image. In his examples, that movement transforms the pigment into the image. But with encaustic, even at a distance we sense the surface. Lansing's are genuinely unreproducible works, since we see in the catalogue the images but not the textures, which, though they could be captured in photographs, could not be seen in a picture showing an image that pops out only when we move back.

If her works do not look much like abstract-expressionist paintings, that is because a certain time of art history, and of Lansing's personal life, stands between them and these works. After Marden, who can paint expressive brushstrokes without it being an ironical gesture, in need of being placed in pictorial quotation marks? To this imagined movement in time needed to place her work corresponds a related movement in space. To see Lansing's pictures we must thus imagine moving, as she has in her life (and as two of her favorite writers, Henry James and Vladimir Nabokov, have in fiction), between the cultures of two continents that, nowadays when the space between them can be traversed so quickly, seem very distant.

18

Michael Venezia

Venezia's paintings are three-bar units, painted on the face facing outward. Resting on a horizontal shelf, abutting but physically unattached, the units are made of solid wood, their cut edges visible close up. The unevenly textured paint has a ridge at the center; often traces of underpainting come through. Each painting is on a separate wall. In a wide-angle instillation shot, several works are visible. But when I faced one painting the others in the same room were at the periphery of my visual field. In some works, the hues of the units are close and relatively dark; other paintings are brighter, but turning off the lights and using the overhead natural lighting undercut that effect.

The central problem of abstract painting, now even more than in its early heroic era, is how to compose. Many painters use string-bag compositions, shallow spaces holding an assortment of representations that coexist in the pictorial space without rhyme or reason. Others present freshly painted simulacra of old wall surfaces, or employ that deceptively difficult format, the monochrome. Almost all of this eclectic painting fails to take seriously the

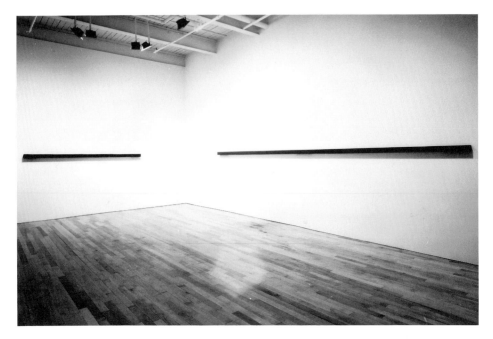

Fig. 25. Michael Venezia, instillation view

legacy of early modernism. Certainly it fails to deal with the achievement of the extreme painter Venezia, and I, most admire, Mondrian.

Venezia's relation to that artist is pretty complex. Mondrians are often framed. (So too is a related painting with extreme dimensions, the narrow vertical Newman at the Modern.) But a Venezia is unframable, although its surface is delicate. His paintings are all frame if you think of the bars as framelike; or, alternatively, they have no frame, if the bars be thought of as equivalent to the traditional canvas. Deconstructing the traditional picture support, Venezia's shelves hold the painting, but from below. Mondrian runs his horizontal and vertical lines across one another, and when color appears from beneath, as in *Broadway Boogie-Woogie* (Fig. 19), that is an effect of aging. Unlike Mondrian, Venezia is not an easel painter. By virtue of their length, though not of their surface area, his paintings are large-scale works.

These comparisons may suggest that Venezia's art is more "advanced" than Mondrian's. In some ways, however, it is more "traditional." Unlike Mondrian's classic works, his paintings do not use primary colors. In the

1970s, Venezia used sprayed pigment, making the whole surface one area; now, working from three units of paint, he has moved forward by going back to a more traditional technique. Most paintings come into existence gradually as the paint is applied. But since what Venezia makes are *pieces of paint*, his works are completely painted before they exist as paintings, before he makes final decisions about what units to use in his compositions.

Extreme paintings are often unreproducible. What disappears in a photographed Ryman is the artwork itself, which is almost indistinguishable from the white wall behind. What vanishes in a photograph of a Venezia are the perceivable color relations. A shot of the whole painting only shows a line of color, and a close-up of the junction of units falsifies the effect of the whole. Ryman's solution to the problem of composition is to eliminate color relationships, turning to virtuosic variations on the theme of the support.[1] Venezia's procedure, the converse of Ryman's, making the support a shelf, allows very varied composition in color. Like Dan Flavin, Venezia uses long, thin units, but Flavin's sculptures look very different, especially in photographs. Extreme paintings and sculptures remain different artforms.

January 1991 in New York was a time of closely hung shows (Chuck Close's room at the Modern, Collins and Milazzo's exhibit at Janis Gallery). Compared with those cluttered instillations, Venezia's display was liberating. His paintings, which take a lot of wall space but achieve their effect economically, deal in a radically new way with perennial concerns of colorists. "Radical" is an often-misunderstood word. Artists who would deconstruct the museum with their anti-aesthetic, aesthetically unadventuresome work are not really radical, not anymore. Compromise, a virtue in life and in politics, is a weakness in art. And nowadays, only the most radical, uncompromised abstract painting can command attention. Venezia is a "conservative" painter who seeks to conserve what is worth preserving, the tradition of high modernist abstraction, by the most radical means possible. His work reminds us how few artists achieve true simplicity. It is hard to be direct.

1. This, I now (1993) realize, is wrong about Ryman.

19

David Sawin

These thirty-two very beautiful paintings (1949–1988), displayed in one room (Newport Art Museum, Newport, Rhode Island, 5 November–31 December 1988), record an extraordinary, extraordinarily strange career. David Sawin was a student of Meyer Schapiro, who collects his work. Recently retired, he taught at Brooklyn College. In the early 1960s, he became friends with Arthur Danto, who has written about him and who introduced me to him.[1] But apart from one highly intelligent early review by Fairfield Porter (*Artnews*, April 1958), he has, I believe, attracted no further critical attention.

Sawin's paintings are varied. Apart from the three early dark paintings, and one female nude, he works in three genres: landscapey still lifes, landscapes, and untitled images that suggest landscapes. Facing the entrance was a landscape from the 1950s, *Nyack Garden*, which might be a Fauvist work in a dark key, juxtaposed with a landscape from 1963, Monet-esque

1. See Arthur C. Danto, "David Sawin's Paintings," in his *Encounters and Reflections: Art in the Historical Present* (New York, 1990), 15–24.

Fig. 26. David Sawin, *Untitled,* no date

in color though unlike a Monet in composition. On the right was a splendid 1958 landscape of a gloomy day seen as if in a clouded-over Constable scene, hung beside an extraordinarily joyous, long, horizontal work. The large still life of fruit on a table from 1965, next to them, would appear an off-color Cézanne but for the intrusion of the blue sky. Sawin's nude, pressed into the surface as if a Dubuffet, reclines upward like an Avery woman, her pinkish body blending into the dark field of color behind.

To the left of the door were three pictures of apples. In the first the green apples are separate; in the next one, from 1965, they cluster together; and by 1981 they are transformed into merging shapes. Next was a 1979 still life with Morandi-esque bottle, the forms at rest though a great force presses rightward from the far left. Further right was an untitled work from 1979, in which, in what seems a landscape, a hill appears anchored to the

sky, held up by a yellow pylon. *Luminous Shore* (1981) is a reminder that Sawin might have, had he so chosen, made almost conventionally charming paintings. *Radiant World,* from the same year, in which largish color areas move diagonally upward and leftward, is a reminder of how much he, and we, would have lost had he made that choice. Several recent landscapes bend a shape, whose representational significance is difficult to determine, against one vertical edge of the painting. The blue at the top of *A Miraculous Landscape* (1988) defines a sky, but what in the world are the yellow forms below it, or the (orange!) treelike structure in *Summer Hills,* also from 1988? Looking back, the daring effects of these near abstractions make the earlier represented elements seem more elusive.

Sawin paints and repaints slowly, working on a relatively small scale. Although he never repeats images, every work is obviously in his style, which is always unmistakable. All my stylistic comparisons to other artists only emphasize how unique his work is, for Sawin, the most self-sufficient important painter I have ever met, has a rare gift: absolute single-mindedness. His depicted things merge even as they emerge from his brushwork, which is everywhere full of life. Whatever he paints he transforms, creating a world in which, unexpectedly, color finds color in harmony. Not the least of Sawin's accomplishments is to have inspired Arthur Danto's loving catalogue essay, a Proustian meditation on style in art *and* life, which weaves together motifs from Pater, Nietzsche, and Danto's own earlier writings into a seamless whole, achieving a unity as pleasurable, and unexpected, as do these paintings.

Index